Louis
Comfort
Tiffany

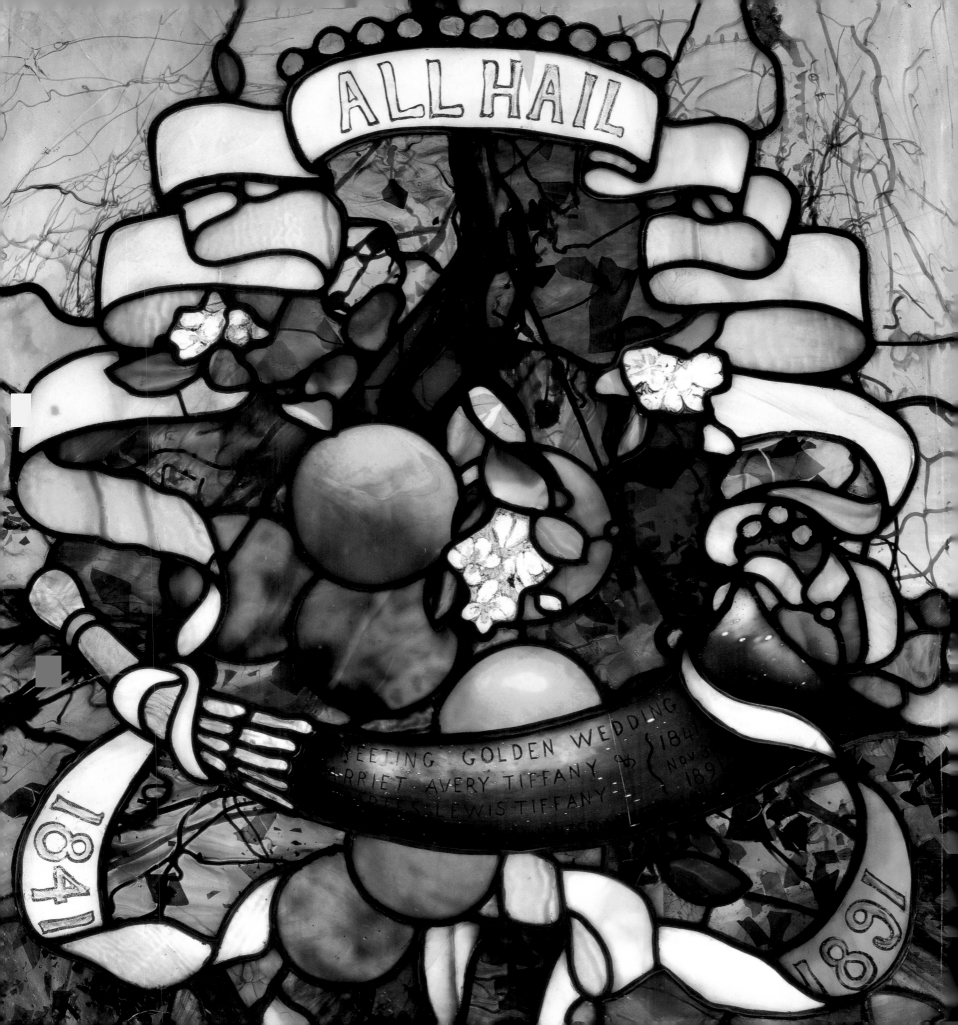

Louis Comfort Tiffany
artist for the ages

Marilynn A. Johnson

with essays by Michael John Burlingham,
Martin Filler, Nina Gray, and Rüdiger Joppien, and
contributions by Michele Kahn and Joan T. Rosasco

Exhibitions
International™

SCALA

This book is dedicated to

Edgar Kaufmann, Jr.
Robert Koch
Hugh and Jeannette McKean
and Lillian Nassau

pioneers who revived Tiffany's reputation in the
mid-twentieth century and who saved major
examples of his work

Contents

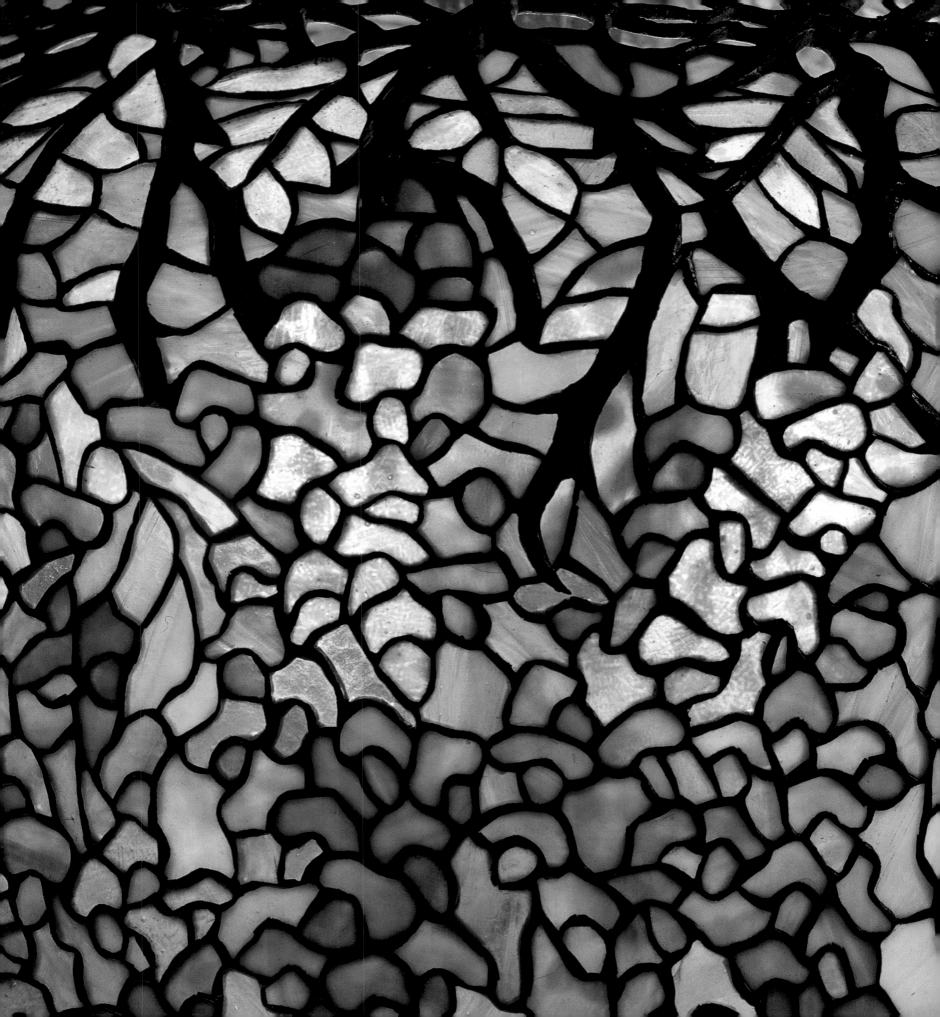

Louis Comfort Tiffany: Artist for the Ages is the
first comprehensive exhibition of Tiffany's work
since the late 1980s.

The foremost American designer of the late nineteenth
and early twentieth centuries—and the first Design
Director of Tiffany & Co.—Louis Comfort Tiffany is revered
for his glass vessels, stained-glass lamps and windows,
jewelry, enamels, ceramics, furniture, and precious
objects. All are represented in this exhibition that features
120 works from approximately forty museum and private
collections, as well as the Tiffany & Co. Archives.

The Tiffany & Co. Foundation, which provides grants to
nonprofit organizations dedicated to arts education and
preservation, traditional craftsmanship, and environmental
conservation, is proud to sponsor Louis Comfort Tiffany:
Artist for the Ages. The exhibition exemplifies the shared
mission of Exhibitions International and The Foundation
to promote excellence in the decorative arts.

Fernanda M. Kellogg
President
The Tiffany & Co. Foundation

Detail cat. 92

Foreword

Louis Comfort Tiffany: Artist for the Ages exemplifies the mission that Exhibitions International has set for itself: to bring the work of major figures in the decorative arts to a wide audience and to illuminate it with the best scholarship. Acclaimed and admired in his lifetime, Louis C. Tiffany was also intensely private and elusive. By the time of his death in 1933, the ornamental style that he espoused had fallen from favor. Rediscovery and appreciation began in the post-World War II period when disenchantment with pure functionalism led to a reevaluation of the Arts and Crafts, Aesthetic, and Art Nouveau movements of the late nineteenth and the early twentieth centuries. Louis Comfort Tiffany, who creatively bridged all three, is a more complex figure than has been previously acknowledged.

Marilynn A. Johnson, for many years a curator in the American Wing of The Metropolitan Museum of Art, has devoted much scholarly attention to Louis Comfort Tiffany. For this exhibition, she has visited both familiar and obscure sources to reexamine his output and to produce a fresh overview of Tiffany's full career and every medium he exploited. The exhibition will demonstrate that Tiffany's work is at once astonishingly diverse and expressive of a single vision. Louis Comfort Tiffany: Artist for the Ages covers the full range of Tiffany's production, identifying the unifying themes and preoccupations that recur in many media. Aware of the uniqueness of his *oeuvre*, Tiffany contrived whenever possible to place examples of his best work in public and private collections both in the United States and abroad. Some of these works are celebrated, others almost unknown. This exhibition brings to light many treasures.

Louis Comfort Tiffany: Artist for the Ages is the first comprehensive survey of Tiffany's work in the United States since 1989 when Masterworks of Louis Comfort Tiffany was organized by the Smithsonian Institution. In 1999, Rüdiger Joppien, Head of the Twentieth Century Department at the Museum für Kunst und Gewerbe in Hamburg, Germany, organized the first Tiffany exhibition ever mounted in Europe, including many objects collected by European institutions in Tiffany's lifetime. Louis Comfort Tiffany: Artist for the Ages will be the first important exhibition in the twenty-first century.

The exhibition and this catalogue are the result of the dedicated work of many talented people. Exhibition curator, Marilynn A. Johnson, who took over the project in June 2003, developed the concept and structure and chose the works of art to be exhibited. Working under the constraint of a tight schedule,

she has brought to this project her expertise, her enthusiasm, and her unique sensitivity to Tiffany's aesthetic goals. She is also the general editor of this publication in which the reader will find illuminating essays by Michael Burlingham, Martin Filler, Nina Gray, Rüdiger Joppien, and Marilynn Johnson herself that complement the dazzling visual experience of the exhibition. Michele Kahn contributed the bibliography and much valuable research. Joan T. Rosasco, who coordinated the publication for Exhibitions International, is responsible for the extended catalogue entries. Osanna Urbay, the able manager of the exhibition, supervised the myriad details involved in securing art loans and developing the exhibition tour. Leah Goldberg Shandler supervised fundraising for the project. Dorys Codina meticulously oversaw all financial and legal aspects. The gifted photographer, Richard Goodbody, is responsible for many of the handsome plates that illustrate this volume. Stephen Frankel and Kate Clark, our able editors in New York, fastidiously prepared the manuscript for the publisher. Jennifer Wright at Scala, New York, and Esme West at Scala, London, have been enthusiastic about this publication from the beginning, and we are grateful to them for their support, encouragement, and patience. Nigel Soper is the brilliant designer who has made this book as beautiful as befits the subject.

It gives me great pleasure to acknowledge the generous support of The Tiffany & Co. Foundation for the exhibition and this publication and to give particular thanks to Fernanda M. Kellogg, Senior Vice President of Tiffany & Co. and President of The Tiffany & Co. Foundation.

Finally, our sincerest gratitude must be extended to the lenders to the exhibition who have generously agreed to share fragile and much-loved works of art. Many others, listed too briefly in the acknowledgments, made much appreciated contributions to the project.

David L. Shearer
Director
Exhibitions International

A Word from the Curator

Marilynn A. Johnson

When I was a child my father told my brother and me about a fabled estate on Long Island where his older brother, Midwestern sculptor Jon Magnus Jonson, had studied. The extraordinary house and property were, of course, Laurelton Hall; "Uncle Jack" was a Tiffany Fellow in 1927. My first visit to The Metropolitan Museum of Art was also in my childhood, to an exhibition called "Artists for Victory," in which my uncle's sculpture, the *Cargador*, was being exhibited. I remember a flight of stairs that seemed endless and vast echoing halls.

Many, many years later, in 1966, I came to the Metropolitan Museum's American Wing as a Chester Dale Fellow, and stayed for sixteen years. After the 1970 exhibition, 19th Century America, I became an Assistant Curator responsible for all nineteenth-century furniture and silver, and two years later, as an Associate Curator, for all American textiles and glass as well. The latter included the Favrile glass vessels of Louis Comfort Tiffany, and a landscape window given in 1926, but walled up during Tiffany's years of obscurity.

In the late 1970s, as we prepared for the opening of the new American Wing, we uncovered the window to install it in the American Wing courtyard. Looking over installation plans, I realized there was a great gaping space between the wonderful Sullivan staircases on the South Wall. We needed something of the late nineteenth century or early twentieth century to balance the early-nineteenth-century bank façade on the North Wall. I thought of Tiffany.

I called Tiffany scholar and collector Hugh McKean, and then flew to Florida to have lunch with him at Winter Park. Although we originally agreed upon a gift of the Columbian Exposition chapel, ultimately it was the columnar entrance to Laurelton Hall that came to the Wing, along with the semi-permanent loan of the window then known as "The View of Oyster Bay." As we conserved and installed the Laurelton Hall Loggia, I felt that curious sense of coincidence that occurs in life, as well as a sense of completion.

I felt that again in 2003 when I returned to Tiffany after years of retirement. This book is dedicated to four pioneers who were instrumental in restoring Tiffany's reputation and saving his work. Although there were other important scholars and collectors, these were the pivotal figures in the Tiffany Revival. I was fortunate to know them all. I audited Edgar Kaufmann's class at Columbia and, with Dianne Hauserman Pilgrim, approached him about creating a way we could buy nineteenth-century objects as we saw them. He established the Kaufmann fund, which brought many wonderful objects to the American Wing, including a Tiffany mosaic column. Robert Koch and I were often on the same lecture circuit, and I visited him and his wife, Gladys, at their home in Connecticut. There he showed me some of his extensive research archive, including his file on the New Amsterdam Theater, with its Art Nouveau interior, rare in America. I met Lillian Nassau, an impressive figure in the field, when she gave the Tiffany mosaic fountain, and I oversaw its installation in the American Wing courtyard. Because of our work to bring the Laurelton Hall Loggia and The View of Oyster Bay window to the American Wing, I have particular

appreciation for Hugh McKean. The proverbial "gentleman and scholar," he had an unswerving devotion to the memory of Louis Comfort Tiffany and to the preservation of his work.

The range of that work goes far beyond Tiffany's superb creations in glass. This exhibition explores work in many media. It is not intended as another Masterworks exhibition. Although many objects in it are of masterworks status, others illustrate Tiffany's wide-ranging imagination and his experiments in various arts, as well as his desire to bring art into the average American home. As with any exhibition and book, some important material has been omitted. There is little evidence of his ecclesiastical decorations, the majority of which are still in the churches for which they were designed. Because of the fragility and high values of Tiffany objects, and because this exhibition travels to four venues, some of the objects we wished to show were not available. Exhibitions International is a museum service organization; we have therefore concentrated on the collections of museums rather than on private collections that are not usually available to the museum-going public. To help the audience for this exhibition and the readers of the book to understand the sources of Tiffany's designs more clearly, we have divided the material in the catalogue into some of the most significant design categories. Clearly with a larger representation of Tiffany's work, other categories would be possible. There is also sometimes considerable overlap within the categories; for example, since it is impossible to consider Tiffany's representation of nature without considering also his debt to the arts of Japan, one can find designs depicting dragonflies in both categories. The study of Tiffany is a well-plowed field, but although the time allowed for this project was unusually short—not even two years—we have tried, insomuch as possible, to present new material in both objects and scholarship.

Clearly a project like this would be impossible without the help and support of many people. I am grateful to David Hanks and to David Shearer for their continued encouragement, and to the essay authors, Nina Gray, Rüdiger Joppien, and Martin Filler, for their meaningful contributions to this book. For the curator, being in touch once again with former colleagues and working with new ones has been rewarding. The names of those who gave their assistance and expertise appear below, but in many cases a mere mention does not adequately convey their contributions. To you all, a profound thank-you.

I would like to extend a specific thank-you to several colleagues who worked most closely on the exhibition or the book: to Michael Burlingham, for his generous sharing of scholarship and his valuable comments on the manuscript; to Kate Clark, my editor, whose patience and painstaking attention to detail have been invaluable; to Michele Kahn, who provided extensive bibliography beyond that which appears in this volume, and who not only located and copied many well-known period articles, but also carefully color codified them and even sometimes summarized them for the curator; to Joan T. Rosasco, who supervised this publication, wrote the insightful entries and contributed meaningful ideas and creative suggestions. Finally, last alphabetically, but in no other way, to Osanna Urbay, the best exhibition coordinator one could hope to have. Her unfailing good humor under considerable stress and her dedication and diplomacy in working with many people are a large part of why this exhibition has come to fruition.

For all of the audience of this exhibition and the readers of this book we wish not simply that they will go away with a better understanding of Louis Comfort Tiffany and his times, but that they may have an experience like that of an unknown visitor to the 1970 exhibition at the Metropolitan Museum, 19th Century America, described by

Joseph Purtell in *The Tiffany Touch*. Conditioned, unlike today's visitors, by years of disdain for Tiffany's work, he stood "for many minutes" in awe before a case of Tiffany's glass, and was overheard to say, "Why, it's beautiful!"

We wish to thank, first of all, the lenders whose generosity has made this exhibition possible:

Allen Memorial Art Museum, Oberlin College, Oberlin, OH: Stephanie Wiles, Director; Lucille Stiger, Registrar | **The Baltimore Museum of Art**, Baltimore, MD: Doreen Bolger, Director; Sona Johnston, Senior Curator of Paintings and Sculpture Before 1900; Susan Dackerman, Curator of Prints, Drawings and Photographs; James A. Abbott, former Curator of Decorative Arts; Catherine Stewart Thomas, Assistant Curator of Decorative Arts; Michael Scott, Rights & Reproductions Coordinator | **The Brooklyn Museum**, Brooklyn, NY: Judith Frankfurt, Deputy Director for Administration; Linda S. Ferber, Curator of American Art; Kevin L. Stayton, Chair, Decorative Arts; Barry Harwood, Curator, Department of Decorative Arts; Elizabeth Reynolds, Chief Registrar; Jennifer Lesslie, Assistant Registrar for Domestic Loans; Ruth Janson, Coordinator, Rights & Reproductions | **Chrysler Museum of Art**, Norfolk, VA: William J. Hennessey, Director; Catherine Jordan Wass, Deputy Director of Operations; Gary Baker, Curator of Decorative Arts; Sara Beth Walsh, Assistant Registrar | **Cincinnati Art Museum**, Cincinnati, OH: Timothy Rub, Director; Anita Ellis, Director of Curatorial Affairs and Curator of Decorative Arts; Amy Miller Dehan, Assistant Curator of Decorative Arts; Rebecca M. Posage, Associate Registrar; Scott Hisey, Photographic Services Coordinator & Rights & Reproductions Administrator | **The Cleveland Museum of Art**, Cleveland, OH: Katharine Lee Reid, Director; Charles L. Venable, Deputy Director for

Collections & Programs; Lynn Cameron, Executive Assistant, Decorative Arts; Louise Mackie, Curator of Textiles & Islamic Art; Mary Suzor, Chief Registrar; Gretchen Shie Miller, Associate Registrar for Loans; Monica Wolf, Rights & Reproductions; Kathleen Kornell, Rights & Reproductions; Deirdre Vodanoff, Assistant, Textile and Islamic Art | **Cooper-Hewitt, National Design Museum, Smithsonian Institution**, New York, NY: Paul Warwick Thompson, Director; Sarah Coffin, Curator of 17th and 18th Century Decorative Arts; Cynthia Trope, Department of Product Design and Decorative Arts; Barbara Duggan, Collections Manager, Textile Department; Jill Bloomer, Image Rights and Reproductions | **The Corning Museum of Glass**, Corning, NY: David Whitehouse, Director; Jane Shadel Spillman, Curator of American and 19th Century Glass; Tina Oldknow, Curator of Modern Glass; Warren Bunn, Registrar; Jill Thomas-Clark, Rights & Reproductions | **Currier Museum of Art**, Manchester, NH: Susan Strickler, Director; Andrew Spahr, Chief Curator; Karen Papineau, Registrar | **Driehaus Enterprise Management Inc**., Chicago, IL: Richard H. Driehaus; Maureen Devine, Curator; Elise Schimeck, Registrar & Assistant Curator | **Gail Evra** | **Everson Museum of Art**, Syracuse, NY: Debora W. Ryan, Curator; Karen Convertino, Registrar; Amanda Clifford, Assistant Curator | **Haworth Art Gallery**, Accrington, England: Jennifer Rennie, Curator | **Carl Heck** | **Herbert F. Johnson Museum of Art**, Cornell University, Ithaca, NY: Frank W. Robinson, Director; Andrew C. Weislogel, Curator; Matthew J. Conway, Registrar; Whitney Stewart Tassie, Exhibitions Assistant; Kerry McBroom, Rights and Reproductions; Michael Sampson, former Assistant Curator | **Jason McCoy Inc**., New York, NY: Stephen M. Cadwalader | **The Johns Hopkins University, Historic Houses**,

Baltimore, MA: Rob Sarnio, Director; Jacqueline O'Regan, Curator, Evergreen House | **Mark Twain House & Museum**, Hartford, CT: John V. Boyer, Executive Director; Debra Petke, Chief Curator; Patti Philippon, Collections Manager | **Memorial Art Gallery of the University of Rochester**, NY: Grant Holcomb III, Director; Marjorie B. Searle, Chief Curator; Monica Simpson, Permanent Collection Registrar; Susan Nurse, Visual Resources Coordinator, Rights & Reproductions | **The Metropolitan Museum of Art**, New York, NY: Alice Cooney Frelinghuysen, the Anthony W. and LuLu C. Wang Curator of American Decorative Arts; Peter M. Kenny, Curator, American Decorative Arts; Amelia Peck, Associate Curator, American Decorative Arts; Elaine Bradson, Associate Administrator of the American Wing; Deanna Cross, Photograph Library; Karen Zimmerman, former Administrative Assistant; Nestor Montilla, Registrar's Office; Tatiana Chetnik, Registrar Assistant | **The Museum of Modern Art**, New York, NY: Terence Riley, Chief Curator, Department of Architecture & Design; Paola Antonelli, Curator, Department of Architecture & Design; Danté Ruzinok, Assistant to the Chief Curator; Christian A. Larsen, Department of Architecture & Design; Nobi Nakanishi, Department of Architecture & Design; Thomas D. Grischkowsky, Archives Specialist, Museum Archives | **The Museum of the City of New York**, New York, NY: Deborah Dependahl Waters, Head of Collections and Exhibitions; Andrea Henderson Fahnestock, Curator of Paintings & Sculpture; Kerry L. McGinnity, Assistant Registrar; Marguerite Lavin, Rights & Reproductions | **Lillian Nassau Gallery**, New York, NY: Paul Nassau; Arlie Sulka; Eric Silver | **National Museum of American History, Smithsonian Institution**, Washington, DC: Brent D. Glass, Director; Susan Myers, Curator Emerita, Department of History, Division of Social History; Ann Golovin, Curator Emerita; Bonnie Campbell Lilienfeld, Assistant Chair, Division of Social History; Ana Lopez, Assistant to Bonnie Campbell Lilienfeld; Margaret Grandine, Manager of Outgoing Loans; Carol Slatick, Loans Coordinator for Packing and Shipping; Dave Burgevin, Smithsonian Photographic Services | **Neil Lane Jewelers**, Los Angeles, CA: Neil Lane; Eva Gaustad | **Neustadt Museum of Tiffany Art**, Long Island City, NY: Nina Gray, Consulting Curator; Lindsy R. Parrott, Collections Manager & Assistant Curator; Susan Greenbaum, Conservator | **New Orleans Museum of Art**, New Orleans, LA: E. John Bullard, Director; John Keefe, Curator, Decorative Arts; Paul Tarver, Registrar; Jennifer Ickes, Associate Registrar | **The Newark Museum**, Newark, NJ: Mary Sue Sweeney Price, Director; Ulysses G. Dietz, Curator of Decorative Arts; Amber Woods Germano, Associate Registrar; Scott Hankins, Assistant Registrar | **New-York Historical Society**, New York, NY: Jan S. Ramirez, Director; Margaret K. Hofer, Curator of Decorative Arts; David Burnhauser, Registrar; Marybeth Kavanagh, Director of Rights & Reproductions; Jill Reichenbach, Coordinator, Rights & Reproductions; Nicole Wells, Assistant, Rights & Reproductions | **Shelburne Museum**, Shelburne, VT: Hope Alswang, President & CEO; Henry Joyce, Curator; Barbara C. Rathburn, Associate Registrar; Nancy Ravenel, Objects Conservator; Julie B. Sopher, Rights & Reproductions Manager | **Raphael Sinai** | **Strong Museum**, Rochester, NY: Christopher Bensch, Director of Collections; Kate Turner Morgan, Collections Manager | **Tiffany & Co. Archives**, Parsippany, NJ: Annamarie Sendecki, Archivist; Louisa Bann, Manager, Research Services; Stephanie D. Carson, former Archives Registrar; Meghan Magee, Archives Registrar | **The Toledo Museum of Art**, Toledo, OH: (see below) | **University of Michigan Museum of Art**, Ann Arbor, MI: James Steward, Director; Lori

Mott, Registrar; Ann Sinfield, Assistant Registrar | as well as several private collectors who chose to remain anonymous.

The following individuals provided valuable assistance in the preparation of this publication:

Rolf Achilles, Smith Museum at the Navy Pier, Chicago, IL; James and Dorothy S. Baker; Barrett Friendly Library, Mountainhome, PA; Judith A. Barter, Field-McCormick Curator of American Arts, The Chicago Art Institute; Roger M. Berkowitz, retired President, Director, CEO, Toledo Museum of Art; Frederick Brandt, Consulting Curator of the Frances and Sydney Lewis Collection, Virginia Museum of Fine Arts; Rachel Brishoual, Responsible de la Photothèque, Union Centrale des Arts Décoratifs, Paris, France; Elizabeth Broun, Director, Smithsonian American Art Museum, Smithsonian Institution; April Brown, Collection Assistant, Morse Museum of American Art, Winter Park, FL; Elizabeth Brumagen, Librarian, Rackow Research Library, Corning Museum of Glass, Corning, NY; Robert T. Buck, retired Director, Exhibitions International; Mary Ellen Christman; Donna Climenhage, Curator, Morse Museum of American Art, Winter Park, FL; William and Nathalie Comfort; Priscilla Cunningham; David Dearinger, former Curator, National Academy of Design, now Boston Atheneum; David DeLong, Department of Architecture & Historic Preservation, University of Pennsylvania; Bert Denker, Decorative Arts Photographic Collection, Winterthur Museum, Garden & Library; Libby De Rosa; Isabelle Dervaux, Curator, National Academy of Design; Alastair Duncan; Martin Eidelberg, Professor Emeritus, Rutgers University, New Brunswick, NJ; Patricia Elliott, Head of Education, Winterthur Museum, Garden & Library; Nancy G. Evans, retired Registrar, Winterthur Museum, Garden & Library; Wilson Faude, Hartford, CT; Andrea Felder, New York Public Library Photographic Services; Nonie Gadsden, Assistant Curator of Decorative Arts and Sculpture, Museum of Fine Arts, Boston; Wolfgang Gluber, Curator, Department of Applied Arts, Hessische Landesmuseum Darmstadt, Germany; Lee Grady, Archivist, McCormick Collection, Wisconsin Historical Society, Madison; Christopher Gray, "Streetscapes" Columnist, The New York Times; Susan Grinols, Manager, Photographic Services, Fine Arts Museums of San Francisco; Catherine Hinan, Director of Public Affairs/Publications, Morse Museum of American Art, Winter Park, FL; Lisa Hinzman, Photo Reproduction and Business Manager, Library-Archives, Wisconsin Historical Society, Madison; Penelope Humphrey, Reference Librarian, Brevard County Library, Cocoa, FL; Christina Japp, 20th Century Decorative Arts, Sotheby's, New York; Erica Kelly, Prints & Photographs, Library of Congress, Washington, DC; Mitchell Koch; Karri Jurgens, Curator, Maymont House, Richmond, VA; Allison Ondrasik King, Research Librarian, Brevard Community College Library, Cocoa, FL; Melina Lamarche, Christie's Images, New York; Serge Lemoine, Musée d'Orsay, Paris, France; Marie Long, The LuEsther T. Mertz Library, The New York Botanical Garden; Françoise Lordonnois, Paris, France; Jacqueline Lordonnois, Provins, France; Anne M. Lyden, Assistant Curator, Department of Photographs, The J. Paul Getty Museum, Los Angeles, CA; Catherine Lynn; Benjamin Macklowe, Macklowe Gallery, New York; Denise Mahoney, Collection Manager and Research Assistant, Art Institute of Chicago; Lary Matlick, Macklowe Gallery, New York; Roberta A. Mayer, Bucks County Community College, Newton, PA; Nancy McClelland, McClelland+Rachen, New York; David McFadden, Curator, Museum of Arts and Design, New York; Betsy Mclean; Allen Michaan; R. Craig Miller, Curator, Architecture, Design & Graphics, Denver Art Museum; Milo

Naeve, Field McCormick Curator Emeritus American Arts, Art Institute of Chicago; Tracey L. Neikirk, Museum Educator, The Mariner's Museum, Newport News, VA; Elizabeth O'Leary, Associate Curator, Decorative Arts, Virginia Museum of Fine Arts; Jack Ophir, Ophir Gallery, Englewood, NJ; David T. Owsley; Howell W. Perkins, Manager, Photographic Resources, Virginia Museum of Fine Arts; Clinton Piper, Rights & Reproductions, Western Pennsylvania Conservancy; Carole Pope; James Potsch, Graphics Department, Wright, Chicago, IL; Jesse and Charles Price; Nolwenn Rannou, Chargée d'études documentaires, Archives d'architecture du XX siècle, Institut français d'architecture, Paris, France; Stephan Saks, New York Public Library Photographic Services; Ruth and Joseph Sataloff; Jody Sidlauskas, Archives Assistant, Wallace Library, Rochester Institute of Technology; Richard Sorensen, Rights & Reproductions, Smithsonian American Art Museum, Washington, DC; Joseph R. Struble, Assistant Archivist, George Eastman House International Museum of Photography and Film, Rochester, NY; Jennifer Thalheimer, Collection Manager, Morse Museum of American Art, Winter Park, FL; Julie Tozer, Assistant to the Curator, Avery Drawings and Archives, Columbia University; Lynda S. Waggoner, Director of Fallingwater and Vice President, Western Pennsylvania Conservancy; Dale Wheary, Director, Maymont House, Richmond, VA; Dot Wiggins, Rights and Reproductions, Winterthur Museum, Garden & Library; Calvin and Annie Wong; Elise Wright, Richmond, VA; Janet Zapata; James Zemaitis, 20th Century Decorative Arts, Sotheby's, New York.

Finally, a heartfelt thanks to the gracious staff at the four museums that chose to host this exhibition:

Seattle Art Museum, Seattle, WA: Mimi Gardner Gates, The Illsley Ball Nordstrom Director; Julie Emerson, Curator of Decorative Arts; Zora Hutlova Foy, Manager of Exhibitions & Curatorial Publications; Liz Andres, former Exhibitions & Collections Coordinator; Feliza Medrano, Exhibitions & Collections Coordinator; Phil Stoiber, Senior Associate Registrar; Mike McCafferty, Chief Designer & Head of Museum | **The Toledo Museum of Art**, Toledo, OH, which also lent their beautiful blood red Tel El Amarna vase and the Necklace with Grapes: Don Bacigalupi, Director; Jutta-Annette Page, Curator of Glass; Pat Whitesides, Registrar; Nicole Rivette, Assistant Registrar for Collections | **Dallas Museum of Art**, Dallas, TX: Jack R. Lane, The Eugene McDermott Director; Kevin W. Tucker, The Margot B. Perot Curator of Decorative Arts and Design; Tamara Wootton-Bonner, Director of Exhibitions and Publications; Jennifer Bueter, Exhibitions Assistant; Susan Squires, Assistant Registrar; Kevin Button, Manager of Installation Design; Evan Forfar, Head Preparator; Judy Conner, Director of Marketing & Communications; Diana Duncan, Director of Development | **Carnegie Museum of Art**, Pittsburgh, PA: Richard Armstrong, The Henry J. Heinz II Director; Maureen Rolla, Assistant Director; Sarah Nichols, Chief Curator and Curator of Decorative Arts; Elizabeth Agro, Assistant Curator of Decorative Arts; Monika Tomko, Registrar; Allison Revello, Associate Registrar; Meg Bernard, Development.

Preface

Michael John Burlingham
Great-Grandson of Louis Comfort Tiffany

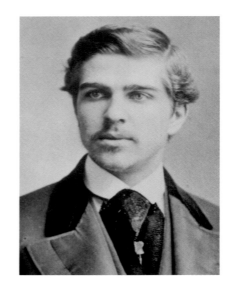

Tiffany was so completely a creature of his family and times that I can't imagine his springing from another point on the space-time continuum. Clearly, his extraordinary career could not have existed had he been born, somehow, with the same DNA in a different era or to a different family. By the surname Tiffany, of course, I mean to indicate not just Louis Comfort but equally his father, Charles Lewis, and his paternal grandfather, Comfort.

In the aughts of the nineteenth century, Comfort had walked off the family farm in Attleborough, Massachusetts, to become an early industrialist; in 1837, Charles had quit the Windham County, Connecticut, mill village of his birth to become a purveyor of luxury goods in the fastest growing city in the United States; and after the Civil War, Louis had spurned the material world only to double back to a career in commercial art on his own terms. As a Jeffersonian agricultural nation became a Hamiltonian urban-industrial one, the family honed its aesthetic sense. It was manifest in Comfort, who selected the colors and patterns for his cotton cloth, and deepened in Charles, whose first display window on Broadway was judged "something like a picture."[1]

Louis came of age during the ascendancy of American landscape painters and joined their ranks two years after Charles bought part of an old Dutch farm at Irvington-on-Hudson. Until Charles moved to New York twenty-five years earlier, the Tiffanys had never been without an agricultural base since their arrival from Britain in the mid-seventeenth century; even Comfort had kept a farm to supply his mill workers. For young Louis, the purchase of this rural estate—located on the "park" side of the Albany Post Road overlooking the Tappan Zee—grafted the scion to old rootstock and commenced a passionate love affair with nature. From the lush blooms of wisteria that framed the view from the piazza of Tiffany Hall to a dragonfly alighting on a dandelion seed ball in the fields below, Louis absorbed the profound sense of the organic that became his leitmotif in glass and every other medium he tackled.

I would not like to speculate on his place in art history had the Aesthetic Movement not "legitimized" the decorative arts in the 1870s just as figurative art was eclipsing the landscape and Louis was running headlong into his limitations as a painter. This fluke of history led him famously to declare, "We are going after the money there is in art, but art is there all the same."[2] It allowed him to put the family's greatest strengths behind him and shift his emphasis from simply limning to designing, supervising, and marketing the handiwork of

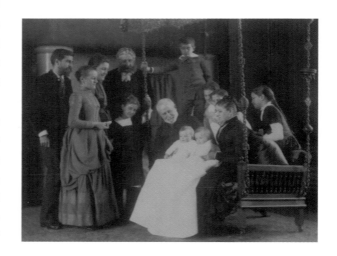

Cat. 1
Family Group with a Cow
1888
Gouache and watercolor
on board
Marks: signed *Louis C.
Tiffany*
20¼ x 28¾ in. (unframed)
31 x 38 in. (framed)
Private Collection

Louis Comfort Tiffany and his
family spent the summer of
1888 at Somesville, a resort
on Mt. Desert Island in Maine.
He painted several pictures of
his family with cows and
oxen. In this bucolic scene,
we see Tiffany's second wife,
Louise Wakeman Knox, with
the three children from his first
marriage and one of the twins
from his second marriage in a
daisy-scattered meadow with
a charmingly docile white
cow. The light-dappled land-
scape has the freshness of
contemporaneous works by
Renoir. This gouache is a
study for an oil painting of the
same subject.

a small army of artisans. It is important to remember—certainly Louis never
forgot for a second—that while others handled the fabrication, he was an artist,
and everything for which he is remembered, from snowflake-pattern wallpaper
to thistle-motif pottery, was art.

A glance at his younger brother Burnett Young, who was overwhelmed by
the circumstances of his life, dispels the notion that Louis's accomplishments
were somehow inevitable. His talent was evident even to his own children. As
youngest daughter, Dorothy Trimble, put it, "He had the most creative mind you
can imagine … He was creating something every minute. If he saw something,
he'd create something [by] free association … That was very exciting."[3] To his
credit, Louis put his circumstances to work for him while maintaining his
equilibrium through countless acts of creation and creative midwifery as,
artwork by artwork, he left the world every bit as beautiful as he found it.

1. Gertrude Speenburgh,
The Arts of the Tiffanys
(Chicago: Lightner,
1956), 18.

2. Candace Wheeler,
Yesterdays in a Busy Life
(New York: Harper &
Brothers, 1919).

3. Dorothy Tiffany
Burlingham, taped interview
by Peter Heller, London,
June 13, 1975.

Louis Comfort Tiffany
A Nineteenth-Century Artist

Marilynn A. Johnson

"Tiffany was so completely a creature of his family and times that I can't imagine his springing from another point on the space-time continuum."

Michael John Burlingham

Rich in drama, color, and complexity, the years of Louis Comfort Tiffany's life are perhaps best characterized by change. "The Age of Revolution" is the way noted historian Jacob Burckhardt (1818–97) in 1871 described the middle years of the nineteenth century. Often quoted, the phrase connotes not simply the wars and uprisings that shook Europe in this period, but also the revolutionary changes that challenged and transformed almost every aspect of human life. Industry and the urban landscape, agriculture, communication and transportation, economics and political theory, the natural sciences and the study of man's origins, art, religion, medicine—all saw changes unparalleled in history. Burckhardt himself commented on "the multiformity of modern life as compared to earlier life."[1]

The year in which Louis Comfort Tiffany was born, 1848, saw more political revolutions in Europe than had any preceding year; within a relatively short span there were uprisings in Paris, Berlin, Vienna, where three occurred, and Venice. One might imagine that these faraway revolutions would have little if any impact upon the life of a man born a vast ocean away. In a world where countries were becoming ever more interconnected, however, such was not the case. The first impact upon the life of Louis Comfort Tiffany was economic; the precarious position of European and particularly French aristocrats caused them to sell their jewels. Charles Lewis Tiffany, father of Louis, had an unerring instinct for opportunity. Through John Young, a partner, Charles Tiffany and the firm of Tiffany, Young

and Ellis, purchased a quantity of spectacular gems, reputedly including diamonds once owned by Marie Antoinette. That 1848 purchase would help to establish Charles Tiffany as a major purveyor of jewels, and in 1853, with the retirement of his partners, to transform the firm into Tiffany & Co.

The second effect of the 1848 revolutions upon the life of Louis Comfort Tiffany would be less immediate, but nevertheless influential: an exodus from Europe of talented and well-trained artisans. At least three such artists fleeing the conflicts in Europe arrived in New York in 1848: the architect Detlef Lienau, who brought with him the Mansard roof of Baron Haussmann's Paris and the style that would be called "Second Empire"; the cabinetmaker/decorator Leon Marcotte;[2] and the cabinetmaker/designer Gustave Herter,[3] who with his brother Christian would create a major decorating firm in the 1860s, but who found his initial employment as a silver designer for Tiffany, Young and Ellis.

Mechanization, which had begun in Europe in the late eighteenth century, was by the 1840s taking command in the United States as well. The rise of industry on the continent of Europe and in England and the United States created a new working class that included women and children and, in response to the plight of that working class, a new group of theorists. In 1848, two relatively unknown political thinkers published a work that would have extraordinary and far-reaching effects for more than a century. Their names were Karl Marx and Friedrich Engels, and the work was, of course, *The Communist Manifesto*.

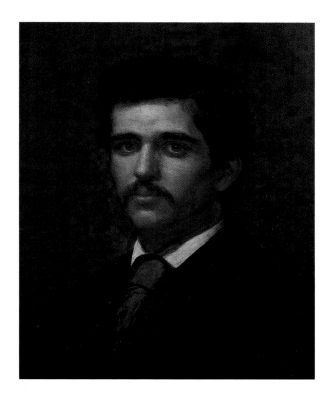

Fig. 3
Louis Comfort Tiffany, self-portrait, c. 1872, oil on canvas, National Academy Museum, New York (1257-P).

If revolutions and theoretical dissent seemed to be fragmenting society and pitting nation against nation and class against class, unifying events also occurred in the midcentury. The most important of these was the 1851 Great Exhibition held at the Crystal Palace, London. Conceived in part to foster friendship between nations, it was a resounding success and the first of a series of World's Fairs that would continue into the twentieth century. These fairs would prove valuable not only for understanding other cultures, but also for disseminating their rich and often hitherto unknown design vocabulary.

As impressive as the exhibits it housed, the building designed for the Exhibition by Joseph Paxton was in fact a huge greenhouse of iron and glass, hence its name. Enclosing live trees within its spaces, it seemed as startling and unusual as the exotic products of distant nations. It would, however, set the stage for the Crystal Palace of the New York Fair in 1853, and for a new kind of construction that would include vast train sheds and iron-clad "fireproof" buildings, including those of James Bogardus in New York.

Although on the continent these years were the age of revolution, England was in many ways enjoying a period of equipoise and prosperity. A network of rails connected many parts of the British Isles, and trains carrying passengers and products steamed across a once-tranquil agrarian landscape, often traveling over rivers spanned by iron bridges. Transportation on the water was also changing. In 1855, the first iron Cunard steam vessel crossed the Atlantic in just nine and a half days. This technological age of iron and steam, however, had both negative and positive ramifications. Across England, as well as parts of America and Europe, factories powered by steam belched smoke and spewed waste, destroying green valleys, creating vast wealth for the few and often misery for the many. English reformers and writers alike agreed that despite the dominance of the British Empire these were "hard times."

Enormous changes in scientific thought shook England as much as did changing political and economic realities. In 1852, Herbert Spencer first used the word "evolution." In 1859, Charles Darwin published *On the Origin of Species by Means of Natural Selection*. Nature had been perceived by the romantic poets as beautiful and beneficent. With the new doctrine of "survival of the fittest" the image of a cloud of daffodils that gave solace to William Wordsworth would be replaced by a more scientific image by his successor as poet laureate in 1850, Alfred, Lord Tennyson. Nature became "red in tooth and claw."

Into this time and this world where paradoxically the only constant seemed to be change, a world of contradiction where for the English-speaking nations the two dominant concepts were the idea of progress and the belief in the perfectibility of man, was born Louis Comfort Tiffany on February 18, 1848. Few lifespans in history would witness such revolutions in every area of life as would the eighty-five years that Tiffany lived. These revolutionary changes would have a profound

influence on his career as an artist. Tiffany would see vast changes in his personal life also. Never a "rags to riches" tale, the story of Tiffany's life would nevertheless be fraught with drama and, in the loss of loved ones and the changing perceptions of his art, more than a little pathos. From a pinnacle of international fame at the turn of the nineteenth century, his reputation would plummet to obscurity and even derision by the time of his death, only to rise again, phoenix-like, in the mid-twentieth century.

Born with a "golden spoon in his mouth,"[4] and with a name that already suggested good taste, affluence, and luxury, Louis Comfort Tiffany grew up in a family that was strict but loving and supportive. He was the eldest surviving son, and one of six children born to Harriet Olivia Young Tiffany and Charles Lewis Tiffany, whose mercantile genius in creating the store that later became Tiffany & Co. would play a significant role in Louis's life. The wealth and position Charles Lewis Tiffany attained gave his son an education that included not only formal schooling, but also the mind-stretching advantages of extensive travel, and the opportunity to meet many of the most original creative spirits of his time. Through contact with his father's firm of Tiffany & Co., Louis would have firsthand exposure to the applied arts, including knowledge of the latest trends in design and advances in technology. Despite the differences between the hardheaded businessman father and his equally headstrong son,[5] Charles Lewis Tiffany was unquestionably a major influence, imbuing his son with a puritan work ethic, encouraging and even underwriting Louis's various pursuits, and always quietly promoting his mature work.

Louis's formal education included three years at the Eagleswood Military Academy near Perth Amboy, New Jersey. From 1862, the year after the Civil War had begun, until 1865, the year it ended, Tiffany studied in his school classes, and after some time, informally in the studio of the landscape painter George Inness (1824–95), who lived and worked in the Eagleswood community.[6] Other than in his ability to inspire and to set high ideals, Inness seems to have done little to teach the young Louis, who nevertheless would always sympathize with Inness's precept that the "aim of art is not to instruct, not to edify, but to awaken an emotion."[7] During this same Eagleswood period Tiffany visited the studios of other American artists, and made the acquaintance of one who was to be mentor, friend, and business associate in the years to come: the painter Samuel Colman.[8] Like his first painting mentor, Inness, and like Colman, Tiffany would throughout his career as a painter explore the potential of light and color to achieve emotional impact.

During the summer of 1865, following his graduation from Eagleswood, Tiffany stayed at Tiffany Hall, his father's summer home near Irvington-on-Hudson, where he spent much of his time with sketchbook and pencil in hand wandering the land and drawing.[9] Louis's interest in sketching may predate the Eagleswood era, and may stem in part from the influence of Edward C. Moore, head of the silversmithing company founded by his father, John C. Moore, and during Louis's youth, through an 1851 arrangement with Tiffany & Co., both principal silver manufacturer and dominant designer for the Tiffany firm. Moore had a program of design education in which he encouraged drawing from nature. It came to be called "The Tiffany School."[10]

Of perhaps equal educational significance and influence for Tiffany, however, was the Grand Tour, a requisite part of any affluent young man's education, that Louis embarked upon in November of 1865, with his sister Annie Olivia and their aunt, and completed in March of the following year. It was the first of a number of such tours, which would soon take him beyond the traditional Europe to the exotic countries of the Near East. On this first trip Louis kept a sketchbook, now in the collection of the Morse Museum of Art, with fifty drawings made on board the *Scotia* and in England, Ireland, France, Italy, and Sicily. This trip has been seen as a turning

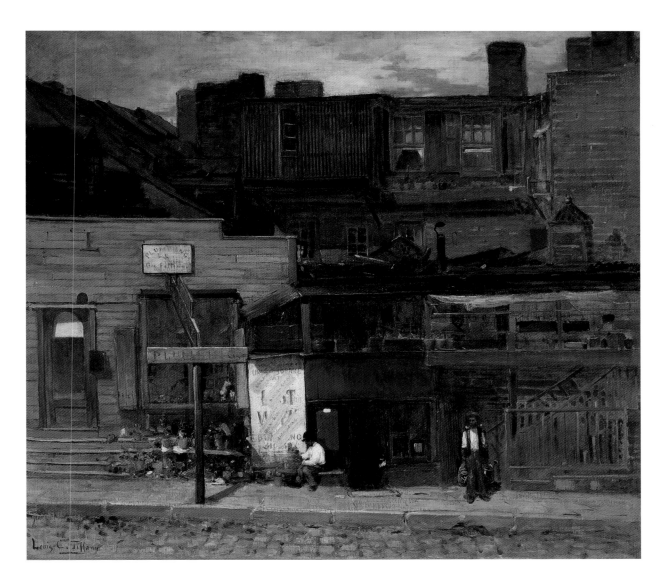

Cat. 2
Duane Street, New York
c.1877
Oil on canvas
Marks: signed *Louis C.
Tiffany*
26¾ x 30¹/₁₆ in.
Brooklyn Museum of Art,
Dick S. Ramsay Fund,
47.175

Tiffany exhibited this painting in Paris at the Exposition Universelle in 1878. He has chosen as his subject a collection of drab, ramshackle wooden houses that face a cobbled street. There are two men in shirtsleeves, one holding two watering cans, the other seated on a bench, apparently tending a potted plant. We notice a profusion of small green plants in terra-cotta pots lined up on steps and window ledges, presumably for sale. Half-effaced signs advertise a plumbing business. Despite the air of poverty, we sense that the picture is a commemoration of a lost New York and of the artist's own early youth. He had been born at 57 Warren Street in lower Manhattan in 1848, three blocks south of Duane Street. His father's first store, then called Tiffany & Young, had opened nearby, opposite City Hall at 259 Broadway, in 1837. By 1870, it had moved north to Union Square at Sixteenth Street. By the late 1870s, lower Manhattan was being rebuilt with taller brick buildings, as contemporary photographs reveal.

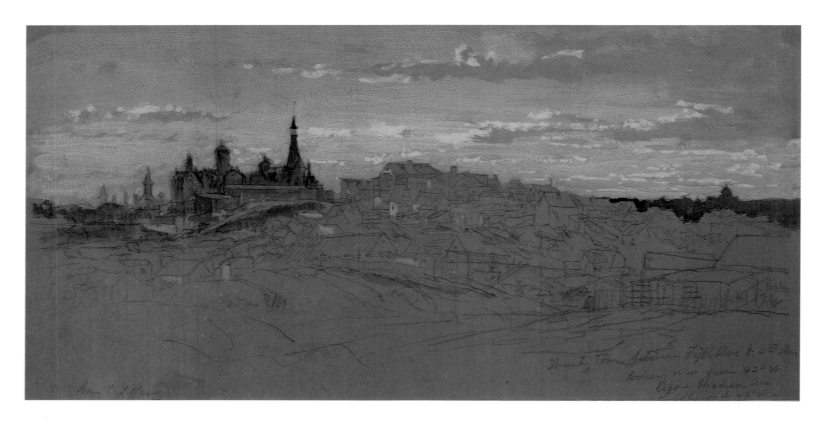

Cat. 3

Shantytown
c. 1867–70s
Gouache, pencil, and
watercolor on paper
Marks: signed *Louis C.
Tiffany*; inscription
*Shantytown between Fifth
Ave and Fourth Ave looking
N.W. from 42nd St before
Madison Ave extended
through* the rest illegible
10¼ x 20¼ in. (unframed)
14 x 24 in. (framed)
Private Collection

During the nineteenth
century, the development of
Manhattan moved rapidly
northward. In areas not yet
formally laid out, squatters
occupied shacks in squalid
shantytowns. The
inscription on this unfinished
cityscape identifies it as a
view of New York during a
time of demolition and
construction. Tiffany
witnessed similar scenes in
Paris where the schemes of
Haussmann that involved
piercing boulevards through
the city fabric produced
temporary ruins.

point in Louis's life.[11] Following this experience and perhaps because of it, Louis, just eighteen years old in 1866, seems to have made some serious decisions about his future life and career, seeking formal and informal training as a painter.

Louis Comfort Tiffany's first career would, in fact, be that of a painter, working over time in a variety of media, but in his life he would have a series of careers, constantly exploring new forms and expressions in his relentless "quest of beauty." In 1866, however, the principles of the Aesthetic Movement and its extension of the boundaries of art were just beginning to reach the United States, and painting and sculpture were still the acceptable art forms. In early November of 1866 the National Academy of Design admitted Louis into the antique classes, where he could draw from plaster casts of classical sculpture. Despite this traditional training, Tiffany would always have some problems with his draftsmanship, and would always remain somewhat weak in depicting the human body.

A first presentation of his work to the public occurred in 1867 when Tiffany showed his watercolor *Afternoon* at the National Academy of Design on Twenty-third Street at Fourth Avenue. In 1868, he returned to France to study in the Paris atelier of Léon Charles Adrien Bailly, "a thorough teacher of drawing,"[12] whose influence on Tiffany seems negligible. The final year of the decade found Tiffany back in New York, painting and exhibiting Hudson River landscapes related in their misty atmosphere and diffused light to the Luminist works of artists like Kensett and Sanford R. Gifford. There is also a close relationship between Tiffany's Hudson River views of the late 1860s and early 1870s and those of Samuel Colman, with whom Tiffany also studied informally.[13]

In 1869, Tiffany leased a studio at the Young Men's Christian Association at 52 East Twenty-third Street across from the National Academy. It was probably there that Tiffany met another artist named Gifford. Robert Swain Gifford, eight years Tiffany's senior and already a painter of the picturesque, was, like Tiffany, intrigued by images and tales of the Orient.[14] Together Tiffany and Gifford set out for North Africa in late July of 1870, stopping first in London, then in Malaga, Southern Spain, and then in Gibraltar before arriving in Tangier sometime in September.[15] By late 1870, despite frustrations, homesickness, and Tiffany's indecision, of which Gifford complained in his letters home,[16] the pair had reached Cairo (see cat. 4). In Egypt Tiffany became seriously ill with the measles, and, largely confined to bed, was nursed by Gifford, who finally succeeded in getting his colleague to Italy and then home. There in perhaps a romantic triumph over truth, Gifford and Tiffany presented the fruits of their Oriental sojourn, both in paintings and memorabilia, to an admiring audience of New York cognoscenti invited to their adjoining studios. This reception may well be Tiffany's first major marketing of his work and his image, and perhaps proved to him that the exotic was highly profitable.

Throughout the 1870s Orientalism was a dominant theme in Tiffany's most admired paintings, such as *On the Way to Old and New Cairo, Citadel Mosque of Mohammed Ali, and Tombs of the Mamelukes*, *The Snake Charmer of Tangier*, and *Market Day Outside the Walls of Tangier*. The first, exhibited at the National Academy of Design in 1872, portrayed the dust, heat, and light of the East more successfully than the somewhat stiffly posed travelers in the foreground. The second, *The Snake Charmer*, presented at a New York gallery, was perceived as "striking," largely because of its subject matter.[17] The third, *Market Day*,[18] exhibited at the National Academy in 1873, was apparently based upon not only Tiffany's actual observations, but also a photograph.[19] Tiffany continued to produce Near Eastern scenes and subjects throughout the 1870s in both oil and watercolor; at the Philadelphia Centennial Exhibition of 1876, six of his eleven exhibited works were Oriental in character. Although by the end of the decade Tiffany had embarked upon two new careers, those of glassmaker and of interior

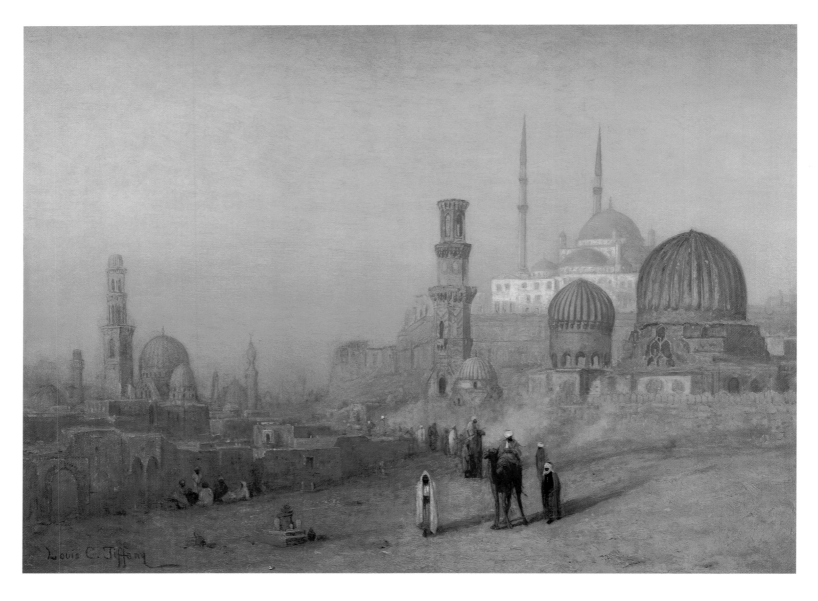

Cat. 4
View of Cairo
c. 1872
Oil on canvas (in Arab-style frame)
Marks: signed *Louis C. Tiffany*
30½ x 40 in. (unframed)
47½ x 57½ in. (framed)
Private Collection

In 1868, Tiffany spent a year in Paris where he studied painting with Léon Charles Bailly (1826–?). In *The Art Work of Louis C. Tiffany*, ghostwritten for Tiffany by Charles de Kay, we learn that while in Paris he was particularly impressed by the work of the Orientalist painter Léon Adolphe August Belly (1827–77) and visited his studio. Tiffany copied Belly's most celebrated work, *Pilgrimage to Mecca* (now in the Musée d'Orsay, Paris) in 1890,

proof of his continuing interest in this artist (Christie's, New York, 12 December 1997, Lot. 158).

Tiffany would follow in the footsteps of many nineteenth-century artists and make repeated trips to North Africa, the first in 1870–71 when he traveled with his friend and fellow artist R. Swain Gifford. The outbreak of the Franco-Prussian War would have limited travel to the European continent that year.

designer, throughout his working life Tiffany and his companies would draw upon the Orient for major design inspiration.

In the exhibits at the 1876 Philadelphia Centennial Exhibition, Tiffany found other design inspirations. Although the most publicized symbol of the exposition was the towering presence of the Corliss Engine, which engendered paeans of praise, the arts of Japan, essentially unknown to Americans until Commodore Perry opened Japan to trade in 1854, elicited almost equal admiration. The Japanese building was considered as nicely put together as a piece of cabinetwork, its workmen perceived as inheritors of a medieval system of handcraftsmanship. Through publications such as the London *Art Journal*, Tiffany would have been familiar with Japanese art. Short articles had appeared in several periodicals prior to the Centennial.[20] In 1875, however, *The Art Journal* began publishing a copiously illustrated series of articles on Japanese art by Sir Rutherford Alcock, whose early collection had elicited much admiration at the London Exposition of 1862. In addition, Tiffany would have known firsthand the collection amassed by his early mentor Edward C. Moore.[21] The Centennial, however, was probably his first extensive exposure to Japanese culture and the art that was taking London and Paris by storm.

In 1876, the English reform designer Christopher Dresser came to the United States to visit the Centennial Exhibition and to lecture on household art. Tiffany & Co. hired him to travel to Japan and purchase objects for resale.[22] Dresser unquestionably influenced Louis Comfort Tiffany, both by his writings and by his profound interest in Japanese art. In 1877, Tiffany & Co. published a sale catalogue of the objects brought back by Dresser (see fig. 4). There were 1,902 lots offered for sale. According to Dresser himself, Tiffany & Co. "sold what they did not care to retain under the auction hammer; the other part is now doing its tutorial work ..." This statement suggests that the purpose of the collection was more than commercial, and that objects were kept and studied for design inspiration.[23] The wide range of objects included many that would echo in Tiffany's mature work. Raku pottery had a surface simulated years later in some of Tiffany's glass; metalwork such as a bronze crab undoubtedly served as a design impetus. In the late 1890s Tiffany's foundry would produce a bronze crab inkwell, and would exhibit it at the 1899 Grafton Gallery exhibition in London.[24]

Participation in the Centennial by exotic countries became possible in part through major engineering advances. The year 1869 had seen two such feats, the completion in the United States of the transcontinental railroad, which enabled Japan to send an entire trainload of art and artisans to Philadelphia in 1876, and the completion in the Near East of the Suez Canal, which created a passage to India. In the main building of the Centennial Exhibition the

Fig. 4
Dresser Collection of Japanese Curios and Articles Selected for Tiffany & Co. (Leavitt Auctioneers, New York City), sale of June 18, 1877, Tiffany & Co. Archives, 2004.

arts of India appeared in a small display drawn primarily from the India Museum in London. Among Indian objects exhibited were wood carvings as well as illustrations of architecture. In addition, Messrs. Watson & Co. of Bombay offered for sale carved "Bombay blackwood furniture, and a selection of jewelry."[25] An illustrated compendium of the Centennial exhibits emphasizes the gold of India, as well as "minerals used for ornaments," including agates, carnelians, tourmalines, sapphires, rubies, garnets, and other stones.[26]

Within a few years, in 1881, Louis Comfort Tiffany's friend and associate, Lockwood de Forest, would travel to India on an extended honeymoon, and purchase decorative elements and architectural fragments, furniture for his own use, as well as a substantial amount of Indian jewelry. Some of the former purchases would be incorporated into Tiffany interiors, but the jewelry, in partnership with Louis Comfort Tiffany, de Forest would sell to Tiffany & Co. for more than twice the purchase price. In May of 1882, on his way back to the United States, de Forest would stop in Cairo and Damascus to purchase Near Eastern tiles, carpets, chests, metalwork, and old weapons. One further major purchase on the account of the short-lived firm of Tiffany & de Forest occurred in Paris in June 1882. There de Forest bought 2,500 Japanese sword guards.[27] A large number of these went to Louis Comfort Tiffany for his personal use, but it seems probable also that Edward C. Moore purchased part of this collection, as de Forest met with Moore in London following his visit to Paris. Moore by this time had sold his business to Tiffany & Co. in 1868 and was the head designer for the silver department. He is known to have had a large collection of Japanese sword guards and to have employed the mixed metals found on them, and in some instances their shapes or motifs, in his designs for Tiffany & Co. His influence on Louis Comfort Tiffany has yet to be fully explored, but it seems clear that his amassing a library of art and design books

about foreign and ancient cultures, his collecting of actual objects from these cultures—glass and ceramic, metalwork, and even Native American "Indian" baskets—and his philosophy of design were of paramount importance in the shaping of Louis Comfort Tiffany's design aesthetic.[28]

The jewelry that de Forest and Tiffany sold to Tiffany & Co. from de Forest's 1881–82 trip helped to keep Louis Comfort Tiffany and the partnership solvent. In the years immediately following the Centennial, however, Louis was still struggling to find his place in the art world, and to make a living in his chosen profession. The records of R. G. Dun & Co., a credit-reporting agency, in 1878 designate Tiffany a decorator and artist and cite his having "no means whatever," but being assisted by his father.[29] Tiffany's connection with the Society of Decorative Art in New York in 1877, 1878, and 1879 gave him valuable sources for textiles and embroideries, and fostered his relationship with Candace Wheeler, Lockwood de Forest, and Samuel Colman, all of whom served with him on the Society's Committee on Design.[30] In 1878, Tiffany gave up his studio at the Twenty-third Street YMCA and was living in and then working from a penthouse at the Bella Apartments at 48 East Twenty-sixth Street. His earliest efforts at decorating, which continued for several years, were in the design of this residence, which was subsequently praised or featured in a number of publications.[31]

By the summer of 1879, in what was his first major commission in this field of interior design, Tiffany took on the decorating of the Fifth Avenue residence of pharmaceutical millionaire George Kemp. Again the results showed a fascination with the Near East, as well as an eclecticism typical of the time. *Artistic Houses*, an 1881–82 compendium of rooms in the homes of the rich and famous, praised Kemp's drawing room, or salon, described as "Arabic" with "an inclination to the Persian in the forms," praising it as a "delicious melody of color."[32] Evoking three of the five senses in that short

phrase, the writer emphasizes the sensuous quality that was so much a part of the appeal of Orientalism. To the sense of sight, mesmerized not simply by color but by dramatic opalescence and shimmering light, one can add the sense of touch. With its contrasts of inlaid, carved, and pierced wood, velvety oriental rugs, geometric fretwork and rich silks, "quiet" blue plush, and smooth glass tile, this is a highly tactile room. Although he is nowhere mentioned by name, Tiffany, the "artist," created an interior that was opulent and sumptuous. Extraordinarily complex when viewed in the flattened single plane of the photographed room, and replete with some details that are not Near Eastern in origin, this interior yet seems completely integrated, a fact not lost upon the writer for *Artistic Houses*, who noted, "The more carefully the spectator examines into details, the more confident is his conviction that not one article of furniture or ornamentation in this artistic apartment was put there

save under the guidance of an intelligent purpose faithfully exercised and lavishly equipped."

Exotic woods are part of the lavish effect; the mantel was ornamented with seventeen woods other than that of its structure. Holly, used for architectural features such as dado and floor (for another Tiffany design of the same period for a dado, see fig. 5), was a unifying element, and was the primary wood for some of the furniture. Described in a contemporary magazine article, these pieces were "of white holly, carved, turned, and inlaid with mother-of-pearl."[33] A gentleman's chair (see fig. 6 and cat. 97) in the right foreground of the photographed room features latticework drawn from the screens found in Egypt, as well as marquetry vines and leaves that evoke the influence of India.

The drawing room, or salon, of the Kemp house was unquestionably Tiffany's major achievement for this commission, but *Artistic Houses* illustrates two other rooms, the dining room and the library. Both

Fig. 5
"Wall Papers. Fig.4 – A Dado Designed by Mr. L. C. Tiffany" *Carpentry and Building*, December 1880, p. 223, The New York Public Library, Astor, Lenox and Tilden Foundations. The design shows Japonesque influence in the prunus branches, pine boughs, and stylized forms from nature.

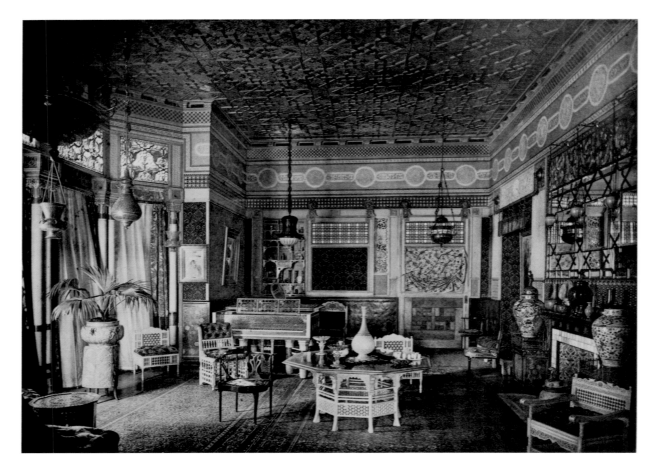

Fig. 6
"Mr. George Kemp's Salon,"
*Artistic Houses, Interior
Views of the Most Beautiful
and Celebrated Homes in
the United States*, New
York, D. Appleton & Co.,
1883, vol. I, part 1, no. 21,
Smithsonian Cooper Hewitt,
National Design Museum.

are somewhat more conventional, yet bear distinctive Tiffany touches, such as the fruits, plants, and vegetable canvas, which he painted on gilded canvas for a frieze above oak paneling in the dining room, and a gilt cove with iridescent shells in the library. A drawing exists for one piece of furniture designed for the Kemp house (see fig. 7). It shows a bureau bearing a large shell. Essentially Colonial Revival in form and style, it has also a touch of exoticism in the spindle fan that forms a spandrel between case and mirror, and illustrates Tiffany's imaginative eclecticism in design.

Although Tiffany alone seems to have been the decorator for the Kemp house, by the fall of 1881 there were three companies bearing Tiffany's name, all operating from 333 Fourth Avenue, and all established in 1880. All had probably been merged into one company, Louis C. Tiffany & Co., Associated

Artists, by the time Rochester millionaire William S. Kimball contacted Tiffany in 1881 about the decorating of his house. A thirty-room mansion, the "Kimball Castle" had one bedroom lined with bamboo and finished in a Japanese style,[34] but the triumph of design was in the entrance hall—a "Moorish" screen, which Tiffany employed to convey "distance and mystery."[35] Not Moorish at all, but composed of panels of teakwood that Lockwood de Forest sent to New York from India, the screen was pierced to transmit light.[36] Light and color again dominated the room designs. In the library, a "remarkable mantel of mahogany" was lighted by a stained-glass window on each side (see fig. 8).[37] The conservatory featured a "window set with small and brilliant jewels, seeming like flowers." On the landing of the stairs beyond the hall stood a massive organ, its keyboard flanked by large mosaic

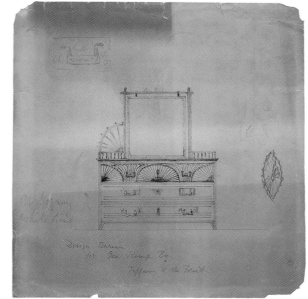

panels of glass, the whole surmounted by a screen of open-work and glass.[38]

Time would deal harshly with William Kimball's extraordinary house, as with the majority of Tiffany's great interiors. By 1948, the "Castle," unoccupied since Mrs. Kimball's death in 1923, was in a state of ruin, its rooms vandalized for their fittings. Illegal cockfights had been held in its art gallery, where walls had once displayed valuable paintings, some of which had gone to The Metropolitan Museum of Art. A series of articles in local newspapers told the story of the sad demise of Rochester's greatest house, past the point of being restored and adapted, being razed for a parking lot.[39]

A different kind of client for Louis C. Tiffany & Co., Associated Artists was Samuel Clemens, who

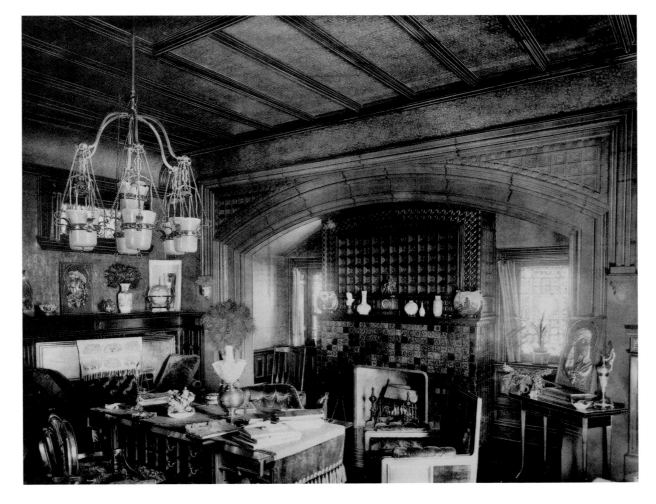

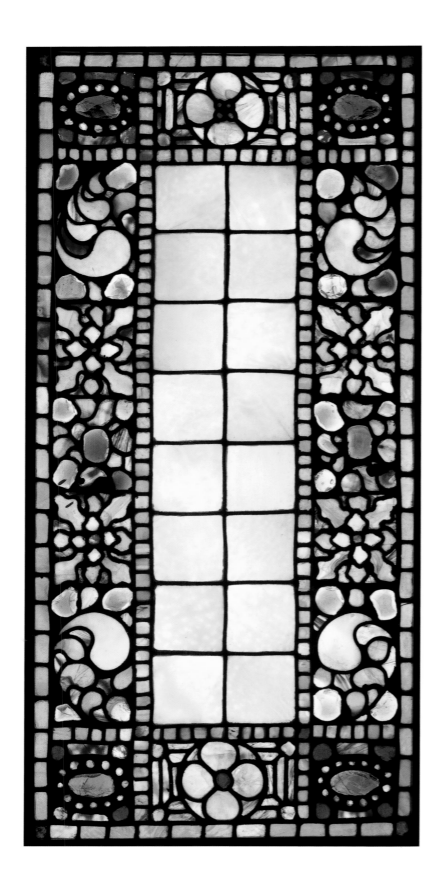

Cat. 5
Window with Decorative Border
c. 1882
Leaded glass
36 x 19 in.
Memorial Art Gallery of the University of Rochester, gift of Ruth Rand Rapport in memory of Harold S. Rand, 98.69

This ornamental window, probably designed for the William S. Kimball House, takes the form of a central panel surrounded by a wide border that incorporates irregular glass gems. Comma-shaped cabochons are similar to those used later in the Havemeyer flying staircase rail (see cat. 108). In the painting *Moroccan Interior* of 1895 (Forbes Magazine Collection), Tiffany depicted a leaded-glass window with a decorative border, suggesting that his own windows may depend as much on Middle Eastern as on Western medieval sources.

with his wife Olivia in October 1881 contracted for painting or papering the entire first floor of their picturesque, rambling "stick-style" house at Nook Farm, Hartford, Connecticut. Better known by his pen name, Mark Twain, Clemens was perhaps America's most celebrated author, and many of his notable works were written in this home during a few happy years before recurring tragedies led to its abandonment.[40] Believing that red was the most desirable color for a hall,[41] the firm painted the walls in a deep Venetian shade with geometric patterns in black. Similar patterns were painted on the ceiling, but here were complemented with silver, and silver stenciling covered the woodwork. A door from the Mark Twain house (see cat. 6 and fig. 9) was included in the landmark 1958 Tiffany exhibition at the Museum of Contemporary Crafts.[42] The walls in the drawing room were salmon pink, again with silver stenciling; the peacock-blue walls of the library were stenciled with gold. A richly textured lincrusta-type wall covering of lilies appeared in the dining room, where a new mantel was installed and Tiffany tiles used as a fireplace surround. In 1883, the mantelpiece in the hall was embellished with East Indian woodwork and brass from Tiffany and de Forest. For Mark Twain this house had "a heart, and a soul, and eyes to see us with."[43] Today the viewer visiting Twain's comfortable but unpretentious retreat feels a sense of warmth and welcome. Splendid though the decorations of Tiffany and his colleagues are, the effect is one of a much-loved home rather than that of a house meant to impress the viewer with the owner's wealth and status.[44]

Startlingly different from any Tiffany-designed furniture executed up to 1882 were the pieces Louis ordered on April 9 of that year for his own apartment at the top of the Tiffany residence at the corner of Madison and Seventy-second Street, New York. An imposing and massive mountain of stone somewhat in the Richardsonian tradition, the house was formally commissioned April 19, 1882, by Charles Lewis Tiffany from architects McKim,

Mead & White to contain three family apartments: the lower two floors for himself, although he never lived there,[45] the mid-level for Louis's married sister Annie Mitchell and her family, who lived there only briefly, and the top two floors for Louis and his family. Louis in 1872 had married Mary Woodbridge Goddard, who died in January 1884, before the house was completed. Clearly Louis had the practical considerations of dining with children in mind when he sketched the breakfast room furniture for the New York partnership of J. Matthew Meier and Ernest Hagen.[46] In the tradition of innovative and reform furniture of the nineteenth century, Tiffany created tables and chairs that were simple, functional, sturdy, and undecorated. Two large tables, "of the same width and height: but different lengths" could be used apart or placed together for the utmost flexibility. A smaller table, which appears in a view of the room published in two different periodicals in the fall of 1900 (see fig. 10),[47] apparently served as a side table. Like the two larger tables it had a sawhorse base, but unlike them only one sawhorse, and all the tables seem to have been based on architectural drafting tables.[48] Extending functionalism even further, the table tops were conceived and executed "to be independent of the bases for convenient cleaning, moving, and storage."[49] The comfortable, ample chairs, based upon vernacular forms, were made of maple and inexpensive pine and upholstered with leather. Both tables and chairs had a white enameled surface, which would have facilitated cleaning and which set off construction details such as black painted screws on the table bases, and black tacks on the chair backs. In 1900, fifteen years after the breakfast room furniture was delivered, a contemporary writer stated, "Nothing could be more simple, and yet striking, than the furniture in Mr. Tiffany's breakfast room."[50] In stark contrast to the elaborate furniture being created for the late-nineteenth-century wealthy, both by Tiffany himself and his peers, this extraordinary suite stands as a reminder of

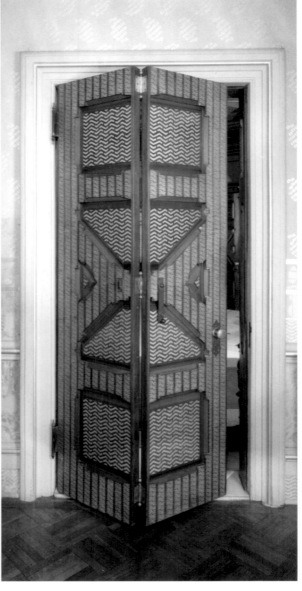

Cat. 6
Parlor Bifold Door (detail)
From the drawing room of
the Mark Twain House
Louis Comfort Tiffany & Co.,
Associated Artists
c. 1881
Bronze powder paint, silver-
plated hardware, walnut
89 x 38¼ x 2 in.
The Mark Twain House &
Museum, Hartford, CT

The silver *boteh*, or paisley
motif, stencilled on the
pale salmon-colored walls
of the Mark Twain House
parlor clearly references
oriental textiles. Small
patterns set into geometric
compartments on the bi-
fold doors—interrupted
waves and interlocked
squares—seem indebted to
basketry. Inventive and

playful, they enliven the
surface with a metallic
sheen and, from a distance,
mimic precious inlays.

Fig. 9
Parlor door, from the Mark
Twain House, nineteenth-
century photograph, The
Mark Twain House &
Museum, Hartford, CT.

Tiffany's wide-ranging interests, his knowledge of the precepts of the reform movements in England, and his bold and imaginative experimentation in design.

Exoticism was, however, still a major feature of Tiffany's decorating, and the romantic drama of Tiffany's vision for the remainder of his apartment interior has through the years occasioned equally romantic descriptions, particularly of the studio, which according to English visitor Cecilia Waern contained at its entrance "the whole street-front of a house in India."[51] Alma Mahler, in memoirs called *And The Bridge is Love*, wrote of a boundless hall with "luminous colored glasses that shed a wondrous, flowery light." Accompanied by her husband, the composer/conductor Gustav Mahler, and by Louisine Havemeyer (Mrs. Henry Osborne), Mrs. Mahler described an experience that was "a

dream: 'Arabian Nights' in New York."[52] In the twentieth century Edgar Kaufmann, Jr. likened the lofty studio with its freestanding four-sided fireplace and massive chimney to a space scooped out by a giant hand. He commented, "No mere revivalist could have spun this shimmering web, yet no one ignorant of the great spatial adventures of the past could have conceived the task either."[53]

From the late 1870s through the decade of the '80s Tiffany, sometimes working alone, sometimes with a partner or with associates, would be called upon to decorate both public and private interiors, from the Veterans' Room and the library of the Seventh Regiment Armory in New York, to Steele MacKaye's Madison Avenue Theater and later his Lyceum Theater, to rooms in the homes of the prominent men of his era: John Taylor Johnston,

Fig. 10
Breakfast room, Louis Comfort Tiffany's apartment in the Tiffany House at Madison Avenue and Seventy-second Street, New York, *Architectural Record* 10, 1900, Avery Architectural and Fine Arts Library, Columbia University.

Fig. 11
Paintings gallery, H. O.
Havemeyer House,
Architectural Record 1,
Jan–Mar, 1892, Avery
Architectural and Fine Arts
Library, Columbia University.

Hamilton Fish, William H. de Forest, Cornelius Vanderbilt II,[54] William T. Lusk, and Ogden Goelet. Even the White House would have the Tiffany touch after President Chester Arthur refused to live in a dwelling he considered shabby and commissioned Tiffany to spruce up the principal rooms.[55]

In 1888, Louisine and Henry Osborne Havemeyer turned to Louis Comfort Tiffany and Samuel Colman for the decoration of their New York home at Fifth Avenue and Sixty-sixth Street. Distinguished collectors with unerring taste, the Havemeyers wanted rooms that would not only set off their extraordinary paintings and objects, but that would also present an original vision, rather than the repetitive clichés of the fashionable decorator.[56] The originality of the design Tiffany and Colman gave them would have been apparent the moment the visitor encountered the extraordinary pair of entrance doors. Of patinated bronze frame and wood with applied bronze studs on the exterior, and panes of opalescent glass to transmit light, the doors had an interior surface featuring a contrast of lead came with smooth beach stones.[57] Glittering with elaborate glass mosaics on the walls and more than a million Hispano-Moresque tiles on the floor, the hall must have dazzled the visitor who stepped into it. A Favrile glass and gilded metal firescreen (see cat. 106) further suggests the intricate splendor of this space, which set the tone of the remainder of the rooms. Probably the two best-known and most successful of these were the paintings gallery (see fig. 11), with its famous flying staircase, and the music room (see fig. 12). Glass played a major and harmonizing role in both these

spaces. In the paintings gallery the "spectacular staircase was suspended, like a necklace, from one side of the balcony to another"; the sides of it, like the balcony railing, "a spider web of gold filigree dotted with small crystal balls."[58] See cat. 108 for a panel from this railing.

Like the paintings gallery the music room was a feast for the eyes. Richly textured, with complex contrasts of surface ornament, both of these rooms yet conveyed a sense of unity, contemplation, and repose suitable to their artistic purposes. Once more the Near and Far East dominated, with Near Eastern carpets on the floor of the paintings gallery, an Asiatic porcelain jar, probably Chinese, on a tile-top table, which was, like the chairs, surprisingly simple, probably so that the furniture would not distract the eye from the superb paintings. For a feeling of lightness, the pieces were all enameled white, like the furniture in Tiffany's breakfast room and the dining room furniture he would years later design for Laurelton Hall. The music room was also a mélange of collections and influences. Asian silks with lustrous surfaces covered the walls; Japanese bamboo apparently inspired the gilded cornice and ceiling. Japanese lacquerwork formed a major part of the display in a large cabinet, where carved ivory inro also appeared, the latter reputedly furnishing a source for the carving on the furniture. Made of several woods, including ash, satinwood, and mahogany, and showing the influence also of the Near East, the extensive suite of furniture included chairs, tables and settees with shallow carving of

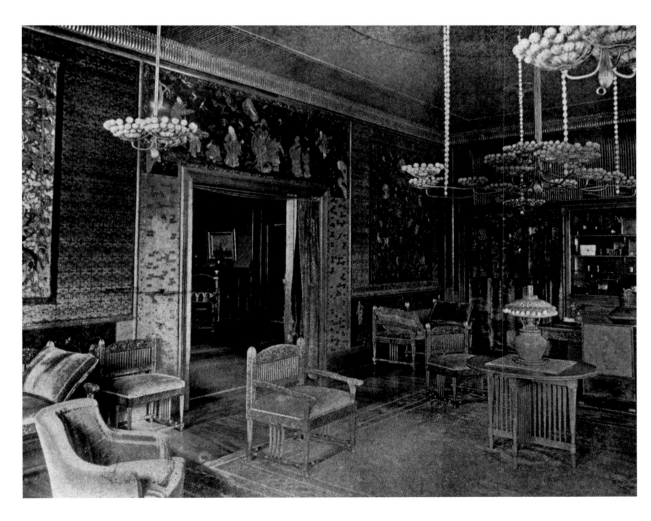

Fig. 12
Music room, H. O. Havemeyer House, *Architectural Record* 1, Jan–Mar, 1892, Avery Architectural and Fine Arts Library, Columbia University.

plant and flower forms, all rubbed with gold leaf (see cat. 107). Above all this was one of the great glories of the room, a huge chandelier complemented by several smaller chandeliers, all based upon one of Tiffany's favorite flowers, the wild Queen Anne's lace. Hundreds of small opalescent glass balls fit into a wire stem connecting to a ring composed the sections of the blossom's head. Amazingly delicate, whether a single blossom or a large cluster, these chandeliers must have seemed like ethereal flower clouds floating overhead. No less a personage than Siegfried Bing, major French art dealer and critic, noted the success of the Havemeyer interiors. "Art objects of the most far-flung origins are placed side by side, but the ingenious eclecticism responsible for these interiors has so skillfully combined disparate elements, integrating them so artfully, that we are left with an impression of perfect harmony."[59]

The extraordinary glass chandeliers that illuminated the Havemeyer music room were examples of an art medium that had long fascinated Tiffany. Throughout his career as a decorator, glass had played a major role in his interiors, and critics had applauded his efforts. In 1881, *The Art Amateur* published an article stating, "there are healthful signs of the development of a genuine and permanent American school of art, having for its basis strong and original work. Mr. Louis C. Tiffany has produced stained glass of high artistic value."[60] Earlier in the year another periodical had extolled the innovations of Tiffany and John La Farge with their new method in which "the leads actually represent the outlines of the picture ..."[61] The artistic value of Tiffany's stained glass drew praise from Roger Riordan also in the first article of a series of three appearing in this same year in *The American Art Review*. Although much of the article is devoted to the history of stained glass, in the last two pages Riordan turns to the contemporary scene. He skirts the problem of who first introduced opalescent glass into the United States with the words, "The

'opal' glass which has been introduced by Mr. La Farge and Mr. Tiffany ..." His illustration of an American "screen" of "pure mosaic glass" is an Eggplant window, possibly the one designed for the Kemp house of 1879, but more likely the one Tiffany would include in the 1899 Grafton Gallery exhibition. Apparently three of these windows were made over a period of time.[62] The drawing by Riordan is meant to show, "the mode in which Tiffany handles his splendid material. The thick stalks of the vine, the outlines of the lattice-work which supports it, and the veinings of the leaves, are all designed by the leading. The modelling [sic] of the leaves and fruit is given by the inequalities of the glass itself, and the play and gradation of color in its substance."[63] Clearly Tiffany had already begun utilizing many of the techniques that would continue to distinguish his stained glass.

Tiffany had registered three patents for glass on February 8, 1881: one for iridescent glass tesserae, which apparently included tiles as well as mosaic pieces; one for superimposing stained-glass panels to increase brilliance and iridescence; and one for using metallic oxides to produce iridescence on window glass.[64] If Tiffany made the tiles bearing this early patent date soon after the patent was granted and if we are to accept the chronology in *The Art Work of Louis C. Tiffany*, a publication said to have been written by Tiffany's friend Charles de Kay from information supplied by Tiffany, these tiles would have been produced at the Heidt glasshouse in Brooklyn. Tiffany reputedly experimented with glass at Thill's glasshouse in Brooklyn as early as 1875, and in 1878 established his own glasshouse under the direction of Andrea Boldini of Venice. De Kay tells us, "This house burned down, as did a second. From about 1880 to 1893 Mr. Tiffany experimented at the Heidt glasshouse."[65] New York directories of the mid-1880s help to document Tiffany's increasing interest in glass. Although a New York directory of 1885[66] arranged by name lists among other Tiffanys, "Tiffany Louis C., decorator, 333 Fourth av.

h. 48 E.26th" above "TIFFANY LOUIS C. & CO decorators" at the same business address, a second directory of only one year later[67] with listings by business headings cites under "Glass, Mosaic & Stained. / THE TIFFANY GLASS CO. / 333 Fourth av." and under "Glass Stainers & Enamelers.... Tiffany Glass Co, 333 Fourth av." The year 1885 saw the founding of the Tiffany Glass Company, and the beginning of a shift in Tiffany's focus away from interior design and toward experimentation with the medium that would gain him his greatest acclaim.

Fig. 13
The Tiffany Glass Company, hand-colored pattern sheet for stained glass, ©1888, Museum of the City of New York.

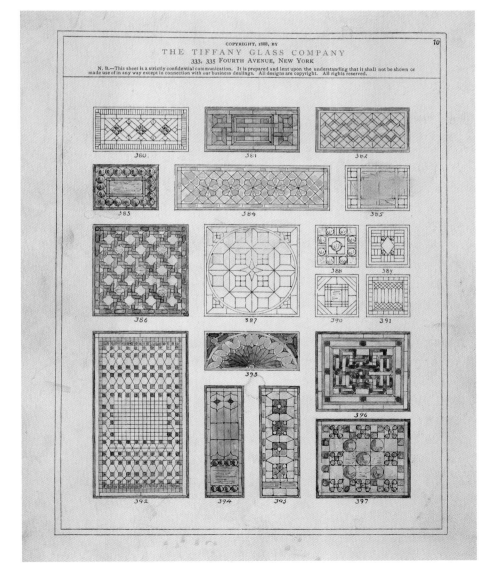

About 1885, Tiffany began work for one of the most prominent families in Baltimore, the descendants of Robert Garrett (1783–1857), founder of Robert Garrett & Co. and of the family fortune. This work by Tiffany and his various companies extended over a substantial period of time, and included some major stained-glass windows. In 1884, John Work Garrett (1820–84), son of Robert and president of the B&O Railroad from 1858, had died. As his wife Rachel Harrison had predeceased him by one year, his sizable fortune went to his children. The money seems to have engendered a flurry of decorating projects on the part of his heirs. In 1872, John Work Garrett had purchased 11 West Mt. Vernon Place and given it to his son Robert, probably as a wedding gift. John Work Garrett never lived at no. 11; rather, at the time of his death his townhouse was at the southwest corner of Monument and Cathedral Streets, a home inherited from his father. This home apparently was part of the inheritance of John Work Garrett's daughter, Mary Elizabeth Garrett (1854–1915), who quite promptly set about embellishing it.

Mary Elizabeth Garrett had lived in New York, where her friends included Julia Brasher de Forest, Lockwood's sister, and Louise Wakeman Knox, second wife of Louis Comfort Tiffany and cousin once removed to Lockwood de Forest. Mary was in fact a witness at the marriage of Louise Knox to Tiffany.[68] It is not surprising, then, that Mary turned to both Tiffany and de Forest to decorate 101 West Monument Street. For her Tiffany executed at least five stained-glass windows (see fig. 14 and cats. 58 and 59) now in the collection of the Baltimore Museum of Art. One of these, a tour de force that depicted fish in fishbowls as well as flowers and fruit so pleased Tiffany that he echoed the theme of fish and fishbowl in a window he exhibited at the Columbian Exposition in Chicago in 1893. Later he also exhibited the original design for this window at the 1899 Grafton Gallery exhibition, as well as duplicating the window for his Long Island home,

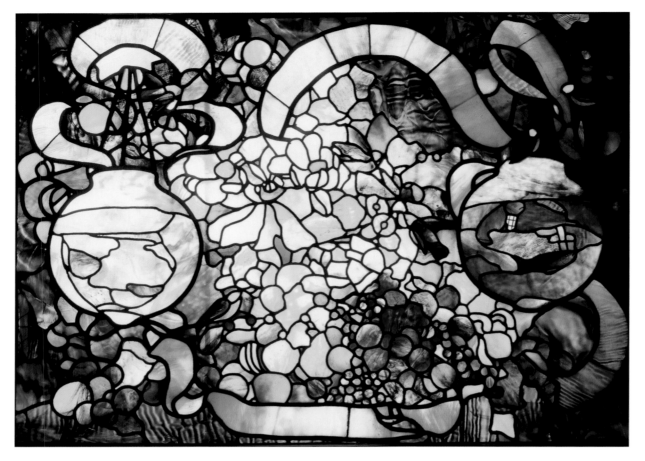

Fig. 14
Louis Comfort Tiffany,
stained-glass window panel
with fish, flowers, and fruit,
from the dining room
transom, the Garrett House,
Monument Street,
Baltimore, c. 1885, leaded
Favrile glass, The Baltimore
Museum of Art: BMA
1979.173.

Cat. 7
Window Panel: Anniversary
1891
Leaded glass
Marks: inscription *ALL HAIL /
GREETING GOLDEN
WEDDING / HARRIET
AVERY TIFFANY & /
CHARLES LEWIS TIFFANY /
FROM THEIR DAUGHTER
AND SON LOU AND LOUIS
Nov 30 1891 / 1841 / 1891*
26½ x 21¾ in.
The Mark Twain House &
Museum, Hartford, CT,
1975.2.1

Louis Comfort Tiffany
created this richly colored
window to celebrate his
parents' fiftieth wedding
anniversary in 1891. Using
heavily textured glass, it
displays a fruitful bough
from which a horn is
suspended, at once
Trumpet of Fame and
Cornucopia, with a
commemorative banner
proclaiming the occasion.
The pearls along the top of
the scroll suggest a crown.
This early window is a
bravura demonstration of
the resources of textured
and colored glass, as well
as a subtle recognition of
the bounty provided by the
elder Tiffanys to their
progeny.

Laurelton Hall.[69] The window also seems in many ways to be a precursor of the Anniversary window created for his parents in 1891 (see cat. 7).

In addition to the Tiffany contracts, Mary Elizabeth Garrett commissioned Lockwood de Forest to refurbish in paint and gilt a hall and dome for her house, as well as furnish an East Indian room.[70] Some of Mary Garrett's East Indian furniture wound up at Bryn Mawr College when she moved into the Deanery with her close friend M. Carey Thomas in 1904. East Indian woodwork went to the Baltimore Museum of Art upon the destruction of the house, considered a "white elephant," in 1939.

Although the exact chronology is as yet unknown, Tiffany was also commissioned to decorate portions of the home of Mary Elizabeth's brother, T. Harrison Garrett (1849–88). For this house, known as "Evergreen," Tiffany provided chandeliers for the hall, Favrile glass sconces, and according to tradition, designed a dining room. T. Harrison was an avid collector of Asian art, and Lockwood de Forest also contributed to the decoration. After her husband's death Alice Whitredge Garrett continued to patronize Tiffany; a wrought-iron grape and grapevine gate protected the main entrance door, and a glass and iron canopy shielded those who entered by a side door. In 1920, T. Work Garrett, the eldest son, inherited Evergreen. His wife, Alice Warder, brought to the house her own Tiffany objects. The Tiffany material at Evergreen has also been amplified by the early Tiffany collection given to Johns Hopkins by Margaret B. Wilson.[71]

Yet another Garrett brother, Robert (1847–96) patronized Tiffany for windows for his home at 11 Mt. Vernon Place, formerly 11 West Mt. Vernon Place, close to the home of his sister on Monument

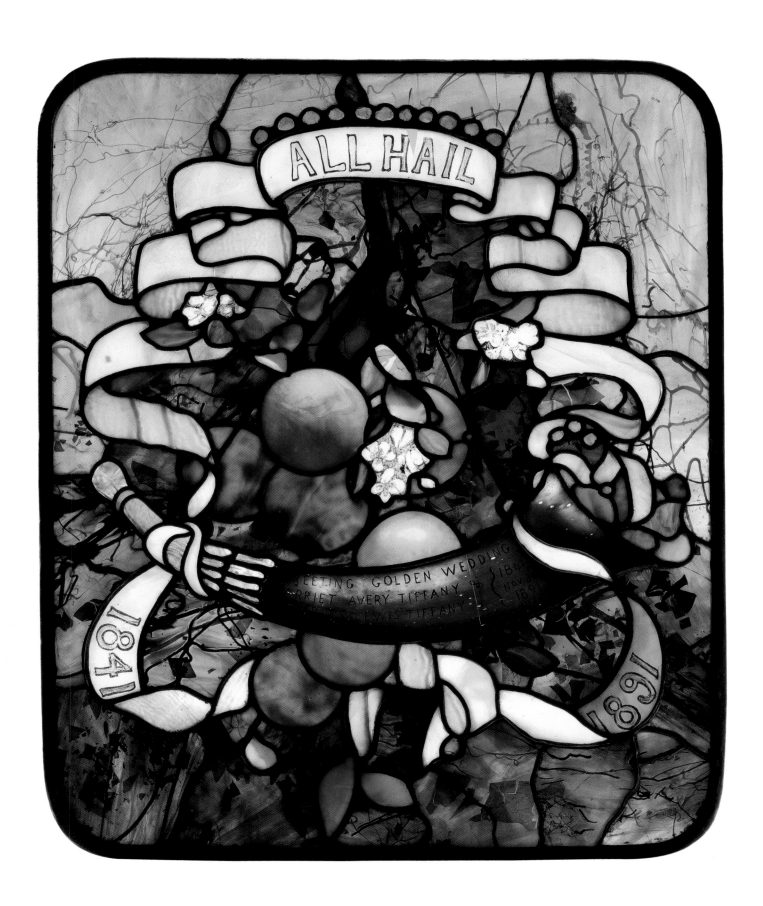

Street. Despite the strong protest of neighbors, the architect Stanford White consolidated two townhouses into one "New York style" brownstone for Robert Garrett and his wife Mary Sloan Frick. Although Tiffany would have been known to Robert Garrett, White reputedly contacted him for the windows. The Tiffany lower window for the Great Hall was removed many years ago and its fate is unknown. The upper window, titled "The Standard Bearer" and measuring eight by ten feet, was restored some time ago for the Engineering Society, which occupies the building, now known as the Garrett-Jacobs House.[72] The stained-glass windows that Tiffany designed and produced for the Garrett family are the most important commissions he executed for them, but the impressive and later collection of blown glass Favrile vessels at Evergreen House represent yet another career for Louis Comfort Tiffany, and one at which he would excel.

Knowledge of European advances in art glass unquestionably influenced Tiffany to consider this new venture of making art glass, which was nevertheless a logical progression in his continuing fascination with a medium that had almost endless possibilities for expressing his love of light and color. Through his connection to Tiffany & Co., Louis Comfort Tiffany would have known the work of English art-glass makers, particularly that of Thomas Webb & Sons, as early as the 1870s, and may also have known of the work of Émile Gallé as early as 1884. Certainly there are strong parallels in the careers of the Tiffany and Gallé.[73] At the Paris Exposition Universelle of 1889 Tiffany's rival John La Farge took major prizes for stained glass, while Thomas Webb & Sons won a first prize for their art glass, and Gallé's glass also won the acclaim of the critics. Louis exhibited only one painting, but his father's firm, Tiffany & Co., exhibited jewelry, including enameled orchids designed by Paulding Farnham.[74] Tiffany & Co. also showed a collection of American gemstones assembled by George Frederick Kunz, Tiffany & Co.'s eminent mineralogist whose professional focus was on gemstones. The displays of art glass apparently impressed Louis Tiffany. Intrigued with the European art scene, and perhaps already envisioning a future market for his products, Louis traveled extensively in Europe in 1889, and even visited the Nancy workshop of Gallé.[75]

Influenced perhaps by the triumphs of Webb and Gallé at the 1889 Paris Exposition Universelle, in 1890 Tiffany brought to the United States Arthur J. Nash, who had worked in England first for Edward Webb & Sons at the White House glassworks and then for Thomas Webb & Sons of the Dennis Glass Works, both near Stourbridge. Art glass in England was in trouble, in part because of a flood of imported cheap glass, but Nash had learned of Tiffany's experiments from American friends, and Tiffany heard of Nash, perhaps from the head of the glass department at Tiffany & Co. When he first came to America, Nash apparently carried out experiments for Tiffany at an unidentified Boston glasshouse. On February 18, 1892, Tiffany established the Tiffany Glass and Decorating Company. A furnace was constructed at Corona in Queens, Long Island, and under the direction of Nash experiments in producing glass began there. With the establishment of the glasshouse, Nash's family came from England. Two of Arthur Nash's sons, Arthur Douglas Nash and Leslie Hayden Nash, would prove to be important figures in the Tiffany companies. The highly personal and somewhat prejudiced journal of Leslie Nash, now in published form, furnishes valuable insights into the workings of Tiffany's glass production.[76]

In April 1893, a new company, the Stourbridge Glass Company was incorporated as a separate entity to produce glass vessels. The incorporation procedure took place in New Jersey. Nash's name appears on the papers, which include other names but not the name of Louis Comfort Tiffany. Late in June 1893, the Tiffanys invested in the company and took control of it. In October 1893, the Stourbridge Glass Company caught fire, a constant

hazard in the industry, and was destroyed. Although Nash at this time owned only one share worth $100, his son Leslie recounts that the loss was a great blow to him, perhaps because he lost valuable papers as well as his investment.[77] Not for the first time Charles Lewis Tiffany came to the rescue, with a loan to rebuild the factory. Although some accounts state that Tiffany first presented his glass vessels to the public in 1893, there seems at this time no evidence to substantiate such a claim. Other than the drama surrounding the new Stourbridge Company and the fire that destroyed the factory, 1893 seems to have been a year of transition, when Tiffany was preoccupied with organization and experimentation at Corona, and the presentation of his art in stained glass and mosaic glass to an admiring public visiting the Columbian Exposition in Chicago between May and October.

Tiffany used space reserved for his father for his presentation, which centered upon a remarkable chapel that catapulted Tiffany and his Tiffany Glass and Decorating Company to international fame.[78] A booklet published as "A synopsis of the Exhibit of the … company in the American section of the Manufactures and Liberal Arts Building at the World's Fair, Jackson Park, Chicago, Illinois, 1893…. "[79] describes the chapel, meant to illustrate the products of the company's Ecclesiastical Department, as "constructed on Romanesque lines … from the designs of Louis C. Tiffany, the President of this Company." To present the quality of the Company's domestic decoration, it also describes the Dark Room and the contrasting Light Room. In both these rooms glass plays a major ornamental role. In the Dark Room, for example, the pilasters of the mantel are of glass mosaic, while above the pilasters there is a border of "iridescent bluish-green glass inlaid into … Connemara marble." On either side of the mantel is a seat; one of these seats has above it an ornamental window of floral design surrounded by green glass jewels. On the other side is a mosaic panel similar in character to the window. The windows that appear in the Light Room are especially significant. One of these is Feeding the Flamingoes, which eventually found its way to Tiffany's home, Laurelton Hall.[80] The second is a window similar in concept to the one Tiffany had executed for Mary Elizabeth Garrett of Baltimore, c. 1885. It portrays "paroquets [sic] resting upon a branch … from which is hanging a globe of gold fishes." To obtain the realistic effect, opalescent glass alone was used "in accordance with the principles that govern mosaic work," and "without the assistance of paints or enamels." This ability to achieve effects without painting on the glass was a significant one and one of which Tiffany was particularly, and justifiably, proud. Pride is evinced also in one of the opening statements of the synopsis: "we cover the whole field of decoration—frescoes and mural paintings, colored glass windows, marble and glass mosaics, wood-carving and inlaying, metal work, embroideries, upholsteries, and hangings." Of significance also is the fact that nowhere in the booklet or in accounts of Louis Comfort Tiffany's exhibits at the Fair is any mention made of glass vessels, although his experiments in producing art glass were apparently well under way.

The factory for making glass remained in Corona, Queens; in Manhattan the Tiffany Glass and Decorating Company continued as a studio and showroom. The 1892 and 1893 editions of a King's Handbook of New York City show an early view of the Tiffany Glass and Decorating Company building, 333–341 Fourth Avenue (now Park Avenue South) at the southeast corner of Twenty-fifth Street (see fig. 15). Actually comprising several buildings, which still stand and have recently been restored, the complex is of substantial size. Tiffany first leased 333 from the Goelets by 1880. At some time after the establishment of the Tiffany Glass Company in 1885, he leased 341 as well, and about 1891 added a third building around the corner on

Twenty-fifth Street.[81] A description of the Company praises Tiffany, stating, "Today America leads the world in the making of stained-glass windows; a result brought about mainly through the investigations and experiments of Louis C. Tiffany, an artist of rare ability." The text helps to explain the size of the buildings with a comment that the demand for Tiffany windows was so great that "the company is compelled to keep in stock over a hundred tons of glass in the raw state, and employ a large corps of artists exclusively for this branch of its business." It further states that just as the glass department has grown, so too has every other department, so that "in the studios of the company all forms of artistic handicraft are found. Churches, houses, hotels and theatres are decorated and furnished throughout."[82] Despite commentary on various departments and their products, there is no mention of Tiffany glass vessels in the 1892 or 1893 handbook.

A patent applied for in September 1894 and registered in November describes the trademark of the Tiffany Glass and Decorating Company, "unadorned capital letters in Roman type but of different sizes, 'T G D Co' surrounded by two circles of different sizes…. Within the inner and outer circle are the words 'Tiffany Favrile Glass Trade-Mark Registered.'" The patent further states that between the words "Favrile" and "Glass" descriptive words may be used, such as "Fabric," "Sunset," "Horizon," "Twig," and "Lace," etc. According to the patent the essential features of the trademark are the monogram of the letters "T G D Co" and the word "Favrile." The patent further states, "This trade-mark has been continuously used by said corporation since its incorporation in February, 1892."[83] Although the patent gives valuable information, this last statement should not be taken literally. The earliest version of the word "Favrile," created by Tiffany and derived from the Latin *fabrilis*, or possibly more directly from a Saxon word meaning "handwrought," was "Fabrile," which appeared on labels of vases c. 1893.[84]

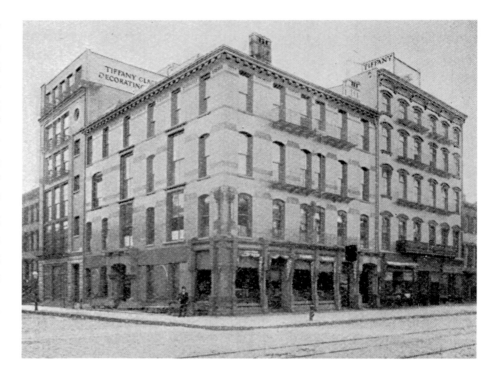

The showrooms of the Tiffany Glass and Decorating Company featured an exhibition of the new blown glassware, apparently offered for sale, in the spring of 1894.[85] A review of that exhibition, published in July in *The Art Amateur*, has been much quoted. An earlier review exists, however, published May 20, 1894. On page 17 of the *New York Times* under the title "Pots and Flasks of Many Hues/ L. C. Tiffany and Dr. Doremus Try for Colored Blown Glass," an anonymous writer gives a highly detailed account of the "objects for use and decoration," which he saw on the second floor of the Tiffany Glass (and Decorating) Company. The color experiments made by Tiffany and "the younger Dr. Doremus" took place, he states, in Mr. Tiffany's studio, the glassmaking at Corona. The lengthy article is, at this time, the earliest known published description of Tiffany's early glass, and is so specific that with careful study some actual examples might be linked to it. In addition to vessels, often in "forms and shapes from mediaeval German, French, and Venetian glass," Tiffany was producing globes, "balloon-like forms, with iridescent or opaline colors

distributed over them," for electric lights. One of the most interesting passages describes Tiffany's Lava glass; from this description clearly among Tiffany's earliest blown glass productions.[86] "Mr. Tiffany seems to have succeeded least in the bowls, ash receivers, and bottles of turbid glass resembling lava. They look like pieces turned on a lathe from stone…. Others in this line resemble pottery." To the writer the Lava pieces lacked the "light of glass," and he seems to consign them to the category of "attempts that were better thrown away." His distaste is clear; the glass was not.

About this same time Tiffany sent examples of his work to be displayed and sold at the Paris gallery of Siegfried Bing. The relationship with Bing was major to Tiffany's success in Europe, and instrumental in the long-standing characterization by scholars of Tiffany as an Art Nouveau artist.[87] In October of 1894 Tiffany advertised Favrile glass in *The Decorator and Furnisher*, giving the address at 333–341 and stating that "The Tiffany Chapel as Exhibited at the World's Fair Will Remain On Exhibition Daily Until December 1st." The brief advertisement is important for two reasons. First it makes no mention of the vessels apparently being produced at this period.[88] Second, it features the early logo of the Tiffany Glass and Decorating Company, which lacks the two circles of the patent as well as the words they enclose, and is simply the large *T* flanked by an almost equally large capital *G* and *D* above a small capital *C* and *O*. Although vessels are not specifically offered in this October 1894 advertisement, on November 23, 1894, Tiffany & Co. published its 1895 *Blue Book*, or catalogue, which is quite specific in its offer of "Tiffany Favrile Glass made by a new process, and blown under the personal supervision of Mr. Louis C. Tiffany."[89] The *Blue Book* rather than the advertisements seems the first public announcement of the sale of glass vessels. About the same time that the *Blue Book* was being published at the end of 1894, an 1895 photographic companion to King's 1893

handbook, titled *King's Photographic Views of New York* was being readied for print. In it is a photograph that would appear also in an advertisement in the February 1896 issue of *Art Interchange*. While the photograph remains the earliest known of Favrile glass vessels, publication in the King's *Views* may be earlier than the publication in *Art Interchange* (see fig. 16). The text that accompanies the photograph is almost the same text as that on the invitation to a fall 1895 exhibition of Favrile glass, including blown vessels, at the Tiffany Glass and Decorating Company building. The King's *Views* text accompanying the photograph, however, differs in the inclusion of one phrase, "the subtle quality of the texture," which does not appear on the invitation. Another early view of the Tiffany Glass and Decorating Company appears in the article in the King's *Photographic Views* of 1895 (see rear cover). In the three editions by King, there may be three "firsts": the earliest publication of a photograph showing Favrile glass vessels, the earliest description by Tiffany of his Favrile glass vessels, and the earliest published views of the Tiffany Glass and Decorating Company building.

In 1896, promotion of the new Favrile glass vessels accelerated. On January 23 George Frederick Kunz, distinguished gemologist for Tiffany & Co., wrote to Professor G. Brown Goode of the United States National Museum (popularly known as the Smithsonian) in Washington, D.C., saying he was "so forcibly struck with the beauty, variety and originality of the last six months' production in glass of Mr. Louis Tiffany" that he thought the Museum should secure a representative collection.[90] Implying that he was acting on his own, Kunz offered a loan collection of glass worth from $500 to $1500 with the stipulation that in six months or so one fourth or one half be purchased. A month later Kunz followed up with a letter stating Charles L. Tiffany had consented to buy a collection passed upon by a committee (the committee consisted of Louis Tiffany, Charles Tiffany, Charles T. Cook of Tiffany & Co., and

Kunz himself) and place the pieces, which Kunz described as "epoch-making," on loan with the option of purchase. In this same month of February 1896 the Tiffany Glass and Decorating Company exhibited Favrile glass vases and plaques at the annual show of the American Water-Color Society.

Negotiations and arrangements between the Tiffany Glass and Decorating Company and the Smithsonian continued for some time, with two casks containing twenty-three pieces being shipped on March 14 "by direction of Mr. Charles L. Tiffany." The letter confirming the shipment, signed by Pringle Mitchell, included both "display-cards" for the cases and "a diagram showing the position in which the different pieces should be placed." Later in March a memorandum to the registrar of the Smithsonian by the acting curator cited forty pieces, with two metal stands, from Charles Tiffany to be accessioned. One of the glass vessels, not by Tiffany but rather a John Northwood cameo vase by Thomas Webb & Sons, was offered as a gift. The transaction was completed in late June at a cost of $640.99.

Presentation of the glass vessels increased in Europe as well, through the efforts of both Charles Tiffany and Louis Comfort Tiffany. The Tiffany Glass and Decorating Company exhibited at La Libre Esthétique in Brussels and the Société Nationale des Beaux-Arts in Paris, while Tiffany & Co. offered Favrile glass for sale to the public at its London store. The South Kensington Museum in London (now the Victoria and Albert Museum) acquired its first Favrile vessel of a collection that would grow to twenty-one pieces. On the continent Siegfried Bing retained exclusive rights to retail Tiffany glass. In his *La culture artistique en Amerique*, published in this same year of 1896, Bing repeatedly praised Louis Comfort Tiffany and cited him as a pioneer in extending the boundaries of art.[91]

The premises back at 333–341 Fourth Avenue and 102 East Twenty-fifth Street, New York, were at this time a hive of activity. The buildings were a combination of showroom, studio, and factory. By 1896, the corner building, 341, included a store on the first floor, offices on the second, a workshop and drafting room on the third, a leading and glazing workshop on the fourth, and a metalshop on the fifth.[92] To Cecilia Waern, an English critic who published a series of articles in *Studio*, this last, "half-studio and half-workshop," was one of the most fascinating parts of the building, where choice pieces of blown and molded glass lay about, including the "dark-green 'turtle-backs'" to make "delightful" hall lamps (see cat. 8).[93] Some nine months later, in a follow-up article on Tiffany Favrile glass, Waern amplified the estimate of glass kept on hand, cited in King's 1895 handbook as one ton, to "200 to 300 tons of it generally kept in stock in the cellar, partly in cases, partly in labeled and numbered compartments on racks. These number 5,000—i.e., 5,000 colours [*sic*] and varieties are

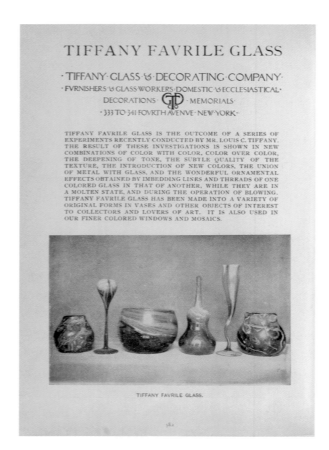

Fig. 16
"Tiffany Favrile Glass," *King's Photographic Views of New York, a souvenir companion to King's Handbook of New York City*, Boston, 1895, p.580, The New-York Historical Society.

kept accessible."[94] Clearly this was big business.

In her first article Waern stated that the "large and comprehensive establishment … built up by degrees by the talent, versatility and business ability of Mr. Louis Comfort Tiffany" was hard to classify by European notions. She further said that it was a "firm," undoubtedly, but a firm that emphasized handicraft, and was ever sensitive to the individual needs of its clients. Nevertheless, as Tiffany constantly expanded his output of windows, lamps, and ecclesiastical fittings, he was opening himself to all the problems of mass production, including repetition, lack of originality, and even to some extent the sacrifice of quality, especially in design.

There was no lack of originality, however, in his blown glass vessels. Waern stated, "The vases speak for themselves." Moreover, she added, "Mr. Tiffany never repeats himself; each piece of Favrile is necessarily unique."[95] Among the pioneer collectors who appreciated the novel and individual character of the Tiffany vessels were the distinguished connoisseurs Henry and Louisine Havemeyer. Late in 1896, they offered an extensive collection to The Metropolitan Museum of Art; on January 8, 1897, the fifty-six pieces were received.[96] Once more there was careful control of the presentation; Louis Comfort Tiffany himself arranged the exhibition.

In July 1897, yet another museum acquired Tiffany glass when the Tiffany Glass and Decorating Company sold twenty-nine Favrile pieces to the Cincinnati Art Museum for $512.40. The objects ranged in price from a modest $3.00 to $60.00 for an eighteen-and-a-half-inch vase (see cat. 126). Two were half-price because they had cracks. (It was not unusual for Tiffany to offer cracked pieces to museums, who could thus more readily afford a collection and could display the vessels in a way that did not reveal any imperfections) The numbers on their bases ranged from 40 to 5605.[97] Eleven of the pieces on the July 1 list from the Tiffany Glass and Decorating Company bear an *X* before their num-

bers, a prefix that at least one scholar believes ceased being used by 1896.[98] In 1898, eight more pieces were accessioned by the museum, all noted as "Gift of A. T. Goshorn," as were the 1897 acquisitions. Alfred Traber Goshorn, Harvard graduate, lawyer, and Civil War veteran, was the first director of the Cincinnati Art Museum. He had been Director General for the 1876 Philadelphia Centennial Exhibition, so he would have been familiar with the work of Tiffany & Co. and the paintings of Louis Comfort Tiffany. The presentations that Goshorn made to the Cincinnati Museum, along with the collections at the Smithsonian and the Metropolitan Museum furnish an invaluable resource for studying the early glass vessels of Louis Comfort Tiffany.[99]

Not yet content with the scope of his productions, which had in this decade expanded into not only blown glass vessels but also lamps and metalwork, Tiffany by 1898 was making enamelware, first at the Seventy-second Street house, then at Twenty-third Street, and finally at Corona.[100] In addition, he had moved on from glass shades for kerosene, gas, or electric lights to complex leaded-glass shades. These shades, which would somewhat resemble miniature versions of his stained-glass windows, could soften the glare from the incandescent bulb that his contemporary, Thomas Alva Edison, had developed in 1879, and make Tiffany's leaded glass available to a wider audience. Beginning in 1898 and going into 1899, Tiffany exhibited his electric lamps with leaded shades for the first time at Siegfried Bing's L'Art Nouveau gallery. In July of 1899 at Bing's landmark exhibition L'Art Nouveau at the Grafton Galleries in London, Tiffany exhibited his earliest documented leaded lamp shades, the Nautilus (see cat. 21) and the Dragonfly, (see cat. 66) as well as windows, blown Favrile vessels, mosaics, and metalwork.

Some indication of the size of the workforce required for Tiffany's varied productions is given in a booklet on mosaics, published in 1896 by the Tiffany Glass and Decorating Company, which

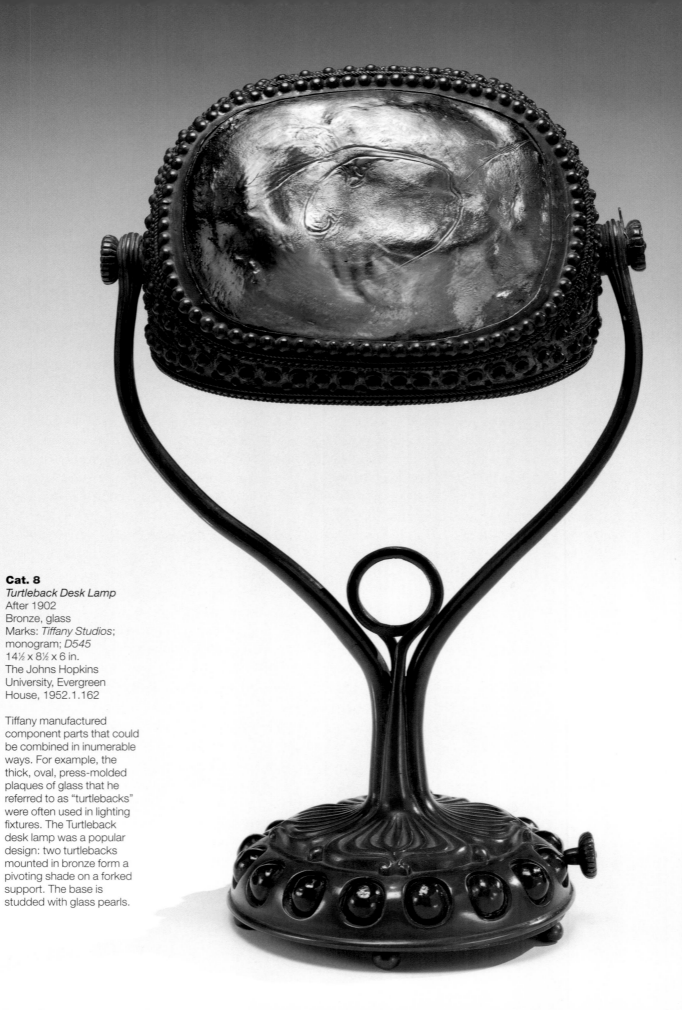

Cat. 8
Turtleback Desk Lamp
After 1902
Bronze, glass
Marks: *Tiffany Studios*;
monogram; *D545*
14½ x 8½ x 6 in.
The Johns Hopkins
University, Evergreen
House, 1952.1.162

Tiffany manufactured
component parts that could
be combined in inumerable
ways. For example, the
thick, oval, press-molded
plaques of glass that he
referred to as "turtlebacks"
were often used in lighting
fixtures. The Turtleback
desk lamp was a popular
design: two turtlebacks
mounted in bronze form a
pivoting shade on a forked
support. The base is
studded with glass pearls.

states that forty to fifty young women were employed, "working at either mosaic or windows, generally ornamented."[101] Two years later a trade journal of 1898 tells where he recruited some of these skilled artisans. When he began creating mosaics in 1879, the author says, Tiffany considered who should do the work. He concluded that the workers should be "young women from the art schools in this city." He therefore employed "Young women from the Art League, Cooper Institute, the School of Applied Design and the Art Department of the Young Women's Christian Association," believing "that they had their color sense more fully developed than any men he could get." At this time, the article continued, about a dozen of these young women, who were "trained in form and in the use of their hands … were busy carrying out a design of the 'Last Supper' … intended for the Paris Exposition."[102]

The young women in the Mosaic Department, in a practice prevalent at the time, were paid less than men, who were threatened by this cheap labor and sometimes went on strike. Most of these young women, however, were filling time until marriage and children, and many left after a short time. For those who were career-oriented, and showed talent as well as serious purpose, there were rewards. From the earliest years of his career as a decorator Tiffany had considered ability before gender. Thus Candace Wheeler was an equal partner, and Lydia Field Emmet, the artist who designed the Autumn window Tiffany exhibited at the 1893 Columbian Exposition, a respected freelance contractor. Throughout all his ateliers a handful of women over a period of years held major positions as designers and skilled fabricators and were paid good salaries, as well as given credit for their work. Because they were not kept anonymous, their names and specialties have come down to us: Agnes Northrop, designer of floral and landscape windows; Julia Munson (Sherman), enamel and jewelry artisan; Patricia Gay and Alice Gouvy, also enameling specialists; Meta Overbeck, jewelry spe-

cialist; and Clara Driscoll, designer of lamps, including the Dragonfly lamp. On April 17, 1904, *The New York Daily News* would cite Clara Driscoll as one of the highest-paid women in America, with an annual salary of $10,000, the equivalent of well over $100,000 today.

In the year 1900, Tiffany's reputation abroad reached its apogee. Early in that year Tiffany reorganized his businesses once again, and on April 2 incorporated the Allied Arts Company, which included the Schmitt Brothers Furniture Company that had been purchased in 1898. Remembering the lessons he had learned from 1889, Tiffany set out to win the international recognition he had not sought a decade earlier. The Exposition Universelle opened in Paris on April 14. Among Louis Comfort Tiffany's exhibits were Favrile glass objects, windows, mosaics, enamels, and lamps, including Clara Driscoll's Dragonfly, which gained its own prize. Louis Comfort Tiffany himself gained a grand prize for applied arts. The adjacent exhibition of his father's company Tiffany & Co. included Favrile glass scent bottles with jeweled mounts by Paulding Farnham (see cats. 10 and 11). The French bestowed upon Louis Comfort Tiffany and Tiffany & Co. vice-president Charles T. Cook, their highest honor, making them both chevaliers of the Legion of Honor. Once again Tiffany reached beyond these honors, and apparently cognizant of the widest possible audience, as well as being able to list Tiffany glass in exotic locales, he donated windows and Favrile glass to the Imperial Museum and the Fine Arts Society in Tokyo.[103] Once again he also reached beyond the various media his studios had mastered, by this time glass, enamel, metal, wood, and textiles, and began making art pottery.

In a period of such art potteries as Rookwood, Weller, Roseville, Chelsea and Dedham, Grueby, Newcomb, Van Briggle, Pewabic, and Marblehead, Tiffany was up against stiff competition. The medium never commanded the attention he gave to glass, and was notably unsuccessful. There is a tale,

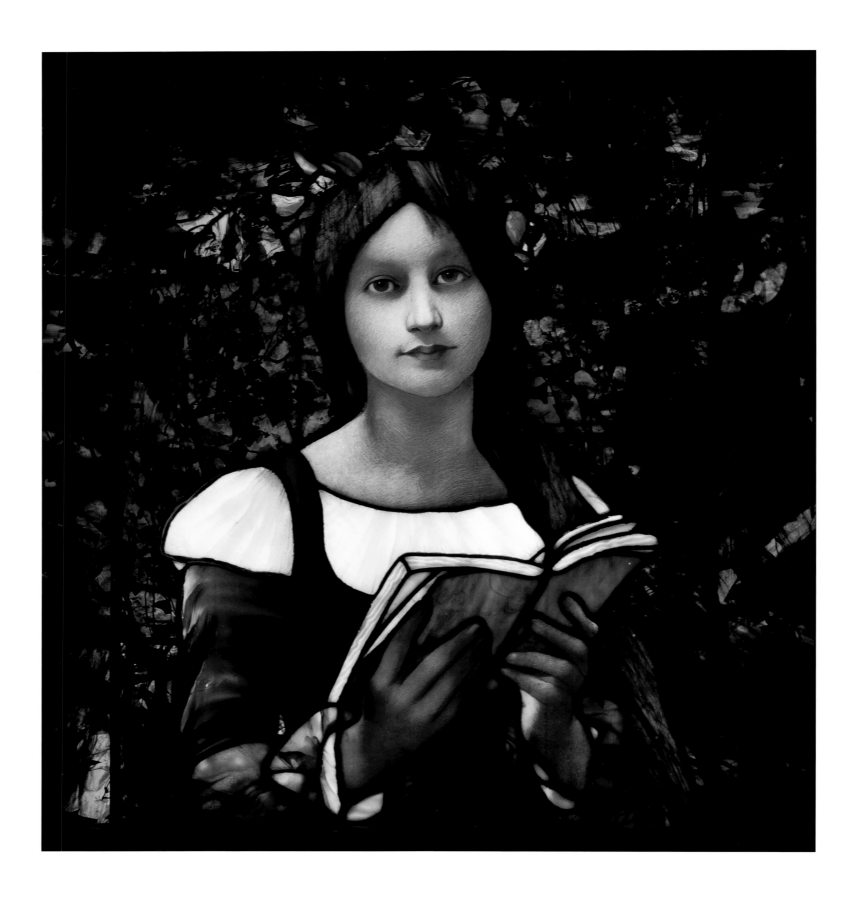

perhaps apocryphal, that when Tiffany was known to be coming to the factory at Corona, the workmen said, "Hide the pottery," perhaps so that he would not see the unsold stock. When he visited the factory, Tiffany, ever the perfectionist, was known to strike and break with his cane any glass or pottery that did not meet his standards. The best of Tiffany's pottery, like the best of his other products, has its own character and charm. It is generally a molded pottery rather than pottery thrown on a wheel, and the most interesting pieces are often in the shape of actual growing plant forms: ferns, cat-tails, asparagus, artichoke/thistles, cabbages. As befitted these objects from nature the glazes were usually soft greens and yellows, or a combination of both; there was also a line of "old ivory" glazes. Much of Tiffany's pottery had unglazed exteriors, but a glazed interior, often green. Pieces molded in conventional rather than organic forms were ornamented with favorite motifs from nature: flowers, leaves and branches, birds, fern fronds, and mushrooms. About 1908 Tiffany introduced a new line of "bronze" pottery (see cat. 110), but all pottery production apparently ceased in 1914, probably because of a limited market. Nevertheless, in the opinion of one writer/critic, "a successful piece of Tiffany pottery is a work of sophistication, elegance, and subtlety."[104]

If the year 1900 was a high point for Tiffany's fame abroad, the year 1901 saw equally great success for him at home. At the Pan American Exposition in Buffalo, the arts of the Tiffanys dazzled viewers almost as much as the symbolic electric tower, which could be seen from miles away. Although lamplight and gaslight remained the rule, the direct current advocated by Thomas Edison had already for some time lit homes, public buildings, and earlier expositions. Now the alternating current of Nikola Tesla and George Westinghouse had combined with the stunning power of Niagara Falls to create brilliant light that could be extended almost indefinitely in a grid system. In this unfailing

light at the Exposition, Tiffany & Co. exhibited gold and silver Favrile glass mounted vases and scent bottles (see cats. 10 and 11), and the newly named Tiffany Studios exhibited Louis Comfort Tiffany's collection of ancient Egyptian, Phoenician, and Roman glass, as well as their own windows, mosaics, and blown vessels. A contemporary article raved about the sensation Tiffany's Favrile glass had caused at the Paris Exposition, but stated that the display at Buffalo was "superior in every way to that made in Paris." Moreover, according to the writer, the exhibit featured "more than three thousand pieces, no two … of similar design or coloring."[105]

The connections between Tiffany & Co. and the various businesses of Louis Comfort Tiffany, always close because of Charles Lewis Tiffany's interest in his son's art, as well as because of shared exhibition spaces at international expositions, became even closer in 1902. At ninety years of age, Charles Lewis Tiffany died, and Louis Comfort Tiffany took over not only a vast fortune, estimated at that time as more than three and a half million dollars, but also the controlling interest in Tiffany & Co. Changes took place in the structuring of both Tiffany & Co., where Charles T. Cook became president and Louis Comfort Tiffany became first vice-president, and in Louis Tiffany's companies as well. Although the name was apparently in use at least since 1900, on February 25, 1902, the Tiffany Studios became incorporated, replacing the Tiffany Glass and Decorating Company, which continued to survive, at least nominally, through a complex series of stock transfers.[106] On September 29 in New Jersey, a certificate of change of name replaced the Stourbridge Glass Company with Tiffany Furnaces, which encompassed Tiffany's work in metal, enamelware, and pottery, as well as glass.[107] Finally, on November 18, 1902, the Allied Arts Company was consolidated into the Tiffany Studios. Having assumed the position of Art Director of Tiffany & Co., Louis, assisted by Julia Munson, began making jewelry.

In 1902, Tiffany also purchased about 580 acres of land at Oyster Bay, Long Island, on which sat an old resort hotel, Laurelton Hall. Tearing the structure down, he began meticulous plans for an enormous country house. To the family's dismay, Laurelton was meant to replace the Tiffany's much-loved nearby country residence called "The Briars." Although Laurelton has been termed an Art Nouveau mansion, it was in fact an eclectic but essentially Near Eastern fantasy, from a nineteenth-century tradition of the exotic that went back to such houses as Samuel Colt's Iranistan or Frederick Church's Olana. With its hanging gardens and intricate water system, its high-ceilinged central fountain court and its curtain walls of glass, it evoked an estate for a climate much warmer than that at Cold Spring Harbor. Soon it became evident that such practical considerations as heating the enormous house, roughly the length of a football field, had been sacrificed to aesthetic concerns. A power plant was added on the shore, with a smokestack in the shape of a graceful minaret to prevent any unsightly intrusion.[108] Although the family did not really move in until 1906, the house itself was basically completed in 1904, sadly not in time for all of the Tiffany family to enjoy it. In May of 1904 Louise Wakeman Knox Tiffany, Louis's second wife, died at age fifty-three. At fifty-six Louis Comfort Tiffany was once again a widower.[109]

The Louisiana Purchase Exposition opened in St. Louis on April 30 of 1904, just nine days before the death of Louise Tiffany. The judges awarded Louis Comfort Tiffany a diploma of honor for applied arts that included a display by Tiffany Studios of Favrile glass and the first public showing of Tiffany art pottery. Five pieces of Tiffany's enamelware and the first public showing of Louis's jewelry appeared in the adjacent Tiffany & Co. display area. In the following year, 1905, Louis Comfort Tiffany purchased a building at the southeast corner of Madison Avenue and Forty-fifth Street and relocated the showrooms and workrooms of his Tiffany Studios.

Fashionable New York was moving uptown.

The decade from 1906 through 1916 would see continuing success and, for much of the period, continuing production in a variety of media. In the fall of 1906, Tiffany & Co. in its 1907 *Blue Book* offered Louis Comfort Tiffany's glass-decorated metalwork, including desk sets, picture frames, and candlesticks (see cat. 104). Expanding production in the area of furniture, already undertaken by the Allied Arts Company and Tiffany Studios with the incorporation of Schmitt Brothers Furniture Company, continued in 1907/8 with the acquisition of Lockwood de Forest's furniture company in Ahmedabad, India. In this same year, however, the jewelry and enamelware became part of Tiffany & Co. and were moved to the sixth floor of the store after their purchase from Tiffany Furnaces. At yet another exposition in the United States, the Tri-Centennial at Jamestown, Virginia, Tiffany Studios received a grand prize.

Although the enormous energy and creativity that characterized Louis Comfort Tiffany's work before the turn of the century seems to have been somewhat waning by the second decade of the twentieth century, major commissions and some innovative techniques still occurred. Tiffany's two most impressive mosaics were executed in 1911 and 1915. The 1910–11 mosaic fire curtain for the National Theater in Mexico City was not only a dramatic view of the two mountains seen from the president's palace, but also a miracle of engineering in its mechanism to raise and lower its twenty-seven tons in seven seconds. Tiffany himself is said to have developed the system of counterbalancing weights.[110] In 1915, the Studios completed The Dream Garden, a forty-nine foot scene executed by thirty artisans after a painting by Maxfield Parrish. The mosaic was commissioned by Edward Bok for his new Curtis Publishing Company building in Philadelphia. In a booklet published by the company, Tiffany expressed his contribution, which emphasized the presence of depth and perspective in contrast to the flat mosaic pictures of the

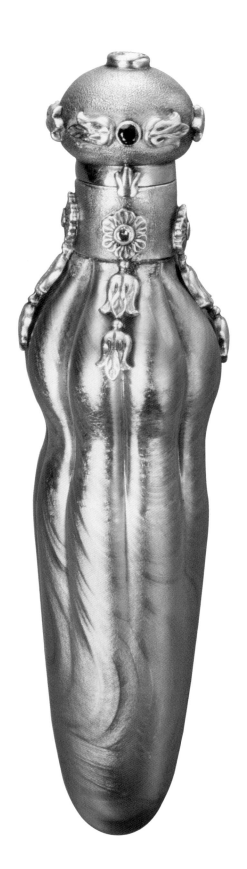
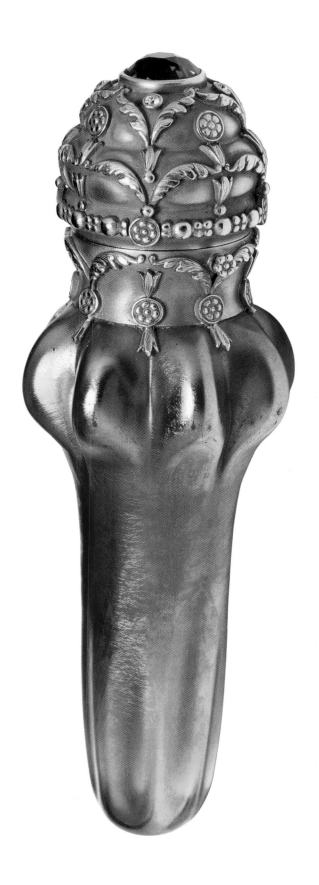

Cat. 10
Scent Bottle
c. 1900
Glass, gold, amethyst, emerald, pink tourmaline, sapphire, diamonds
Marks: *TIFFANY & Co.*
4⅞ x 1⅛ in.
Tiffany & Co. Archives, A1996.04

Cat. 11
Scent Bottle
c. 1902
Glass, gold, tourmaline, diamonds
Marks: *Tiffany & Co. 14 K*
4¼ x 1⅛ in.
Tiffany & Co. Archives, A1999.08

Paulding Farnham, head designer at Tiffany & Co., created a series of precious *vinaigrettes*, small purse-sized perfume flasks, for display at the Exposition Universelle in Paris in 1900, mounting Tiffany Glass and Decorating Company's Favrile glass in gold or silver studded with gemstones. The shimmering play of colors was greatly admired.

past. Although the building no longer belongs to the Curtis Publishing Company, it still stands, and "The Dream Garden" remains intact within it.[111]

The last of Tiffany's major innovations in blown glass vessels was his creation, about 1912, of a group of vases and bowls he called "Aquamarine" because in the lower part of them solid glass simulated water with embedded plants or sea life (see cats. 23 and 24). Tiffany & Co. first offered this glass in the 1913 Blue Book, published in the fall of 1912. About the same time, Tiffany and Arthur J. Nash developed the mature Morning Glory vase (see cat. 56), which was exhibited at the 1915 Panama-Pacific International Exposition in San Francisco.

During these years both the world of politics and the world of art again saw revolutionary changes. Beginning in February and continuing into March of 1913 an exhibition at the New York Sixty-ninth Regiment Armory introduced cubism to the public. Marcel Duchamp's painting Nude Descending a Staircase created a sensation. Tiffany was horrified by what he perceived as the ugliness of works by the "modernists," whom he saw as merely striving after new techniques. (It mattered little that much of his own art was based upon new techniques.) In 1914, what was happening in Europe eclipsed any controversy over European art movements. Beginning with the assassination at Sarajevo of Archduke Francis Ferdinand, heir to the throne of Austria, and his wife, a series of events resulted in Germany's declaring war on Russia and France, and invading Belgium. Soon the major countries of Europe, and some minor ones as well, were embroiled in a conflict that extended to Great Britain, but not to the United States until April of 1917, when the U.S. declared war on Germany. World War I would last until the armistice on November 11, 1918.

In these years of upheaval Tiffany's life appears to have been only minimally affected. In 1913, at the Tiffany Studios showroom, Tiffany had hosted an elaborate costume party and masque with an Egyptian theme. The first of several such celebra-

tions over the next few years, this fete began with invitations in hieroglyphics, with translation beginning, "Hail to thee, Great ones." The great ones came in any manner of costumes, including the wrappings of a mummy (John W. Alexander). They viewed a kind of performance art that included Antony and Cleopatra and their exchange of love presents, a beautiful youth for Cleopatra and in return for Antony, a "wonderful gift," a carpet that when unrolled produced Ruth St. Denis to do an Oriental dance. Tiffany's second major fete, the "Men of Genius" dinner, took place at Laurelton Hall on May 16, 1914. For the 150 male guests who came and went by private train from New York, young women, including Tiffany's daughters and daughters-in-law, wearing peacock headdresses and ancient Greek costume, served the menu, which featured peacocks. The last of the fetes, on February 19, 1916, was held as a luncheon and a retrospective exhibition at the Tiffany Studios' showroom. A masque titled "The Quest Of Beauty" allegorically presented Tiffany's ideas and theories of art.[112]

There is a quality of the inevitable in the events of the next few years. In 1918, the board of Tiffany & Co. accepted Tiffany's resignation as Art Director. Tiffany sold the Studios building and moved the Studios' operations several times before settling upon a location at his studio at 46 West Twenty-third Street. In 1919, the sons of Arthur J. Nash, A. Douglas and Leslie Hayden Nash took over the Corona factory. In 1920, Louis Comfort Tiffany retired from Tiffany Studios, and Joseph Briggs, who had come to work for Tiffany when he was only seventeen, and who for a time had been Tiffany's personal assistant, became the Studios' director.[113] About this same time Tiffany reorganized Tiffany Furnaces as Louis C. Tiffany Furnaces, Inc., but four years later that company also was dissolved.

In these later years of his life, as Tiffany saw a diminishing taste for his wares, which had become progressively more conservative, perhaps in

response to market demand, he seems to have become ever more aware of his place in posterity. In 1914, ostensibly at the request of his children, he produced a book, *The Art Work of Louis C. Tiffany*, in conjunction with his good friend Charles de Kay. Published anonymously in a limited edition sumptuously printed and bound, the book was clearly a vanity production, and was given to family members and to friends who were prominent and powerful (see cat. 12). In a creative solution to the problem of what to do with Laurelton Hall, in 1919 Tiffany established the Louis C. Tiffany Foundation for art students to live and study there. An endowment of one and a half million dollars, and the collections and beauties of Laurelton, to which Tiffany had now brought his greatest works, seemed to ensure the lasting success of the venture. The first students came to Laurelton in 1920.

Louis Comfort Tiffany was seventy-two at this time, and the students saw him as a benevolent old man who imposed no strict curriculum, but allowed them to find inspiration as they wished. As for his reaction to the work of the students, he apparently often found it baffling, particularly when it strayed beyond the boundaries of art as he had known it. This last decade of Tiffany's life was a quiet period, but he must have found the final years of his life somewhat painful. In 1930, his greatest achievement as a decorator of domestic interiors was destroyed when the Havemeyer House was razed. In the same year the Nash brothers closed the Corona factory, and in 1932 Tiffany Studios declared bankruptcy.

Louis Comfort Tiffany died on January 17, 1933, one month before his eighty-fifth birthday. He had been born in a year of revolution. During his lifetime countless other conflicts had occurred, including major ones such as the American Civil War in his youth and World War I in his late middle age. Revolutionary changes had occurred in every other area of life. Fueled lamps had given way to gaslight, and gaslight to electricity. Iron framed buildings like the Crystal Palaces had given way to steel structures that could "scrape the sky"; in 1929 the Empire State building had dramatically altered the skyline of New York. Carriages had given way to automobiles, and in leading cities underground transit systems carried millions of people to and from jobs. Airplanes crossed the continents and seas more quickly than the fastest trains or ocean liners. Countries such as Japan, unknown to the Western World of the mid-nineteenth century, had become world powers. Governments had both risen and toppled. The map of Europe was greatly altered. In Russia the Marxist Communism forecast in the year of Tiffany's birth held sway. In America the vast fortunes created by nineteenth-century industrialization had shrunk, their proud possessors now victims of the stock market crash of 1929 and the ensuing economic depression. Captains of industry, in earlier years of major importance to the Tiffany companies as clients, struggled to maintain their lifestyle, the huge houses that had once proclaimed their success now relics of another age.

Everything had changed, and yet in some ways it seemed that history repeated itself. War once again loomed on the European horizon. In this year of 1933, Hitler would be named Chancellor of Germany, and Japan would withdraw from the League of Nations. Despite turmoil at home and abroad, Americans still clung to the nineteenth-century idea of progress, and still proclaimed it in international expositions. In Chicago, in 1933, yet another World's Fair opened, optimistically titled "A Century of Progress." (The Victorian idea of the perfectibility of man was perhaps more difficult to sustain in this year when Hitler demanded and received dictatorial rights, and established the first concentration camps.) Men still grappled with the relationship between man and the machine and the question of whether mechanization had made the working man, and woman, more free, or only created a new kind of slavery. Given the temper of the times, however, such philosophical speculation might seem

both silly and superfluous. The handcrafted studio production that Louis Comfort Tiffany had propounded as both economically feasible and artistically satisfying was now an anomaly. There were many workers who would have welcomed the monotony of the assembly line in this world where men stood on street corners, querying "Brother, can you spare a dime?"

In the nineteenth century, Charles Lewis Tiffany had created an enormous wealth that shielded Louis Comfort Tiffany from such harsh realities. Although his wealth was considerably diminished, Louis Comfort Tiffany in his later years maintained his lifestyle, and still lived in his Seventy-second Street home, which he had deeded to his children in 1919, and in his country home, Laurelton Hall, technically the property of the Louis C. Tiffany Foundation. Accompanied by his longtime nurse/companion, Sarah ("Patsy") Hanley, and sometimes by family members, he still traveled in a private railroad car to his Miami home, Comfort Lodge. Other factors in his life had served to shield him also; his youth at the time of the Civil War had protected him, as had his age at the time of the "War to End All Wars."

Nothing, however, could protect Tiffany from the tragedies that occur in all lifetimes, in his case the untimely deaths of his two wives and two of his young children, as well as an adult child. Nothing could shield him from the enormous and inevitable changes in taste that destroyed the market for his work. For a time, nothing could change the prevailing opinion that his lamps and glass should be considered "silly and fussy and always in the way," worthy only of being consigned to oblivion with the other "gimcracks of yesterday."[114]

A picture of Louis Comfort Tiffany in old age shows a man still handsome and elegant, appearing surprisingly benign (see fig. 17). Perhaps Tiffany still felt that his ideals and his work would survive, the latter represented in stained-glass windows and in mosaics in hundreds of churches

Cat. 12
The Art Work of Louis Comfort Tiffany
Garden City, New York: Doubleday & Co. 1914
Book printed on Japan paper, gilded leather binding
Marks: personalized inscription to Mr. and Mrs. Andrew Carnegie; signed *Louis C. Tiffany*; stamped *copy 34 of 492 copies for private distribution*
12¾ x 9¾ x 1¾ in.
Museum of the City of New York, gift of Mrs. Roswell Miller, 46.351.38

This handsome volume, commissioned by Tiffany, and sumptuously bound in gold, is a record of his artistic career. Tiffany sent presentation copies to numerous personal friends and clients. This copy belonged to the Andrew Carnegies. Charles de Kay's name does not appear as author, but he is known to have written the text.

and public buildings across the nation and in blown vessels carefully placed and preserved in major museums. Perhaps he felt he had ensured artistic immortality through the continuing existence of Laurelton Hall, to which he had brought his major creations, and through the foundation he had set up there for young artists. The serene countenance reveals no inkling of the major events that would destroy many of his creations: the decorated interiors through changing taste, the stained glass through normal deterioration or deliberate vandalism,[115] the fragile glass vessels through indifference or carelessness. He could not foresee the future economic plight of his foundation, nor the destruction by fire of his greatest monument,

Laurelton Hall. In the serene countenance there is no sign of the hard taskmaster who demanded beauty and struck down imperfection. In his face, as in the accounts of Tiffany in his last years, there is no indication of an old man railing against an unjust fate. Perhaps despite the now profound disinterest of critic and public, Louis Comfort Tiffany had faith in the enduring quality of his finest work. Perhaps having seen so much change in his eighty-five years he felt that the world that seemed to have turned away from his art would turn back, and the wheel would once more come full circle.

Everything had changed—and would change again.

Fig. 17
Louis Comfort Tiffany in old age, Tiffany & Co. Archives.

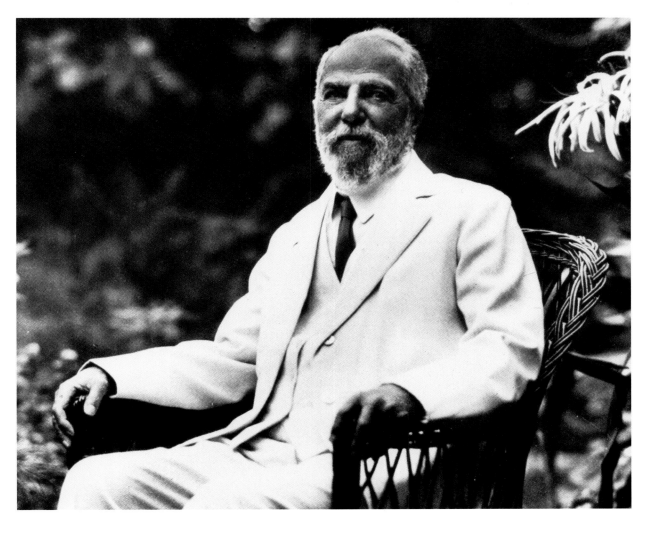

NOTES

1. Asa Briggs, ed., *The Nineteenth Century: The Contradictions of Progress* (London: Thames & Hudson, 1970), 25.

2. Nina Gray, "Leon Marcotte: Cabinetmaker and Interior Decorator," *American Furniture* (1994): 1. For further information on Marcotte, see Gray, this volume, p. 61.

3. Charles H. Carpenter, Jr. with Mary Grace Carpenter, *Tiffany Silver* (New York: Dodd, Mead & Company, 1978), 8.

4. Charles de Kay, *The Art Work of Louis Comfort Tiffany* (Garden City, N.Y.: Doubleday & Co., 1914; repr., Poughkeepsie, N.Y.: Apollo Books, 1987), 5.

5. Hugh F. McKean, *The "Lost" Treasures of Louis Comfort Tiffany* (Garden City, N.Y.: Doubleday & Company, 1980), 13–14.

6. Doreen Bolger Burke, "Louis Comfort Tiffany and His Early Training at Eagleswood, 1862–1865," *American Art Journal* 19 (1982): 29–39.

7. Gary E. Reynolds, *Louis Comfort Tiffany: The Paintings*, exh. cat. (New York: Grey Art Gallery and Study Center, New York University, 1979), 10, quoted from Samuel Isham, *The History of American Painting* (1905; repr., New York: Macmillian Company, 1936), 256.

8. Michael Burlingham, *The Last Tiffany: A Biography of Dorothy Tiffany Burlingham* (New York: Atheneum, 1989), 44.

9. Ibid, 40.

10. Janet Zapata, *The Jewelry and Enamels of Louis Comfort Tiffany*, (New York: Harry N. Abrams, Inc., 1993), 19–20.

11. Reynolds, *The Paintings*.

12. De Kay, *The Art Work*, 8.

13. See Reynolds, *The Paintings*, 12–13, and McKean, *The "Lost" Treasures*, 20, figs. 15 and 16, where similar scenes of Dobbs Ferry by Tiffany and Colman are dated c. 1880.

14. In this narrative, as in the catalogue by Holly Edwards, *Noble Dreams, Wicked Pleasures: Orientalism in America, 1870–1930* (Princeton, N.J.: Princeton University Press, 2000), the term "Orient" will be used to describe only the Near and Middle East and its extension into North Africa. See Oleg Grabar, "Roots and Others," 3.

15. There appears to be a conflict between footnote 30, p. 138, in *Noble Dreams, Wicked Pleasures* where Gifford in a letter to Lydia Swain dated September 11, 1870, states, "We shall take the steamer and go to Tangier on the African coast. We have some photographs from there and we will probably find what we want there," and the statement on p. 163 that "Tiffany spent about three weeks in Tangier (3–26 September 1870)." There is also confusion about the trip in Reynolds. Basing his conclusions upon a photograph album owned by Tiffany and now in the collection of the Morse Museum, Winter Park, Florida, Reynolds assumes correctly that Tiffany's first trip to North Africa was in 1870, but makes the assumption upon erroneous grounds. The date May 3 for Tangier and May 14 for Seville apparently refer to a different trip. Numerous other sources cite Samuel Colman rather than R. Swain Gifford as Tiffany's travel companion on this trip.

16. The letters of Robert Swain Gifford in the collection of the New Bedford Whaling Museum Library, Mss. Collection #12, give details of places visited on this trip and even exact dates. These letters, vividly descriptive and immensely touching, deserve far more space than can be given to them here. They also connote important influences on Tiffany's work. For example, from Naples, which Gifford and Tiffany visited twice, they made several side trips, including a trip to Pompeii and Herculaneum and a trip to Catania, a city built of lava. The author is indebted to the following individuals for copies of these letters: Laura Pereira and Mary Jane Blasdale of the Museum, Celeste Penny, who transcribed the letters, and Dorys Codina of Exhibitions International, who obtained the letters for the author.

17. Reynolds, *The Paintings*, 16–17. *Old and New Cairo* is now in the collection of the Brooklyn Museum, while *The Snake Charmer* is in the collection of the Metropolitan Museum.

18. *Market Day* is now in the collection of the National Museum of American Art, Smithsonian Institution.

19. This photograph, by an unknown artist, was in an album kept by Tiffany and is now in the collection of the Morse Museum in Winter Park, Florida. The inscription on it, "Tangiers May 5th market day," further confuses the issue of the chronology of Tiffany's first visit to North Africa (see n. 13). Was the album acquired separately from the taking of the trip?

20. See, for example, FRC (author's initials), "The Art of Japan," *The Art Journal* (December 1, 1872): 293–95, or "Japanese Metal Work," *The Furniture Gazette* 1 (September 27, 1873): 391, which quotes from a *New York Times* review of an exhibition at The Metropolitan Museum of Art.

21. Moore had probably begun collecting Japanese art about the time of the Paris Exposition of 1867. By 1891, when his collection was bequeathed to The Metropolitan Museum of Art, it numbered almost nine hundred items. These included textiles, pottery, metalworks, baskets, lacquer and papier-mâché, ivory, and large groups of sword guards, daggers, and swords. See Carpenter, *Tiffany Silver*, 183–84.

22. See David Hanks, *The Decorative Designs of Frank Lloyd Wright* (New York: E. P. Dutton, 1978), 3–5. See also Catherine Lynn, "Surface Ornament: Wallpaper, Carpets, Textiles, Embroidery," 76 and 106, and "Dictionary," 421–23, both in Doreen Bolger Burke et al., *In Pursuit of Beauty: Americans and the Aesthetic Movement* (New York: Rizzoli, 1986).

23. Carpenter, *Tiffany Silver*, 184.

24. The author is indebted to the Tiffany Archives and the staff there, Annamarie Sendecki, Louisa Bann, and Stephanie D. Carson, for making a photocopy of this catalogue available to her.

25. Roberta Mayer, *Understanding the Mistri: The Arts and Crafts of Lockwood de Forest (1850–1932)*, (PhD diss., The University of Delaware, 2000), 43–45.

26. J. S. Ingram, *The Centennial Exposition Described and Illustrated* (Philadelphia: Hubbard Bros.,1876), 588.

27. Mayer, *Understanding the Mistri*, 138.

28. Commentary on this influence occurs in Zapata, *The Jewelry and Enamels*, 19–22.

29. For information gleaned from these records, and for a straightening out of the tangled web of Tiffany's various companies, see the excellent work of Roberta A. Mayer and Carolyn K. Lane, "Disassociating the 'Associated Artists': The Early Business Ventures of Louis C. Tiffany, Candace T. Wheeler, and Lockwood de Forest," *Studies in the Decorative Arts*, 8, no. 2, (Spring–Summer 2001), The Bard Graduate Center for Studies in the Decorative Arts, Design, and Culture. The author would also like to acknowledge the man who saved these R. G. Dun papers from destruction and placed them at the Baker Library at Harvard University in 1962, her late brother, Glenn LaPorte Johnson, then manager of Public Relations for Dun & Bradstreet. At the same time he arranged for the sizable gift of nineteenth-century city directories to the Winterthur Museum Library, and placed account books and business manuscripts at numerous other libraries. All of these

materials were in the process of being discarded by a librarian who had no concept of their historic worth.

30. See Amelia Peck and Carol Irish, *Candace Wheeler: The Art and Enterprise of American Design, 1875–1900* (New York: Metropolitan Museum of Art, 2001). Roberta Mayer, *Understanding the Mistri*, and Wayne Craven, "Samuel Colman (1832–1920), Rediscovered Painter of Far-away Places," *American Art Journal* 8, no.1 (May 1976): 16–37.

31. The most prominent of these was *Artistic Houses* (New York, 1883–84), but the Bella rooms were also described by Donald Mitchell in 1882 in a series of articles for *Our Continent* and praised in an article on studios in the January 1880 *Art Journal*. See Mayer and Lane, "Disassociating the 'Associated Artists,'" 7.

32. One is reminded of Tiffany's claim, made years later, that it was his first trip to the Near East that opened his eyes to the importance of color. Lecture to the Rembrandt Club, Brooklyn, 1917, published as statement in "Color and its Kinship to Sound," Robert Koch in "Selected Statements by Louis C. Tiffany," *Tiffany's Art Glass*, (New York: Crown Publishers, 1977), 36, an important comment as he considered himself primarily a colorist. Edwards in *Noble Dreams, Wicked Pleasures* points out that, because Tiffany's illness would have curtailed his experience of the Orient, he may have been reliving this trip through a haze of years.

33. Alexander F. Oakey, "A Trial Balance of Decoration,"

Harper's New Monthly Magazine 64 (April 1882): 738.

34. Arnold Lewis, James Turner, and Steven McQuillin, *The Opulent Interiors of the Gilded Age* (New York: Dover, 1987), 80.

35. George Sheldon, *Artistic Houses* 2 (New York, 1883–84): 159. The photograph of the hall, opposite page 159 in *Artistic Houses*, was reversed but has been corrected by subsequent scholars.

36. Mayer and Lane, "Disassociating the 'Associated Artists,'" 23.

37. Sheldon, *Artistic Houses*, 160. For a similar window, reputed to come from the Kimball Castle, see cat. 5.

38. Sheldon, *Artistic Houses*, 160.

39. A number of these articles appeared in local newspapers. The most complete of them, titled "Wrecker's Ax to Fall on Kimball's 'Castle,'" was in the August 22, 1948, issue of the Sunday magazine for the *Democrat Chronicle*. The author is indebted to Jody Sidlauskas, Archive Assistant at the Rochester Institute of Technology, for copies of these articles and for photocopies of photographs of the house in its days of grandeur. Through the years several pieces of furniture from the Kimball House have surfaced. A screen now in the collection of the Virginia Museum of Fine Arts is illustrated in Eleanor H. Gustafson, "Museum Accessions" *Antiques* (July 2001): 34. For seating furniture see Alastair

Duncan, *Louis C. Tiffany: The Garden Museum Collection* (Woodbridge, England: Antique Collectors' Club, 2004), 86–89. In the summer of 2004 a clock from the Kimball Castle sold for a substantial sum at an auction in upstate New York.

40. The Mark Twain House survives as the nucleus of a remarkable museum and educational complex. Its painstaking restoration, completed in 1977, is a tribute to the efforts of a dedicated group of Hartford preservationists. For the story of its restoration see Wilson H. Faude, *The Renaissance of Mark Twain's House: Handbook for Restoration* (Larchmont, N.Y.: Queen's House, 1978); for information on the role of Tiffany see also Wilson Faude, "Associated Artists and the American Renaissance in the Decorative Arts," *Winterthur Portfolio* 10 (1975): 101–30; and for clarification on the various contracts and the dates of the redecorating see Mayer and Lane, "Disassociating the 'Associated Artists,'" 22–23.

41. Faude, *Renaissance of Mark Twain's House*, 35.

42. See Robert Koch, Thomas S. Tibbs, and Robert Laurer, *Louis Comfort Tiffany, 1848–1933*, exh. cat. (New York: Museum of Contemporary Crafts of the Craftsmen's Council, 1958). In *Rebel in Glass* (p. 3) Koch credits the exhibition and catalogue to Thomas S. Tibbs.

43. Faude, *Renaissance of Mark Twain's House*, Epilogue, 97.

44. For the excesses of the age and information on

other Tiffany commissions, see Neil Harris, "Louis Comfort Tiffany: The Search for Influence," in Alastair Duncan, Martin Eidelberg, and Neil Harris, *Masterworks of Louis Comfort Tiffany*, (New York: Abrams, 1989), 14–48.

45. This apartment was occupied by Henry Villard. For illustrations of the interior see McKean, *The "Lost" Treasures*, 110–11.

46. For an exemplary study of this furniture, which was also executed for The Briars and is now in the collections of the Mark Twain House and the Art Institute of Chicago, see Milo M. Naeve, "Louis Comfort Tiffany and the Reform Movement in Furniture Design: The J. Matthew Meier and Ernest Hagen Commission of 1882–1885," *American Furniture*, (Hanover, N.H.: Chipstone Foundation), 2–16.

47. *Architectural Record* 10, no. 2 (October 1900): 195; and "The Most Artistic House in New York," *Ladies' Home Journal*, 17, no. 12 (November 1900): 13.

48. Ibid, 11.

49. Ibid, 3.

50. *Ladies' Home Journal* 17, no. 12 (November 1900): 13, caption for photograph of the breakfast room.

51. Cecilia Waern, "The Industrial Arts of America: The Tiffany Glass and Decorative [sic] Co.," *The Studio* 11, no. 53 (August 1897): 161.

52. Robert Koch, *Rebel in Glass*, 69, quoting Alma Mahler, *And the Bridge Is Love* (New York: Harcourt, Brace and World, 1958).

53. Edgar Kaufmann, Jr.,

Interiors (December 1957): 120.

54. See Gray, this volume, p. 63.

55. Because of space, the author has discussed only interiors that are represented in the current exhibition.

56. Alice Cooney Frelinghuysen, "The Havemeyer House," in *Splendid Legacy: The Havemeyer Collection*, exh. cat. (New York: Metropolitan Museum of Art, 1993), 174. This highly readable and thorough account of the Havemeyer House is an important study, as is the work of Frances Weitzenhoffer, *The Havemeyers: Impressionism Comes to America* (New York: Harry N. Abrams, 1986).

57. Throughout his life Tiffany was intrigued by "found objects," particularly from nature. He collected beach stones as a child and as a young man, and used them elsewhere in his art, including in the library chandelier for the Havemeyer House, the Columbian Exposition chapel, windows (see McKean, p. 53, fig. 37, "Pebble Window from the Joseph Briggs House," and Waern, "The Tiffany Glass and Decorative [sic] Co.," p. 161, "Window Made of Beach Pebbles.") He also used them in "Pebble" lamps of the late 1890s, one example of which is in the Sydney and Frances Lewis Collection at the Virginia Museum of Fine Arts.

58. Aline Saarinen, *The Proud Possessors: The Lives, Times, and Tastes of Some Adventurous American Art Collectors*

(New York: Random House, 1958), 157.

59. S. (Siegfried) Bing in *Artistic America, Tiffany Glass and Art Nouveau*, translated by Benita Eisler from the 1895 French volume, introduction by Robert Koch, (Cambridge, Mass.: MIT Press, 1970), 130.

60. "Is Our Art Only a Fashion?" *The Art Amateur*, 5, no. 11 (June 1881): 2.

61. "The World's Work: American Progress in the Manufacture of Stained Glass," *Scribner's Monthly* XXII, no. 3. (January 1881): 486.

62. For the Kemp house window, see McKean, *The "Lost" Treasures*, 51, fig. 42. Email correspondence between the author and Morse Museum curator Donna Climenhage confirms that the photograph in McKean was reversed in printing.

63. Roger Riordan, "American Stained Glass: First Article," *The American Art Review* 2, 1st Division (1881): 229–34. For another example and discussion of the possibility that more than one version was made, see Duncan, *Garden Museum Collection*.

64. For the mark on a group of early tiles bearing this patent date, see McKean, *The "Lost" Treasures*, 286. Examples of some of these tiles are in the collection of two museums in Rochester, New York, suggesting they were salvaged from a Rochester house, possibly the Kimball mansion.

65. De Kay, *The Art Work*, 19–20.

66. *Trow's New York City Directory for the Year Ending May 1, 1885*, 98 (New York: The Trow City Directory Company): 11.

67. *The Formerly Wilson's Business Directory of New York City 1886*, 39, (New York: The Trow City Directory Company): 11.

68. The author is indebted to Michael Burlingham for this information.

69. Duncan, *Masterworks*, 126, and Alastair Duncan, *Tiffany Windows* (New York: Simon & Schuster, 1980), 116, 161.

70. See Mayer, *Understanding the Mistri*, 228–31.

71. Also in the house, now owned by Johns Hopkins, are Lockwood de Forest cabinets once belonging to Julia Rogers, who was part of the Mary Elizabeth Garrett, Julia de Forest, Louise Wakeman Knox Tiffany circle.

72. Katharine B. Dehler, "Mt. Vernon Place at the Turn of the Century: A Vignette of the Garrett Family," *Maryland Historical Magazine* 69, no. 3 (Fall 1974): 279–92. The author is indebted to Catherine Thomas of the Baltimore Museum for a copy of this article, and to Jacqueline O'Regan for information on Evergreen House. She is also indebted to James Abbott for taking her to Evergreen House.

73. Martin Eidelberg, "Tiffany and the Cult of Nature," in *Masterworks*, 71–79.

74. Janet Zapata, "The Rediscovery of Paulding Farnham, Tiffany's Designer Extraordinaire, Part I: Jewelry," *Antiques* 139, no. 3 (March 1991): 556–57; also John Loring, *Paulding Farnham: Tiffany's Lost Genius* (New York: Abrams, 2000), 48–49. There seems little question that these realistic flowers, according to Zapata executed in the hard, dull enamels perfected by Edward C. Moore, influenced the later enamel flowers produced by Louis C. Tiffany, although Louis preferred the common American flowers, such as Queen Anne's lace, or wild carrot, to the exotic orchids preferred by Farnham.

75. Eidelberg, "Cult of Nature," 79, quoting Charpentier. See also Joppien, this volume, p. 81.

76. Martin Eidelberg and Nancy McClelland, *Behind the Scenes of Tiffany Glassmaking: The Nash Notebooks* (New York: St. Martin's Press, in Association with Christie's Fine Arts Auctioneers, 2001). Commentary by Eidelberg and McClelland further amplifies the information in the notebooks. Some of the original Nash notebooks and a Nash scrapbook are now owned by The Tiffany Archives, Parsippany, New Jersey, where the author and the exhibition coordinator, Osanna Urbay, consulted them in October 2003. Other parts of this collection, including an extensive photograph album, went to the Matsue Garden Museum in Japan. In addition to the Nash collection, interesting information about the workings of the glasshouse exists in the pioneering work by Albert Christian Revi, *American Art Nouveau Glass* (Camden, N.J.: Nelson, 1968). Revi interviewed many of Tiffany's gaffers, whom he lists and discusses in terms of the division of labor.

77. Nash's formulas for the glass were in code so that no one, not even Tiffany, could decipher them. If he did lose some of these formulas, he reconstructed them. The formulas and the key to the code are now at the Corning Museum's Rakow Research Library. The author is indebted to Michael Burlingham for clarifying and providing information about the Stourbridge Glass Company.

78. Joppien, this volume, p. 78. Lawrence Ruggiero, "A Tiffany Masterpiece Rediscovered," *The Tiffany Chapel at the Morse Museum* (Winter Park, Fla.: The Charles Hosmer Morse Foundation, 2002), 22–23.

79. *A Synopsis of the Exhibit of the Tiffany Glass and Decorating Co.* (New York: Press of J. J. Little & Co., 1893; repr., New York: Clearwater Publishing, 1988), available at Avery Library, Columbia University, New York.

80. There are numerous representations of this window in Tiffany literature. See for example McKean, *The "Lost" Treasures*, 68, fig. 54, and Koch, *Rebel in Glass*, 120.

81. Christopher Gray, "Turn-of-the-Century HQ of Louis Comfort Tiffany," *New York Times* (October 4, 1998): RE5. The author is indebted to Michael Burlingham for a copy of this article.

82. Moses King, ed., *King's Handbook of New York City* (Boston: Moses King, 1892), 285–86.

83. The patent is reproduced in part in Koch, *Rebel in Glass*, 118.

84. The Fabrile label appears as fig. 3a, on page 509 of Martin Eidelberg, "Tiffany's Early Glass Vessels," *Antiques* 137, no. 2 (February 1990): 502–15. In this article, unquestionably the most important work on the early glass of Tiffany, Eidelberg also speculates, on page 504, on the reason for the change from "Fabrile" to "Favrile."

85. Ibid, 504.

86. Scholars have previously believed that Lava glass was introduced after 1900. See Eidelberg, "Early Vessels," 510, and Loring, *Louis Comfort Tiffany at Tiffany & Co.*, 149. This dating may stem from the research of Robert Koch, but it seems probable that Lava glass was improved and became more impressive with time.

87. See Joppien, this volume, and "Kunstglaser," in Rüdiger Joppien, ed., *Louis C. Tiffany: Meisterwerke des amerikanischen Jugendstils*, exh. cat. (Köln: DuMont, 1999). See also Herwin Schaefer, "Tiffany's Fame in Europe," *The Art Bulletin* 44, no. 4 (December 1962): 309–28; for information on Bing, see the work of Gabriel P. Weisberg, including *Art Nouveau Bing: Paris Style 1900* (New York: Abrams, in association with the Smithsonian Institution Traveling Exhibition Service, 1986) as well as the recent *The Origins of Art Nouveau: The Bing Empire*, Gabriel Weisberg, Edwin Becker, Evelyne Posseme, eds. (Amsterdam: Van Gogh Museum/Musée des Arts Décoratifs/Mercatorfonds, 2004), catalogue of the exhibition Van Gogh Buys at Bing's at the Van Gogh Museum, Amsterdam,

November 26, 2004 to February 27, 2005.

88. Eidelberg, "Tiffany's Early Glass Vessels," 507. Eidelberg seems to say that "Favrile" glass in these advertisements refers to the vessels; however, the patent for Favrile glass (see above) makes clear that it refers to all of Tiffany's glass.

89. *Blue Book* (New York: Tiffany & Co., 1895), 277.

90. Letter in the files of the Smithsonian Institution, now the National Museum of American History.

91. Bing, *Artistic America*, 125, 135, work in stained glass; 141, work in mosaic; 147, "establishment of a vast central workshop."

92. Duncan, *Garden Museum Collection*, 540. Information also came from Christopher Gray, Office for Metropolitan History, The New York Times. In an email to Joan Rosasco, Gray cites a building permit for alterations as the source.

93. Waern, "The Industrial Arts of America: The Tiffany Glass and Decorative [*sic*] Co.,": 162.

94. Cecilia Waern, "The Industrial Arts of America: The Tiffany or 'Favrile' Glass," *The Studio* 14, no 63 (June 1898): 15.

95. Ibid, 20, 21.

96. For illustrations and an overview of the Tiffany collections see Alice Cooney Frelinghuysen, "Louis Comfort Tiffany at The Metropolitan Museum of Art," *The Metropolitan Museum of Art Bulletin* 56 (Summer 1998).

97. There has been much controversy about Tiffany's numbering system. Decades ago, Robert Koch and Paul Doros worked out a numbering system that seems to work in many instances. This system is codified on p. 22 of Paul E. Doros, *The Tiffany Collection of the Chrysler Museum at Norfolk*, exh. cat. (Norfolk, Va.: Chrysler Museum at Norfolk, 1978). Albert Christian Revi contributed his idea taken from gaffer Jimmy Stewart that the glass objects were numbered when they were sent out rather than when they were produced. When Dr. Martin Eidelberg completes and publishes his study, many questions should be answered. See his discussion in the article, "Tiffany's Early Glass Vessels," *Antiques*.

98. Eidelberg, "Early Vessels," 510.

99. The author is indebted to Amy Dehan of the Cincinnati Museum of Art for information on Goshorn and for copies of the extensive correspondence, which indicates a quite "hard-sell" approach on the part of Tiffany's representative.

100. For the definitive work on his enamelware see Janet Zapata, *The Jewelry and Enamels of Louis Comfort Tiffany* (New York: Abrams, 1993).

101. Quoted by Duncan, *Garden Museum Collection*, 189. McKean says that at their peak Tiffany's enterprises employed over 200 artisans and designers, in *The "Lost" Treasures*, 6; Duncan says that at the peak of production the window department alone employed this number, in Alastair Duncan, *Louis Comfort Tiffany* (New York: Abrams, 1992), 70.

102. *China, Glass and Lamps: A Weekly Journal for the Buyer* 15, no. 9 (February 9, 1898): 16. Duncan illustrates a late mosaic and bronze Last Supper panel on pages 450 and 451 of *Garden Museum Collection*, as well as a cartoon on page 452 by Frederick Wilson for a Last Supper mosaic panel commissioned by the First Independent Christ's Church of Baltimore, illustrated in the *International Studio* (May 1906).

103. Although the Imperial Museum's collection has often been cited as proof of Tiffany's far-reaching influence, the gift was apparently not greatly valued when it was received. In 2003 Alastair Duncan told the author he himself opened and unpacked the crates in 1990; the gift had been in storage for almost a century. Today the greatest collection of Tiffany, a collection formed by Takeo Horiuchi since the early 1990s is at the Louis C. Tiffany Garden Museum in Matsue, Japan.

104. David Rago, "Tiffany," *American Art Pottery* (New York: Knickerbocker Press, 1997), 101. The leading authority on Tiffany art pottery is Dr. Martin Eidelberg. See his early work, "Tiffany Favrile Pottery: A New Study of a Few Known Facts," *Connoisseur* (September 1968): 57–61, and his recent work, "Nature is Always Beautiful," *American Ceramics* 14 (April–June 2003): 44–47. See also Alice Cooney Frelinghuysen, *American Art Pottery: Selections from the Charles Hosmer Morse Museum of American Art* (Orlando, Fla.: Orlando Museum of Art, in association with the University of Washington Press, Seattle, 1995).

105. James L. Harvey, "Source of Beauty in Favrile Glass," *Brush and Pencil* 9, no. 36 (December 1901): 167, 174.

106. According to Michael Burlingham's research, the Tiffany Glass and Decorating Company still existed in October of 1905, when it sublet the Fourth Avenue buildings, in a curiously Malaprop-like transaction, to the Fifth Avenue Auction Rooms.

107. The author is indebted to Michael Burlingham for incorporation dates. As with the name "Tiffany Studios," the name "Tiffany Furnaces" was apparently in use, at least within the organization, for several years before the formal adoption. See Zapata, *The Jewelry and Enamels*, 47.

108. In 1980, in preparation for a lecture on Laurelton at a Corning Museum symposium, the author walked the grounds of the estate with Michael Burlingham. At that time the minaret still stood, one of the few remnants of the vast complex.

109. As this book goes to press the best and most complete published description of Laurelton occurs in the work of Hugh McKean, who lived at Laurelton as a Tiffany Fellow in 1930. See McKean, *The "Lost" Treasures*, especially pages 113–30. The Metropolitan Museum of Art, however, is planning for 2006 a major exhibition and catalogue on Laurelton and Tiffany's other homes, with curator Alice Cooney Frelinghuysen and co-author Richard Guy Wilson.

110. McKean, *The "Lost" Treasures*, 145.

111. For an autobiography of the crusading and complex Edward Bok, see *The Americanization of Edward Bok* (New York: Charles Scribner's Sons, 1922).

112. All of these fetes are described in detail and illustrated in Chapter 17, "Hail to Thee, Great Ones," of McKean, *The "Lost" Treasures*.

113. For information on Briggs see Douglas Jackson, "Reflections on Joseph Briggs," *Important Works of Art by Louis Comfort Tiffany* (New York: Sotheby's, December 4, 1999), 12–13, and C. S. Nicholls, ed., *Encyclopedia of Biography* (New York: St. Martin's Press, 1997), 375–77. After his retirement, Briggs returned to his home in Accrington, England. He took with him a remarkable body of Tiffany's work, which is now in the collection of the Haworth Gallery. See cat. 70.

114. Emily Genauer in a review of the 1934 Machine Age exhibition. See Filler, this volume, p. 99.

115. See Filler, this volume, p. 98.

Tiffany's Contemporaries
The Evolution of the American Interior Decorator

Nina Gray

Louis Comfort Tiffany, though trained as a painter, had his first financial success as an interior decorator. When *Artistic Houses* was published in 1883–84, the work of Louis C. Tiffany & Co. (or Louis C. Tiffany & Co., Associated Artists) was represented by eight interiors.[1] Tiffany had taken up the business of designing interiors only in 1878, but almost immediately worked at the top end of the business. According to Candace Wheeler, one of his partners, Tiffany said, "I have been thinking a great deal about decorative work, and I am going into it as a profession. I believe that there is more in it than in painting pictures.... We are going after the money there is in art, but the art is there, all the same."[2] While Associated Artists disbanded shortly after the publication of *Artistic Houses*, Tiffany would continue to decorate interiors, despite his ever-broadening interests in glass, as well as in enamels, textiles, pottery, and metalwork.

The economic prosperity of the Gilded Age in the United States precipitated an unprecedented domestic building boom, especially the construction of imposing city residences and country houses. The newly rich demonstrated their wealth in the traditional medium of grand architecture. The construction of great houses required a commensurate expenditure on the embellishment of the interiors. As American consumers became increasingly more cultured and, in turn, more ambitious about matters of furnishing and decoration, the need for men of taste to design and execute sophisticated decorating schemes grew. The interior decorator emerged during the last quarter of the nineteenth century with a significant role: creating complex and stylish interiors.

Over the course of the Gilded Age, that role evolved aesthetically and commercially. The high-style interiors of the 1870s were mainly created by cabinetmakers. During the 1880s, artists took up the decoration of interiors and added a new level of aesthetic sophistication. Most of the architects who were commissioned to design the houses of the very wealthy during the 1890s designed the interiors as well, and focused on harmonizing the interior decoration with the exterior. By the outbreak of World War I, the design of interiors had largely become the decorator's art of assembling harmonious antiques and reproductions. When Tiffany Studios published the brochure *Character and Individuality in Decorations and Furnishings* in 1913, Tiffany's work, like that of his contemporaries, had evolved over thirty-five years into both a very different aesthetic and a very different business model.

James Maher has described the changes in the meaning and function of the decorator as a profession.[3] He traces the beginning of the evolution of the modern decorator to post-revolutionary France. Through the eighteenth century, the responsibility for decorating interiors—including not only the ornament of the walls, floors, and ceilings, but also the choice and treatment of furnishings—fell to the architect. With the collapse of the system of royal patronage and the rise of middle-class consumers, a new order emerged. This new order witnessed a new independence and increased influence of specialists who would have acted as subcontractors, answering to the architect under the old system:

> One wonders, who under the new disposition held the pencil? Who was responsible

for the actual design of an interior: the floors, the walls, the ceilings, the door and window surrounds, the cornices, the coves, the great staircases with their wrought-iron and bronze railings, and the chimney-pieces (with which the design of the room so often began)? Under the old system, decoration took its logic from the architecture of a house. After the diffusion of responsibility, it assumed a new logic, one that remains a mystery. Design coherence, a legacy of classical tradition, began to disappear. Variety, innovation, and idiosyncrasy came to the fore, declaring the presence of the new rich and their new taste.[4]

In France, decorating fell to the *tapissier*, *ébeniste*, and other merchant-craftsmen, while in the United States, cabinetmakers, artists, architects, dealers, and others became the new decorators. However, just as Napoleon III's widespread building programs of the 1850s and '60s brought a revival of the architect/decorator in France, the education and training of Americans in Parisian ateliers, beginning with Richard Morris Hunt (1827–95), transmitted the French practices to America during the second half of the nineteenth century. Hunt initiated a movement of architect involvement in interior decoration that would also transform the field.

American decorators emerged from diverse backgrounds during the nineteenth century, and their interiors reflected their different qualifications. American decorators, like American artists, architects, and other craftspeople, created interiors that were distinctly American.

In the United States, before the advent of professional decorators, architects had planned the embellishment of the interior spaces and the furnishing was generally left to the patron. Books such as Andrew Jackson Downing's *The Architecture of Country Houses* (1850) and H. Hudson Holly's

Modern Dwellings in Town and Country (1878) offered guidance on the appointment of various rooms and the selection of furniture from the architect's perspective. Downing (1815–52) went so far as to recommend certain cabinetmakers, including George Platt, Alexander Roux, and Edward Hennessy, whose work he illustrated in *The Architecture of Country Houses*. Platt's business as a decorator was not in competition with Downing's services. These treatises anticipated the approach of the professional decorator whose responsibility was to complete the work of the architect on the interior.[5]

Cabinetmakers were the first professionals to comprehensively undertake the design of fashionable interiors. They expanded their business to encompass architectural embellishment, wall coverings, upholstery, lighting, and more. Firms such as Herter Brothers, Pottier and Stymus, Kimbel and Cabus, and Leon Marcotte were among the best known. Marcotte listed himself as a decorator in New York in 1858.[6] When he immigrated to New York in 1848, he was better known as a cabinetmaker in partnership with Auguste-Emile Ringuet-LePrince, although he was trained as an architect at the École des Beaux-Arts. In addition to his role as a decorator, he advertised a lengthy list of other services including those of cabinetmaker, furniture dealer, rug dealer, supplier and maker of bronzes, exporter, and commissioned merchant in deluxe furnishings, gas fixtures, chandeliers, art furniture, looking-glass plates, and tapestries.[7] The job of decorating the interiors of the newly constructed mansions for wealthy clients in the United States during that period was highly competitive, and proposals and bids were often sought from several firms.

In 1877, Marcotte won the contract to decorate Cyrus Hall McCormick's house at 675 Rush Street in Chicago; his proposal was selected over those of Herter Brothers and Pottier and Stymus.[8] Marcotte's work was commensurate with the sophisticated designs and ensembles of the most

fashionable decorators. The contract detailed exactly where the work of the architect and his contractor ended and where Marcotte's began. For each room, a list of materials was specified, including woodwork, trim, and furnishings. Marcotte designed furniture, as well as the interior wall, floor, and ceiling treatments.[9] Not surprisingly, the interiors featured elaborate architectural mantels and chimneypieces in addition to carved woodwork and lavish furniture. The library of the McCormick house

(see fig. 18) was executed in ebonized wood inlaid with tin and a wall covering of leather paper featuring blue flowers on a gold ground. The ceiling was painted after designs by Marcotte & Co., which also designed, fabricated, and installed all the woodwork, including the doors, as well as the marble fireplace, and the mirrored mantel. The furnishings consisted of crimson silk curtains and portieres, blue upholstered chairs and sofas, and an ebonized library table. The carpet, fabrics, wallpaper, and

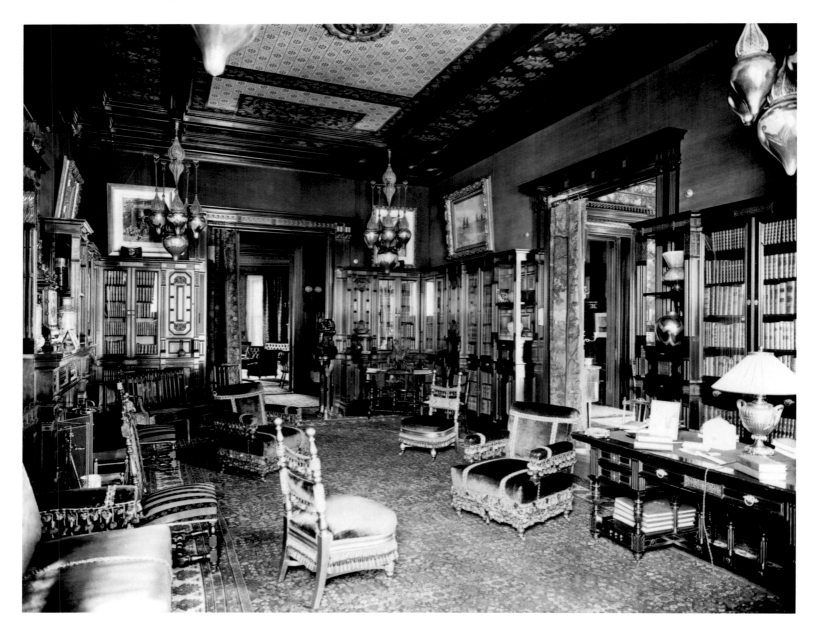

brass chandelier were shipped from Paris.[10] All these elements combined to make a sumptuous, elegant room.

Marcotte's death in 1887 changed the tenor of his business, although it would continue until 1922.[11] In the 1880s, Christian Herter and Alexander Roux also died, Auguste Pottier retired, and the partnership of Kimbel and Cabus ended, all signaling a major change in the realm of the cabinet-maker/decorator.[12] All of these firms continued in business under new management—or, in the case of Kimbel and Cabus, each partner established his own business—but the loss of creative leadership made room for other professionals, including artists and architects.

The next stage in the evolution of the decorator came with the architect/decorator and the artist/decorator coordinating interior design and directing the cabinetmakers and other subcontractors. One of the most fascinating commissions of the early 1880s was the house of Cornelius Vanderbilt II at 1 West Fifty-seventh Street,[13] designed by George B. Post, who had trained with Richard Morris Hunt.[14] The mansion was a combination of artist-designed rooms by Louis C. Tiffany and John La Farge, and architect-designed rooms by Post, subcontracted to cabinetmakers. La Farge and Tiffany had great freedom in their decorations. Tiffany dealt directly with Cornelius Vanderbilt II, to whom he submitted his designs on June 2, 1881. Once approved, Vanderbilt directed Tiffany to turn the proposal over to Post: "I like the plan very much indeed. Please show it to Mr. Post as soon as possible—so that all building plans will work in together."[15] Tiffany was paid $30,000 for the parlor decoration, with additional payments totaling $3,200 for curtains and portieres.[16] In 1882, the room was described as follows:

> The drawing-room connects with the
> library by folding doors; the decoration of
> this apartment is being done by Tiffany.

The treatment is both elaborate and rich to the last degree. The large folding doors on the south side are balanced on the north side by a large cabinet mantel in the wall. There are four pilasters on either side, and these pilasters, together with the wainscoting, which is of maple, are inlaid with classic designs in metal and glass. The whole is being wrought out with rare combination of delicacy and strength, while the color is in agreeable half-tints in light and delicate variation. As in his treatment of the Goelet rooms, where he has for the first time introduced examples of the decorative art of India, so also in the Vanderbilt drawing-room Mr. Tiffany has made another experimental departure. The ceiling of this drawing-room is in mosaics of glass, in small panels. There is a large panel in the center, about nine feet square, in the middle of which is a Moorish design, surrounded by a circle of cherubs. The glass panels of the ceiling are subdivided by demarcations of woodwork in geometrical designs.[17]

La Farge's decoration, like Tiffany's, was dominated by his artistic style. La Farge also came to decorating from painting, although he achieved greater professional success in painting than Tiffany. La Farge's business as a decorator began when he founded the La Farge Decorative Arts Company in 1880 in partnership with Mary Elizabeth Tillinghast (1845–1912).[18] *The New York Times* recognized him in 1881 as. "a man who has done much to foster the growing public taste for art-work in the interior decoration of houses."[19] He was especially appreciated for his role in bringing stained glass into domestic settings. Sadly, La Farge's business collapsed after five years due to personal and professional disagreements that were exacerbated by financial problems.[20] La Farge continued to

Fig. 18
Library of the Cyrus Hall McCormick House, 675 Rush Street, Chicago, designed by Leon Marcotte in 1880. The room featured woodwork and furniture by Marcotte & Co. and furnishings that he imported from Paris.

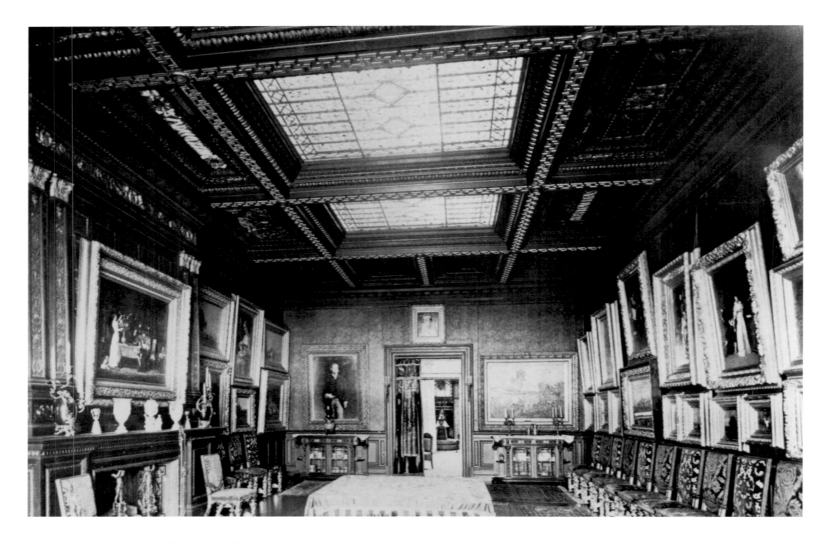

pursue the artistic embellishment of interiors on his own, providing stained-glass windows and murals. The Cornelius Vanderbilt II house was his most extensive domestic interior-design project, and one of his few commissions on which Tiffany also worked.[21] In 1883, as the initial stage of building the house was nearing completion, an article in the magazine *The Art Amateur* declared, "The suite of rooms in Mr. Vanderbilt's house, including the dining-room, water-color room, and smoking room, is the most important example of decorative work yet attempted in this country, in both respect to the scale on which it is employed and to its artistic intentions."[22] La Farge was responsible for the decoration of the dining room and the watercolor room,

for which he was paid more than $50,000.[23] He determined the type and placement of the decorative scheme for the dining room (see fig. 19), and designed the carved panels in the ceiling, the cove panels, the chimneypiece and overmantel, the glass skylight, and the metal moldings that surrounded the skylight and the dome lights. La Farge's carved panels and glass ceiling determined the overall feeling of the room, which also served as an art gallery. The use of stained glass was a major component of artistic interiors in the 1880s. It was the dominant decorative feature in the Vanderbilt house's dining room, not least because of its size and the fact that the colored and transparent glass modulated the light. The carved panels of

Fig. 19
Dining room of the Cornelius Vanderbilt II House, 1 West Fifty-seventh Street, New York; designed by John La Farge c. 1883.

mythological characters were exquisite, reflecting La Farge's mastery of the human figure on a monumental scale.[24] La Farge also designed the portieres, which were executed by Mary Elizabeth Tillinghast, who headed the embroidery department in La Farge's decorating business.[25] Post's ledgers also record the fees paid to other subcontractors, including Charles Yandell for leather for the dining-room walls, George W. Koch for parquet flooring, and W. H. Jackson for metal moldings.[26] These payments suggest that Post designed and coordinated these items and was paid a percentage of each fee. There is no information given about the furniture or its upholstery, suggesting that Mr. and Mrs. Vanderbilt selected and paid for these elements themselves.[27] In contrast to the work of cabinetmaker/decorators during that period, La Farge's responsibility did not extend so far as the furnishings.

When Cornelius Vanderbilt II renovated and expanded his house in 1892, he once again hired Post.[28] Although La Farge's work was preserved, it was reconstructed in different rooms; a cross section of the renovated house (see fig. 20) shows the carved panels from the dining room moved to the billiard room, along with the monumental fireplace by sculptor Augustus Saint-Gaudens. The drawing room decorated by Tiffany does not seem to have survived the redecoration. Unfortunately, this drawing does not include details of the furniture in any of the rooms.[29] In place of American artists and decorators, the Parisian firm of Jules Allard et Fils was contracted for the new rooms.[30]

Vanderbilt's enlarged house was included in *Stately Homes in America* by Harry Desmond and Herbert Croly (1903).[31] *Stately Homes* included many of the same interiors as *Artistic Houses*, but focused on them as representations of the ways

Fig. 20
Longitudinal section looking through the suite of rooms in the Cornelius Vanderbilt II House, 1 West Fifty-seventh Street, New York, c. 1892; George B. Post, architect.

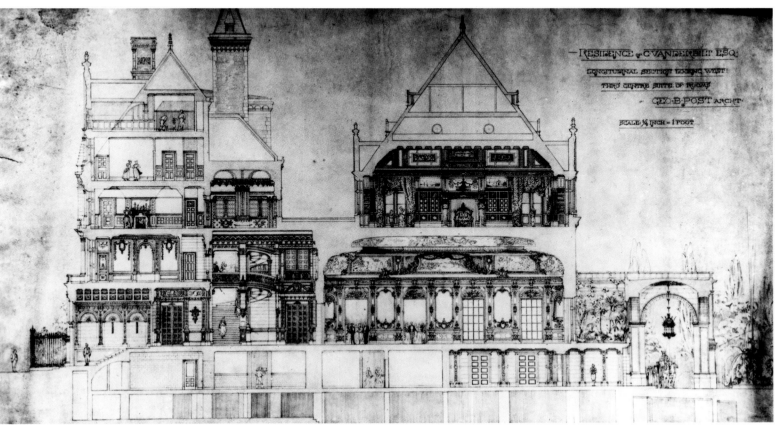

that rich men lived and put them into a historical context that was not necessarily flattering.[32] In contrast to the interiors in *Artistic Houses*, which were chosen to illustrate the innovative and sophisticated work of American designers, Desmond and Croly chose to emphasize the "stately home" as "the peculiar product … partly of the most recent American architectural ideas, and partly of the tastes, the ambitions, the methods, and the resources of contemporary American captains of industry."[33] The authors discussed in great detail the idea that the prime motivation for building these grand houses was to demonstrate the owners' wealth, and concluded that "our American residences … will not be understood unless it is frankly admitted that they are built for men whose chief title to distinction is that they are rich, and that they are designed by men whose architectural ideas are profoundly modified by the riches of their clients."[34] On the subject of the interiors, Desmond and Croly favored the architect's functioning as the interior designer, rather than using a decorator, who they thought should only collect and sell the materials that the architect needed.[35]

Interiors designed by architects were different from those of cabinetmakers and artists. Most often, the architects who had been responsible for the exterior building continued the work on the interior, setting the tone for the decoration through the design of the shell of the room, which was constructed according to their specifications by subcontractors.

Stanford White, a partner in the renowned New York architectural firm, McKim, Mead & White, executed much of the firm's interior decoration and maintained highly personal relationships with his clients and patrons. He was a specialist in ornament, and the interiors that he designed were richly composed layers of decoration that combined art, antiques, and architecture. White often integrated the work of his artist-friends, including La Farge and Tiffany, into his interiors, resulting in some of his most creative and innovative work. White designed an alcove for the salon of Anne and Louise Cheney in Manchester, Connecticut (see fig. 21), one of many projects he undertook for the family. The alcove featured Thomas Wilmer Dewing's monumental painting *The Days,* for which White and his assistant Joseph Wells designed a unique combination of a picture frame with a companion sofa.[36] The ornament on each of the two pieces is different but complementary, featuring scrolling vines and leaves combined with architectural details including egg-and-dart molding, beading, and fluting. Joseph Cabus, formerly of Kimbel and Cabus, made both the sofa and the frame. No longer a designer of furniture, Cabus had become a fabricator, executing the exact design and finish specified by the architect.[37] Anne Cheney wrote to White in May of 1888, "The bench has come, it is simply stunning & we are all in a state of great delight over it.... I can't find any words to thank you for all the lovely things you do for us & each new thing that comes, deepens the debt that we owe you. With thanks for the seat which is exquisite in all its details."[38]

White's distinctive work as an interior decorator depended on his huge inventory of beautiful objects, which he used in exquisite combinations to create lavish rooms for his wealthy clientele. Lawrence Grant White wrote about his father's work as an interior designer:

In order to furnish their houses, he made frequent trips abroad and returned laden with carved doorways, mantels, furniture, rugs and tapestries. The incredible amount of material he collected in these European raids had an enormous influence in educating public taste to appreciate the decorative arts of Europe. Once, when reproached for thus despoiling the old world to embellish the new, he defended his actions by saying that in the past,

Fig. 21
Alcove of the salon in the Anne and Louise Cheney House, Manchester, Connecticut, designed by Joseph Wells and Stanford White in 1890.

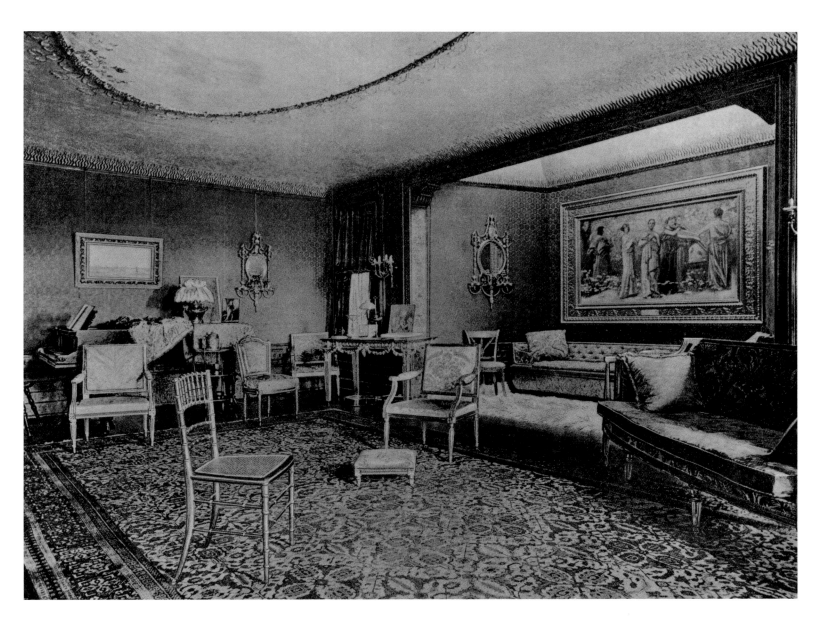

dominant nations had always plundered works of art from their predecessors; that America was taking a leading place among nations and, therefore, had the right to obtain art wherever she could.[39]

The residence that White designed for himself, at 121 East Twenty-first Street, represents the culmination of his decorating talent. He was at the forefront of creating an Old World aura in Gilded Age America through the conspicuous use of European antiques. White looked at pieces not only for their individual beauty, but also as elements of larger decorative and architectural compositions. He had a special appreciation for Italian Renaissance architectural fragments, including ceilings, mantels, and doorways, and would often use one of these pieces as the initial design element of a room, then select the other elements to create a coherent whole.[40] The Italian Baroque ceiling in the drawing room— a large central panel, depicting angels bringing tidings of Christ's birth, with elaborate carved

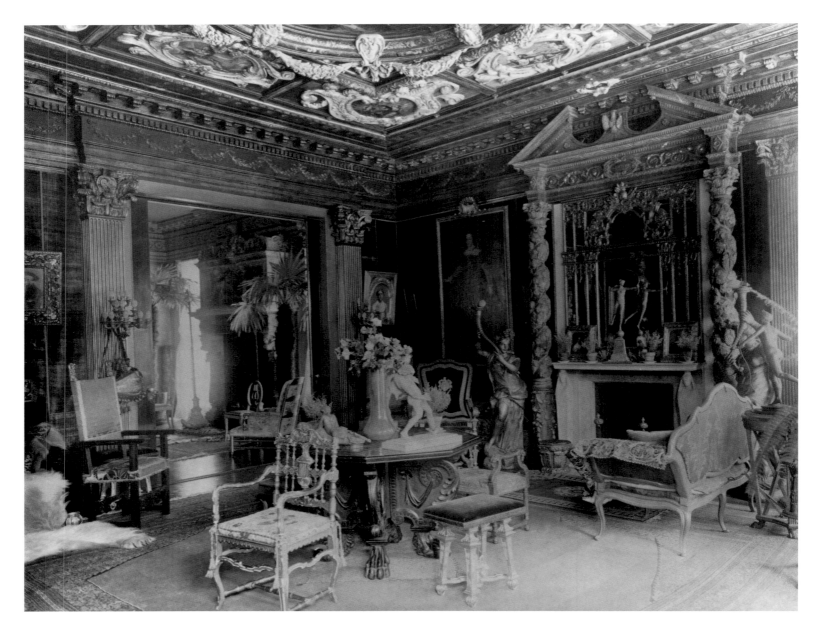

surrounds—was among the most valuable objects in White's collection.[41] White enhanced the decoration of the drawing room with architectural elements that complemented the ceiling, including a doorway that he used as an overmantel and surround, featuring Spanish twisted columns with grapevines, which he combined with a Venetian mirror and an Italian Renaissance entablature and broken pediment. All of these pieces were acquired and assembled without regard to period or geographic consistency, yet were integrated harmoniously, giving the room an Old World ambience (see fig. 22). White's collaboration with Saint-Gaudens is commemorated by a small 1899 version of Saint-Gaudens's colossal 1892 sculpture of Diana (which graced the top of the original Madison Square Garden), visible on the mantel of the drawing room. White's house represents a total work of art, with his collected objects playing an intrinsic role in producing the final effect.

Fig. 22
Drawing room of the Stanford White House, 121 East Twenty-first Street, New York, 1901; decorated by Stanford White.

In contrast to the opulent individuality of White's own house, other commissions from the office of McKim, Mead & White display a more restrained classicism, such as their restoration or refurbishing of several rooms in the White House for Theodore Roosevelt in 1902, including the State Dining Room and the Blue Room. During the nineteenth and early twentieth centuries, many of the most talented architects and decorators were called upon to assist with the decoration of the president's mansion in Washington, D.C.[42] By 1884, there were changes to the Red Room by several famous firms, including Herter Brothers furniture purchased during Ulysses Grant's administration, and woodwork, wall coverings, and lighting added by Tiffany and Associated Artists (see fig. 23) during Chester Arthur's residence in the White House. Each firm had contributed truly distinctive work that could be identified as its own particular style.

> The Red Room, used as a reception parlor by the ladies of the President's household, already had a home-like look, from the presence of a piano, a handsome embroidered fire-screen (a present from the Austrian commissioners at the Centennial Exhibition), and some small adornments; and in the recent general renovation of the Mansion, it has been given an imposing carved-wood mantel of thirteenth century style, set off with tiling of tortoise-shell glass. Some beautiful work has been done, besides, in the ceiling and in the walls, and the whole effect of carpet, furniture, and wall-tints is exceedingly rich and warm.[43]

In addition to the Red Room, President Arthur had commissioned Tiffany and his associates to renovate the Blue Room, the East Room, the State Dining Room, and the first-floor hall.

When Theodore Roosevelt was in office, he felt that all vestiges of Victorian decor should be replaced. Whereas the earlier treatment of the rooms featured complex arrangements of pattern, texture, and color—precisely the things to which an artist would be attentive—the newly designed rooms by McKim, Mead & White (see fig. 24) emphasized an architectural dignity. It was their design that dominated the interiors, and firms such as Marcotte & Co. and Herter Brothers acted merely as subcontractors carrying out their specifications. Marcotte supplied the tufted seating furniture and small white-and-gilt chairs, while Herter Brothers made the draperies.[44] Tiffany's magnificent carved and inlaid fire surround was replaced by one of neoclassical carved marble. The furnishings were subordinate to the architectural dignity of the room, which was determined by the more sedate mantel and moldings. McKim, Mead & White's work with Marcotte & Co. at the White House illustrates the enormous changes that had occurred in the approach taken by the architect/decorator since the 1880s.

At the turn of the century, the wave of classicism introduced by firms such as McKim, Mead & White spread. Beginning in the late 1890s, Ogden Codman,[45] the Boston-born decorator and architect, was one of the most influential figures in interior decorating. He lived and studied in France, and in 1882 returned to Boston, where he attended the Massachusetts Institute of Technology's School of Architecture for one year. In 1891, he opened a practice in Boston, and in 1893 moved to New York City and opened an office there. He was best known for his adaptations of French eighteenth-century styles, and his influence was widespread, especially after the publication of *The Decoration of Houses,* co-authored with Edith Wharton, in 1897. Codman integrated historical motifs into harmonious interiors with meticulous coordination of the decorations, textiles, and furnishings. He used his extensive library of books on architecture and design for inspiration, often adapting specific eighteenth-century rooms. His interiors were historically accurate in their interpretation of archi-

tectural elements, but nonetheless original decorative ensembles. Most of the fabrics, furniture, hardware, and other supplies that he used were imported from France.

At the time that *The Decoration of Houses* was published, Codman had recently decorated ten bedrooms of The Breakers, Cornelius Vanderbilt II's mansion in Newport, and was working on a commission for Mrs. Frederick Vanderbilt at the Vanderbilt Mansion in Hyde Park, overlooking the Hudson River in upstate New York. The mansion was designed by McKim, Mead & White, who were also responsible for the decoration of many of its interiors.[46] Codman's decorations for Louise Vanderbilt's bedroom and boudoir were remarkable for their elaborate design and choice of materials. Codman took great care in his design for her bedroom (see fig. 25), which

he planned so that the architectural elements were dominant. The symmetry of the space was maintained by the placement of the windows and doors opposite one another and balanced by the bed at one end facing the mantel at the other end. These features were central to the ideas put forth by Codman and Wharton.[47] They wrote that decoration must be brought back to being treated as "a branch of architecture."[48] Codman used the design of French State bedchambers as a model and separated the bed from the rest of the room with a curved railing. His work, while faithful to eighteenth-century proportion and design, was usually composed of reproduction furniture and decorations. He designed most of the seating furniture for Mrs. Vanderbilt, while the more elaborate case pieces were made by Parisian cabinet-maker Paul Sormani.

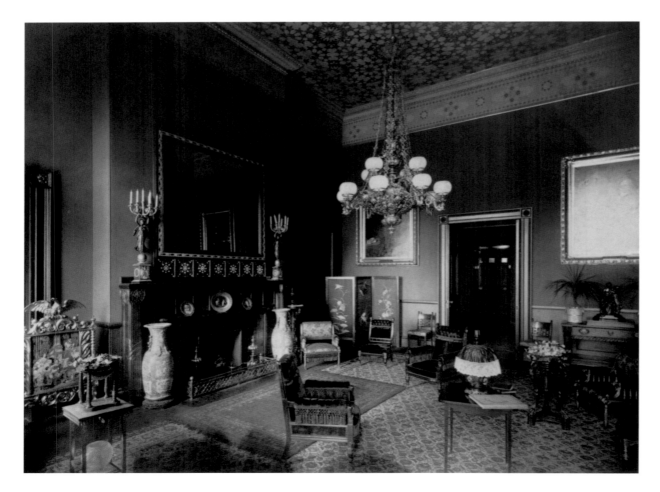

Fig. 23
The Red Room in the White House, Washington, D.C., c. 1890, featuring Herter Brothers furniture (added when Grant was president in the 1870s) and woodwork, wall coverings, and lighting by Tiffany (added when Arthur was president in the 1880s).

The sketches, working drawings, and highly finished presentation elevations done in watercolor clearly show Codman's working method and the order in which he felt particular features had to be designed.[49] The layout and floor plan (see fig. 26) came first, and during this phase imperfections and other problems were addressed. For example, Codman moved the door between Mr. and Mrs. Vanderbilt's bedrooms slightly to line up with the window opposite, and added a false door in the northwestern corner to provide a symmetrical arrangement with the windows on the eastern wall.[50] Next, Codman planned the proportions of the base, dado, wall panels, and cornice. Following that, he added elements of the ornamentation, including the paneling on the doors and the scrolls of the panel surrounds, then put in more ornamen-

tal details and the locations of decorative paintings. Finally, the furniture and accessories were added.

Elsie de Wolfe presents the final stage in the evolution of the design of interiors: the professional decorator. De Wolfe came to the business from a background in theater, where she was renowned for her sense of style.[51] Social connections provided her with entrée into the world of high-style interior decoration, and Stanford White gave de Wolfe her first big commission—to decorate the interiors of the Colony Club in Manhattan, for which he was the architect. De Wolfe treated interior decoration as a branch of fashion, applying her superb sense of fabric, color, design, and accessorizing. She also capitalized on the publicity that could be generated by writing about her own house, much the same way that her theatrical notices often detailed her

Fig. 24
The Red Room in the White House, Washington, D.C., c. 1904, redesigned by McKim, Mead & White.

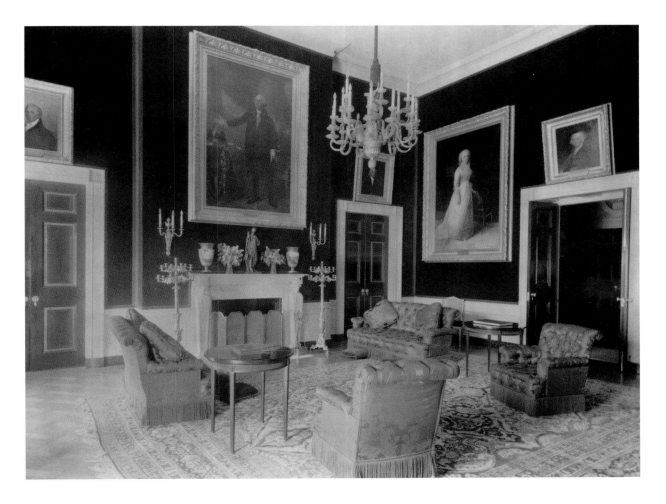

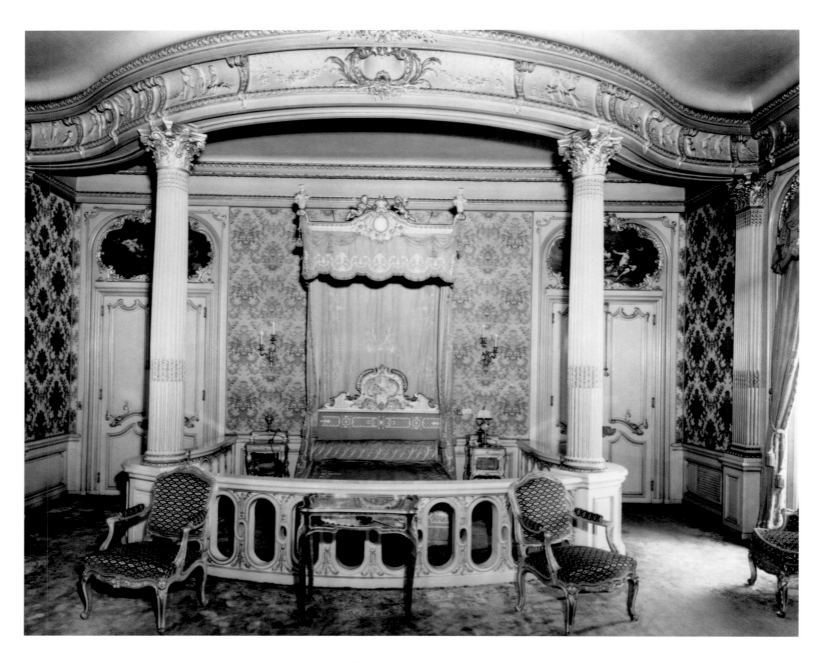

magnificent wardrobe. Like Codman, de Wolfe wrote a book on decorating, *The House in Good Taste*.[52] It was first issued as a series of articles in the *Delineator* in 1911, and then expanded into a book in 1913.[53] Unlike Codman, whose book was intended for the very wealthy, de Wolfe sought a much wider audience. She did not try to do the work of the architect and believed that a good architect would give "inspiration for the interior. He will concern himself with the moldings, the light openings, the door handles and hinges, the unconsidered things that make or mar your house."[54] She advocated simplicity, suitability, and proportion as the guidelines for the decoration of interiors. "Suitability" encompassed the function of the room and the needs of its owner. "Proportion" governed the relationship of the furniture to the space. "Simplicity" implied the clearing out of Victorian clutter and

Fig. 25
Louise Vanderbilt's bedroom in the Vanderbilt Mansion in Hyde Park, New York, designed and decorated by Ogden Codman in 1897–98; McKim, Mead & White, architects.

the importance of cleanliness and light.[55] To illustrate these ideas in her book, de Wolfe included photographs of her own bedroom in the house at 123 East Fifty-fifth Street (see fig. 27), known as "the house of many mirrors." The decor of this room shows many of her preferences, including an open fireplace, a mirror above the mantel, chintz bed hangings and upholstery, and a mixture of genuine eighteenth-century furniture, reproductions, and modern upholstered chairs. The French bed is the focal point of the room, and the rest of the room is furnished in harmony with it. The room is well lit by sconces and table lamps. Everything is provided for comfort.

By 1910, when Tiffany published a short article called the "Gospel of Good Taste," his philosophy and aesthetics had developed in numerous directions. He was best known for his magnificent glass, as he is today, although by that time his work in interior decoration had become not much different

Fig. 26
Ogden Codman's floor plan for Louise Vanderbilt's bedroom in the Vanderbilt Mansion in Hyde Park, New York, 1897.

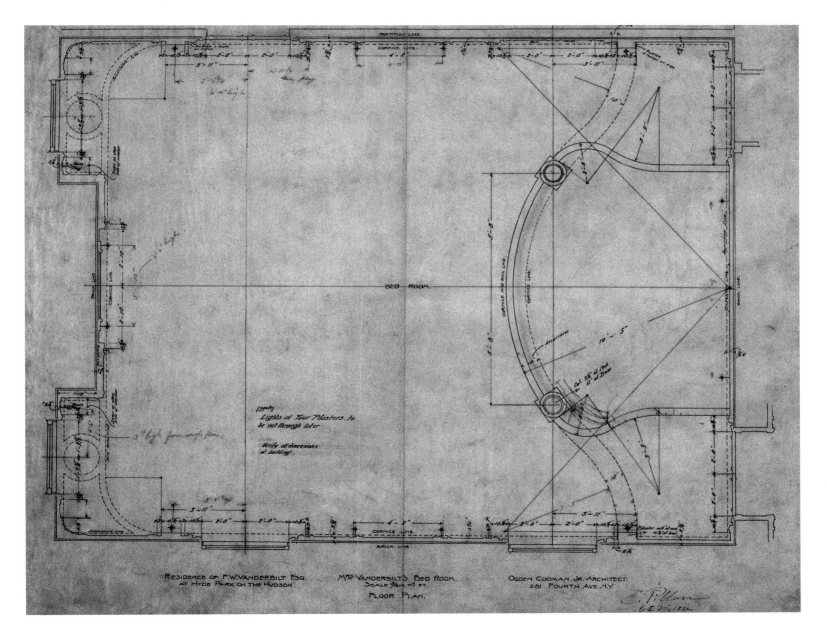

from de Wolfe's. He wrote, "Beauty in the home has little or nothing to do with the amount of money spent; extravagance does not produce beauty; and many of our richest people, like some of our poor people, have not yet come to see the value of good taste. Simplicity, and not the amount of money spent, is the foundation of all really effective decoration. In fact, money is frequently an absolute bar to good taste, or it leads to show and over-elaboration."[56] Like Codman and de Wolfe, part of Tiffany's success as a businessman depended on the publication of articles and brochures that exposed the work of his firm to a wider audience. Tiffany's business was moving after the turn of the century from one that was exclusively high-style to one that was within the broader reach of the upper middle class.

A library furnished by Tiffany (see fig. 28), shown in the Tiffany Studios brochure *Character and Individuality in Decorations and Furnishings* (1913), exhibits many of the same principles advocated by de Wolfe. The room is simply furnished with comfortable-looking chairs upholstered in chintz, with the same material used for the

Fig. 27
Bedroom of the Elsie de Wolfe House, 123 East Fifty-fifth Street, New York, 1910–11, showing some of her design preferences, including an open fireplace, a mirror above the mantel, chintz bed hangings and upholstery, and a mix of period and modern furniture.

Fig. 28
A library furnished by
Tiffany Studios, c. 1913,
shown in the Tiffany Studios
brochure *Character and
Individuality in Decorations
and Furnishings* (1913).

draperies and for the throw pillows on the tufted sofa. The furniture is traditional and vaguely English in taste. There are sconces above each of the bookcases. An oriental rug covers the floor, and the walls appear to be a solid color. The entire ensemble is uncomplicated, with no eccentric furniture or decorations to produce a jarring note. It fulfills, as the brochure states, "the thought and dream of comfort and attractiveness." [57] Tiffany Studios aimed to provide complete decorating services, encompassing furniture, lighting, upholstery and textiles, rugs, woodwork, wrought iron, and "har-

monious decorations." However, unlike de Wolfe, Tiffany Studios made most of the pieces themselves, an approach that was closer to that of the cabinetmaker/decorator.

Just as the nineteenth century's cabinetmaker/decorators and artist/decorators had found the freedom to design interiors that were independent of the general style of the building's exterior, so did the decorators of the early twentieth century, motivated by good taste and comfort, assert a new autonomy.

Tiffany in Europe
The View from Abroad

Rüdiger Joppien

By 1893, the name Louis Comfort Tiffany was already familiar to many people in Europe. The presentation of his works at the World's Columbian Exposition in Chicago caused a sensation, especially the furnishings and decoration of his "Byzantine" chapel (see fig. 29). The colors and synesthetic design of the architecture and objects and their meticulous workmanship all won praise.

Two visitors from Germany who saw Tiffany's work at the fair, Wilhelm Bode and Julius Lessing, were extremely impressed. Both were directors of state museums in Berlin, Bode at the Gemäldegalerie (Picture Gallery), and Lessing at the Kunstgewerbemuseum (Museum of Decorative Arts). Lessing purchased a Tiffany stained-glass window (see fig. 30) and several of the lamps and glass vessels for his museum, making it the first European museum to own Tiffany glass.[1]

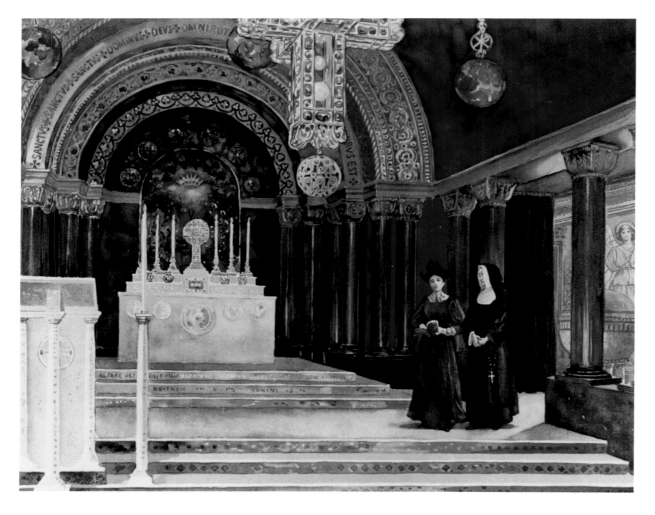

Fig. 29
Joseph Lauber, Tiffany's chapel at the World's Columbian Exposition, Chicago 1893, chromolithograph on woven paper, The Charles Hosmer Morse Museum of American Art, Winter Park, Florida.

Fig. 30
Louis C. Tiffany, stained-glass window with glass pebbles (detail), acquired during the time of the World's Columbian Exposition, Chicago, 1893, Kunstgewerbemuseum, Berlin.

A delegation from the Hamburg Chamber of Commerce was equally enthralled with Tiffany's work. Hans Christiansen, a painter, and Karl Engelbrecht, a glass artist, brought samples of Tiffany glass home with them; a few years later, Engelbrecht started importing American opalescent glass to Germany. Scandinavian and French critics, too, quickly recognized the modernity of Tiffany's handicraft.[2]

This fascination that Tiffany inspired as an artist coincided with Europeans' discovery of American applied arts. The presentation in Chicago demonstrated to them the birth of an American, functionalist modern movement. America had found its own style for utilitarian objects that was crisp and practical, and conveyed a sense of clarity and ease.[3] America's artistic self-discovery meant liberation from European historicism and its bankrupt stylistic models that only repeated the forms of the past, whereas American artists, Tiffany above all, aspired to create a new form of art that drew its inspiration from nature. Although Tiffany found many models in European art that served as important stimuli, they were more contemporary, oriented toward a new goal and style. His aim was to produce original works that would challenge the overwhelming preponderance of European imports (evident, for example, in thousands of stained-glass windows in the churches of the New World). With Louis C. Tiffany, creative America, for the first time, stepped self-assuredly onto the scene, initiating a process that has continued to the present day.[4]

Tiffany had traveled to Europe often. After his first trip, in 1865–66,[5] he returned to Paris in 1868 to study painting with Léon Bailly. In 1870, he traveled with a fellow painter, Robert Swain Gifford (1840–1905), through Europe and several countries in North Africa (Morocco, Algeria, Tunisia, and Egypt). On his trips to France, Tiffany discovered the stained-glass

Fig. 31
Louis C. Tiffany, *Market Day in Nuremberg*, 1897, oil on canvas.

windows of medieval cathedrals and drew inspiration from them for his own experiments in glass.[6] The only one of these trips to France that is known from records he kept is his last major journey, to Brittany in 1907, from which survives his diary[7] and the photographs that were taken during its course. At first, Tiffany's European travels were primarily for pleasure and the study of art, but on later trips he paid increasing attention to the presentation of his own works and to his business affairs, such as the purchase of European works of art for his New York gallery.[8] In the literature on Tiffany, it has remained largely overlooked that in 1894 Tiffany, together with Lockwood de Forest, visited the Royal Copenhagen Porcelain Manufactory, where he asked to be shown ceramic vessels in the latest colored glazes.[9] Other journeys undertaken by Tiffany can be inferred indirectly from related information. In the summer of 1897, Tiffany traveled to Paris for an exhibition at Bing's, and we believe that he also spent time in Munich.[10] The trip to Germany may have included a visit to Nuremberg, for in that same year he made a painting of a market in Nuremberg (see fig. 31).

For reasons both of art and of business, Tiffany must have been in England quite often. Tiffany & Co., the firm founded and owned by his father, Charles Lewis Tiffany, had a branch at 221 Regent Street in London, which also sold works made by Louis C. Tiffany's own company, the Tiffany Glass and Decorating Company.[11] Tiffany was clearly familiar with such new developments in English art and design as the Aesthetic Movement and the Arts and Crafts Movement surrounding William Morris (1834–96). Morris's idea of craft workshops, his insistence on

superb quality of workmanship, and his interest in folk aesthetics must all have appealed to Tiffany. One wonders if Tiffany, while visiting England, ever met Charles Robert Ashbee (1863–1942) or visited the Guild and School of Handicraft that Ashbee started in 1888; it is on record, however, that Ashbee visited Tiffany's workshops during a trip to New York in 1896.[12] Tiffany evidently knew Christopher Dresser (1834–1904), as Dresser had been entrusted with Tiffany & Co. business during his visit to Japan in 1876–77 (during his three-month stay there, Dresser bought Japanese works of applied art for Tiffany & Co., New York). Tiffany must have been familiar with Dresser's so-called Clutha glass from the late 1880s; it was worked directly at the furnace, without any finishing once the glass cooled, thus breaking with the usual practice of glass manufacture at the time.[13] This concurred with Tiffany's philosophy.

Fig. 32
Georges Lemmen, advertisement for Siegfried Bing's l'Art Nouveau gallery, Paris, c. 1898. At the bottom of the advertisement it says, "agent for L.-C. Tiffany for Europe."

His visit to the 1889 Paris World's Fair was a turning point in Tiffany's life. He showed a painting of his there, and saw his old colleague John La Farge—who had since become a rival—win a gold medal for his stained-glass windows,[14] while Tiffany's own entry went unrecognized. He also saw the latest work by French glassmaker Émile Gallé, which was one of the most praised exhibits at the fair and brought Gallé international renown. Tiffany went to visit Gallé's workshops in Nancy, but it is not known if he met Gallé in person there.[15] Nevertheless, the experience must have strengthened Tiffany's resolve to establish his own glass workshop, a goal that he achieved three years later. By 1893, at the World's Columbian Exposition in Chicago, Tiffany was dazzling everyone with stained-glass windows of matchless beauty.[16]

Visitors to the Chicago World Exposition acclaimed the richness and homogeneity of the display in his showrooms, in which masterpieces in a wide range of mediums were gathered together. These had been designed under Tiffany's direction and executed in his workshops; despite their occasionally eclectic composition, they suggested the idea of a *Gesamtkunstwerk*—a total work of art. Tiffany's stained-glass windows, mosaics, and, especially, his suspended electric lamps made a dramatic impact. Here, so it seemed, was an artist who had the skill and the resources to combine beauty of decoration and meticulous craftsmanship with the most modern techniques.

Although the Germans responded enthusiastically to Tiffany's presentation in Chicago, the French reacted with consternation to America's new ascendancy in the luxury trade. In early 1894, the French Government sent Paris art dealer Siegfried Bing, who was of German descent, to New York with the assignment of reporting on the state of American crafts.[17] During this trip, Bing visited Tiffany's workshops and arranged to take over the marketing of his glass in Europe (see fig. 32).[18]

The subsequent partnership between Tiffany

and Bing has frequently been examined.[19] It is noteworthy that Bing immediately recognized Tiffany's potential and purchased some of his works—including a stained-glass window (see fig. 33)—and then sold them to the Musée des Arts Décoratifs and the Musée du Luxembourg when he returned to Paris.[20]

Of course, Bing had noted not only the quality of the vases but also the innovative techniques that had been used in making the stained-glass windows. However, it would presumably have been a difficult task to sell American windows in Europe, owing to strong local competition; moreover, the choice of subjects and their interpretation in many Tiffany windows were not what one would call modern. Bing therefore proposed that a series of different compositions be designed by young French artists and executed in Tiffany's workshop. Bing asked eleven Paris artists, most of whom were members of the Nabis group, including Pierre Bonnard, Maurice Denis, Paul-Elie Ranson, Ker-Xavier Roussel, Paul Serusier, Henri de Toulouse-Lautrec, Felix Vallotton, and Edouard Vuillard.[21] Windows from their designs were made in the winter of 1894–95 in New York and exhibited in April 1895 in the Salon of the Société Nationale des Beaux-Arts in Paris; some of them, including Toulouse-Lautrec's *Au Nouveau Cirque: Papa Chrysanthème*, were transferred that December to Bing's newly founded l'Art Nouveau gallery (see figs. 34, 35, and 36). Apart from the earlier acquisitions by the museums in Berlin and Paris, the windows exhibited in Paris were among the first examples of American opalescent art glass in Europe;[22] they were the result of a transatlantic collaboration, the start of an artistic dialogue between Europe and the United States. Their impact was enormous, setting an entirely new direction for traditional stained-glass art in Europe.

Tiffany's opalescent leaded-glass windows revealed the hand of a painter who was not painting on glass, as was still usual in Europe, but with glass, conjuring from the medium a remarkable variety of

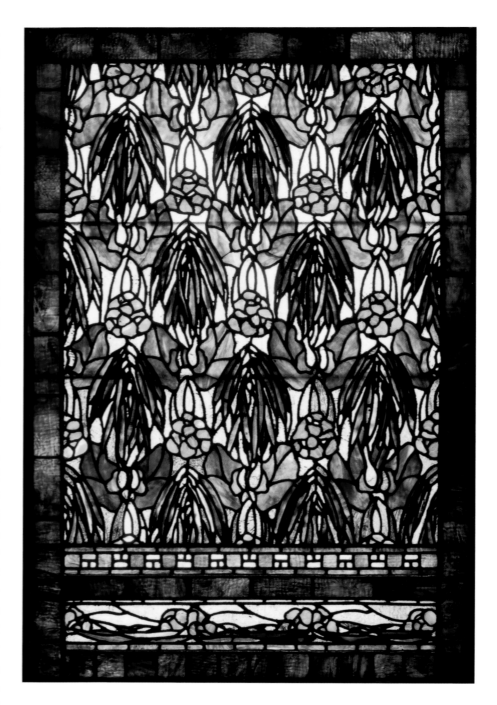

Fig. 33
Louis Comfort Tiffany,
stained-glass window,
c. 1894, Musée des Arts
Décoratifs, Paris.

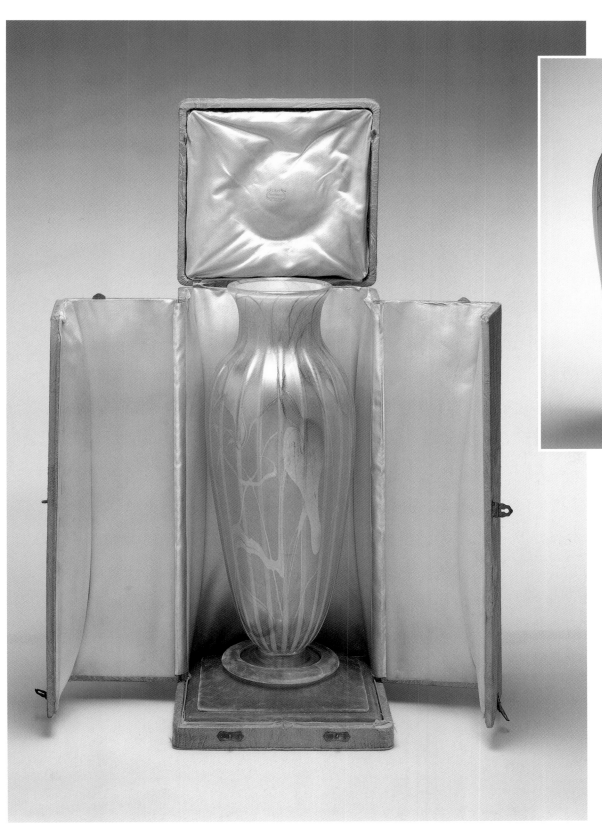

Cat. 13
Vase in Presentation Box
c.1896
Vase: glass; box: fabric over board
Marks: vase etched *F 711 L.C.T.*;
paper label monogram *TGDCO
Registered Trademark Tiffany
Favrile Glass*; inside box lid
stamped *L'Art Nouveau Paris*
Vase: 17 x 6 x 6 in.
Box: 19 in. x 8¾ in. x 8¾ in.
Courtesy of Lillian Nassau Ltd.,
New York

This is a rare surviving example of
the luxurious packaging that gave
Tiffany vases sold by Siegfried Bing
in his Paris gallery L'Art Nouveau
the status of rare and precious
objects. The satin-lined box opens
like a reliquary to reveal the vase:
iridescent white and gold, tall and
fluted, with the majesty of a
classical column. A rarefied piece
such as this may remind us of the
mysterious, flawed vessel in Henry
James's *The Golden Bowl* (1904).

color nuances and refracted light.[23] Tiffany's handling of glass, striating it with color, pinching and fluting the surface, layering and laminating it, demonstrated hitherto-unknown possibilities of manipulating the material. Munich glass artist Karl Ule was one of the first to champion American glass to the German public, praising the Americans' "freshness of invention and practical sense."[24] Karl Engelbrecht from Hamburg also used opalescent glass, which he began importing in 1896, in order to execute designs for windows by himself and by Hans Christiansen.[25]

The success of this first presentation of his works in Paris encouraged Tiffany to send items to the Salon exhibitions there in the following years, thus bringing his latest developments regularly before the European public. Tiffany's glass vessels were the pieces that aroused the most interest abroad. In contrast to the market for his works in the United States, where his glass vessels were only just beginning to be collected in the 1890s and were still less popular than his glass windows and mosaics, their fame and prominence spread rapidly throughout Europe,

Fig. 34
Henri de Toulouse-Lautrec, *Au Nouveau Cirque: La Clownesse et les cinq plastrons,* watercolor, 1891, Philadelphia Museum of Art.

Fig. 35
Louis Comfort Tiffany, after *Au Nouveau Cirque: Papa Chrysanthème,* stained-glass window, 1894–95, Musée d'Orsay, Paris, don Henry Dauberville au nom de ses enfants Béatrice et Guy-Patrice.

Fig. 36
Façade at 19 rue Chauchat, Paris, 1895, Institut français d'architecture, fonds Louis Bonnier. The illustration shows Tiffany's window *Papa Chrysanthème* above the entrance to Bing's L'Art Nouveau gallery.

especially in France, Britain, Scandinavia, and the German-speaking countries. The brand name "Favrile Glass" became a household word.[26]

When Bing opened the l'Art Nouveau gallery just after Christmas in 1895, at 22, rue de Provence (at the corner of rue Chauchat), he was able to offer a wide range of the latest glass designs (see cat. 13). Justus Brinckmann, director of the Museum für Kunst und Gewerbe in Hamburg, was one of the first buyers, as was Jens This, the young director of the Nordenfjeldske Kunstindustrimuseum in Trondheim, Norway.

The breakthrough in Tiffany's acceptance in Europe was due largely to the success in the German and Austro-Hungarian markets, beginning with the 1897 International Art Exhibition in Dresden, where Bing showed five rooms, four of which had been designed by Henry van de Velde.[27] These were decorated as model rooms, which, in addition to featuring van de Velde's furniture, contained painted wall friezes, paneling, wallpaper, paintings, sculpture, ceramics, and glass. Bing exhibited paintings by artists such as Albert Besnard and Fritz Thaulow, ceramics by Alexandre Bigot and by Dalpayrat and Lesbros, bronzes by Constantin Meunier, glassware by Émile Gallé, and lamps and vases by Tiffany,[28] as well as a stained-glass window designed by Paul-Elie Ranson and executed by Tiffany, which had already been shown in 1895 at the Salon of the Société Nationale des Beaux-Arts in Paris.[29] The reviews of the exhibition were all positive and bestowed special praise on Tiffany. Wilhelm Bode, who was an admirer of American art, had already spread the good word about Tiffany from Chicago in 1893, calling him "a genius"[30] and especially singling out his new peacock-feather glassware. In the

"mastery and exploitation of the method, in the fertile inventiveness in treatment of the design and in the painterly effect," Bode wrote, his works surpassed all others in the new style, and thus served as a "yardstick" of the possible.[31]

That same year, Bing organized some other exhibitions of Tiffany glass. After showing a choice collection at Brinckmann's museum in Bing's native city of Hamburg in 1897, he took a travelling exhibition to Reichenberg (Liberec), Vienna, and Budapest within the Habsburg Empire. The exhibition at the Österreichisches Museum für Kunst und Industrie (Austrian Museum of Art and Industry) in Vienna opened in the autumn of 1897. To spur public interest there, Bing wrote an essay for *Kunst und Kunsthandwerk*, a publication issued by that museum, in which he expounded on Tiffany's development as a glass artist; owing to delays, however, this was not published until March 1898.[32] Implicit in Bing's offer to mount a Tiffany exhibition at a particular museum was the idea that the museum purchase Tiffany works for its collection. This was how, in 1898, he sold seven pieces of glass to the museum in Vienna; in the spring of 1898, the Budapest Museum of Decorative Art received the exhibition and likewise acquired several examples for its permanent collection.[33]

What appealed to visitors most of all were Tiffany's iridescent decoration and luster effects, with their shimmering, ecstatic colors and their corroded surfaces reminiscent of excavated finds from antiquity and of natural phenomena such as insects' wings. Tiffany had enriched with many new effects the already familiar process of inducing iridescence in glass by the vaporization of metal oxides; he even began decorating isolated parts of the glass surface with iridescence. The glass historian, Gustav Pazaurek, director of the North Bohemian Museum of Art and Industry at Reichenberg, though at an early stage attracted by Tiffany glass, soon issued a warning against the over-exploitation of its coloristic effects, but the

popularity of Tiffany glass in general seemed unshaken.[34] In 1899, *Dekorative Kunst* reported that "American glass was being produced in thousands of workshops in Europe."[35]

Germany proved especially receptive to the new material; soon opalescent glass was being imitated and produced by Bohemian glass manufacturers such as Loetz Witwe and Pallme & König, which began to put glassware similar to Tiffany's on the market. The exhibitions in Reichenberg, Vienna, and Budapest stimulated not only huge public demand but also chemical experimentation in local glassworks. In articles about European and especially Bohemian glass between 1898 and 1900, art critics often mentioned imitations or "Tiffany style" glass.[36] Today, art historians are less dismissive of such developments, and tend to refer to them as similar experiments along different paths. Nevertheless, the technique of induced iridescence in Bohemian glass became so prevalent that Pazaurek felt impelled to declare Tiffany "accountable" for the outbreak.[37] In any case, Pazaurek preferred Gallé's stylistic orientation in glass, because decoration made on cold glass was more in accord with the Bohemian glass tradition, whereas Tiffany's approach was regarded as being more in the Venetian manner.

Siegfried Bing had originally made a name for himself as a connoisseur of Japanese art before becoming involved with contemporary European art in the mid-1890s. His l'Art Nouveau gallery was one of the best addresses in Paris, and a visit to this gallery was de rigueur for anyone involved in the museum world, if only to see the open display of the works (see fig. 37). Besides the gallery, Bing owned workshops for the applied arts and acted as a distributor of utilitarian objects designed by his house artists Edouard Colonna, Georges De Feure, and Eugène Gaillard. Bing's son Marcel headed the goldsmith's workshop, where he and Colonna occasionally made mounts for, among many other objects, Tiffany glass (see fig. 38).

Fig. 37
A corner in a room of Bing's
gallery, with an armchair by
Henry van de Velde (1895)
and a table lamp by Louis
C. Tiffany (c. 1898).

In Julius Meier-Graefe Bing possessed an able promoter of his ideas and a source of inspiration. For about six months Meier-Graefe acted as his business manager at the l'Art Nouveau gallery, before he set up the art magazine *Dekorative Kunst* in October 1897. In 1899, Meier-Graefe opened a similar, rival business enterprise in Paris, *La Maison Moderne*. He was also an early admirer of Tiffany and wrote many articles about his glass; he later sold Tiffany glass in his own gallery.[38] In an 1896 essay, he pointed out the contrasting aspects and techniques of Gallé and Tiffany and declared the two men to be manifestations of national schools;

he compared Gallé's symbolism and profuse manner of decoration—"all is blown and polished in a kind of religious ecstasy"—to Tiffany's "feeling for free beauty" and "richness of color."[39] Meier-Graefe liked to see the aura of an object and its special decorative quality spring from the properties and conditions determined by the material. Bing likewise stressed the importance of the hot glass process and wrote about Tiffany's method of working: "the means employed for the purpose of ornamentation, even the richest and most complicated, are sought and found in the vitreous substance itself, without the use of either brush,

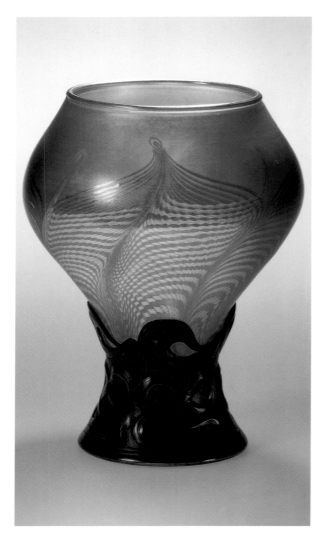

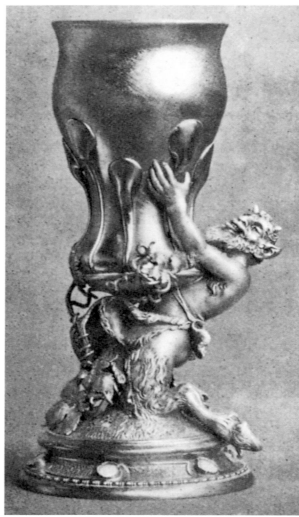

wheel, or acid. When cool, the article is finished."[40]

Bing's art-dealing contacts enabled him to place a great quantity of Tiffany glassware in European museums between 1894 and 1901: in France this was the Musée du Luxembourg, the Musée Galliera, the Musée des Arts Décoratifs, and the Musée des Arts et Métiers in Paris; the Musée National de Céramique in Sèvres; and the Musée Adrien Dubouché in Limoges. Beyond France Tiffany's—or Bing's—customers also included the Musée d'Art et d'Histoire in Brussels, the Kunstgewerbemuseum in Zurich, the Kunstindustriemuseum in Copenhagen, the museums of Bergen, Oslo, and Trondheim in Norway, and the Stieglitz-

Museum in Saint Petersburg. However, the greatest concentration of collections of Tiffany glass was in Germany and Austria-Hungary; these were acquired either directly from Bing or from galleries associated with Bing. In Austria-Hungary, works by Tiffany were purchased not just by the museums of applied arts in Budapest and Vienna, but also by museums in Brünn (Brno) and Reichenberg; in Germany, Tiffany pieces entered the collections of museums in Berlin, Darmstadt, Dresden, Frankfurt, Hamburg, Hanover, Karlsruhe, Krefeld, Leipzig, Nuremberg, Munich, and Stuttgart.[41]

Bing also supplied a number of glass galleries with Tiffany glass. His works were available in sev-

eral German cities: in Berlin at the Hohenzollern-Kunstgewerbehaus and at Keller & Reiner, in Dresden at Arnold and at Richter, and in Munich at Littauer; they could also be found in smaller cities such as Nuremberg. These galleries worked in cooperation with Bing, and frequently displayed objects of modern applied art from France, Japan, and the United States in exclusive presentations.[42] In Berlin, the Hohenzollern-Kunstgewerbehaus even offered Tiffany glass in exuberantly historicist mounts (by court goldsmith Hugo Schaper), no doubt to emphasize the exceptional value of the glass vessels (see fig. 39).[43]

From May to July 1899 Bing presented a major exhibition at the Grafton Galleries, London, with Tiffany as the central focus (see fig. 40). Tiffany was not unknown in England; a two-part article in the August 1897 and June 1898 issues of *The Studio* had discussed his work in glass.[44] Already in 1896

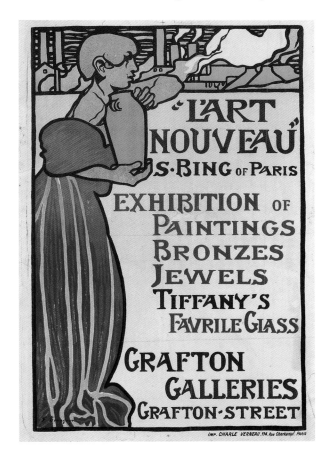

Fig. 40
Frank Brangwyn, poster for the exhibition L'Art Nouveau S. Bing, Grafton Galleries, London, 1899, Museum für Kunst und Gewerbe, Hamburg.

the South Kensington Museum (today the Victoria and Albert Museum) had bought seven pieces from Tiffany & Co. in Regent Street for its own collection, plus several others that were transferred to museums in Dublin, Edinburgh, and Melbourne. Nevertheless, the English market as a whole had yet to be conquered. London was far less under the spell of Paris than Germany and Scandinavia were. England had its own reform movement in the arts and had already assimilated many influences from Japanese art. In addition, English glassworks were among the most productive of the age, along with those in Bohemia.

The London exhibition must have cost Bing enormous effort, as he was already working feverishly on plans for his Pavilion at the World's Fair to be held in Paris in 1900. Thus one may wonder if it was really Bing's own idea to send such a comprehensive show to London—including sculptures by Constantin Meunier and jewelry by Edouard Colonna, as well as paintings and miniatures—and even to produce a catalogue to accompany it.[45] May we not suppose that the exhibition was initiated by Tiffany himself, who needed Bing's collaboration as his European agent?

Bing's essay in the catalogue, a slightly modified version of text first published in *Kunst und Kunsthandwerk* in March 1898, praised Tiffany's return to plain forms and his affinity for antique, medieval, and Venetian models.[46] Bing asserted that Tiffany gave back to glass art its tradition, bringing the elegant tranquility of semi-opaque tones and the gentle, silky matte surfaces to their full eloquence. His vessels were sensuously pleasing to the touch and had wonderful definition in the vitreous mass. Bing dismissed the argument that was often brought against Tiffany—that his glass negated transparency, the main attribute of the medium.

The Studio used the Grafton Galleries exhibition as an occasion to report afresh and more extensively on Tiffany. Horace Townsend, in his article in the June 1899 issue, commented that Tiffany

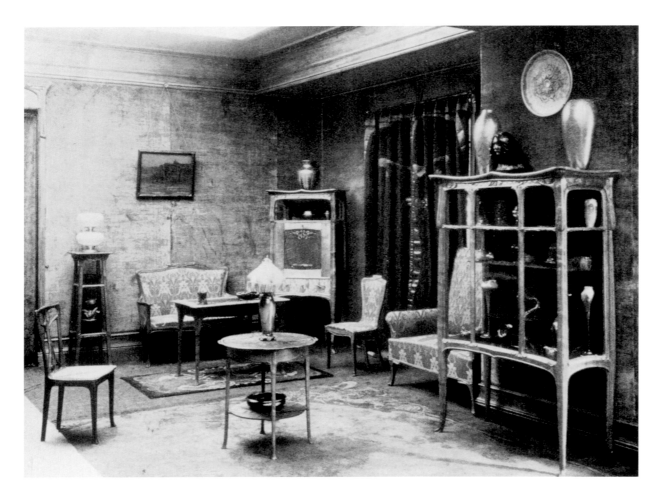

had stripped his storerooms in order to present himself in England with outstanding works.[47] Townsend's article is notable in that it made no mention of Meunier's sculpture, a by-no-means unimportant part of the exhibition, and only touched upon Colonna's jewelry in the last paragraph (there were eleven illustrations of Tiffany's works, but only two of Colonna's). One would be forgiven for surmising that Tiffany, or the London branch of his father's firm, might have "briefed" the magazine. Getting reviewed in *The Studio*, one of the most widely read art magazines of the period, was in every respect desirable. In this way, Tiffany's works, to quote Townsend, attracted "the attention of European connoisseurs."[48] Thus Tiffany's marketing strategy and Bing's high-powered gallery work complemented one another in an ideal fashion.

Tiffany reached the peak of his fame in Europe at the Paris World's Fair in 1900. Here he was represented in three locations: in Bing's pavilion (see fig. 41), at his own display in the American Pavilion (see fig. 42), and at Tiffany & Co.'s stand, where several pieces of glassware were presented mounted in silver. Besides numerous glass vessels, Tiffany showed several stained-glass windows (among them The Four Seasons, a work that received great acclaim), table lamps (including an early example of the famous Pond Lily lamp, see fig. 43), and samples of his latest experiments in enamel work. Many of his products received Grands Prix, and Tiffany himself was awarded the légion d'honneur. His glass offered an alternative to that of Gallé and, as such, was particularly noted by the German art reviews.

Walter Gensel, a critic writing for *Deutsche Kunst und Dekoration,* devoted a whole essay to the Tiffany glass presented at the Paris World's Fair. He praised their outstanding beauty, the "depth and glow of color," the polychromatic layers of molten glass with as many as twelve colors, and the irregularities and random patterns.[49] The concept of abstract art had not yet been defined, but in these descriptions of Tiffany's glass it was within reach.

Despite their high prices, many pieces found their way once again into European collections, this time acquired not only from Bing but also directly from Tiffany. However, one must not conclude that Tiffany's works were purchased only by museums; they were bought by private collectors as well. This is verifiable in at least one instance: the private acquisition of a set of salt cellars by Tiffany (with spoons by Colonna) in a specially made case, which had been exhibited at Bing's pavilion (see fig. 44). There were undoubtedly many other private transactions.

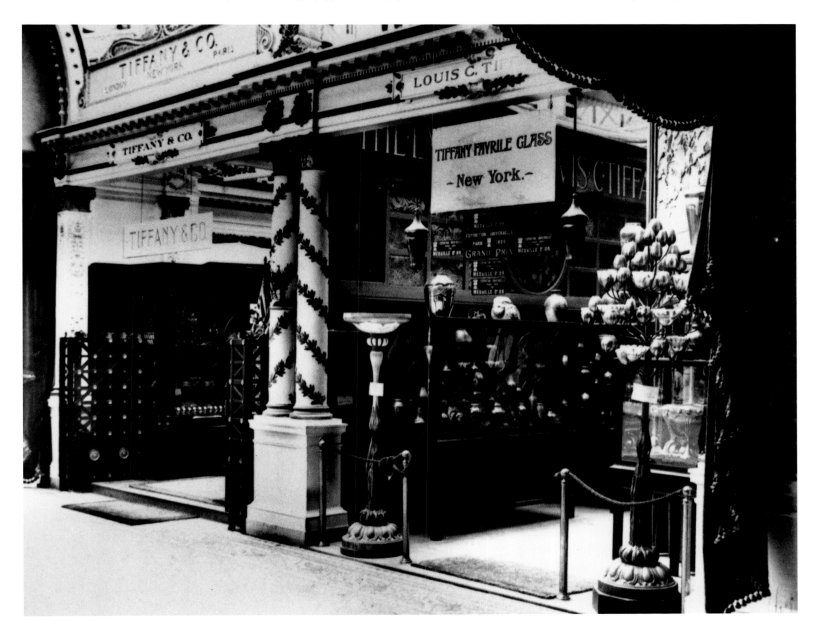

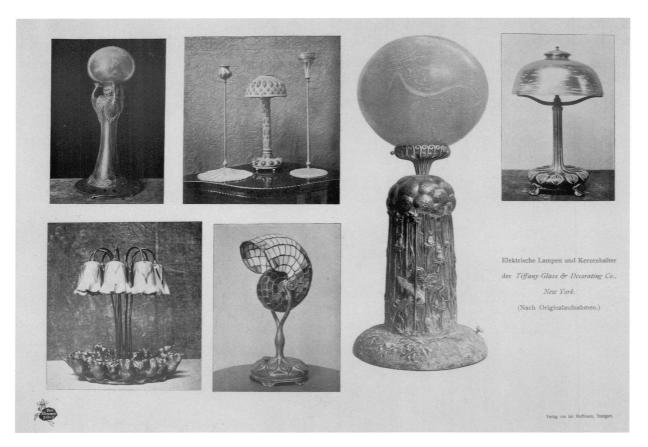

Elektrische Lampen und Kerzenhalter
der *Tiffany Glass & Decorating Co.,*
New York.
(Nach Originalaufnahmen.)

Verlag von Jul. Hoffmann, Stuttgart.

Fig. 43
Louis. Comfort Tiffany, table lamps, exhibited at the Paris World's Fair, 1900.

The Paris World's Fair seems to have marked a cooling of business relations between Bing and Tiffany, and their partnership more or less came to an end soon after. Two years later, at the International Exhibition of Decorative Arts in Turin in 1902, Tiffany presented his works in the American Pavilion without Bing's help. Again he showed windows, a wide range of table lamps, and enamel- and metal-work, as well as selected examples of his new type of glass vessels.[50] Bing also exhibited in Turin, though only products from his house workshops. In the years that followed, Tiffany remained true to Paris—the city to which he owed his fame in Europe—by continuing to take part every year in the Salon. On June 28, 1907, two years after Bing's death, he gave to the Musée des Arts Décoratifs a handsome collection of some of his most important glassware, desirous no doubt of being appropriately represented. The donation took place at a

time in Europe when Art Nouveau was already on the wane. As far as we know, no more noteworthy purchases of Tiffany's works were undertaken by European museums after 1900.

Thus, it is apparent that Europeans' perception of Tiffany's achievements changed during a period of about ten years, from the World's Columbian Exposition in Chicago in 1893 to the International Exhibition of Decorative Arts in Turin in 1902. By the turn of the century, as much as Tiffany's stained-glass windows were admired for their technical proficiency, their subject matter was not always approved of. *Dekorative Kunst* referred to them in 1898 as "religious decorations" done in a "watered-down Byzantine" style.[51] It is true that Tiffany's windows showing biblical subjects were particularly bound to traditional forms; nevertheless, there was an overwhelmingly positive response to their nuanced colors and painterly effects, which entirely

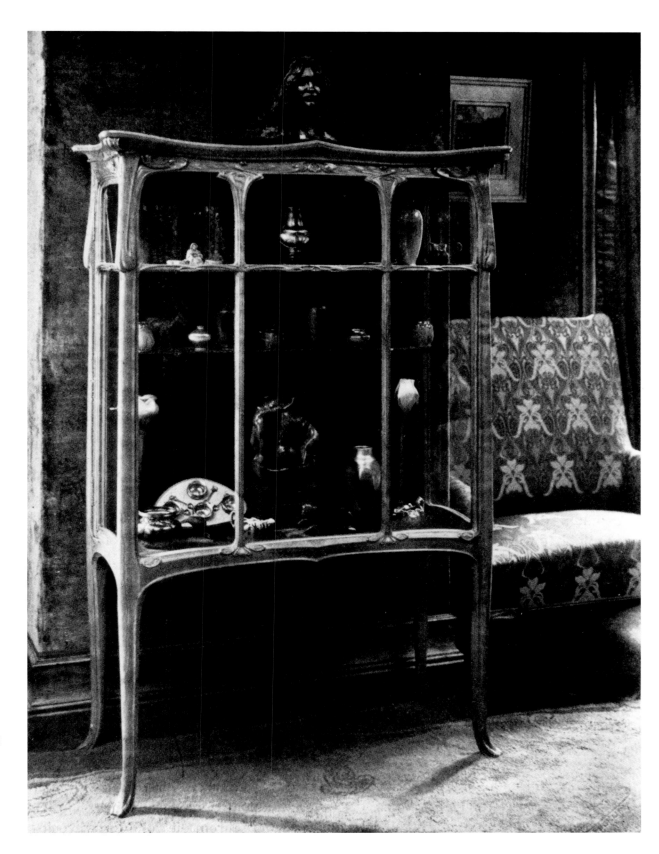

Fig. 44
Edouard Colonna, showcase from the drawing room at the Bing Pavilion, Paris World's Fair, 1900. Inside, at the bottom left, is a silk-lined case containing salt cellars and spoons that are now in a private collection.

transcended the usual reliance on the flat pattern of the lead-lines.[52]

Tiffany's lamps likewise attracted much interest beginning in 1893. Table lamps with blown-glass shades were frequently presented by Bing (1896) and at special exhibitions in Dresden (1897) and London (1899), as well as in Paris (1900) and Turin (1902). There was no lack of response from the art critics,[53] but very few of these pieces were collected by European museums—possibly as few as three.[54] As objects of industrial handicraft, they presumably did not correspond to the classic decorative-arts categories, and the Favrile glass used in the shades was indeed similar to that of the vases (see cat. 14). When Tiffany finally introduced table lamps with leaded-glass shades onto the market around 1898 or '99 and exhibited them at the London Grafton Galleries in 1899 and the Paris World's Fair in 1900, his innovative lighting design, particularly for electric use, does not seem to have been understood or appreciated. Perhaps the aesthetic concept of the utilitarian object had already moved so far toward function and sobriety that Tiffany's naturalistic motifs—the flowers and insects populating his lamp shades—were felt to be too decorative and cloying.

The works that garnered the most positive response were Tiffany's glass vessels. A few years after the Berlin and Paris museums had acquired examples of these at the early date of 1893 to 1895, they were available everywhere on the European market. Bing played the most important role in this phenomenon, as described above. Admittedly, Cecilia Waern's report in *The Studio* and her description of the Tiffany Glass and Decorating Company workshops helped establish Tiffany's reputation in Europe, but it was primarily Bing's marketing that paved the way for Tiffany's recognition. Another significant role was played by Julius Meier-Graefe, who was a great admirer of Tiffany's art in glass, particularly his cabinet-pieces, and often discussed these works in his magazines *Dekorative Kunst* and *L'Art Décoratif*. To quote one

example, "Where Tiffany is completely free and beyond all criticism is in his vases."[55]

Disappearing in Europe as swiftly as it arose there, the Tiffany phenomenon began receding after 1900 and faded noticeably after 1902. Gottfried Heinersdorff, co-owner of the Berlin-Rixdorf glass and mosaic factory of Puhl & Wagner, criticized the vogue for the American opalescent glass just before World War I;[56] as late as 1925 Pazaurek, in his publication *Kunstgläser der Gegenwart* (Contemporary Art Glass), accused Tiffany once again of angling for effects.[57] Tiffany's glass did not recover from these and other unfavorable judgments in Europe for many years afterward.

In 1903, when Tiffany published the company brochure *Tiffany Favrile Glass for Table Use,* he was at the zenith of his fame in the United States. He stated in the brochure that more than thirty European museums owned his works, almost all of them cabinet-pieces, and that he was represented in several museums in the United States, as well as in Tokyo and Melbourne. At that time, his reputation and business in the United States were barely affected by the growing tendency of Europeans to shun Art Nouveau and extravagant decoration that extended to his work too; indeed, the recognition accorded to him by Europe in the past helped him build and expand the American market. For all the flattery of Europe's acclaim, his true aim had always been to conquer the American market, to free his own country from manufactured products imported from Europe. His confidence about this was equal to that of President Theodore Roosevelt (1901–09) when he proclaimed that of all the peoples of the globe, the American people held in their hands the fate of the years to come.[58] Bing, too, was convinced that the United States was about to cast off the artistic predominance of Europe. He articulated these ideas for the last time in 1903, in an essay on Art Nouveau: "I firmly believe that America, more than any other nation, is predestined to lead the art of the future to a golden age of achievement."[59]

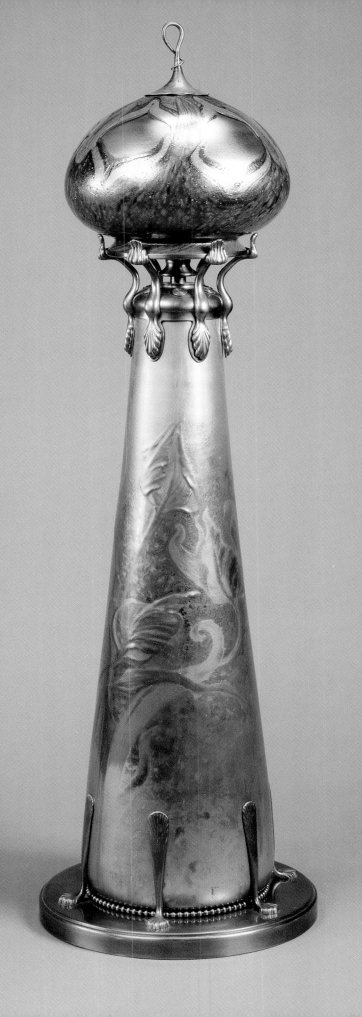

NOTES

1. Wilhelm Bode, "Von der Weltausstellung in Chicago," in Wilhelm Bode, *Kunst und Kunstgewerbe am Ende des 19. Jahrhunderts* (Berlin, 1901), 1–51; Julius Lessing, "Kunstgewerbe," in *Sonderdruck aus dem Amtlichen Bericht über die Weltausstellung in Chicago 1893* (Berlin, 1894), 40–42. Among Lessing's purchases were several ceiling lamps and wall lamps by Tiffany; see Julius Lessing, "Electrische Beleuchtungskörper," *Westermanns Illustrierte Deutsche Monatshefte* 77 (October 1894): 96–108. From 1893 onward objects of American industrial handicrafts were permanently offered in Berlin for many years, see *Deutsche Kunst und Dekoration* 15 (October 1904–March 1905): 172.

2. F. Hendriksen, *Tidskrift for Kunstindustrie* (1894), 190–208, esp. 201–03. A French critic, André Bouilhet, also wrote favorably on Tiffany's exhibits in *Revue des Arts Décoratifs* 19 (1893–94), esp. 72–77.

3. Wilhelm Bode, "Moderne Kunst in den Vereinigten Staaten von Amerika, [Part 2:] Architektur und Kunsthandwerk," *Kunstgewerbeblatt* [New Series] 5 (1894): 113–21, 137–46; Julius Lessing, "Kleine Mitteilungen" (about the American house), *Kunstgewerbeblatt* 5 (1894): 109–10; Julius Lessing, "Neue Wege," *Kunstgewerbeblatt* 6 (1895): 1–5.

4. Tiffany, in his article "American Art Supreme in Coloured Glass" in *Forum*, (July 15, 1893): 621–28, expressed confidence in the future of American glass art. How quickly he realized the goal of exercising an influence on European art is the subject of an essay by Herwin Schaefer, "Tiffany's Fame in Europe," in the *The Art Bulletin* 44 (December 1962): 309–28. On the same subject, see Rüdiger Joppien, "Tiffany und Europa," in *Louis C. Tiffany: Meisterwerke des amerikanischen Jugendstils*, exh. cat., Museum für Kunst und Gewerbe Hamburg (Cologne: Dumont, 1999), 22–29.

5. Tiffany's first trip to Europe took place from October 1865 to March 1866, with an itinerary that included London, Paris, Nice, Rome, and Palermo.

6. In the catalogue that accompanied his 1899 exhibition at London's Grafton Galleries, Tiffany described one of his stained-glass windows as being "in the style of a Chartres window of the Twelfth Century"; *Exhibition of L'Art Nouveau, S. Bing, Paris*, exh. cat. (London, Grafton Galleries: 1899), 21. For some of the places that Tiffany visited in France, and the dates of those visits, see Michael John Burlingham, "Wege eines Künstlers," in *Louis C. Tiffany: Meisterwerke* (see n. 4, above), 35, n. 8.

7. *Louis C. Tiffany: Meisterwerke*, 34.

8. Burlingham quotes from an undated letter written by Tiffany in Paris to his family at home, telling of purchases of artworks for reselling; ibid, 33. Tiffany also introduced works by French studio potters to New York, and used some of them for his own works, such as two ceramic pieces (one by Clément Massier and the other by Adrien-Pierre Dalpayrat) that he turned into lamps; see ibid, 86, 87. Note that the Dalpayrat ceramic was exhibited in Bing's pavilion at the Paris World's Fair in 1900, which is probably where Tiffany purchased it; *see Deutsche Kunst und Dekoration* 6 (April 1900–September 1900): 556.

9. Merete Bodelsen, "Sèvres-Copenhagen. Crystal Glazes and Stoneware at the Turn of the Century," in *The Royal Copenhagen Porcelain Manufactory 1775–1975* (Copenhagen, 1975), 68.

10. In 1897, Tiffany exhibited more than twenty vases and a lamp at the Glaspalast exhibition in Munich (nos. 188–212, "Vasen und Gefäße aus Glas in verschiedener Technik," and no. 213, "Lampe"); while already in Europe Tiffany probably went to see the exhibition. At the same time he was in contact with the Bruckmann publishing house in Munich, which was about to issue the art magazine *Dekorative Kunst*. When the director of the Austrian Museum of Art and Industry, Artur Ritter von Scala, invited Bing to write an article on Tiffany's art glass, Bing reported in a letter, dated September 25, 1897, that he had no access to photographs, as Tiffany had reserved these for his planned article in the first number of *Dekorative Kunst* (Archive of the Museum für Angewandte Kunst, Vienna).

11. See Tiffany & Co., *Blue Book* (New York, 1895), 277–78.

12. Ashbee mentions his visit to the "Tiffany glass works" in a journal entry dated April 30, 1896. My thanks to Alan Crawford, London, for providing me with this information from Ashbee's unpublished journal.

13. On Dresser's Clutha glass, see Michael Whiteway, ed., *Shock of the Old: Christopher Dresser's Design Revolution*, exh. cat. (New York: Smithsonian, Cooper-Hewitt National Design Museum, in association with V&A Publications, London, 2004).

14. On John La Farge, see *John La Farge*, exh. cat. (Washington, DC: National Museum of American Art, 1987); Julie Sloan and James L. Yarnall, "Art of the Opaline Mind: the Stained Glass of John La Farge," *American Art Journal* 24, nos. 1–2 (1992): 4–43; and Julie Sloan, "The Rivalry between Louis Comfort Tiffany and John La Farge," in *Nineteenth Century* 17, no. 2 (1997): 27–34.

15. Thérèse Charpentier, "La clientèle étrangère de Gallé," in *Stil und Überlieferung in der Kunst des Abendlandes. Akten des 21. Internationalen Kongresses für Kunstgeschichte in Bonn*, 1964, vol. 1: *Epochen Europäischer Kunst* (Berlin: Gebrüder Mann Verlag, 1967), 262.

16. *A Synopsis of the Exhibit of the Tiffany Glass and Decorating Co.* (New York: Press of J. J. Little & Co., 1893; repr., New York: Clearwater Publishing, 1988).

17. S. Bing, *La Culture artistique en Amérique* (Paris, 1895), published in an English translation by B. Eisler in Robert Koch, ed., *Artistic America, Tiffany Glass, and Art Nouveau* (Cambridge, Mass.: MIT Press, 1970). See also the recently published catalogue *The Origins of Art Nouveau: The Bing Empire*, Gabriel Weisberg, Edwin Becker, and Evelyne Possémé, eds., (Amsterdam: Van Gogh Museum, 2004), 85–89.

18. In advertisements for "L'Art Nouveau Bing," frequent reference is made to Tiffany glass, such as "(S. Bing) Agent Général pour la Verrerie d'Art de L. C. Tiffany," which appeared in an ad in *Dekorative Kunst* 3, no. 6 (March 1900).

19. See Gabriel Weisberg, *Art Nouveau Bing* (Washington, DC: Smithsonian Institution, 1986); see also Weisberg's comments in *The Origins of Art Nouveau*, (see n. 17, above), 89-95, and Joppien, 240–247. Also earlier, Joppien in *Louis C. Tiffany, Meisterwerke* (see n. 4, above), 23–26.

20. The Musée des Arts Décoratifs acquired a stained-glass window and a bowl, the Musée du Luxembourg originally four pieces. On the early acquisitions of Tiffany glass by the Paris museums see Martin Eidelberg, "Tiffany's Early Glass Vessels," *Antiques* (February 1990): 504 (n. 15), and *Louis C. Tiffany, Meisterwerke* (see n. 4, above), cat. nos. 40–42. For the stained-glass window see Weisberg, Becker, Possémé, eds., *The Origins of Art Nouveau* (see n. 17, above), 282, fig. 73.

21. See Weisberg, *Art Nouveau Bing* (n. 19, above), 49–51, also Weisberg, Becker, Possémé, eds., *The Origins of Art Nouveau* (see n. 17, above), 82–85; also Rüdiger Joppien, "Siegfried Bings Kunsthaus L'Art Nouveau," in Renate Ulmer, ed., *Symbolismus und Jugendstil in Frankreich* (Stuttgart: Arnoldsche Verlagsanstalt,

1999), 116–27.

22. Tiffany had exhibited stained-glass windows in Munich at a much earlier date; see *Illustrierter Katalog der Internationalen Kunstausstellung im Königlichen Glaspalast* (Munich: Verlagsanstalt für Kunst und Wissenschaft, 1883), 252, cat. no. 3169: "Glasfenster entworfen und ausgeführt von L. C. Tiffany in New York."

23. Julius Meier-Graefe said that Tiffany worked with molten glass ("seine Glasflüsse") "like a painter with his colors," *Dekorative Kunst* 1, no. 2 (November 1897): 92. A similar note is expressed by Horace Townsend in his article "American and French Applied Art at the Grafton Galleries": "The whole effect is derived from the display of the glass itself in all its glories of gorgeously blended colors" (*The Studio* 17, June 1899, 43). Charles Sonnier called Tiffany glass "ces verres magiques" in *L'Art Décoratif* 3 (1901): 31.

24. Karl Ule, "Der Einfluß des Opaleszentglases," in *Kunstgewerbliche Rundschau: Beiblatt zur Zeitschrift des Bayerischen Kunstgewerbe-Vereins*, no. 6 (June 1896): 61.

25. Rüdiger Joppien, "Karl Engelbrecht, ein Wegbereiter der Kunstverglasung des Jugendstils," in *Jahrbuch des Museums für Kunst und Gewerbe Hamburg* (Hamburg, 2005): 91–117.

26. Tiffany began to promote his "Favrile Glass" in the autumn of 1894. The term—derived from the Old English word "fabrilis," to indicate that it was handmade—referred both to

glass vessels and to the stained-glass material; see Eidelberg, "Tiffany's Early Glass Vessels" (n. 20, above), 507.

27. Paul Schumann, "Die internationale Kunst-Ausstellung zu Dresden im Jahre 1897," *Deutsche Kunst und Dekoration* 1, no. 1 (October 1897): 12–23. See also Klaus-Peter Arnold, "Van de Veldes Zimmeraustattungen auf der Internationalen Kunstausstellung, Dresden 1897," *Dresdener Kunstblätter* 26, no. 5 (1982): 168–73.

28. *Offizieller Katalog der Internationalen Kunstausstellung Dresden 1897*, 3rd ed. (June 1, 1897): 86.

29. Paul-Elie Ranson, *Femme … la Corbeille de fleurs*, Le Musée départmental Maurice Denis "Du Prieuré," Saint-Germain-en-Laye; see Ulmer, *Symbolismus und Jugendstil* (n. 20, above), 128.

30. Wilhelm Bode, in *Pan* 3, no. 2 (1897): 115.

31. Ibid.

32. S. Bing, "Die Kunstgläser von Louis C. Tiffany", in *Kunst und Kunsthandwerk* 1 (1898): 105–11.

33. Correspondence between Bing and the director of the Budapest Museum of Decorative Art, Jenö Radisics de Kutas, in the museum's archive. See also Vera Varga, *Szecessnio Müveszi Üvegei* (Budapest, 1996), 186, 188, 190, 198, 200, 202, 204, 212, 220.

34. Gustav Pazaurek, *Mittheilungen des Nordböhmischen Gewerbe-Museums Reichenberg* 15, no. 3 (1897): 76, 79.

35. *Dekorative Kunst* 2, no.

3 (December 1898): 98–99.

36. Britta Schulze, "Das Genre Tiffany: Zur Tiffany Rezeption in böhmischen Glashütten um 1900," Master's thesis, 2 vols., University of Bonn, 2003. See also Helmut Ricke, "Die Manufaktur Lötz: Bedeutung und Standort im internationalen Kontext," in Jan Mergl, Ernst Ploil and Helmut Ricke, eds., *Lötz: Böhmisches Glas, 1880 bis 1940*, exh. cat. (New York: Neue Galerie, and Ostfildern-Ruit, Ger.: Hatje Cantz Verlag, 2003), 10–26.

37. Gustav Pazaurek, *Moderne Gläser* (Leipzig: H. Seemann Nachfolger, 1901), 38.

38. See *Louis C. Tiffany: Meisterwerke* (n. 4, above), cat. no. 43. See also Bettina John-Willeke, "Die Galerie 'La Maison Moderne' in Paris," in Ulmer, *Symbolismus und Jugendstil* (n. 21, above), 148–57.

39. Julius Meier-Graefe, "Modernes Kunstgewerbe in Nancy. 1. Die Gläser," *Kunstgewerbliche Rundschau: Beiblatt zur Zeitschrift des Bayerischen Kunstgewerbe-Vereins*, no. 6 (June 1896): 68–70.

40. Bing, Introduction to *Exhibition of L'Art Nouveau, S. Bing* (n. 6, above), 19.

41. See *Louis C. Tiffany: Meisterwerke* (n. 4, above), 22–29. The Nordiska Museet, Stockholm, acquired several Tiffany glasses in 1897; see *Section des Beaux-Arts de L'Exposition Générale des Arts et de L'Industrie*, exh. cat. (Stockholm, 1897), 152.

42. Tiffany archive in the Museum für Kunst und Gewerbe, Hamburg.

43. Tiffany glass vessels

mounted by Hugo Schaper were reproduced in *Kunstgewerbeblatt* 10 (New Series), no. 3 (1899): 42, 45; in *Kunstgewerbeblatt* 11, (New Series) no. 8 (1900): 144–46; and in Georg Malkowsky, ed., *Die Pariser Weltausstellung in Wort und Bild* (Berlin: Kirchhoff, 1900), 36–37.

44. Cecilia Waern, "The Industrial Arts of America: The Tiffany Glass and Decorative Co." in *The Studio* 11, no. 53, (August 1897): 156–65; and "The Industrial Arts of America: The Tiffany or 'Favrile' Glass," in *The Studio* 14, no. 63 (June 1898): 16–21. Waern had previously written *John La Farge, Artist and Writer* (London: Seeley; and New York: Macmillan, 1896); my thanks to Alice C. Frelinghuysen for bringing this book to my attention.

45. Bing, *Exhibition of L'Art Nouveau S. Bing* (n. 6, above); it contained 56 pages and 33 illustrations.

46. Ibid., Introduction, 19.

47. Townsend, "American and French Applied Art at the Grafton Galleries" (n. 23, above), 39.

48. Ibid.

49. Walter Gensel, "Tiffany Gläser auf der Pariser Welt-Ausstellung," *Deutsche Kunst und Dekoration* 7 (October 1900–March 1901): 44-45, 86-97.

50. Georg Fuchs, "Eindrücke aus der amerikanischen Abteilung: 1. Internationale Ausstellung für moderne Dekorative Kunst in Turin," *Deutsche Kunst und Dekoration* 11 (October 1902–March 1903): 181–92; "Die Sektion Amerika. Die Turiner Ausstellung" in *Dekorative Kunst*, 6, no.2 (November

1902): 49–58.

51. *Dekorative Kunst* 1, no. 9 (June 1898): 112.

52. *Dekorative Kunst* praised Tiffany's windows at the Turin exhibition for a last time: "Already the portal shows the splendors of his stained glass windows, wonderful reflexes of color and shimmer of light, which produce different new nuances according to the changes of light and atmosphere." *Dekorative Kunst*, 6, no. 2 (November 1902): 49.

53. *Dekorative Kunst* 1, no. 1 (October 1997): 10–12; and 2, no. 3 (December 1898): 113–15. For a most thorough discussion of Tiffany's early lamps see Martin Eidelberg in *Louis C. Tiffany, Meisterwerke* (see n. 4, above), 215–228.

54. See Weisberg, *Art Nouveau Bing* (n. 19, above), 103 (pl. 21), 210 (pl. 53), and 279 (n. 14).

55. *Dekorative Kunst* 2, no. 3 (December 1898): 99.

56. Gottfried Heinersdorff, *Die Glasmalerei* (Berlin: Verlag Bruno Cassirer, 1914), 31, 32.

57. Gustav Pazaurek, *Kunstgläser der Gegenwart* (Leipzig: Klinkhardt & Biermann, 1925), 10.

58. Fuchs, in *Deutsche Kunst und Dekoration* (n. 50, above): 181.

59. S. Bing, "L'Art Nouveau," *The Craftsman* 5, no. 1 (October 1903): 1–15.

Iridescent Phoenix
The Tiffany Revival

Martin Filler

No single image better symbolizes the nadir to which Louis Comfort Tiffany's artistic reputation had sunk by the time of his death in January 1933 than the scene that unfolded three years later outside the Tiffany Studios building on Manhattan's West Twenty-third Street. After the auction of the studio's contents, a Brooklynite named Lillian Brimberg Nassau (1899–1995) watched in horror as salvage dealers took the master's once-celebrated lamp shades and whacked them against the curbstones to free the intricate bronze and lead frames of their glass inserts before having the metals melted for scrap. Nassau, who had begun dealing door-to-door in old gold and bric-a-brac to support her family during the Great Depression, would, decades later, play an instrumental role in the revival of Tiffany's posthumous fortunes by becoming the foremost dealer in his work. But even as Tiffany auction prices soared to new highs throughout the 1970s, she could never erase from her mind the thought of that shocking cultural vandalism four decades earlier.

The vagaries of the history of taste make it impossible to pinpoint with certainty why particular styles go out of fashion or why they are appreciated again after sustained periods of disfavor. Although much of the work of Tiffany has been characterized as Art Nouveau, enough of his work was based on traditional prototypes for him to be spared some of the disastrous effects of the profound shift in taste that occurred in the United States and Europe after about 1915.

The innovative free styles that flourished internationally about 1900 — regional variants called Art Nouveau in France and Belgium, Modernismo in Spain, Stile Liberty in Italy, Wiener Sezession in Austria, the Glasgow School in Scotland, and the Arts and Crafts Movement in Britain and the United States came to seem outmoded and frivolous with the outbreak of World War I. The new preference for a more sober classicism, which imposed what some saw as a bracing sense of order amidst global chaos, sounded the death knell for Art Nouveau's intuitive, emotive spirit.

Major artists who had been at the forefront of their disciplines — including Louis Sullivan, Frank Lloyd Wright, and Greene & Greene in the United States; C. R. Ashbee and C. F. A. Voysey in Britain; Hector Guimard in France; and Charles Rennie Mackintosh in Scotland — suddenly found themselves without work, their careers in ruins. Only Wright among them would eventually return to the top of his form, in the most astonishing late-career comeback in twentieth-century art.

The Classical Revival that had been gaining momentum in American architecture and design since the World's Columbian Exposition in Chicago in 1893 gave Tiffany the latitude to emphasize that antiquarian component of his multifaceted aesthetic once fashion moved away from what we today think of as his most characteristic productions. But there can be no doubt that the decade and a half from the end of World War I until his death saw a significant diminution of his creative output, both in his flair for bold invention and the marketplace's steadily declining interest in his designs.

Art Deco, which during the 1920s supplanted Art Nouveau as the high style of the period, fostered a superficially modern taste for stylized imagery rather than the flowing lines and sensuous contours

of the natural world, as Art Nouveau had done. Although it now seems incorrect, or at least imprecise, to label Tiffany a Victorian designer—his work, like that of his older contemporary Dr. Christopher Dresser, manages to seem perpetually modern—one must remember that he redecorated the State Rooms of the White House in the Aesthetic style for President Chester Alan Arthur in 1882. Half a century later, Tiffany's leaded-glass lamp shades in particular had come to appear like quaintly old-fashioned relics of that long-ago period, especially as Art Deco gave way to the Streamlined Moderne of the 1930s.

Reviewing the Museum of Modern Art's 1934 Machine Art exhibition (curated by Philip Johnson) in the *New York World-Telegram*, critic Emily Genauer asked, "[W]here are the gimcracks of yesterday, the antimacassars and Tiffany glass lamps and the bronze ladies whose billowing skirts were spread to receive calling cards? Long since vanished from the current scene as being silly and fussy and always in the way." (In hindsight, Genauer's question and answer seem ironic, given MoMA's important role in the rehabilitation of Tiffany's artistic reputation only two decades afterward. Furthermore, the polemical nature of the Machine Art show, which elevated ready-made industrial components such as ball bearings and propellers to the stature of sculpture, makes the forced contrast between handcrafted glass and mass-produced machine parts seem all the more dubious.)

Victoriana, and the fusty social mores it was equated with in the minds of the general public after the liberating atmosphere of the 1920s, became not merely unfashionable but a running joke. Popular movies of the 1930s and early 1940s often lampooned nineteenth-century architecture and design as ridiculously eccentric, as in Howard Hawks's *Ball of Fire* (1941). But a sea change occurred during World War II, when nostalgia for the Victorian Era and its comforting stability was reflected in films such as Vincente Minnelli's *Meet Me in St. Louis* (1944), and in turn was picked up as a marketable if short-lived trend by American decorating magazines. Yet whether portrayed satirically or romantically, the Hollywood version of Victorian design was often scrupulous in its historical accuracy—movie-studio art departments were known to do their research—and leaded-glass lamps in the Tiffany manner sometimes made cameo appearances on movie sets.

Nonetheless, market demand for Tiffany's work continued to languish, as demonstrated by the September 1946 auction at New York's Parke-Bernet Galleries, titled "The Extensive Collection of the Louis Comfort Tiffany Foundation." Held to provide the financial wherewith to transform the foundation from an art colony at Laurelton Hall at Tiffany's estate on Long Island to a foundation that supports artists with grants, the five-day distress sale fetched respectable prices for Tiffany's personal collection of antiques, rugs, and ancient Roman glass. But the 372 examples of his own work brought the disappointing total of only $10,000, yet the same sum as the sale of Laurelton itself brought. The top lot was a six-foot-wide, leaded-glass ceiling lamp that fetched a mere $275.

But there were some prescient bidders at Parke-Bernet that week, including Pittsburgh department-store heir Edgar Kaufmann, Jr. (1910–89) (see fig. 45), who, in addition to being a Frank Lloyd Wright scholar and an aesthete, was associated with the Museum of Modern Art as a design curator from 1937 to 1955. Among his purchases was a 4-inch-high Favrile vase by Tiffany that he would donate to MoMA's permanent design collection in 1947—another step in the designer's continuing rise from posthumous obscurity. Kaufmann, who had studied under Wright at Taliesin and whose father had commissioned Fallingwater from the architect, had gotten Wright to add a guesthouse to that celebrated Pennsylvania landmark in 1938. The younger Kaufmann put a Lotus lamp by Tiffany in the guesthouse, probably around

Fig. 45
Edgar Kaufmann, Jr. at the
dedication of the visitors'
pavilion at Fallingwater, 1981.

the time of its reworking by Wright in 1948.

Another pioneering proponent of the Tiffany revival was midcentury-modern furniture designer Edward Wormley (1908–95), who was Kaufmann's companion at the time. In 1956, Wormley designed the Janus series of walnut tables for the Dunbar Furniture Company, which incorporated iridescent-glass tiles by Tiffany as decorative insets. Among the several forms he devised was a small tripod table reminiscent of a Shaker candlestand, with its horizontal surface paved in a Mondrian-like pattern of tiles in various sizes (see fig. 46). A pair of those tables was owned by Lillian Nassau, whose early clients included Wormley, and it is possible that he acquired the tiles from her extensive stock.

Although Art Deco was and still remains anathema to the Museum of Modern Art — that populist style has always been regarded as a vulgar bastardization of high modernism by MoMA's gatekeepers — its immediate predecessor, Art Nouveau, was admitted to the institution's high

Fig. 46
Edward Wormley, Janus Side Table, 1956, walnut with thirty-nine Tiffany glass tiles, manufactured by Dunbar.

modernist canon. The selective genealogy of modern art as decreed by MoMA's founding director, Alfred H. Barr, Jr., affirmed links between Art Nouveau and Symbolism. By the time of the museum's founding in 1929, both had begun to recede into historical memory, whereas for Barr and MoMA's first design curator, Philip Johnson, Art Deco remained a contemporary embarrassment, undercutting their preference for reductivist modernism. However, in Barr's view, if Symbolism could be seen as a forerunner of certain modernist developments, especially Surrealism, so could Art Nouveau be viewed as a precursor of the process of modernist simplification and stylization that in the 1920s shifted its major source of inspiration from nature to the machine.

Although Kaufmann and Wormley were part of a small coterie of postwar Tiffany enthusiasts, they were far from alone in their conviction that Tiffany was a major master unjustly forgotten. Among their most important collecting confreres was Robert Koch (1918–2003), an art historian whose path-breaking 1957 Yale doctoral dissertation, "Stained Glass Decades: A Study of Louis Comfort Tiffany and the Art Nouveau in America," laid the groundwork for contemporary scholarship on the subject. Koch's research was made available to the general public in his book *Louis C. Tiffany: Rebel in Glass* (1964), which went through several updated editions. His wife and collecting collaborator, Gladys Koch (1918–2002), became a dealer in Tiffany glass, who, although she did not maintain a retail gallery, was for years a fixture at antiques shows (see fig. 47). In moving from private collecting to dealing, the couple followed a pattern shared by several other early Tiffany exponents, including Maude B. Feld (1900–95), who began with a gallery in New Jersey and moved to the more rarefied environment of New York's Madison Avenue in 1959.

Other significant early Tiffany collectors included Hugh F. McKean (1908–95) and his wife, Jeanette Genius McKean (1909–89). As an aspiring young artist, Hugh McKean was selected in 1930 by the Tiffany Foundation to study at Laurelton Hall. The educational experience there was not unlike that at Frank Lloyd Wright's Taliesin Fellowship, which Wright set up in 1932. Established as a kind of court around the great men who founded them, both institutions were based in their patrons' homes, where the eminent and aged masters delivered Olympian pronouncements on their artistic philosophies, and evenings were marked by uplifting musicales—organ recitals at Laurelton Hall and

Fig. 47
Tiffany scholar, Robert Koch, with a display of Tiffany glass belonging to his wife, Gladys Koch, a pioneer dealer in the field.

chamber concerts at the two Taliesins. It is useful to think of the luxury-loving Tiffany and the equally sumptuary-minded Wright in the early 1930s as much-diminished survivors of the Aesthetic Movement, with its emphasis on the integration of the arts and vision of the individual artist as orchestrator of the *Gesamtkunstwerk*—the total work of art.

In 1942, Jeanette McKean founded the Morse Gallery of Art (later renamed, in honor of her industrialist grandfather, the Charles Hosmer Morse Museum of American Art) at Rollins College in Winter Park, Florida, which Charles Morse had helped develop as a resort. Hugh McKean became the school's president in 1951 and remained in that position until 1969, serving as the gallery's director from its establishment until his death. Built around the McKeans' extensive Tiffany holdings—the most comprehensive of any privately assembled collection in the United States—the Morse Museum remains a singular repository of the master's oeuvre. In 1955, Mrs. McKean mounted an exhibition there titled Works of Art by Louis Comfort Tiffany, the first monographic survey of the artist's works in some three decades. But given the museum's remote location in a southern backwater, it did not have the impact of the pivotal Tiffany show that was to be held in New York three years later. It did, however, lead the Tiffany family to invite the McKeans to salvage what they could from the ruins of Laurelton Hall (which burned down in 1957), creating the core of a major collection (see fig. 48).

In 1957, Jack Lenor Larsen, a thirty-year-old fabric designer and member of the American Craftsmen's Council board of trustees, proposed that the council's Museum of Contemporary Crafts organize the exhibition that would at last return Tiffany to his proper place as a giant in the history of decorative arts. Louis Comfort Tiffany, 1848–1933 opened on January 24, 1958, at that museum (now the Museum of Arts and Design), which was on West Fifty-third Street in Manhattan, directly opposite the Museum of Modern Art. The lenders of the three hundred objects on display—Favrile glass, furniture, jewelry, enamels, lamps, metalwork, paintings, pottery, religious objects, and stained glass—comprised a veritable *Who's Who* of Tiffany connoisseurs. In addition to borrowing from such museums as the Louvre, The Metropolitan Museum of Art, the Smithsonian Institution, and the Corning Museum of Glass, the show included works from Tiffany's descendants and from Nassau, Feld, the Koches, the McKeans, Kaufmann, and Wormley.

The largest individual lender to the watershed show was Joseph Heil, a New York oil heir, amateur artist, and collector, who was among Nassau's most active clients. After the Museum of Contemporary Crafts exhibition closed on April 6, 1958, Heil donated 155 pieces of Favrile glass to the Museum of Modern Art. In 2003, MoMA sold all but forty-three of Heil's gifts at a Christie's auction, explaining that the works were deaccessioned because they "utilize decorative elements applied to traditional forms and do not reflect MoMA's sense of values about modern design."

One of the most influential lenders to the 1958 show was Elizabeth Gordon (1906–2000), the editor-in-chief of *House Beautiful* from 1939 to 1964. Gordon is now best remembered for her fervent championing of the work of Frank Lloyd Wright and her equally vehement contempt for the International Style. She used her mass-market publication to advance her xenophobic belief that the allegedly alien International Style was inimical to American values, which she saw perfectly embodied in Wright's designs. In doing so, she took Wright's competitive animus against the International Style, which was in the ascendant during his fallow decades of the 1920s and 1930s, to almost McCarthyite extremes.

In Tiffany, Gordon found not only a distinctively American artist whose work in his favored medium eclipsed that of his European contemporaries, but also a link to the roots of Wright's thought in the nature-based theory of Wright's mentor (and

Fig. 48
Hugh F. McKean standing on the ruins of Laurelton Hall, 1957, archival photograph, Morse Museum of American Art.

Tiffany's contemporary), Louis Henri Sullivan. In the October 1956 issue of *House Beautiful*, Gordon ran an article titled "Iridescence, the New Dimension in Your Decorating," which cited the influence of Tiffany on a new interior design trend and introduced Wormley's Janus tables, inlaid with Tiffany tiles, to the general public.

A year later, Kaufmann wrote an article for the magazine *Interiors*, "At Home with Louis Comfort Tiffany," further emphasizing Tiffany's contemporary relevance. Kaufmann adopted a curious way of displaying his numerous pieces of Favrile glass in his New York homes, first in the Campanile apartment tower on East Fifty-second Street overlooking the East River and later his apartment on Park Avenue and East Sixty-first Street. Instead of protecting his breakable Tiffany objects in a vitrine, as so many other collectors have done, he placed them on the floor around the perimeter of his living room, a striking though anxiety-provoking arrangement that more than one guest understandably found intimidating.

Although the Museum of Contemporary Crafts show bolstered interest in Tiffany's work, the ultimate consecration of Tiffany as a major figure in the annals of design history came from the Museum of Modern Art. No other institution has exerted such a powerful effect in shaping the canonical perception of modernism, and that authoritative stance was enhanced by the opening of MoMA's permanent design collection gallery in 1959, the first installation of its kind. MoMA had been assiduously collecting Tiffany objects for at least a decade. It acquired several outstanding pieces in 1957 with funds provided by Phyllis Bronfman Lambert, the Canadian whiskey heiress, who was often in New York between 1954 and 1959 to supervise the construction of her family's Seagram Building, designed by Ludwig Mies van der Rohe.

The MoMA design collection's inaugural exhibition included several of those Tiffany objects, six of which were illustrated in the accompanying pub-lication by Arthur Drexler and Greta Daniels, *Introduction to Twentieth Century Design from the Collection of the Museum of Modern Art, New York*, and the core display has never been without an example of his work since. Tiffany also figured importantly in MoMA's 1960 retrospective exhibition, *Art Nouveau*, and its accompanying catalogue, which set off a new wave of regard for Tiffany at the beginning of the decade that witnessed his complete return to popular recognition.

Certainly the epicenter of commercial collecting activity in New York during that period was the shop of Lillian Nassau. She started business in a storefront under the Third Avenue el at East Fifty-sixth Street in 1945 (see fig. 49), and in time developed a special interest in European Art Nouveau, including Rozenburg porcelain and Majorelle furniture. She bought her first Tiffany lamp in 1956 for $175 and soon became the major retail source for that long-neglected material. As her son Paul Nassau, now proprietor of the gallery, later recalled, "My mother had a ten-year start on everyone else. People knew if they had Art Nouveau they wanted to sell, they would have to bring it to her."

In addition to Nassau selling to every major early collector of Tiffany, several aspiring dealers began their own businesses by buying from her. Nassau's Tiffany trade accelerated during the mid-1960s, when the new vogue for Art Nouveau paralleled the emergence of the counterculture and psychedelia, inspiring a concomitant identification with phantasmagoric imagery and organic, nature-based design motifs. Although Tiffany looked closely at the natural world for inspiration, he was scarcely a mystic. Thus, the very different way in which his most experimental output was regarded during a decade of extraordinary social and political upheaval is a telling example of how successive generations can see things in art far differently from the intentions of the creator.

The huge success of exhibitions that featured Art Nouveau and late-nineteenth-century design,

Fig. 49
Lillian Nassau in her store on Third Avenue and Fifty-sixth Street in New York.

such as the Victoria and Albert Museum's Aubrey Beardsley retrospective of 1966, which traveled to the Gallery of Modern Art in New York later that year, and the 19th Century America: Furniture and Other Decorative Arts exhibition at The Metropolitan Museum of Art in 1970, was paralleled by a new demand for Tiffany's fin de siècle work. Especially sought-after were lamps and Favrile glass with profiles that were strongly related to Art Nouveau, as opposed to the historicizing forms that he produced throughout his career. A new clientele for Tiffany emerged at a time when other classic, curvilinear antiques of the Art Nouveau were becoming fashionable. Instead of the collector/ scholar/ aesthete/dealers who composed the primary Tiffany audience before 1958, figures from the world of entertainment began to dominate the field at that time.

In 1967, Nassau moved her shop from Third Avenue to a nearby but far more upscale location on East Fifty-seventh Street, long the locus of some of New York's most prestigious art and antiques galleries. There she sold Tiffany pieces to numerous celebrities and VIPs, including all four of the Beatles, several members of the rock-and-roll bands Blood, Sweat and Tears and Led Zeppelin, music producer David Geffen, singers Paul Simon and Barbra Streisand, actors Catherine Deneuve and Marcello Mastroianni, and television executive Frank Stanton. Manhattan showman/restaurateur Warner LeRoy decorated the vast ceiling of his popular restaurant and singles' bar Maxwell's Plum with a dense mélange of Tiffany lamp shades and glass panels that he had acquired at the nearby Nassau shop, although he craftily (and thriftily) intermingled authentic pieces with far less valuable glass artifacts that were merely in a style evoking Tiffany.

Given the renewed demand for works by Tiffany, prices began to escalate sharply. One of the designer's most celebrated designs, the Cobweb lamp, cost $400 when it was first introduced in 1904; in 1972, Nassau was asking $33,000 for one of them, and just eight years later the lamp's value had increased tenfold, as another one fetched $360,000, a new auction record at that time. Although Nassau had never sold Tiffany works at giveaway prices at any point in her career, even she was astonished—and more than a bit appalled—at this stratospheric increase. "No lamp is worth a third of a million dollars!" she declared, although she was ultimately to be proven wrong by market forces, which she had once controlled. (As one employee of the Nassau gallery recalled, "Lillian was tenacious and didn't like anybody competing against her at auction. She was very protective of her market because it was basically *her* market—she created it, she was the mother, and she wanted it all.")

A sharp drop in auction prices for works by Tiffany in late 1981, prompted in part by a recession as well as what seemed like over-inflated values, led to a cooling of the Tiffany market for much of that ultimately prosperous decade. However, as is characteristic of the art trade as a whole even in difficult economic times, rare and prime examples fresh to the market could still command high prices. And in 1997—during the full flush of a major economic boom, two years after Lillian Nassau's death, and fifteen years after her retirement—one of Tiffany's leaded-glass, bronze, and mosaic Lotus lamps brought a world auction record of $2,807,500 at a Christie's sale in New York (see fig. 50).

That transaction took place once again within the small radius of midtown Manhattan's East and West Fifties and Sixties where, with the remarkable concentration of museums and galleries that took up Tiffany's cause, the resurrection of this towering master was largely focused. Although there can be no accounting for the whims of taste, it seems unlikely that Louis Comfort Tiffany's reputation, now so broadly confirmed, will again fall into the penumbra that followed his death, a strange phenomenon that has inexplicably affected great masters in other mediums throughout history.

Fig. 50
Louis Comfort Tiffany, Pink Lotus Lamp, sold at Christie's New York (December 12, 1997, lot 200) for a record price.

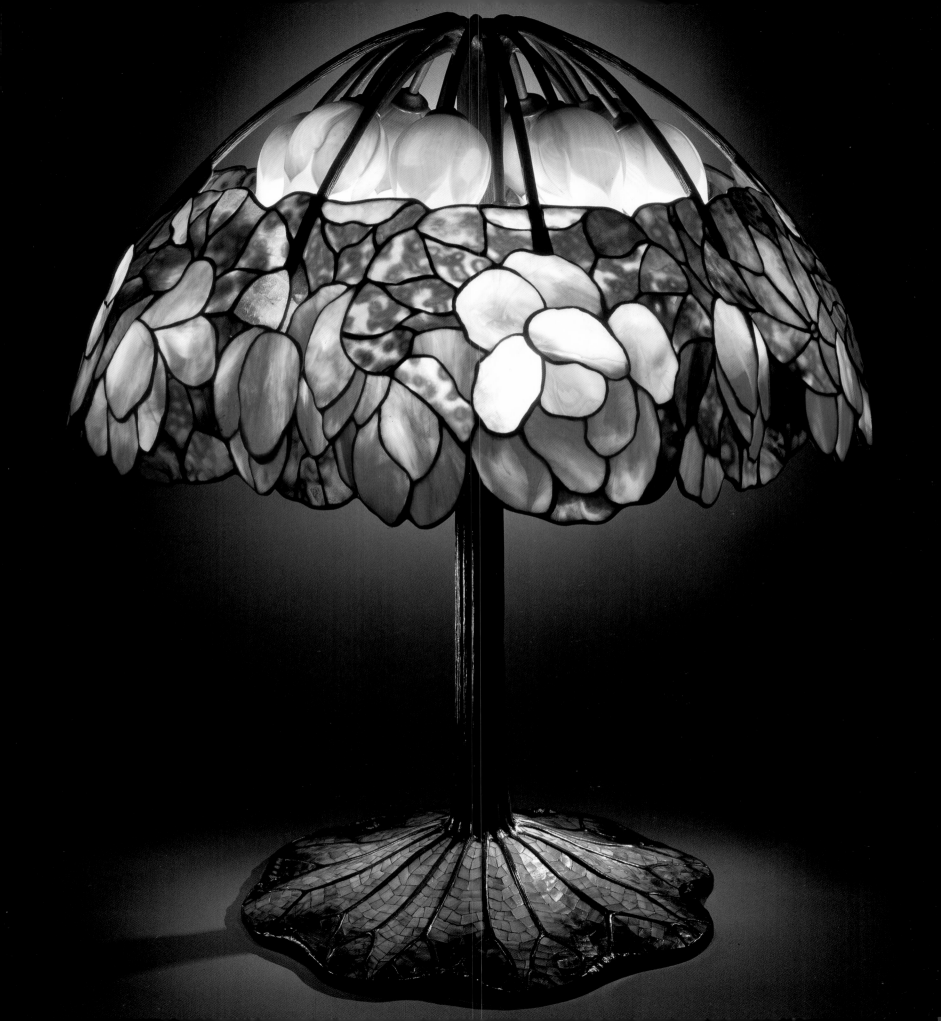

Louis Comfort Tiffany
Artist for the Ages

Marilynn A. Johnson

"Tiffany was one of the most creative of the artist spirits of his time. He took that spirit into craftsmanship and did some remarkably beautiful things for any period."[1]

Frank Lloyd Wright

These words of praise from Frank Lloyd Wright (1867–1959), America's most famous architect, emphasize the creative imagination of Louis Comfort Tiffany and the lasting contributions he made to art. Implicit in these words also, however, is the split between art and craft, a separation that preoccupied all proponents of the three major reform movements of the late nineteenth and early twentieth centuries: the Aesthetic Movement, the Arts and Crafts Movement, and Art Nouveau. The first two of these were of English origin and had far-reaching and profound effects on the United States. Art Nouveau on the other hand, although with roots in England, flourished primarily on the continent of Europe from the 1890s to the onslaught of World War I. Wright, two decades younger than Tiffany, enjoyed his first success as an architect and designer in the years from 1893 to 1901; his theorizing and his work in this period are perceived as strongly influenced by the English Arts and Crafts Movement. Tiffany, a mature and recognized artist by this time, began his earliest production of blown glass vessels in the same period and forged an alliance with Siegfried Bing, chief spokesman for Art Nouveau.

Since the earliest writings of the twentieth-century American modernists, Tiffany has been perceived as an Art Nouveau artist. By the 1950s, this perception seemed established fact. As one scholar has pointed out, however, central to this designation is the question of what is meant by the term "Art Nouveau." The most recent study of Tiffany states, "Art Nouveau was a movement, *not* a style." While these words may owe something to the complexities set forth in an exhibition on Art Nouveau in 2000 and its accompanying catalogue, they are also unmistakably drawn from an article by Professor A. D. F. Hamlin, "L'Art Nouveau: Its Origin and Development," published in *The Craftsman* in December 1902. Viewing Art Nouveau as a negative movement, a "protest against the traditional and the commonplace," Hamlin opens his article with the statement "'L'Art Nouveau,' or 'L'Art Moderne,' as it is sometimes called, is the name of a movement, not a style." He asserts that "It represents anew a search for novelty, the weariness with whatever is trite and commonplace. While many of its roots can be traced to England, its chief growth has been in France (or rather Paris), with offshoots in Belgium, Germany and Austria (or rather Vienna)."

As the first major analysis of Art Nouveau in an American publication, Hamlin's article is significant, but even as he states Art Nouveau is not a style, he suggests some of the stylistic characteristics that have been associated with it. He speaks of "clever designs in which flowers and figures and the inevitable 'New Art curve' are blended." He characterizes a buffet by Gaillard as "Japanese, Louis Quinze and New Art curvilinear, all in one," and sees in the new art two conflicting tendencies: one toward nature, toward floral and animal forms, as the true source of inspiration; the other toward pure fancy, expressing itself in restless movement and fantastic curves. Clearly the whiplash line, now considered the dominant element of high-style Art Nouveau

design, was already apparent and significant. It is not, however, readily apparent in the art of Tiffany.

Hamlin's article engendered a brief spate of articles in *The Craftsman*. The first, by Jean Schopfer, published in June of 1903 was "An Argument and Defense," refuting Hamlin's characterization of Art Nouveau as a negative movement, and giving six positive principles "that Art Nouveau brings with it." It is interesting to note that Schopfer felt the renewal of the new art was most needed in France, where "the decadence was greater than in other countries. Neither Germany, nor England, nor the United States, was, like France, the slave of historic styles."

In October of 1903, an article titled simply "L'Art Nouveau" appeared. Its author, S. (Siegfried) Bing saw himself as "sponsor to the new life," and acknowledged that with the founding of his gallery in 1895 he had unwittingly given the movement its name, "a doubtful honor." Bing cites the importance of M. Octave Maus and the 1894 founding in Brussels of "La Libre Esthétique," and praises Henri van de Velde and his 1895 designs for Bing's Paris "L'Art Nouveau" gallery and for the 1897 Dresden exhibition. To Bing these "constituted in Europe the first important examples (ensembles) of modern decorative art." Like other proponents of the new art, Bing urges "a return to Divine Nature, always fresh and new in her counsels." In his closing pages Bing speaks of the contributions of America, mentioning "men like the deceased archeologist Moore [the designer Edward C. Moore. The designation as an archeologist may be due to a misinterpretation by the translator], like John La Farge and Louis Tiffany…" Although these are, he says, men whom "the old continent would have been proud to possess," nowhere does he suggest that any one of them, even Tiffany, is an Art Nouveau artist.

In June of 1905, A. D. F. Hamlin, again writing for *The Craftsman*, states in an article on "Style in Architecture" that Louis Comfort Tiffany, along with Louis Sullivan, was "one of the first true prophets of Art Nouveau." A prophet, however, is quite different from a proponent. Finding words by Tiffany that indicate he considered himself part of the Art Nouveau movement is difficult, if not impossible. Tiffany's purpose, his passion, was not a reform of the decorative arts, but a single-minded and highly personal pursuit of the beautiful. His association with Bing has caused an association with Art Nouveau, yet was it not eminent good business sense to affiliate with a major European entrepreneur, and thus increase his audience and his market? Louis Comfort Tiffany had learned marketing and entrepreneurship from a master, his father, Charles Lewis Tiffany. Early in Louis's career, following his father's example, he went after the money there was in art, though acknowledging it was art all the same.

Tiffany's reliance upon nature as a renewing source of inspiration has also been considered a reason to call him an Art Nouveau artist, but Tiffany had turned to nature long before the earliest intimations of the Art Nouveau movement existed. Moreover, naturalistic ornament was a primary component of the mid-century rococo revival, which persisted in various manifestations throughout the century. The study of the natural sciences and the proliferation of publications about them, some of them with plates that could almost be art in themselves, provided vital new sources of design. Tiffany would have been familiar with these, from the ten meticulous plates of "Leaves and Flowers From Nature" that conclude Owen Jones's 1856 *Grammar of Ornament*, and that were in part the work of a young Christopher Dresser, trained as a botanist, to the darkly seductive studies by Ernst Haeckel in his works on morphology. In addition to these second-hand sources, there were the direct observations and careful drawings from nature that Edward C. Moore encouraged in the young Louis, and that Tiffany as a mature artist continued to encourage on the part of his designers.

In his championing of the totality of the arts, his acceptance of the belief that there were no lesser arts, only art, Tiffany echoed the primary tenet of

the English Aesthetic Movement of the 1860s and '70s. The Aesthetic Movement was the first of the nineteenth-century reform movements to address and try to eliminate the schism between fine and decorative (or applied) arts, although both the Arts and Crafts Movement and the Art Nouveau Movement would continue aggressively to attempt the correction of that split. There seems also in Tiffany's philosophy more than a little of Aestheticism's "Art for Art's Sake" concept, the belief that "beauty is its own excuse for being." Finally, the Japanese influence, although of major importance in Art Nouveau, was decades earlier central to the Aesthetic Movement, and embraced by its key figures, especially "the greatest aesthete of them all," the brilliant architect/designer E. W. Godwin.

All of the late nineteenth-century reform movements had early common roots in England of the 1830s and '40s and, in varying degrees, in the theorizing of Ruskin and A. W. N. Pugin, as well as in the works of a group of dedicated reformers who were instrumental in organizing the Crystal Palace exhibition. Although ostensibly intended to foster friendship between nations, and somewhat more covertly to stimulate trade and the economy of the mother country, the Great Exhibition was also viewed as a way of stimulating the design arts. Not only Pugin, responsible for the medieval court and great champion of the Gothic, but many other mid-century architects and designers were instrumental in planning and bringing about this first World's Fair. Unfortunately many critics felt the exhibits at the Crystal Palace illustrated the confusion of ornament made possible by machine production as well as a design impoverishment from slavish historicism.

By the 1860s, the great voice for design reform and the source of many of the products that proved it possible came from William Morris. Ardent socialist, champion of the worker as well as of all the applied arts, Morris struggled with the contradiction of his desire to provide art for everyone and his wish to give back to the craftsman/worker the dignity and pleas-ure of hand labor. Louis Comfort Tiffany in the organization of his studios and in his employment of skilled artisans might seem to echo Morris or even Ashbee, but Tiffany had no interest in social causes. Although a fair and respected employer, he relied upon hand labor not for its joy but for aesthetic purposes. "Infinite, endless labor makes the masterpiece," wrote Charles de Kay, but the sentiment and perhaps even the actual wording are those of Tiffany.

Like Frank Lloyd Wright, and unlike Morris, Tiffany accepted the necessity of the machine to produce art for the many. None of his most important designs, however, was machine executed, nor did he, like Christopher Dresser, design specifically with the potential of machine production in mind to become the industrial designer he was sometimes termed by his contemporaries, including Siegfried Bing.

Tiffany was an artist with a complex vision but a single purpose. Although he was influenced by the major reform movements of his time, and drew upon all the design sources available to him, he brought to his art his own unique view of the beautiful. His art as a painter is sometimes strikingly uneven. Yet if he was not so major an artist with the brush as his own age perceived him to be, he was often far better than our age has believed. His plein air views of his family in the meadows of Somesville and Irvington are filled with light and charm. His paintings of fishermen at Sea Bright have a Winslow Homer strength and realism. The quality of his interior design is even more difficult for our time to evaluate. Left with few surviving examples other than the Veterans' Room of the Seventh Regiment Armory and his work on the Mark Twain house, we must turn to the inadequate record of the camera. Photographs are kind to the spare rooms of the International Style. They are not kind to late-nineteenth-century rooms filled with pattern and ornament. To perceive these properly one must be able to walk into the space, not view it as a seeming jumble on one plane. Moreover, the period photographs of Tiffany's rooms lack color, always his greatest strength as well as a unifying element. Nev-

ertheless, when one looks at the major decorating commissions over a period of time, it is clear that Tiffany developed into a highly competent interior designer, capable of meeting the demands of his prominent clients for opulent reflections of their wealth while still creating unified and distinctive rooms.

Furniture in these interiors, perhaps in the early years bearing the influence of Lockwood de Forest and of India, became simpler in the designs Tiffany did for his own breakfast room, where chairs and tables reflected an Arts and Crafts fitness of purpose. A similar functionalism is visible in some of the Havemeyer rooms, surely Tiffany's greatest achievement in decorating. One notes the spare, unadorned designs of some of the furniture, and such flexible forms as a bench with a back that reversed so one could face in either of two directions.

Tiffany was always interested in the mechanical and innovative, an aspect of his work that has been somewhat neglected. From his early use of revealed construction in a wheel to move a door in the Bella apartment to the engineering feat of the Havemeyer flying staircase, to the intricate water system of Laurelton Hall and the forward-looking, enormous panes of glass in its dining-room bay, to the counterweight system he devised to raise and lower the tremendous weight of the Mexico City mosaic curtain, he put his imagination to work not simply to serve aesthetic concerns, but to address practical considerations as well.

That imagination, or "creative spirit," as Wright termed it, led to experiments in many media. Although his photographs are represented in only a half dozen American museums, Tiffany was a highly competent photographer. As some of his photographs reveal, he was always interested in textiles, and his studios produced textiles for both ecclesiastical and domestic use. Metalwork also captured his imagination. From the balustrade and firescreen of the Havemeyer interior to candlesticks and lighting fixtures of the studios, to the desk sets intended as practical embellishments for the American home, Tiffany metalwork is distinctive and often beautiful. His jewelry designs could be notably original, depending often on inspiration both from unpretentious flowers and basic forms in nature and from the use of the less costly but more colorful stones. His art pottery is also original, and while Tiffany furnaces never achieved the extraordinary glazes one would have expected as a natural extension of their work in glass, the vessels are unusual and highly recognizable.

Glass, however, is the medium for which Louis Comfort Tiffany will always be remembered and revered. Whether in mosaics, in stained-glass windows or lamp shades, or in vessels, the vibrant colors of Tiffany glass sing to the viewer. Tiffany was a glass master, one of the greatest masters of this medium. Of all his glass creations, in Tiffany's own time the vases and cabinet pieces elicited the most fervent praise. Future generations may well find these objects, in the Tiffany revival somewhat overlooked as attention focused more upon the windows and lamps, the most satisfying. Whether highly original like Lava glass, with free forms that seem to glow with the fires of volcanic earth, or clearly derived from great objects of antiquity, the historic shapes, the vibrant sang de boeuf or imperial gold glazes of Chinese porcelains, a perfect Tiffany vase is an object of art. For the viewer it elicits the "aesthetic shiver," the "Ah, but it's beautiful!" response.

One of the more valid methods for judging a work of art remains the "touchstone test" advocated by Matthew Arnold, the foremost critic in the English-speaking world of the nineteenth century. Arnold proposed that a work be measured against the greatest examples from the past. By that standard, held against the finest glass art of the ages, the best of Tiffany's work withstands the test. Like all major art, it transcends the barriers of time and space. It overcomes cultural prejudice. It is timeless.

1. Frank Lloyd Wright, in a letter to "Mr. Gessert," quoted by Henry Winters in The Final Dynasty of Louis Comfort Tiffany (Boston: 1971).

Nature is Always Beautiful

"Mother Nature is the best designer" was a guiding tenet for the designers of Tiffany & Co. throughout the nineteenth century, and Louis Comfort Tiffany adopted this cardinal principle as his own. "Nature is always beautiful," Louis proclaimed with a pre-Darwin romanticism that ignored the less pleasant aspects of natural selection and survival of the fittest.

Sketching directly from nature at an early age, Louis was unquestionably influenced by Edward C. Moore and his "Tiffany School." Moore, the guiding genius of Tiffany & Co.'s silverware business, was one of the earliest American Japonists, absorbing the Japanese fascination with the most ordinary elements of nature as well as a meticulous attention to detail.

Louis Comfort Tiffany's fascination with nature was far reaching; throughout much of his career he drew upon fish and sea creatures for decorative motifs or actual objects. A vast array of plant life and flowers were the basis of much of his art. He was an avid gardener, bringing exotic species to Laurelton Hall, and even experimenting with photographing them. The common blooms of woodland and field, however, were his favorites. Winged creatures drew his attention also, not only for their forms, but for their iridescence. Charles de Kay in *The Artwork of Louis Comfort Tiffany* states that Favrile glass "is distinguished by certain remarkable shapes and brilliant or deeply toned colors, usually iridescent like the wings of certain American butterflies, the necks of pigeons and peacocks, the wing-covers of various beetles."

Even colorful stones and volcanic rock dug from the earth lent their complex structures to Tiffany's work. His Agate vases imitated the layers of color found in true agate, as well as in the chalcedony glass of Venice. Lava glass was often irregular in shape to give the effect of a molten flow.

Whatever the influence or impetus that led Louis Comfort Tiffany to draw so widely and deeply upon nature, it was always part of his quest of beauty. Nature's vivid colors, provocative and diverse forms, and sensuous surfaces inspired Tiffany throughout his lifetime, leading him, as Siegfried Bing noted, to present "Nature in her most seductive aspects."

Detail cat. 58

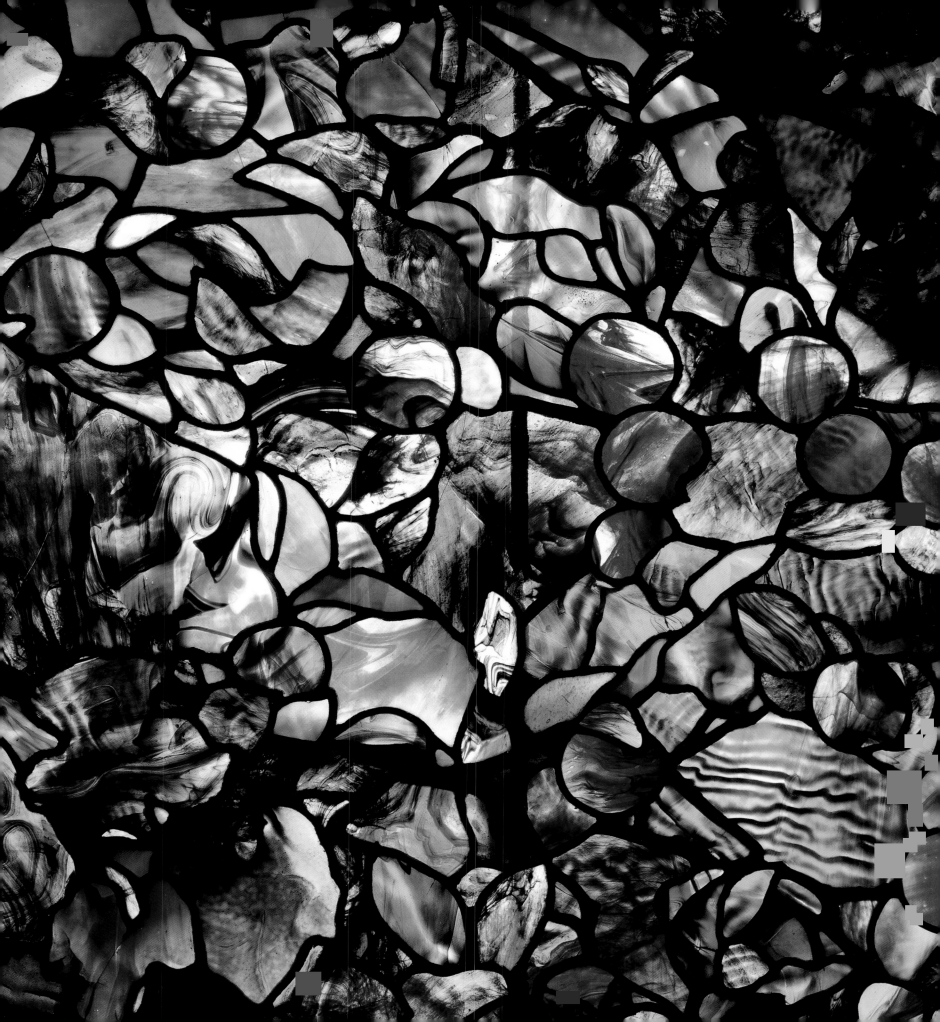

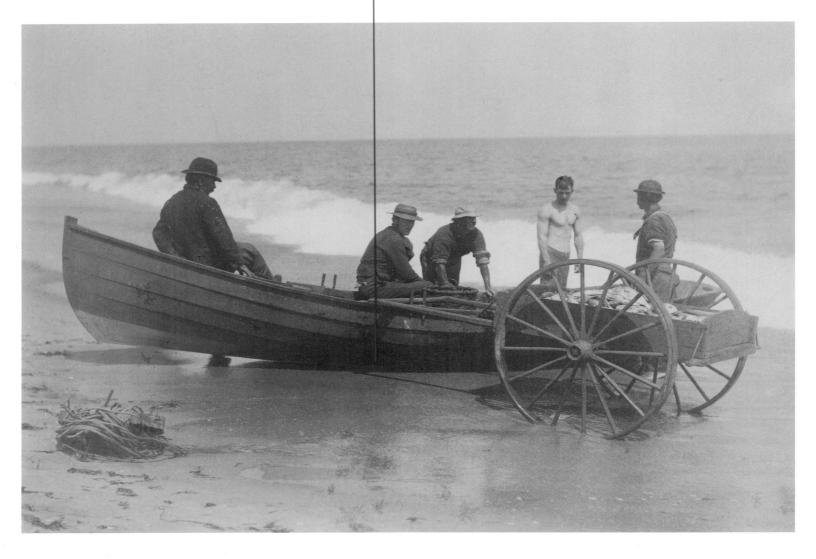

Fig. 51
Louis Comfort Tiffany,
"Fishermen Unloading a
Boat, Sea Bright, New
Jersey 1887," albumen
print on paper mounted
on board, Smithsonian
American Art Museum,
Museum purchase from
the Isaacs Collection made
possible in part by the
Luisita L. and Franz H.
Denghausen Endowment,
1994.181.

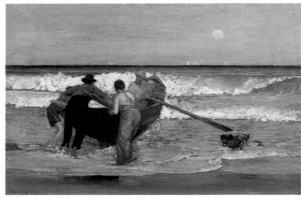

Cat. 15
*Pushing Off the Boat,
Sea Bright, New Jersey*
1887
Oil on canvas
Marks: signed *Louis C.
Tiffany 87*
24 x 36 in. (unframed)
30¾ x 42½ in. (framed)
Private Collection

In the 1880s, Tiffany made a
series of paintings that
record scenes of life in the
fishing village of Sea Bright,
New Jersey, which he also
recorded in photographs
(see fig. 51). Here, four men
struggle to launch a small
boat, pitting themselves
against the powerful,
breaking waves. The
influence of Winslow Homer,
who often treated the theme
of men confronting the sea,
is apparent in this picture.
Tiffany exhibited the
painting at the National
Academy of Design in 1888
and at the Exposition
Universelle in Paris in 1889.

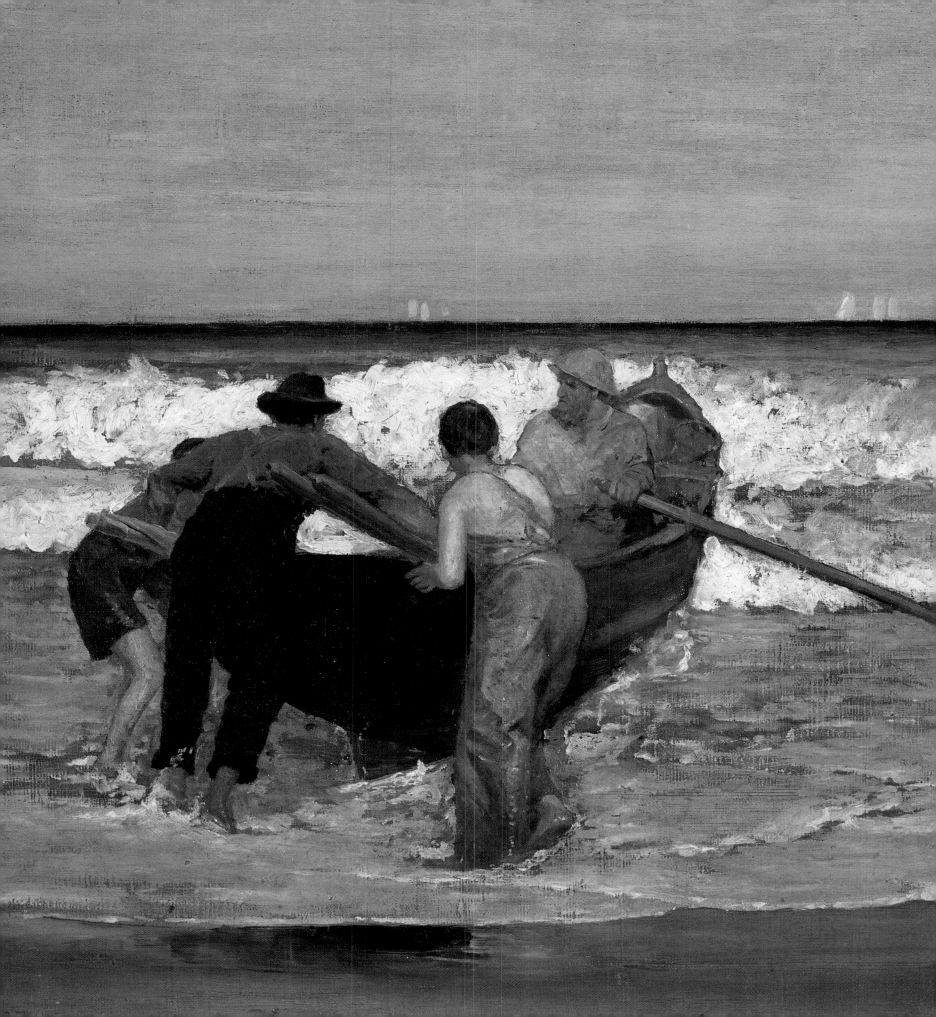

Cat. 16
Design for an Enamel: "Seaweed"
c. 1900–10
Watercolor on paper
Marks: *Louis C. Tiffany 9041 10*; monogram of Tiffany Glass and Decorating Co.
10⅞ x 14 in.
Museum of the City of New York, gift of Grace M. Mayer, 58.326.2

Tiffany's interest in the infinite variety of natural forms extended to the realm of the sea. This nearly abstract image is a study of a tangled skein of seaweed. A small enamel-on-copper box, formerly in the Crawford Collection at the High Museum of Art, has a design of entwined tentacular forms in red, orange, and black that seems to be derived from this or a very similar study (Zapata, 1993, p. 50, fig. 10).

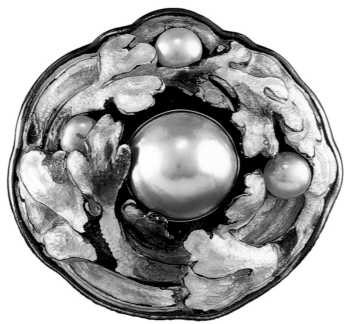

Cat. 17
Seaweed-Motif Brooch
c. 1906
Gold, pearls, enamel
Marks: signed *Tiffany & Co.*
1½ x 1½ in.
Neil Lane Collection

Tiffany was drawn to naturally occurring iridescence. Pearls, precious treasures of the sea, lurk here beneath overlapping strands of seaweed. The motif reminds us of a design of tangled seaweed (see cat. 16) intended for enamel decoration, as well as of the pearly bubbles that erupt through the surface of a Lava vase (see cat. 31) or are caught in the claws of a weird candlestick (see cat. 104).

Cat. 18
Tortoiseshell Vase
c.1915
Glass
Marks: paper label *Tiffany Favrile Glass Registered Trademark*; monogram *TGDCO*; etched *°9192 Louis Comfort Tiffany*
12¼ x 7¾ x 7¾ in.
The Johns Hopkins University, Evergreen House, 40.1.92

The amber color and markings give this glass vase the appearance of tortoiseshell. The pattern spirals around the vessel from the bulbous foot to a wide flaring mouth. The shape is reminiscent of Islamic mosque lamps. Tortoiseshell, actually harvested from a marine turtle, is, along with coral and mother-of-pearl, one of the precious materials derived from the sea.

Note: Robert Koch (Koch 1977, p. 174) and Paul E. Doros (Doros 1978, p. 22–23) proposed a concordance of the registry numbers on Tiffany glass with the dates of its production. While no doubt subject to caution, their chart offers an approximate guide that we have followed whenever possible.

Cat. 19
Window Panel with Starfish
From the Four Seasons
Under the Sea series
1895–1900
Leaded glass
60 x 25 in. (unframed)
64¾ x 29¾ in. (framed)
Carl Heck, Aspen, Colorado

Cat. 20
Window Panel with Sea Anemone
From the Four Seasons
Under the Sea series
1895–1900
Leaded glass
60 x 25 in. (unframed)
64¾ x 29¾ in. (framed)
Carl Heck, Aspen, Colorado

These two leaded-glass panels with a monochromatic green-brown palette are from a set of four windows that transfer the classic theme of the Four Seasons to the marine realm. We might be peering from a bathyscaphe into a world where aquatic creatures pursue their mysterious life cycles. Irregular, horizontal bands of wavy glass imitate the rippling effect of sunlight passing through water.

Each panel is divided into two zones by a light-colored band. The narrow panel at the top is again bisected, showing us the surface of the water with the sky above. The long lower pane reveals the depths of the sea. The panel with small starfish floating up from below may represent Spring. The panel with sea anemone, a species common in warm, tropical waters, most likely shows us Summer. Two additional panels from this series have central, medallion-like circles. In one, with an upper panel that represents a choppy sea, is a fishing net scooping up crabs, most likely alluding to crab season in the Fall. In the fourth window, with an upper panel showing the sharp peaks of icebergs, we witness a spinning school of fish. This panel is certainly Winter. The four windows were formerly in the collection of the Museum of Modern Art, a gift from Joseph Heil, an early collector of Tiffany's work. They were published by Maurice Rheims in *The Flowering of Art Nouveau* (Abrams, 1966).

Related works include a leaded-glass panel in which two fish cavort above wavy fronds of seaweed. Called "Deep Sea" when it was exhibited in Brussels at La Libre Esthétique in 1896, at the Grafton Gallery in London in 1899, and at the Exposition Universelle in Paris in 1900, the panel is now in the Tiffany Garden Museum, Matsue, Japan. In another window, also from that collection, a fish bowl is suspended above water in which a large fish swims around an abstract brown vortex—perhaps chasing its own reflection in a mirrored sphere. Tiffany enjoys the illusions and deceptions that are common to water, glass, and mirrors.

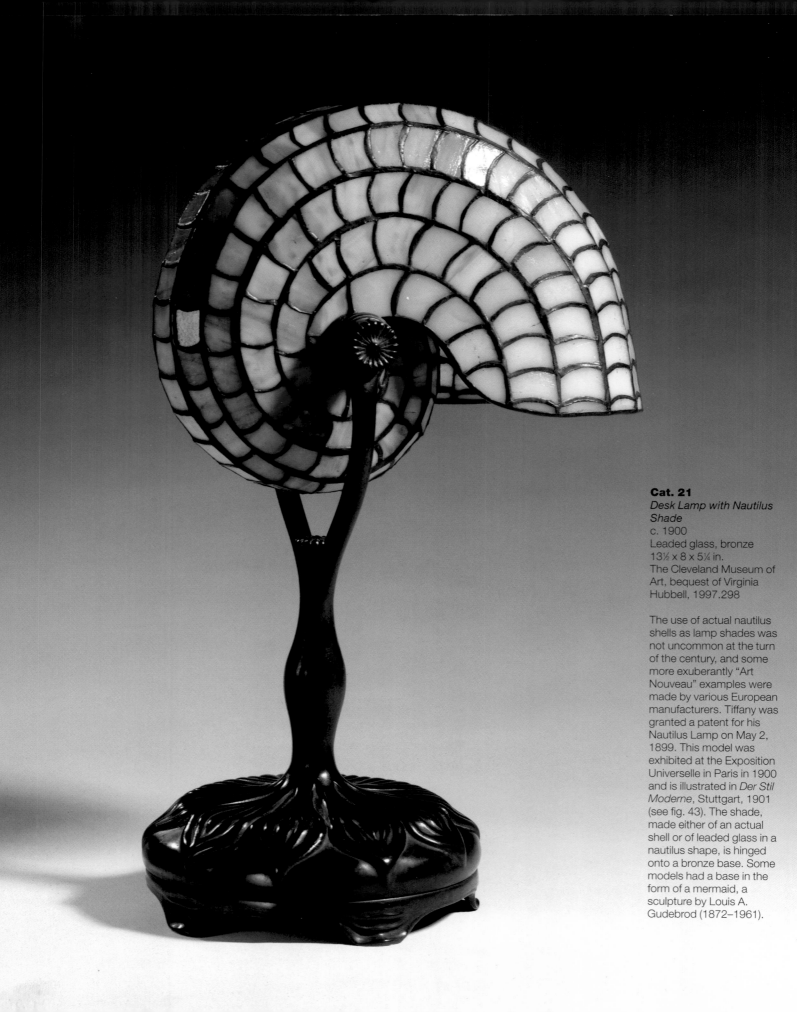

Cat. 21
Desk Lamp with Nautilus Shade
c. 1900
Leaded glass, bronze
13½ x 8 x 5¼ in.
The Cleveland Museum of Art, bequest of Virginia Hubbell, 1997.298

The use of actual nautilus shells as lamp shades was not uncommon at the turn of the century, and some more exuberantly "Art Nouveau" examples were made by various European manufacturers. Tiffany was granted a patent for his Nautilus Lamp on May 2, 1899. This model was exhibited at the Exposition Universelle in Paris in 1900 and is illustrated in *Der Stil Moderne*, Stuttgart, 1901 (see fig. 43). The shade, made either of an actual shell or of leaded glass in a nautilus shape, is hinged onto a bronze base. Some models had a base in the form of a mermaid, a sculpture by Louis A. Gudebrod (1872–1961).

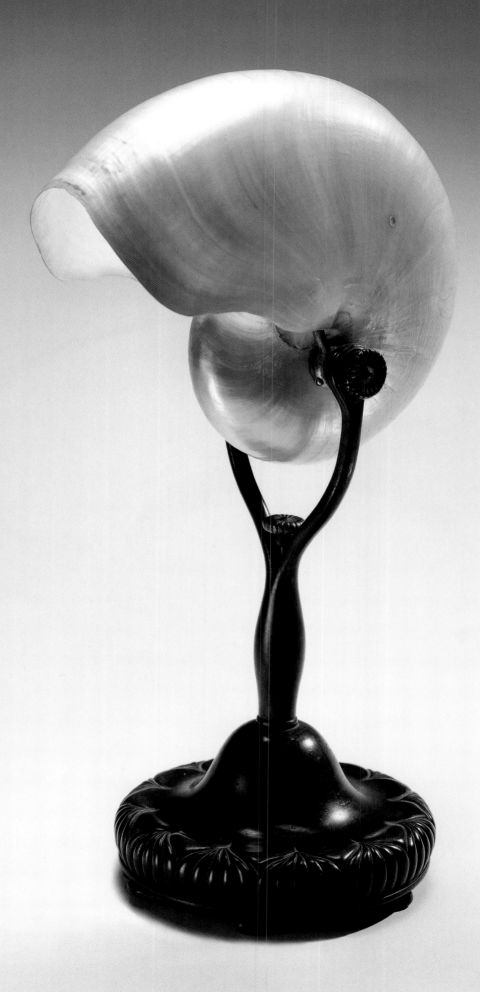

Cat. 22
Desk Lamp with Nautilus Shade
c. 1900
Nautilus shell, bronze
Marks: base stamped
Tiffany Studios New York D797 with monogram of
Tiffany Glass and
Decorating Company
13½ x 8 x 5¼ in.
The Mark Twain House &
Museum, Hartford, CT,
1959.57

Cat. 23
*Aquamarine Vase
with Sea Life*
c. 1913
Glass
Marks: *5194 Gr. L.C.
Tiffany-Favrile*
4¾ in. high
The Corning Museum of
Glass, Corning, NY, gift of
Ellen D. Sharpe 54.4.63

Tiffany's Aquamarine glass, developed in 1912, used the paperweight technique in which sections of colored glass canes are embedded in heavy clear glass that acts as a lens, enlarging the watery world inside. This outer glass is tinted a faint blue-green, giving the teasing effect that one looks into an underwater realm. There is also an implied allusion to the watery blue of the semiprecious beryl of the same name. Robert Koch tells us, "Arthur Saunders, the glass blower, was sent by Tiffany on an all-expense paid trip to the Bahamas with instructions to spend as much time as possible looking at underwater life from a glass-bottom boat" (Koch 1977, p. 20).

In this example, a colony of sea anemones clings to the rocks in what seems to be a small tide pool. Suzanne K. Frantz suggests that its "sensuous realism has more in common with the Symbolist's exploration of the dark side of Nature ... than with the stylized curves of art nouveau." (Bruhn 1995, p. 34).

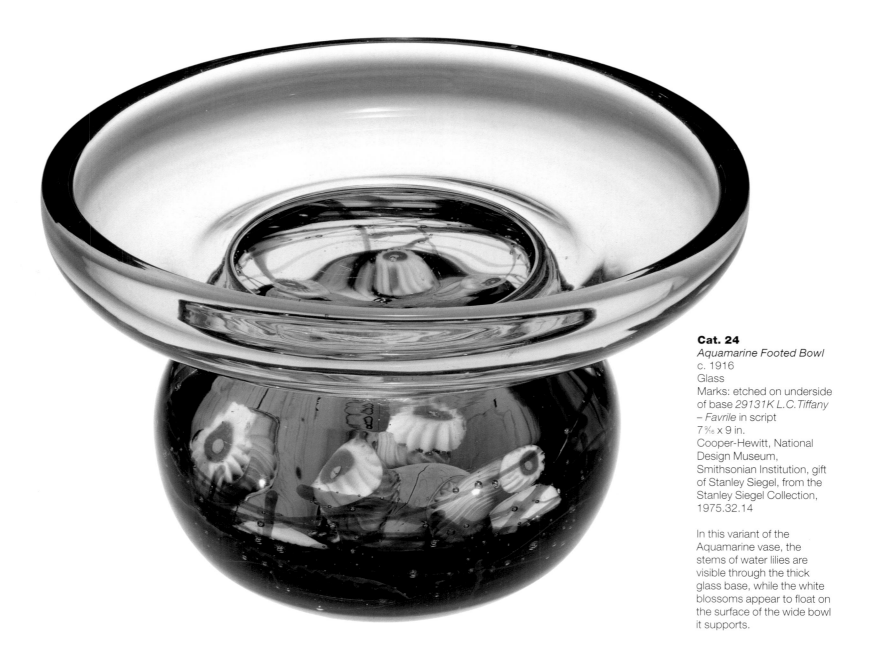

Cat. 24
Aquamarine Footed Bowl
c. 1916
Glass
Marks: etched on underside of base *29131K L.C. Tiffany – Favrile* in script
7 ⁹⁄₁₆ x 9 in.
Cooper-Hewitt, National Design Museum, Smithsonian Institution, gift of Stanley Siegel, from the Stanley Siegel Collection, 1975.32.14

In this variant of the Aquamarine vase, the stems of water lilies are visible through the thick glass base, while the white blossoms appear to float on the surface of the wide bowl it supports.

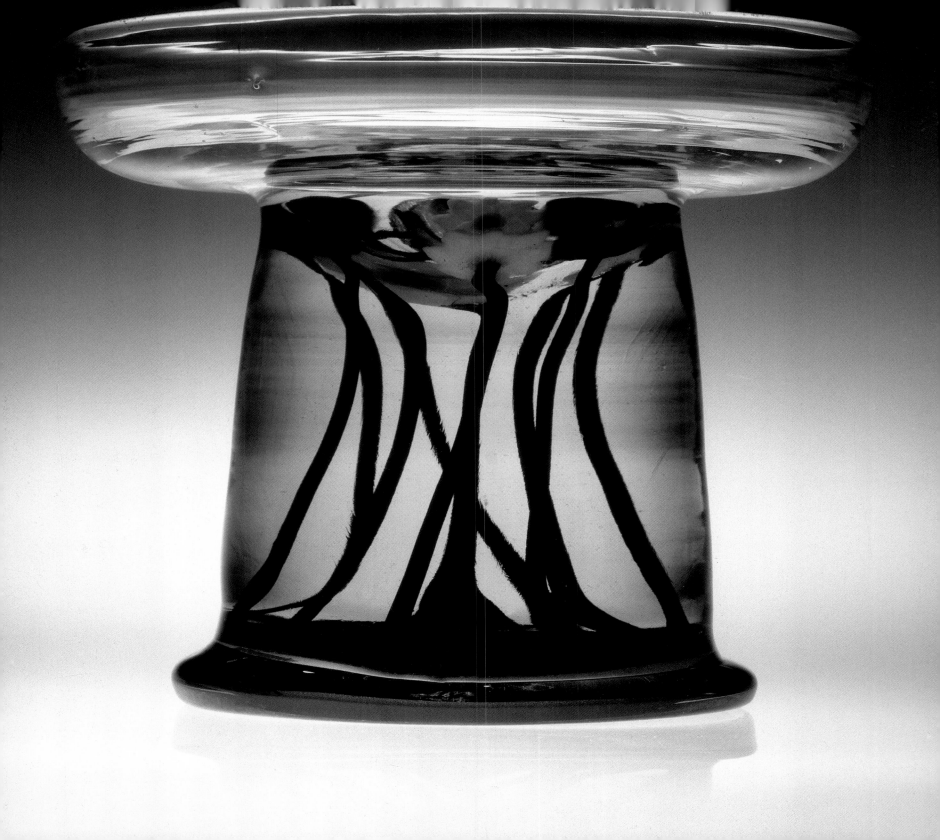

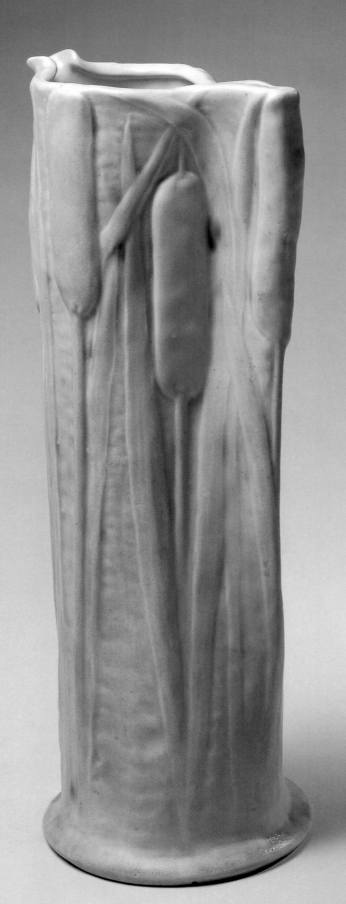

Cat. 25
Water Pitcher with Cattails
c.1905–14
Pottery with yellow glaze
Marks: *LCT 7 P609 LC*
Tiffany Pottery
12 x 4⅛ in.
Tiffany & Co. Archives,
I 1994.4

This tall vessel has been
pinched to create a spout.
The motif, a stand of
cattails, is appropriate for a
water pitcher. There was a
naturalistically colored
enamel version of this
design (Christie's New
York, 12 December 1997,
Lot 160). A drawing for a
similar jug is preserved in
one of the Nash albums,
but that design includes a
large duck among the
cattails; the ceramic pitcher
is reproduced in a
photograph in another of
these albums (Christie's
New York, 8 December
2000, Lot 301, illus. p. 127;
Lot 311, illus. p. 39, top "E").

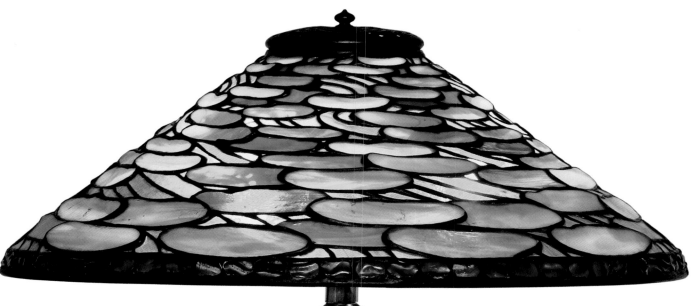

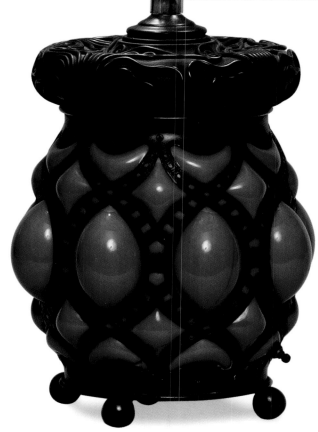

Cat. 26
Lamp with Lily-Pad Motif
1899–1910
Leaded glass, blown glass, bronze
Marks: stamped on metal tag inside shade *TIFFANY STUDIOS NEW YORK 145*; impressed on base *TIFFANY STUDIOS, N.Y.*
23¾ x 20 x 20 in.
The New-York Historical Society, N84.50

The pattern of slightly overlapping acid-green ovals of graduated size that rings this conical shade would appear to be a purely abstract design. In fact, it evokes the flat leaves of water lilies floating over the surface of a pond. Although Tiffany does not drop the reference to the natural world, its hold grows tenuous. We might be reminded of the early studies of water by Mondrian, which eventually segued into arrangements of pure line. The base of this lamp is an example of glass blown into a bronze cage. The bright green glass bulges through the openings, mirroring the oval lily pads above.

Cat. 27

Agate Vase
c. 1898
Glass
Marks: *LCT H 242*
4½ in. high
The Corning Museum of
Glass, Corning, NY,
50.4.523

The earliest man-made glass was not transparent. Core-formed glass vessels from Mesopotamia and Egypt were opaque, often with colored striations to make them resemble vessels carved from precious stones. *Calcedonio*, glass made to imitate chalcedony, jasper, and other semiprecious stones, was invented in Venice in the late fifteenth century, and the technique was revived in the nineteenth century.

Tiffany's Agate glass continues this tradition of imitating hard stones in the medium of glass. To make Agate glass, glasses of differing colors were mixed at a low enough temperature to keep them in distinct layers. Agate glass was quite thick and was usually cut in facets to reveal the swirls of color that are a characteristic of the stone they mimic. In this example, the surface is further animated with a series of raised ribs. In an interview published in 1925, Tiffany is quoted as saying, "The possibilities of glass for duplicating the most precious creations of nature are almost uncanny, and history proves that these possibilities have been known to the artist for thousands of years" (Tait 1925).

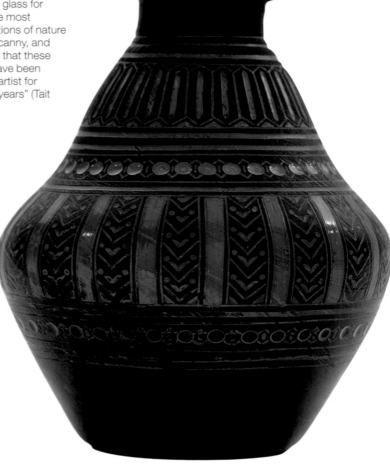

Cat. 28

Agate Vase
1893–96
Glass
Marks: rectangular applied label *3807*; oval applied label *20.°°*; circular applied label *Tiffany Favrile Glass/ Registered Trademark TG DC*
5½ x 4½ x 4½ in.
National Museum of American History, Smithsonian Institution, 30453, (Catalogue #96440), collected by Mr. Charles Tiffany, purchased by the S.I.

This is a rare example of "failed" glass—the surface unexpectedly turned brown in the furnace. To salvage the piece, geometric ornament consisting of bands of ribs, beads, and chevrons was created by cutting through the dark outer layer to reveal the yellow and green glass below. This is one of the thirty-nine glass vessels that the Smithsonian Institution acquired from Tiffany in 1896.

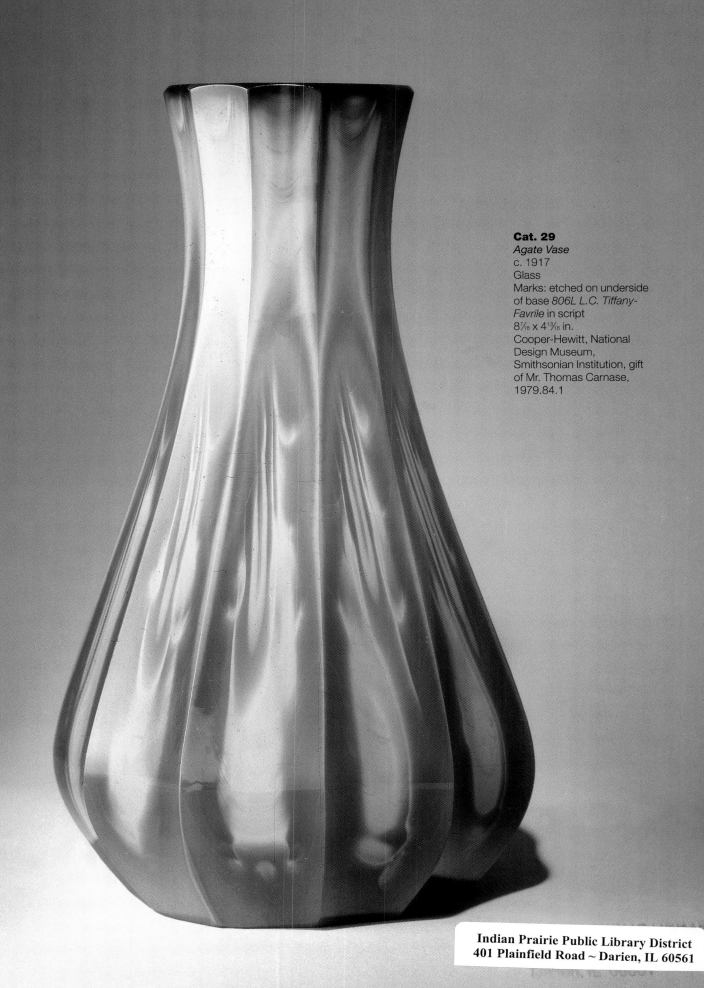

Cat. 29
Agate Vase
c. 1917
Glass
Marks: etched on underside
of base *806L L.C. Tiffany-
Favrile* in script
8⁷⁄₁₆ x 4¹³⁄₁₆ in.
Cooper-Hewitt, National
Design Museum,
Smithsonian Institution, gift
of Mr. Thomas Carnase,
1979.84.1

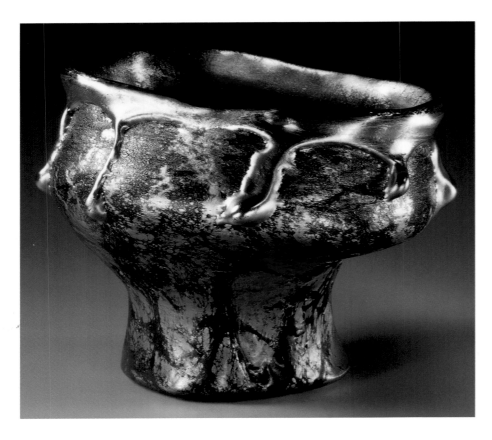

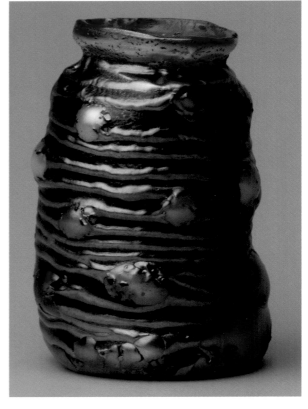

Cat. 30
Lava Vase
c. 1918
Glass
Marks: *6492M L.C. Tiffany Inc. Favrile Exhibition Piece*
5 x 3½ x 5⅞ in.
The Chrysler Museum of Art, Norfolk, VA, gift of Walter P. Chrysler, Jr
71.6198

Lava glass was the most radical of Tiffany's experimental techniques, said to have been inspired by Mount Etna. Tiffany and R. Swain Gifford had traveled to Sicily in 1870. The blackened surface was coated with particularly thick, iridescent gold. The irregular texture gave the appearance of a violent natural phenomenon and emphasized the uncanny quality of molten glass that is similar to the primal magma.

Molten streams of gold ooze over the crater-like rim of this squat, misshapen vessel. It illustrates Tiffany's precocious appreciation of the irregular and accidental. That this piece is marked "Exhibition Piece" further confirms that this was an aesthetic preference. Walter Chrysler, an early collector who acquired this vase for his personal collection, particularly admired Tiffany's Lava glass.

Cat. 31
Lava Vase
1915
Glass
Marks: *7265J – L.C. Tiffany, Favrile*
4⅝ x 2 x 2 in.
The Museum of Modern Art, New York, Edgar Kaufmann, Jr. Fund, 1947.192.1947

In this piece, large pearlescent bubbles seem to erupt from the depths. Tiffany showed a similar vase in Paris in 1906 and presented it to the Musée des arts décoratifs the next year (Loring 2002, p. 153; Joppien 1999, #168, p. 167). This glass was difficult to make and not many examples are known. Edgar Kaufmann, Jr., one of the first to appreciate these radical experiments, chose this piece for his own collection and reproduced it in his pioneering article on Tiffany's work in glass (Kaufmann 1955).

Cat. 32

Inkstand with Mushroom Cluster

c. 1902
Enamel on copper
Marks: *EL 180; LOUIS C. TIFFANY*
4⅛ x 4¼ x 6¼ in.
The Chrysler Museum of Art, Norfolk, VA, gift of Walter P. Chrysler, Jr., 71.2692

Tiffany & Co. had created a sensation at the Paris Exposition Universelle in 1889 with a collection of realistically rendered enamel brooches based on rare exotic orchids. Louis Comfort Tiffany's own enamels are deliberately based on native American plants and insects, often humble varieties. Meticulous watercolor studies for many of them are extant.

This small sculpture is a realistic, life-size depiction of a clump of flat-capped mushrooms. The tallest has a removable top that conceals an inkwell. Tiffany retained this piece in his private collection. The Louis Comfort Tiffany Foundation sold it in an auction in 1946 for $35 (in a lot that also included an enamel vase). Two watercolor drawings by Julia Munson for this piece are preserved in the notebook of Leslie Nash (Loring 2002, p. 122).

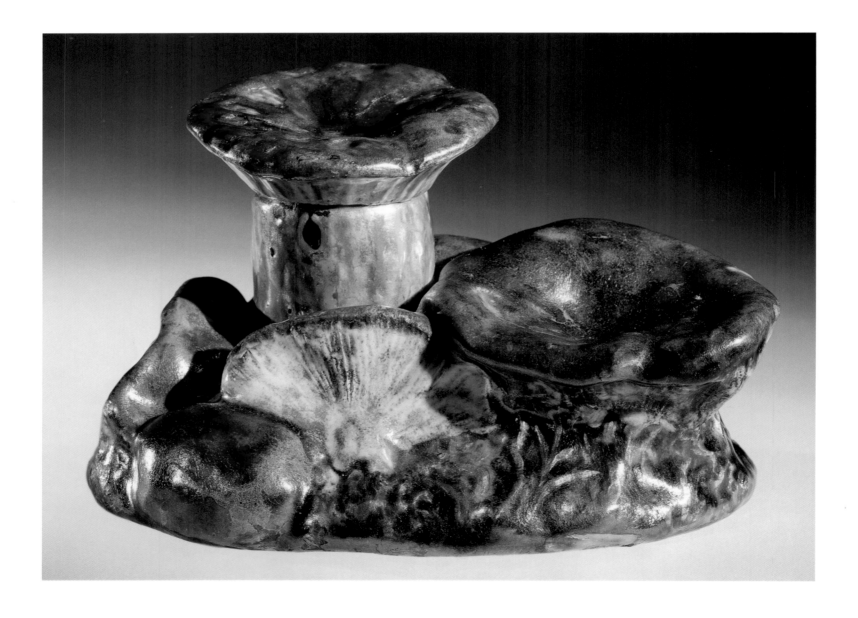

Cat. 33

*Flower Container
with Smilax*
c. 1902
Enamel on copper
Marks: *TIFFANY STUDIOS*;
SG43
7¼ x 8½ x 8½ in.
The Chrysler Museum of
Art, Norfolk, VA, gift of
Walter P. Chrysler, Jr.,
71.2691

Tiffany showed this work for the first time at the Exposition Universelle in Paris in 1900. This flower container, the first known of Tiffany's series of large enamel bowls, is decorated in relief with an autumnal motif of a thorny vine with vivid orange leaves and deep purple berries that has been identified as the smilax known as greenbriar. The top is covered with a pierced latticework lid to hold the stems of flowers. The preparatory drawing for this piece by Julia Munson is preserved in the scrapbook of Leslie Nash now in the Tiffany Archives (see fig. 52). Tiffany often used his enamel pieces as molds for his ceramics. The pottery version of this bowl was displayed at the Paris Salon in 1906.

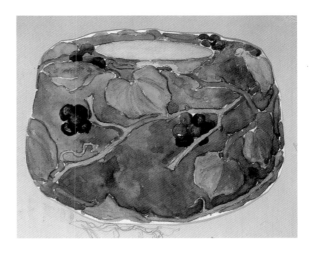

Fig. 52
Watercolor, design for enamel flower container with smilax, Nash Collection, vol. 4, p. 134, Tiffany & Co. Archives, 2004.

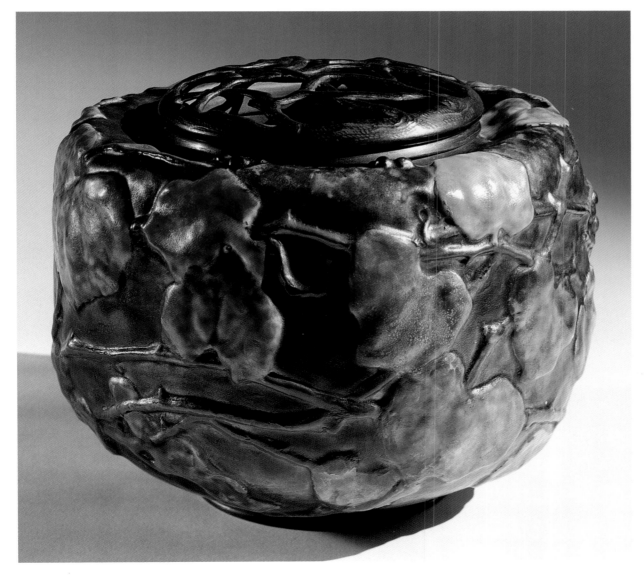

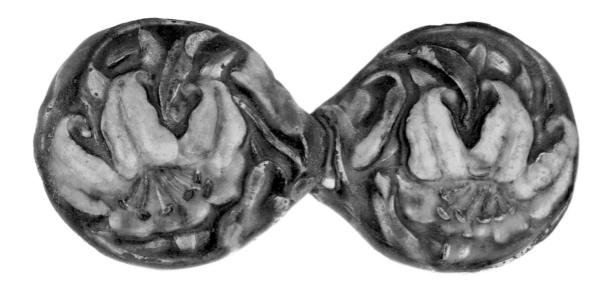

Cat. 34
Cloak Clasp with Tiger Lilies
c. 1904
Enamel on copper
Marks: *EL 260; LCT*
1⅜ x 3⅜ in.
Tiffany & Co. Archives, A2004.07

This clasp with a relief design of twin Turk's cap tiger lilies is a rare example of enamel-on-copper jewelry.

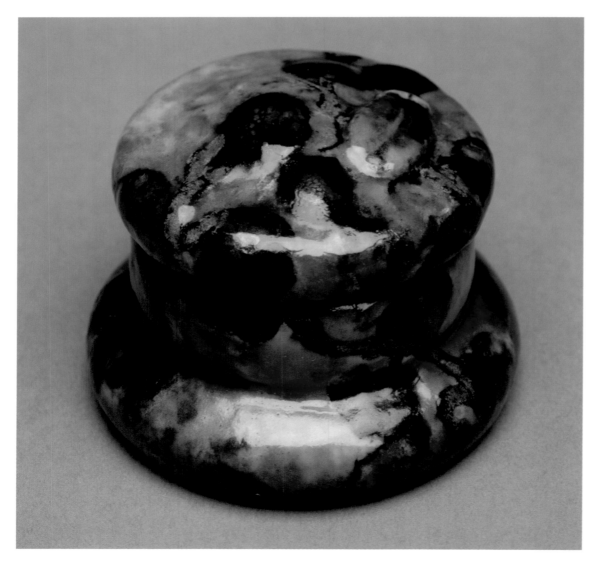

Cat. 35
Enamel Box with Blueberries and Beetle
c. 1898–1904
Enamel on copper
Marks: *Louis C. Tiffany; EL 27*; etched *590/10*
2 x 3 x 3 in.
Private Collection

The surface of this covered box is a mottled yellow-orange against which purplish berries are silhouetted. These seem to be common blueberries, so it may be conjectured that the large insect on the domed lid is a blueberry leaf beetle.

Cat. 36

Vase
c.1900–06
Enamel on copper
Marks: inscription, #27 in
Nash inventory, incised *EL
68 L.C.T. Favrile Pot,
opaque*
2½ x 3¼ x 3¼ in.
Herbert F. Johnson
Museum of Art, Cornell
University, gift of Louis
Comfort Tiffany through the
courtesy of A. Douglas
Nash, 57.099

Although models in nature
were the point of departure
for enamel designs, the
plants studied were often
uncommon, and the
reference can be obscure
for the uninitiated viewer.
On this small bowl, we find
an almost abstract relief
pattern of contrasted shapes
and textures. Rose, lavender,
and yellow lancet leaves or
petals seem to split open to
reveal a core of round,
pearl-like green seeds.

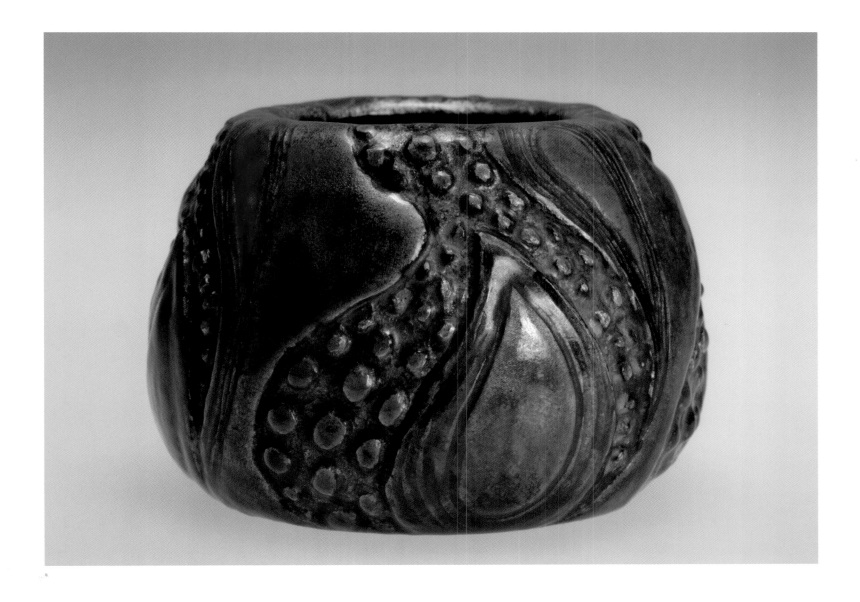

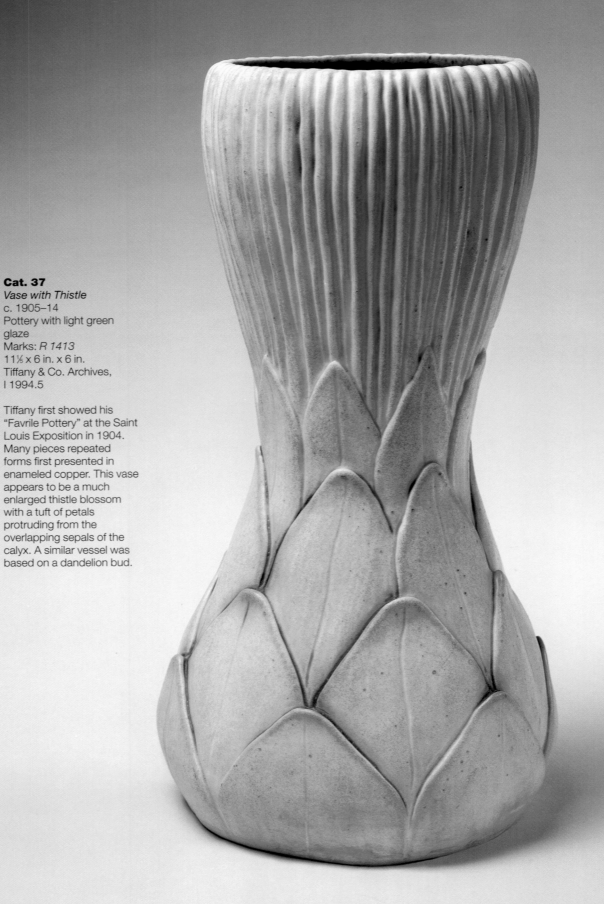

Cat. 37
Vase with Thistle
c. 1905–14
Pottery with light green
glaze
Marks: *R 1413*
11⅛ x 6 in. x 6 in.
Tiffany & Co. Archives,
I 1994.5

Tiffany first showed his
"Favrile Pottery" at the Saint
Louis Exposition in 1904.
Many pieces repeated
forms first presented in
enameled copper. This vase
appears to be a much
enlarged thistle blossom
with a tuft of petals
protruding from the
overlapping sepals of the
calyx. A similar vessel was
based on a dandelion bud.

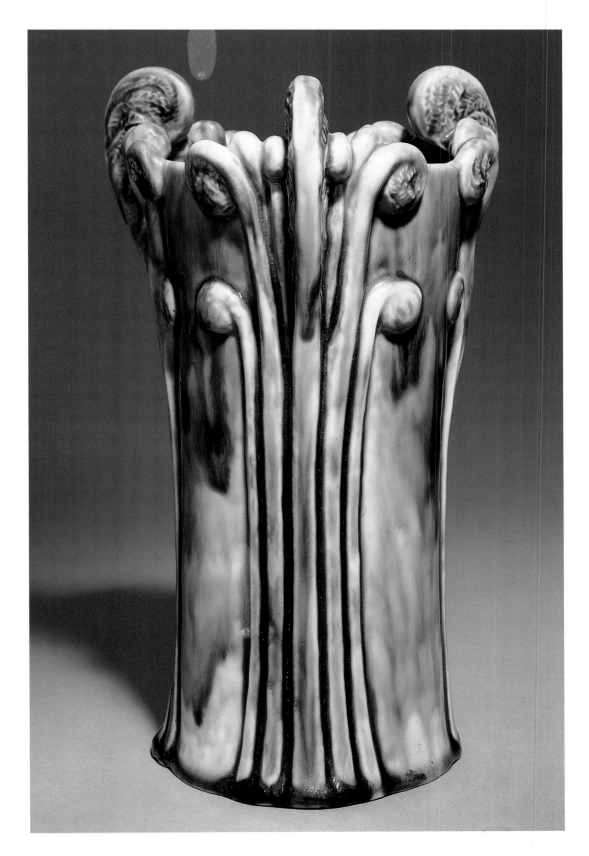

Cat. 38
Vase with Fern Fronds
1905–14
Pottery
Marks: incised *LCT* cipher
9¼ x 5 x 5 in.
Collection of The Newark
Museum, purchased 1975,
Wallace M. Scudder
Bequest Fund, 75.160

Unfolding fiddleheads seem
to mime the natural creation
of form in nature. Watercolor
studies of ferns, stamped
Tiffany Furnaces, are in a
private collection (Zapata
1993, p. 59), and a design
for an enamel vase similar to
this one is preserved in the
Tiffany & Co. Archives (see
fig. 53).

Fig. 53
Watercolor, design for
enamel vase with fern
fronds, Nash Collection, vol.
3, p. 124, Tiffany & Co.
Archives, 2004.

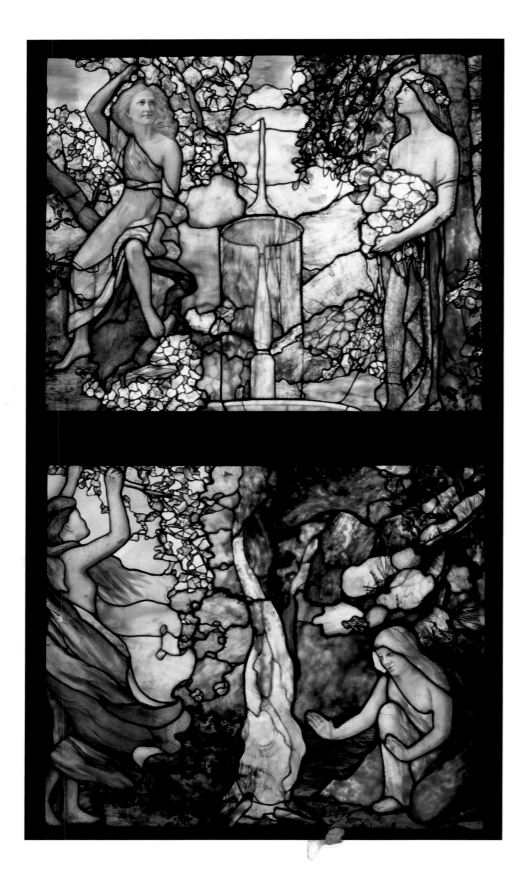

Cat. 39
Two Window Panels:
The Four Seasons
From the Walter Jennings
House
Tiffany Glass and
Decorating Company
1897
Leaded glass
78 x 45 in.
Private Collection, courtesy
Stephen M. Cadwalader,
Jason McCoy, Inc., New
York

Walter Jennings, a founder of
Standard Oil, commissioned
these two panels in 1897
for Burrwood, his country
house at Cold Spring
Harbor, Long Island. The
windows are illustrated in
*Tiffany Studios: Memorials
in Glass and Stone* (1913).
Burrwood was demolished
in 1995.

The Four Seasons are
personified by four maidens
in classical drapery. Spring
and Summer flank a crystal
fountain. The former sits
amid blossoming boughs;
the latter cradles an
abundance of flowers and
fruits. Autumn and Winter
are similarly placed beside
the mounting flames of a
fire. Tiffany has used all the
resources of the irregularly
colored glass to suggest the
glow of fire, the hazy veil of
smoke, and the mobile
transparency of water.

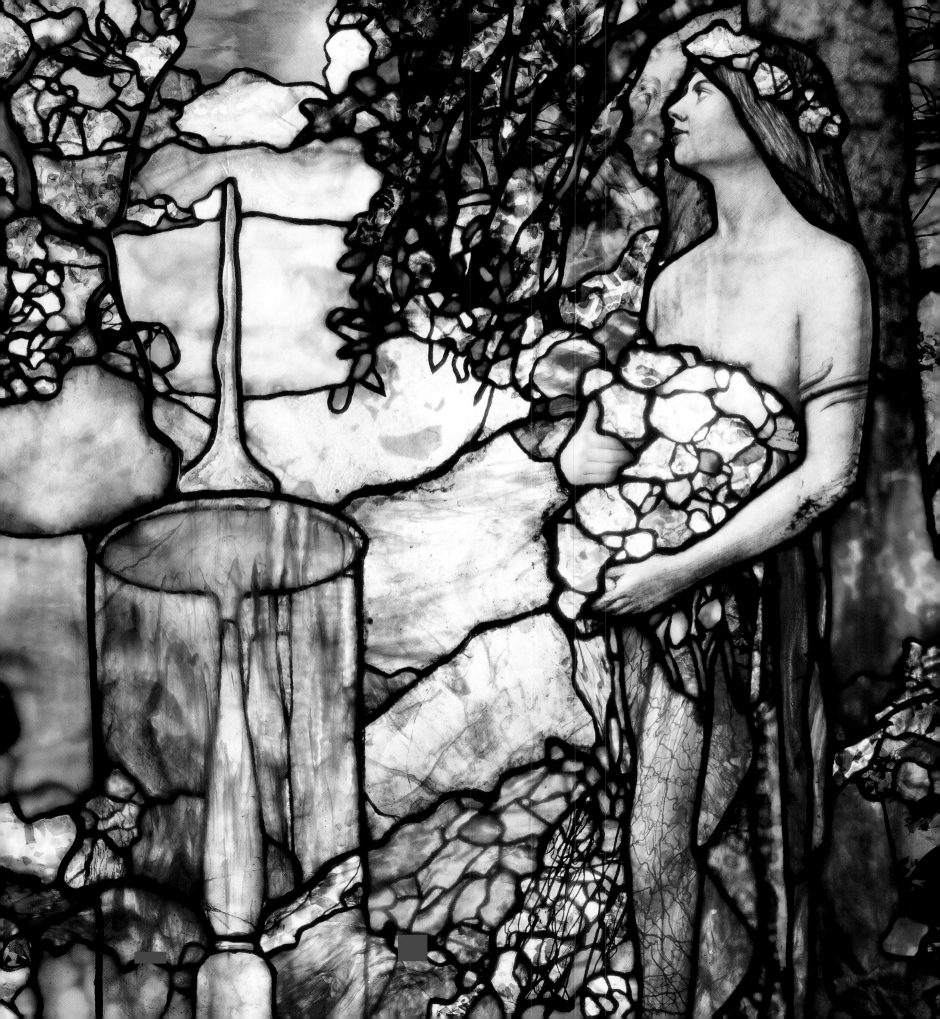

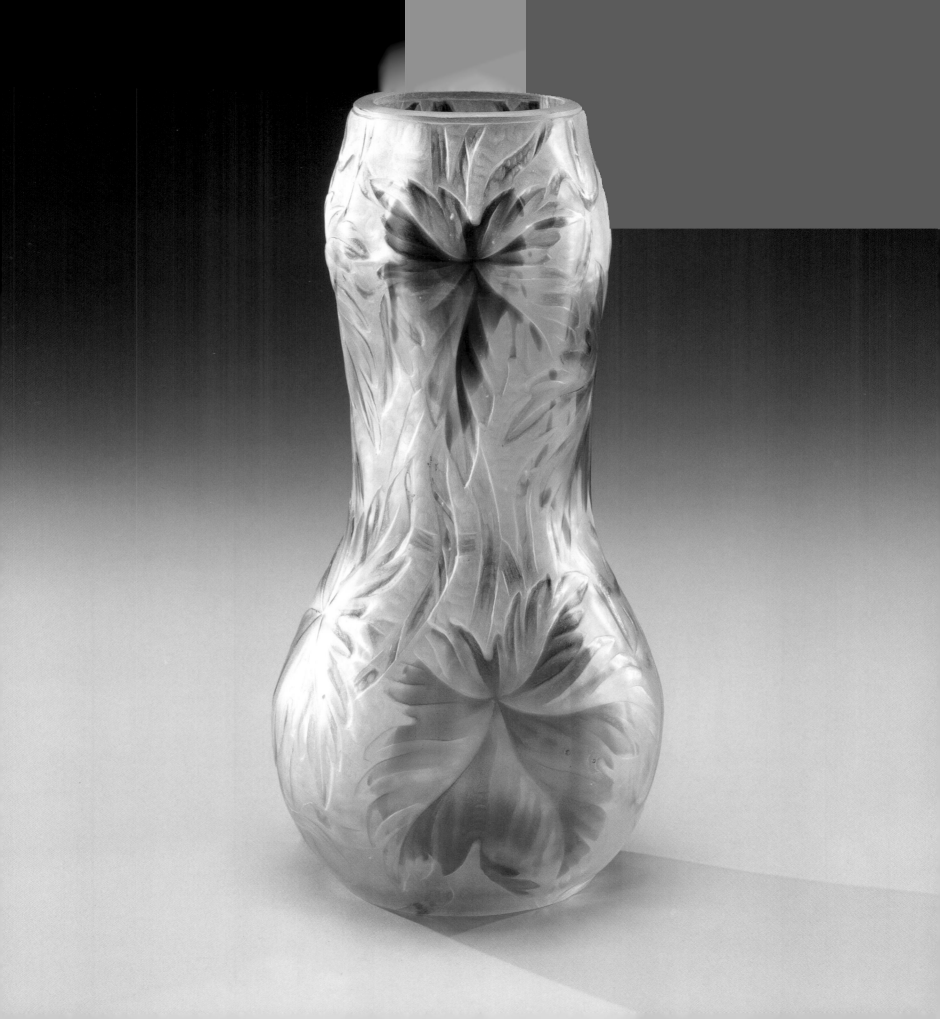

Cat. 40
Vase
Tiffany Studios
c.1908
Glass
Marks: *L.C. Tiffany – Favrile 5433C*
9 in. high
New Orleans Museum of Art, museum purchase, Linda Lobman Memorial Fund, 1995.192

Cat. 42
Vase
Tiffany Studios
c. 1915
Glass
Marks: *L.C. Tiffany – Favrile 2632L*
8⅞ x 4½ x 4½ in.
New Orleans Museum of Art, museum purchase, 1985 Decorative Arts Discretionary Purchase Fund, 1985.09

Cat. 41
Vase
1902
Glass
Marks: *L.C.T. R999*
4½ x 3 x 3 in.
The Museum of Modern Art, New York, Phyllis B. Lambert Fund, 1957.89.1957

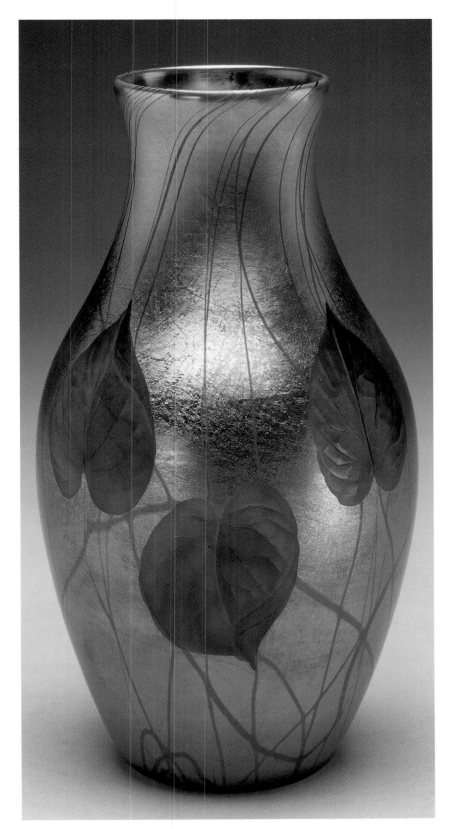

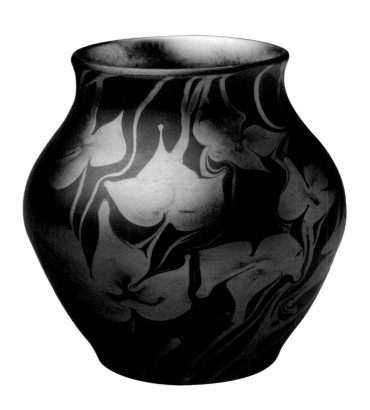

Cat. 43
Floral Study
c. 1920
Cyanotype photograph on original mount
9⅜ x 7½ in.
Allen Memorial Art Museum, Oberlin College, Oberlin, OH, Fund for Photography in honor of Ellen H. Johnson and Art Museum Gift Fund, 1991, 91.3

Louis Comfort Tiffany's interest in photography is well documented. He had a large collection of photographs by others that he marked with a stamp and used as documentation for his work. He was also an active and avid photographer. This is a cyanotype (after the characteristic blue color), a photographic image made directly from a negative onto paper prepared with iron salts that is exposed to sunlight. Such prints were often used as first proofs. It is a study of a blooming epiphyllum, a form of cactus with showy flowers and wide, leaf-like stems. These jungle plants, native to Mexico, Central and South America, often grow in tree crevices much like orchids. Tiffany is known to have cultivated many exotic plants at Laurelton Hall.

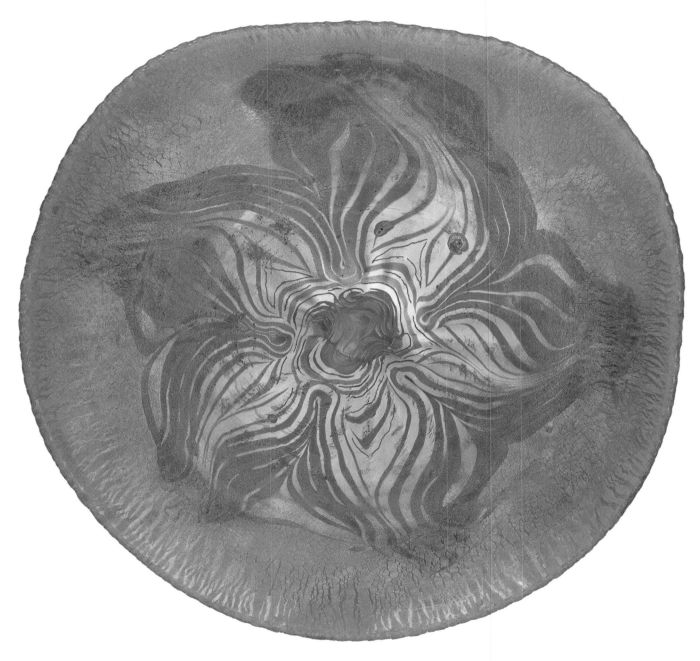

Cat. 44
Plaque
1893
Glass
Marks: on bottom *x 2280*;
on paper label *T G D Co*
[conjoined]
13⅟₁₆ x 13⅟₁₆ in.
The Metropolitan Museum
of Art, gift of H. O.
Havemeyer, 1896, 96.17.53

Favrile glass plaques and
plates are uncommon. This
was one of four roundels
included in the gift of fifty-six
pieces of Tiffany glass that
H. O. Havemeyer presented
to The Metropolitan
Museum of Art in 1896.
They were, Mr. Havemeyer
affirmed, the finest pieces
produced to date, selected

by Louis Comfort Tiffany
himself. The disk displays a
five-part motif that
resembles at once the
petals of a lily and the
petalloids of a sand dollar,
hinting at the underlying
geometric structure of all
natural forms.

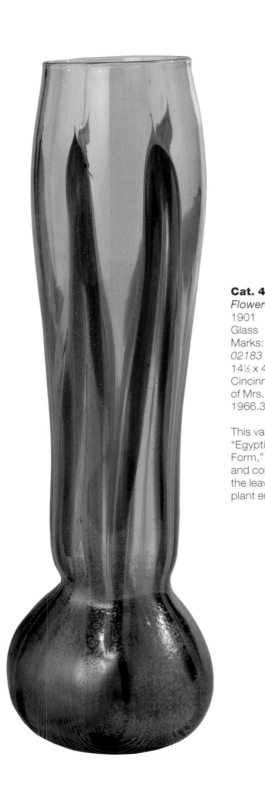

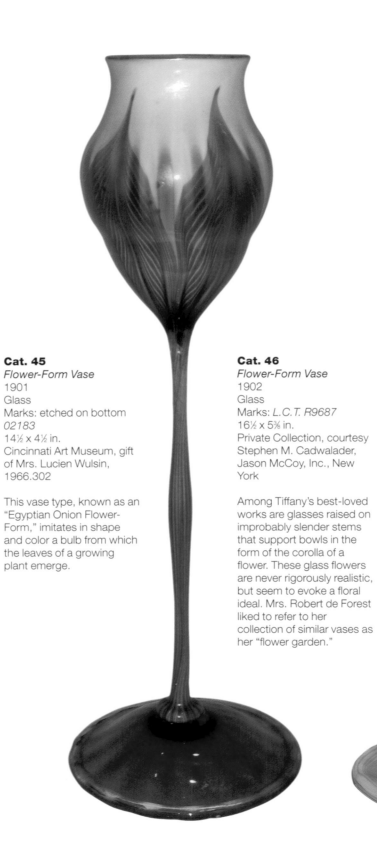

Cat. 45
Flower-Form Vase
1901
Glass
Marks: etched on bottom
02183
14½ x 4½ in.
Cincinnati Art Museum, gift
of Mrs. Lucien Wulsin,
1966.302

This vase type, known as an
"Egyptian Onion Flower-
Form," imitates in shape
and color a bulb from which
the leaves of a growing
plant emerge.

Cat. 46
Flower-Form Vase
1902
Glass
Marks: *L.C.T. R9687*
16½ x 5⅜ in.
Private Collection, courtesy
Stephen M. Cadwalader,
Jason McCoy, Inc., New
York

Among Tiffany's best-loved
works are glasses raised on
improbably slender stems
that support bowls in the
form of the corolla of a
flower. These glass flowers
are never rigorously realistic,
but seem to evoke a floral
ideal. Mrs. Robert de Forest
liked to refer to her
collection of similar vases as
her "flower garden."

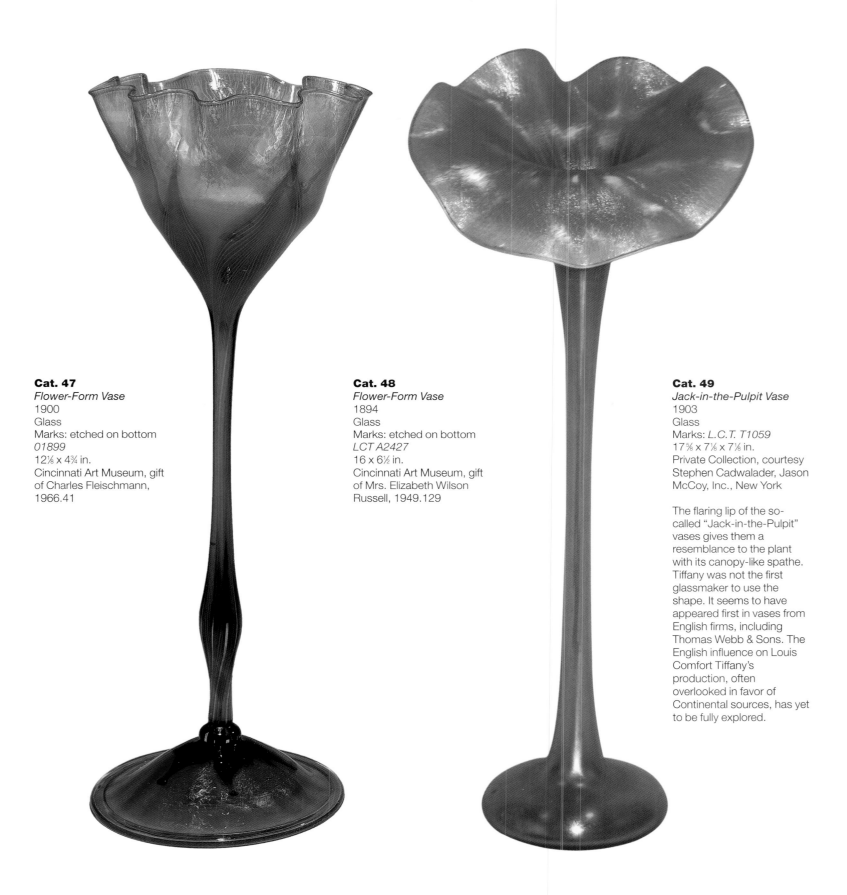

Cat. 47
Flower-Form Vase
1900
Glass
Marks: etched on bottom
01899
12⅛ x 4¾ in.
Cincinnati Art Museum, gift
of Charles Fleischmann,
1966.41

Cat. 48
Flower-Form Vase
1894
Glass
Marks: etched on bottom
LCT A2427
16 x 6½ in.
Cincinnati Art Museum, gift
of Mrs. Elizabeth Wilson
Russell, 1949.129

Cat. 49
Jack-in-the-Pulpit Vase
1903
Glass
Marks: *L.C.T. T1059*
17⅝ x 7⅛ x 7⅛ in.
Private Collection, courtesy
Stephen Cadwalader, Jason
McCoy, Inc., New York

The flaring lip of the so-
called "Jack-in-the-Pulpit"
vases gives them a
resemblance to the plant
with its canopy-like spathe.
Tiffany was not the first
glassmaker to use the
shape. It seems to have
appeared first in vases from
English firms, including
Thomas Webb & Sons. The
English influence on Louis
Comfort Tiffany's
production, often
overlooked in favor of
Continental sources, has yet
to be fully explored.

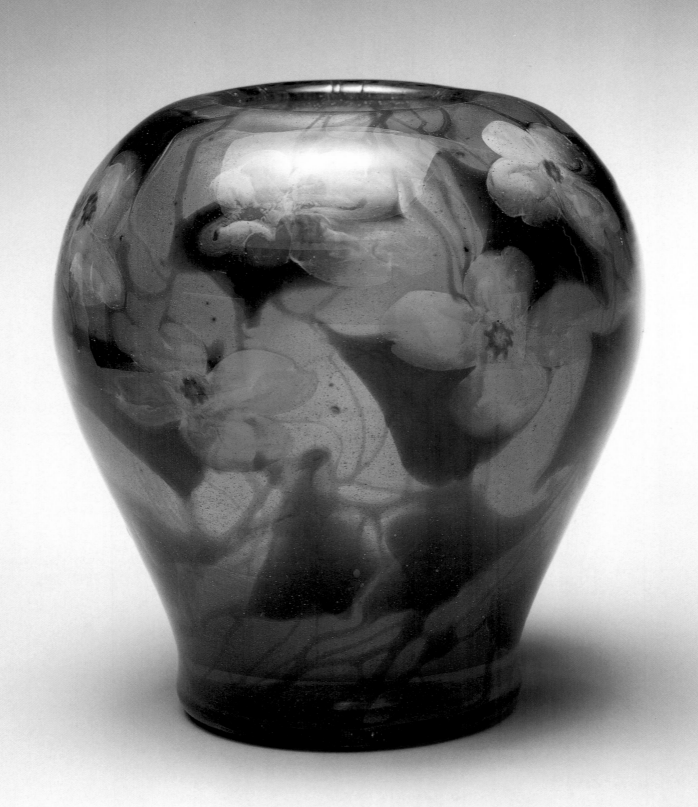

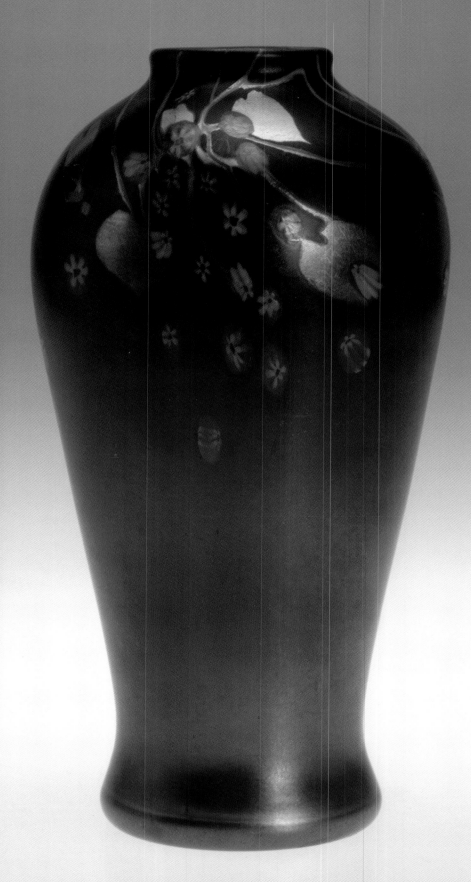

Cat. 50
Vase with Millefiori Decoration
c. 1905
Glass
Marks: etched *U6007 Louis C. Tiffany*
5¾ x 5¼ x 5¼ in.
The Johns Hopkins University, Evergreen House, 1940.1.98

On this squat vessel white dogwood blossoms appear against a golden ground. Known since Roman times, the millefiori technique is a means of producing pattern in glass by incorporating disk-like sections cut from a cane of fused colored glass strands. Traditionally, these rosettes were tiny; Tiffany uses them here for large bold flowers. The vase has been cased in heavy clear glass.

Cat. 51
Vase with Millefiori Decoration
1921 or earlier
Glass
Marks: inscription, #10 in Nash inventory, incised *10.1382 P L.C.T. Favrile*
6½ x 3½ x 3½ in.
Herbert F. Johnson Museum of Art, Cornell University, gift of Louis Comfort Tiffany through the courtesy of A. Douglas Nash, 57.106

The upper part of this tall green vase is sprinkled with small, star-like flowers created using the millefiori technique.

Arthur Douglas Nash (1881–1940) was a son of Arthur J. Nash (1849–1934), the chief designer at Edward Webb, White House Glass Works near Stourbridge, England, whom Louis Comfort Tiffany recruited to oversee his Corona, Long Island glass factory. A. Douglas Nash was assistant manager of Tiffany Furnaces. When Tiffany Furnaces closed in 1924, the A. Douglas Nash Company was created to carry on production, but it could not survive the financial crash in 1929.

Cat. 52
Vase with Pansies
c. 1901
Glazed stoneware
Marks: monogram incised
on bottom *LCT*
10⅜ x 4½ x 4½ in.
Everson Museum of Art,
gift of Bronson A.
Quackenbush, 78.40.7

Among the works produced
in enamel on copper was a
series of cylindrical vases
with various motifs of flora
or fauna. Many of these
were later used as molds for
ceramic pieces such as this.
A version of this pansy vase
in Favrile bronze pottery
(ceramic electroformed with
copper that Tiffany first
offered in 1908) was
formerly in the collection of
Joseph Briggs (Loring 2002,
pp. 218–19).

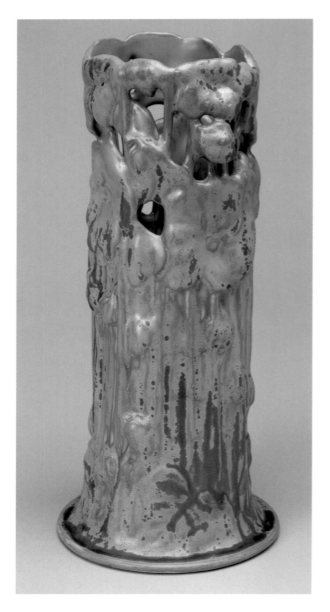

Cat. 53
Laburnum Floor Lamp
Before 1910
Leaded glass, bronze
Marks: shade signed; *1537*
78 x 24 x 24 in.
Courtesy of The Neustadt
Museum of Tiffany Art, New
York, 1986.8U8

The golden racemes of the
laburnum tree, native to
Europe but brought to
America by early settlers,
have sometimes caused it
to be called "golden rain" or
"golden chain." The top of
the shade is composed of
crisscrossed branches and
green foliage from which the
tapering clusters of
blossoms hang down to
form an irregularly scalloped
edge. Glimpses of the
complementary blue sky
sharply define the deep
yellow florets. The pattern is
repeated three times. The
perforated finial takes the
form of an exotic Persian
dome.

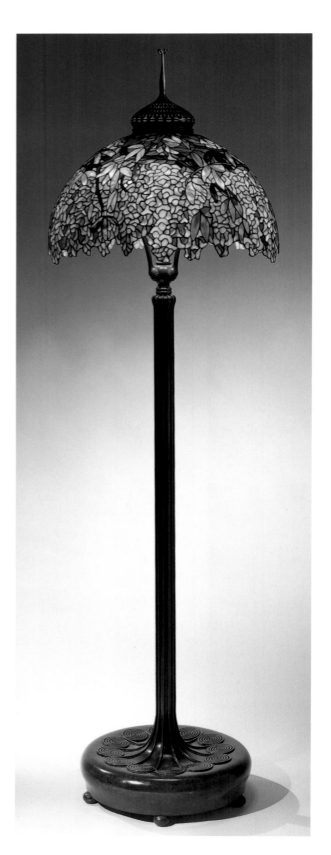

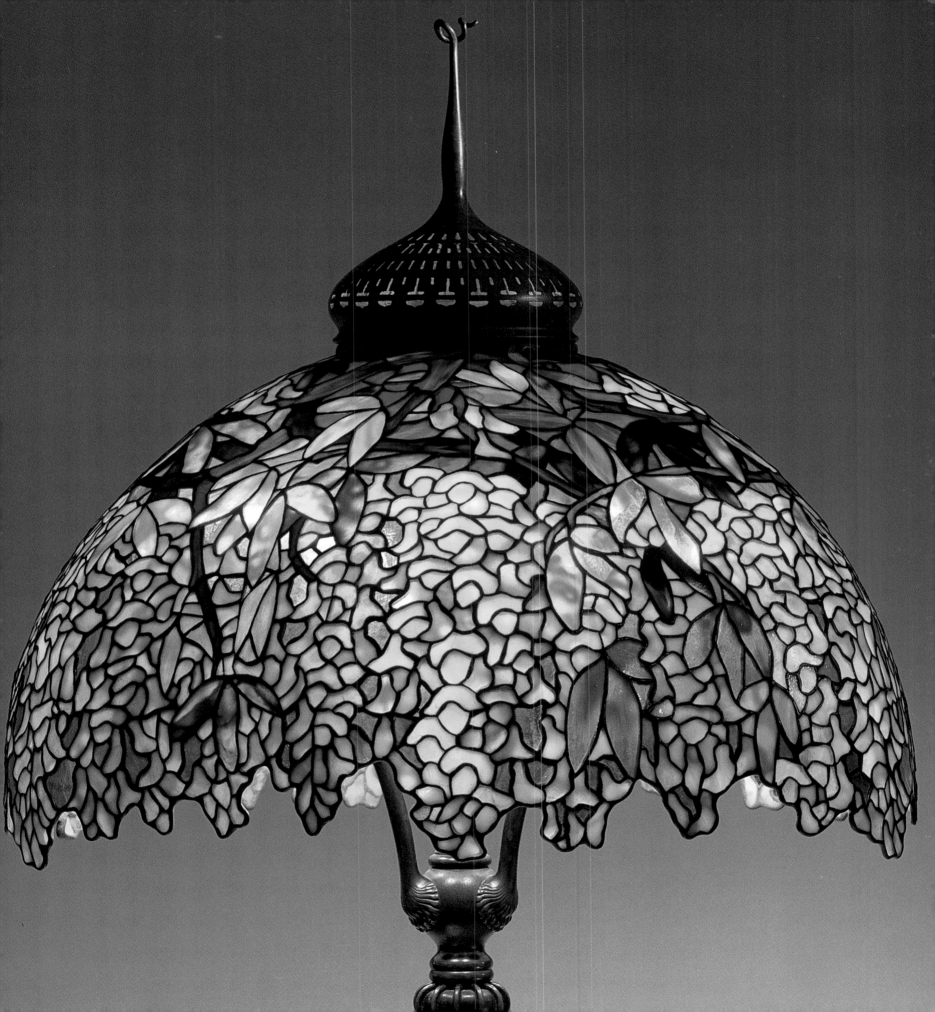

Cat. 54

Stenciled Velvet with Morning Glory Pattern
c. 1908
Silk velvet stenciled with vegetable dyes
8⅝ x 12 in.
The Cleveland Museum of Art, gift of Joseph F. Sindelar, 1948.102

This is one of the rare surviving examples of textiles designed by Louis Comfort Tiffany. He chose motifs that are prevalent throughout his work— dragonflies, leaves, and, here, morning glories. The technique is of interest: the design, in subtle, muted colors has been stenciled on velvet. This may remind us of the experiments with stenciled velvets that Mariano Fortuny was pursuing in Venice in the same period.

Cat. 55

Morning Glory Vase
c. 1905
Glass
Marks: vase etched *L.C.T./Y1300*; insert etched *Y1300*
7¼ x 5 x 5 in.
Museum of the City of New York, gift of Mrs. Carnegie Miller in memory of her mother, Mrs. Andrew Carnegie, 46.351.9 a, b

This vase from the collection of Mrs. Andrew Carnegie is decorated with morning glory blossoms using the millefiori technique. There is a separate inner liner of iridescent Favrile glass. A similar vase with insert is in the Chrysler Museum of Art (Doros 1978, #9, p. 26 and 27). The morning glory, a flower that opens at dawn only to fade as the light withdraws at day's end, was a common symbol of mortality.

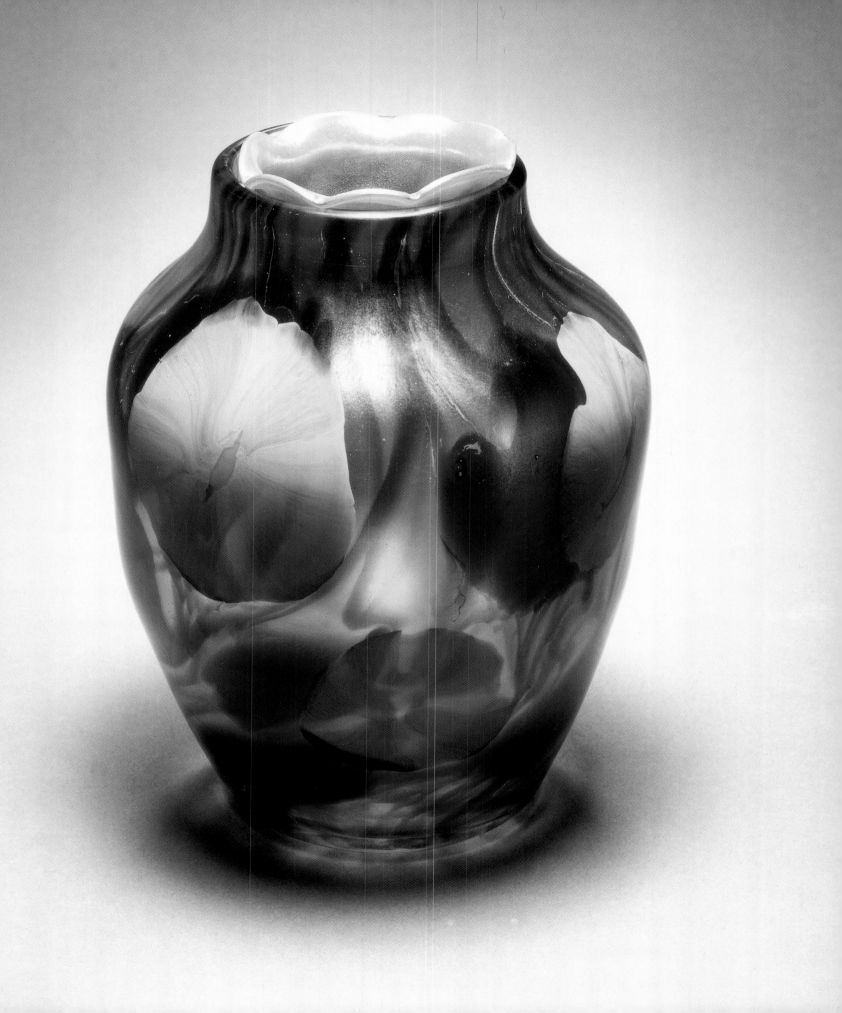

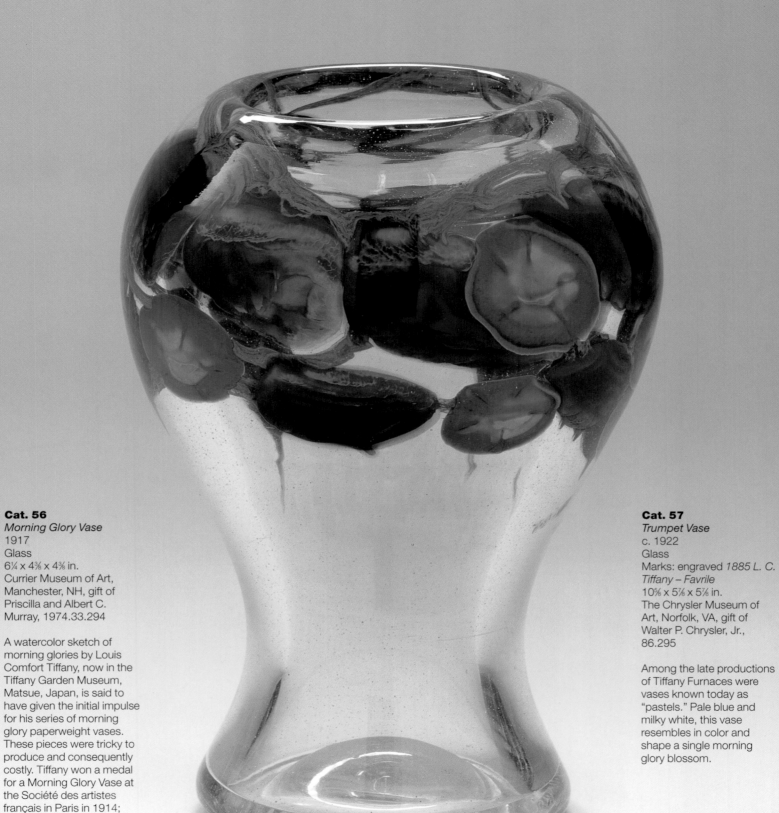

Cat. 56
Morning Glory Vase
1917
Glass
6¼ x 4⅜ x 4⅜ in.
Currier Museum of Art,
Manchester, NH, gift of
Priscilla and Albert C.
Murray, 1974.33.294

A watercolor sketch of
morning glories by Louis
Comfort Tiffany, now in the
Tiffany Garden Museum,
Matsue, Japan, is said to
have given the initial impulse
for his series of morning
glory paperweight vases.
These pieces were tricky to
produce and consequently
costly. Tiffany won a medal
for a Morning Glory Vase at
the Société des artistes
français in Paris in 1914;
examples were also shown
at the Panama Pacific
Exposition in San Francisco
in 1915.

Cat. 57
Trumpet Vase
c. 1922
Glass
Marks: engraved *1885 L. C.
Tiffany – Favrile*
10⅝ x 5⅞ x 5⅞ in.
The Chrysler Museum of
Art, Norfolk, VA, gift of
Walter P. Chrysler, Jr.,
86.295

Among the late productions
of Tiffany Furnaces were
vases known today as
"pastels." Pale blue and
milky white, this vase
resembles in color and
shape a single morning
glory blossom.

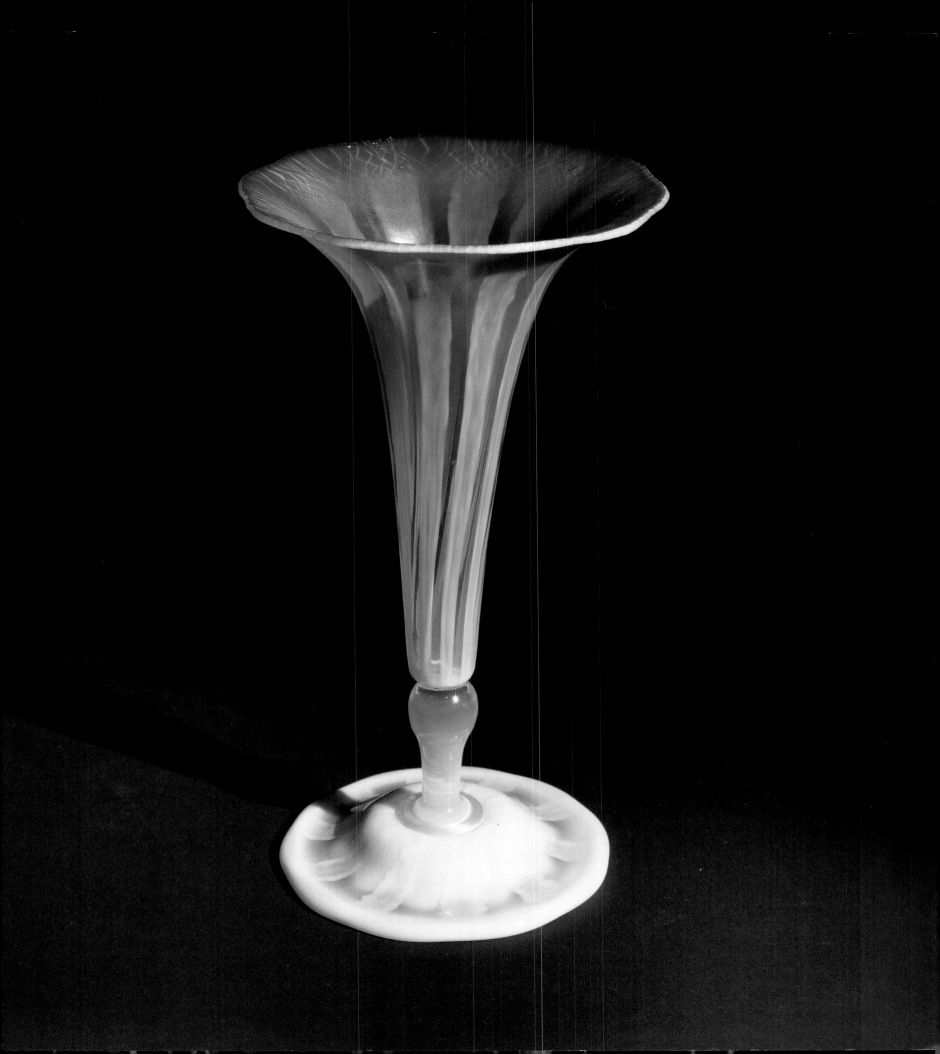

Cat. 58
Window Panel with Red Apples on a Branch
From the Monument Street Garrett House
c. 1885
Leaded glass
30⁷⁄₁₆ x 25 in.
The Baltimore Museum of Art, BMA 1979.176

Cat. 59
Window Panel with Autumn Leaves
From the Monument Street Garrett House
c. 1885
Leaded glass
30⁷⁄₁₆ x 25 in.
The Baltimore Museum of Art, BMA 1979.177

Tiffany designed a series of richly patterned windows for the house occupied by Mary Elizabeth Garrett, a member of a prominent Baltimore family. In one panel, the fruit-laden branches of an apple tree are silhouetted against an intensely blue sky; in another, golden yellow leaves surround clusters of purple grapes that hang from a sturdy vine. A third window (see fig. 14) depicts two suspended fish bowls amid an abundance of fruit and flowers.

Nothing is static—the varying colors and textures of the glass give a sense of vibrating light and movement.

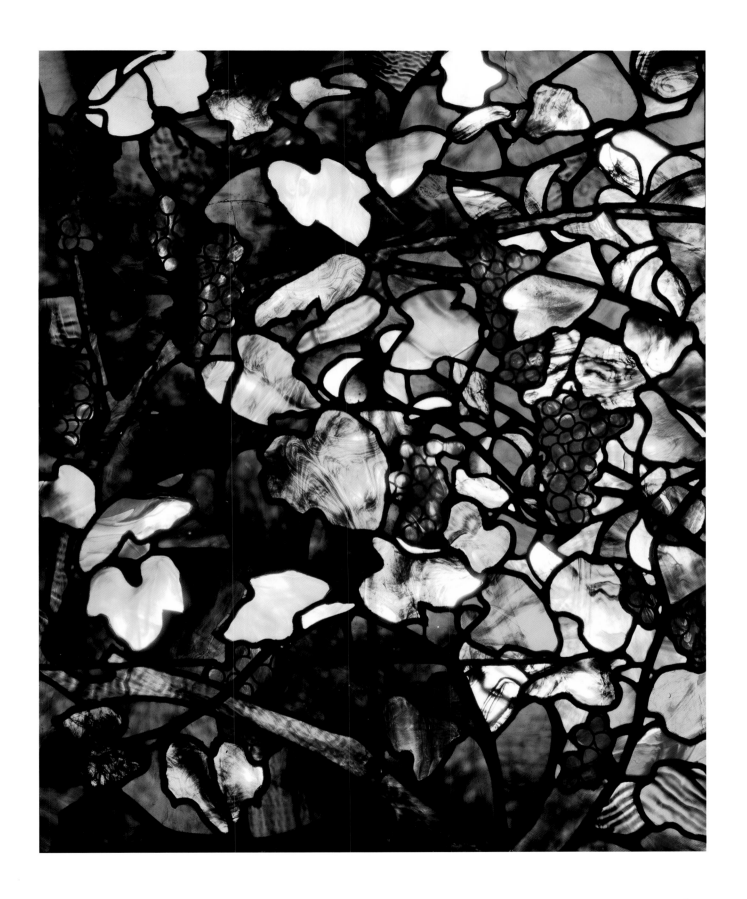

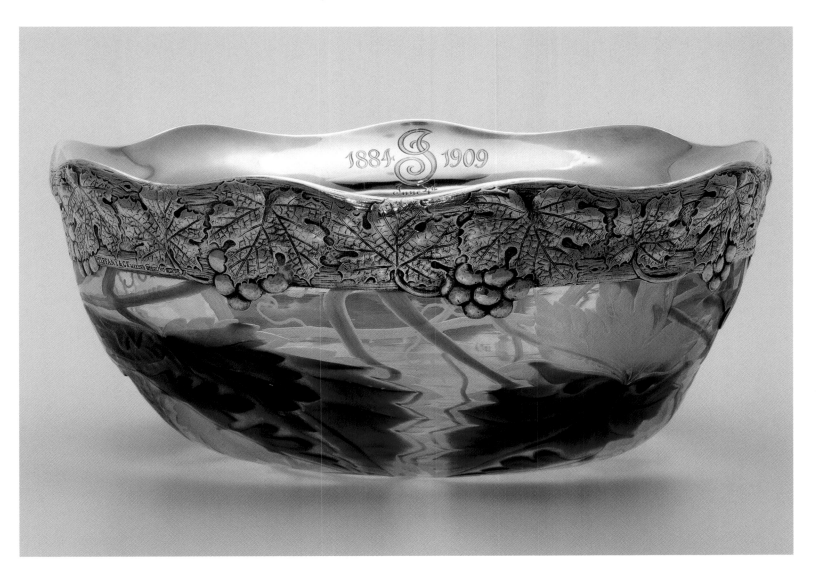

Cat. 60
Bowl with Silver Rim in Grapevine Pattern
c. 1909
Glass, sterling silver
Marks: *L.C. Tiffany 7486B*;
hallmark *Tiffany & Co.
MAKERS STERLING
SILVER*; inscription incised
inside rim *1884-CS-1909
June 4th*
4¾ x 10¾ x 10¾ in.
The Chrysler Museum of
Art, Norfolk, VA, gift of
Walter P. Chrysler, Jr.
71.6285

Vivid green inclusions in this clear glass bowl have been wheel-carved with a motif of grape leaves. Tiffany & Co. mounted the bowl with a silver rim patterned with grape clusters and leaves. The inscription suggests that this was a twenty-fifth anniversary gift. This and similar pieces were designed by Albert A. Southwick (Loring 2002, p. 234–50).

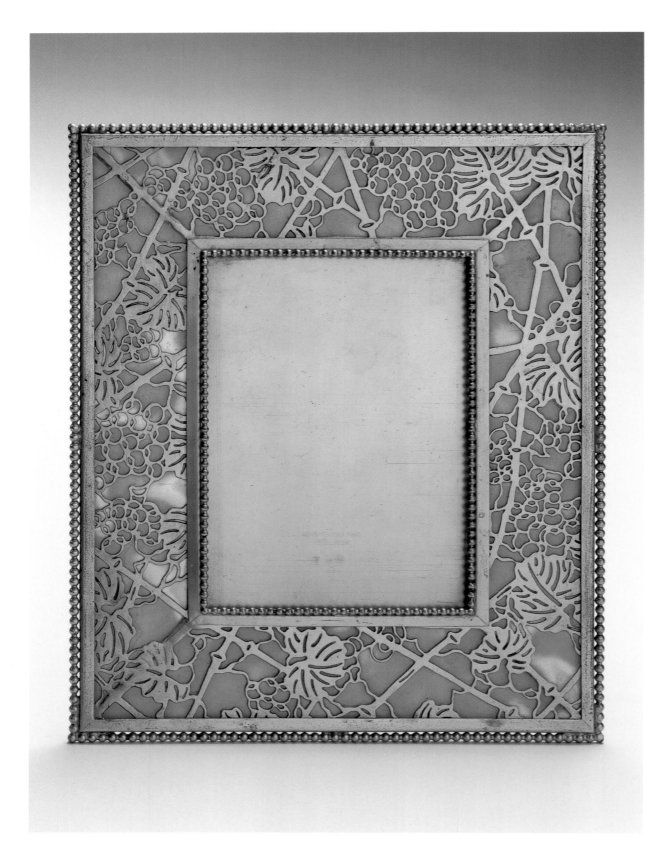

Cat. 61
Picture Frame in Grapevine Pattern
c. 1906
Etched metal, glass
Marks: *Tiffany Studios New York 947*
9½ x 8 in.
The Mark Twain House & Museum, Hartford, CT, 1974.59.1

The popular Grapevine desk set, designed c.1899, features a metal framework, cut from sheet metal, laid against a plaque of Favrile glass. The flat, silhouetted motif of the grapevine on its trellis is similar to Japanese stencil designs. The edges are beaded. There were twenty-six pieces in the set (Loring 2002, p. 179–83).

Cat. 62
Necklace with Grapes and Grape Leaves
c. 1912
Gold, nephrite
Marks: stamped on one link of necklace *Tiffany & Co.*
12⅜ x 3½ in.
Toledo Museum of Art, purchased with funds given by Rita Barbour Kern, 1996.1

The grapevine motif with its Bacchic and Christian symbolism has a long history in Western art. This bib necklace is composed of gold links, finished in imitation of the branches of an espaliered vine, from which hang golden leaves and clusters of nephrite grapes.

Castellani, a firm of nineteenth-century jewelers in Rome that based designs on archaeological proto-types, made "Etruscan" grapevine necklaces in which gold leaves alternated with very similar precious-stone grape clusters. (Susan Soros and Stefanie Walker, *Castellani and Italian Archaeological Jewelry,* 2004, n. 30, p. 347; n. 201, p. 381)

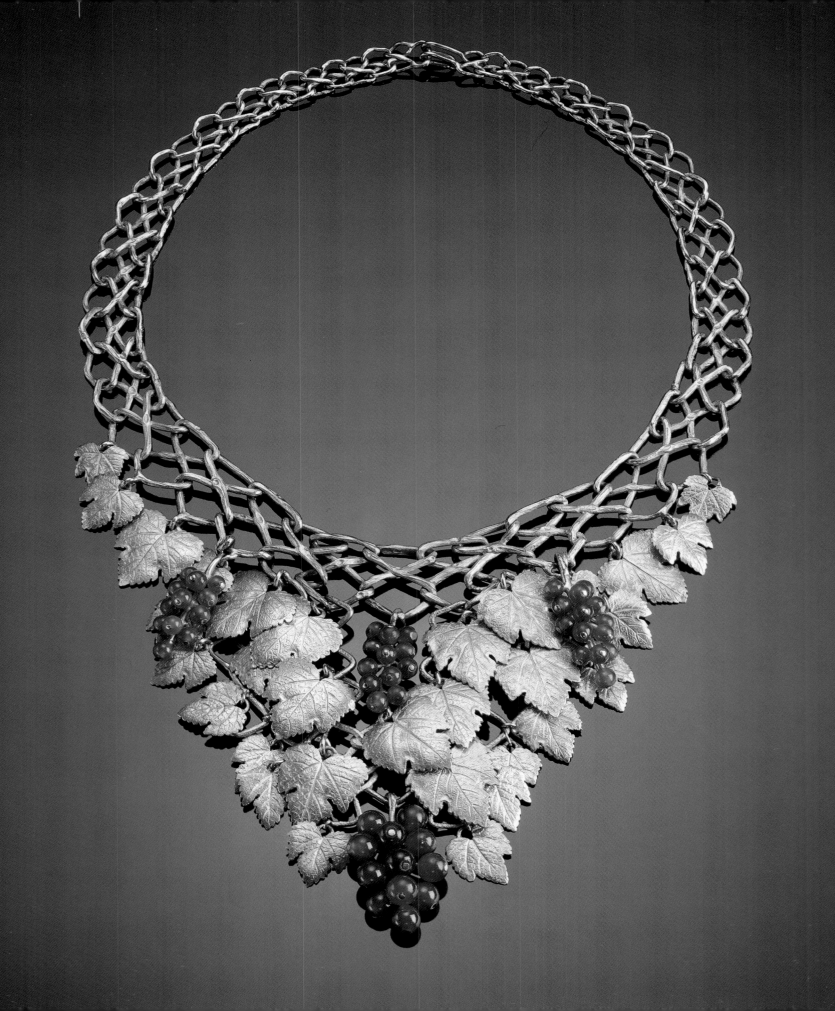

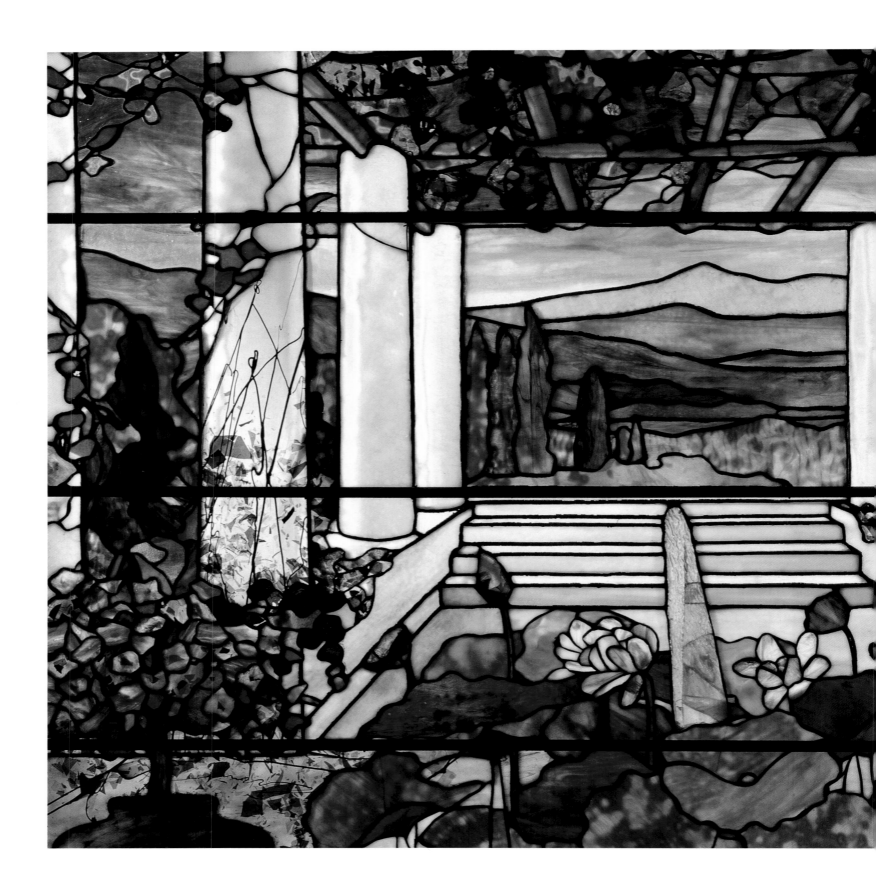

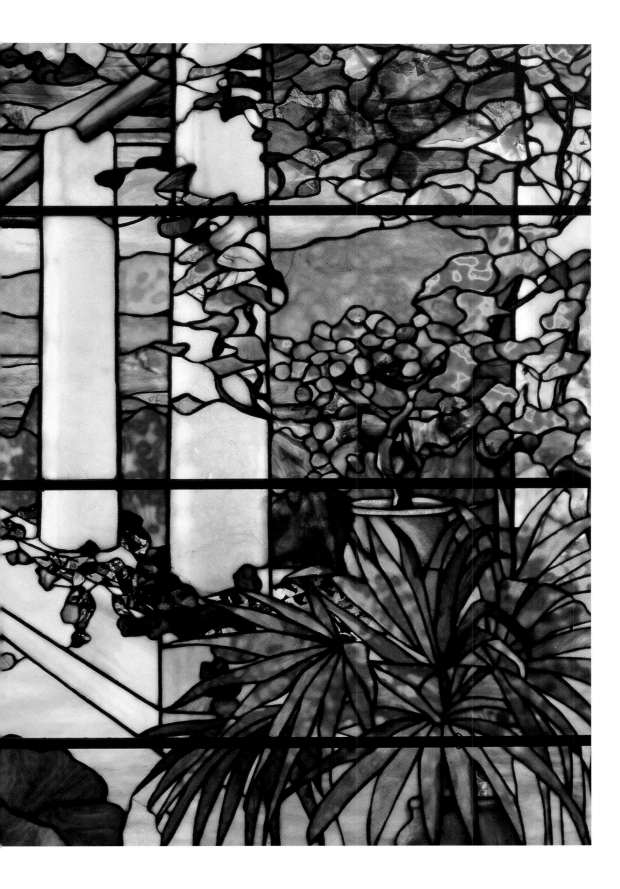

Cat. 63
*Window with Garden
Landscape*
1902–20
Leaded glass
37 x 65½ x 4 in.
Richard H. Driehaus
Collection, Chicago, IL

The white columns of a
pergola frame a view of
distant hills, illuminated by
the setting sun. The
foreground is a garden filled
with flowers: standard
azaleas, palms, and lotus
emerging from a pool. At
the center, a transparent
crystal obelisk might almost
be a frozen fountain. We
seem to glimpse the earthly
paradise.

This is one of two nearly
identical landscape
windows, both from
unidentified houses in New
Jersey. The other is in the
Tiffany Garden Museum,
Matsue, Japan (Duncan
2004; Sotheby's, New York,
2 December 2000, Lot 617,
and 12 March 1999, Lot
244).

Cat. 64
*Stenciled Velvet with
Dragonfly Pattern*
c. 1908
Silk velvet stenciled with
vegetable dyes
13¼ x 4½ in.
The Cleveland Museum of
Art, gift of Joseph F.
Sindelar, 1948.101

Cat. 65
Trivet
c. 1900
Glass mosaic tile, bronze
Marks: stamped *Tiffany
Studios, New York Tiff. Glass
and Decorating Co. 1473*
6¼ x 6¼ x ⅞ in.
The Museum of Modern Art,
New York, gift of Joseph H.
Heil, 1960.295.1960

Cat. 66
Lamp with Dragonfly Motif
1900–10
Leaded glass, bronze
Marks: stamped on metal
tag inside shade *TIFFANY
STUDIOS NEW YORK
1507-29*
28 x 22 in.
The New-York Historical
Society, N84.113

The dragonfly was a
common motif in Japanese
art where it was a symbol of
late summer and early
autumn. It was also
emblematic of martial
success, as various names
for the insect are
homophones for "victory."
The motif was used for
several Tiffany Studios
lamp-shade designs that
were executed in different
colors. In this model, with a
deep blue ground, the
dragonflies are disposed
vertically with their finely
veined double wings
overlapping to form a lacy
lower border. Above them,
oval glass cabochons are
embedded in a corrugated
glass background. The
bronze base, in this
example, is a claw-like
structure mounted on a
platform rimmed with glass
pearls. Clara Driscoll was
the designer of this shade
that won a prize at the
Exposition Universelle in
Paris in 1900.

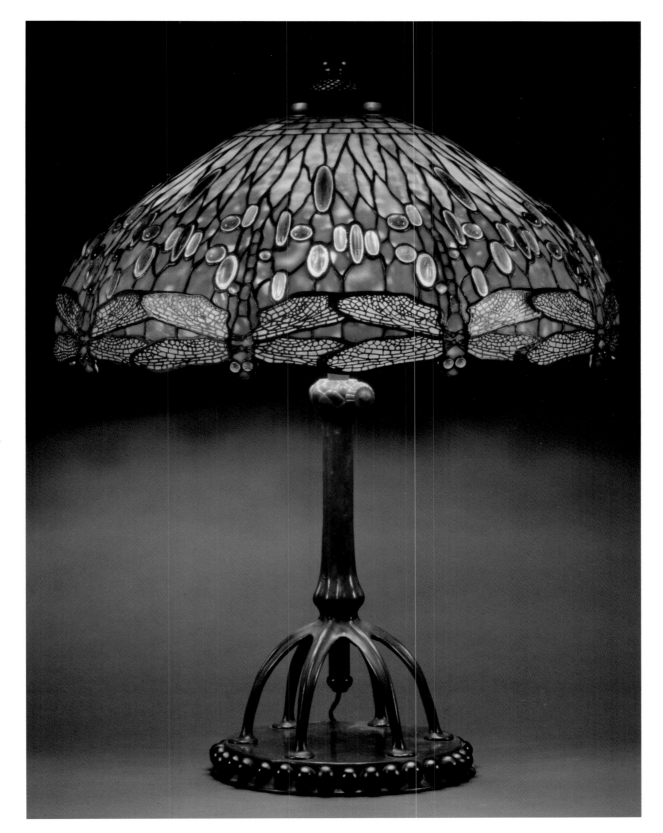

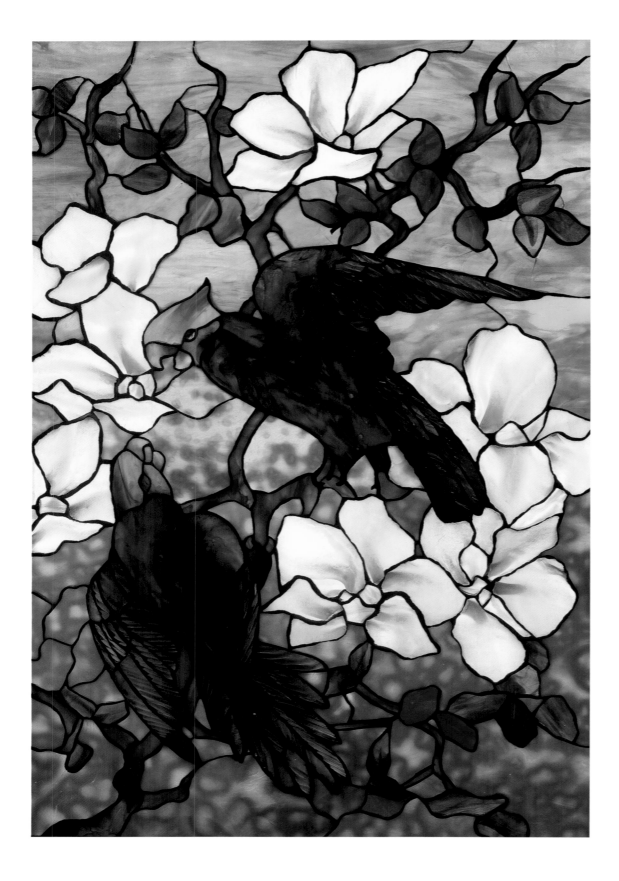

Window with Parrots and Magnolia
1910–20
Leaded glass
26 x 17¾ in.
The Metropolitan Museum of Art, gift of Earl and Lucille Sydnor, 1990, 1990.315

A pair of green and blue parrots with golden heads perches in the flowering branches of what is most likely an evergreen magnolia tree. Ribbed glass gives texture to their feathers. Mottled yellow-green glass suggests bright sunlight filtered through leaves. These birds are Carolina parakeets, the only native American parrot, already rare by the late nineteenth century and now extinct. The bird at the bottom is based directly on the parrot at the upper right of Plate XXVI of Audubon's *Birds of America*. The small size of this piece suggests that it was a domestic commission. A window with similar parrots on a branch with cherries is in the Watts-Sherman Cottage, in Newport (McKean 1980, p. 79, pl. 67). In 1893, Tiffany had displayed a window with Carolina Parakeets and a Goldfish Bowl at the World's Columbian Exposition in Chicago (Christie's New York, 13–14 December 1996, p. 196–199).

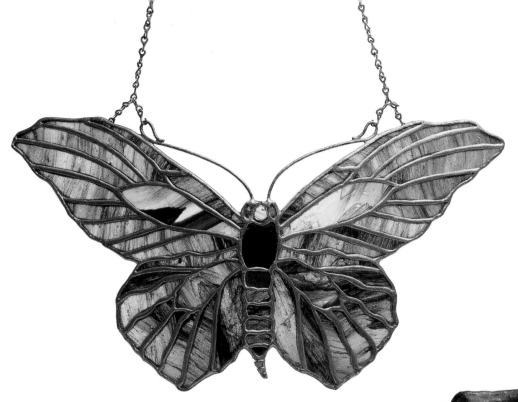

Cat. 69
Enamel Box Cover
c. 1902
Enamel on copper, glass
Unmarked
7⅞ x 5¾ x 1¼ in.
Courtesy of Lillian Nassau
Ltd., New York

Favrile glass blown into the interstices of an openwork metal frame creates a luminous "sky" behind the leafy branch where a small gray bird, perhaps a mockingbird, is perched. Only a handful of examples of this arduous technique are known. A covered jewelry box with a motif of apple tree branches is in The Metropolitan Museum of Art (*Metropolitan Museum of Art Bulletin*, Summer, 1998, p. 79, fig. 101).

Cat. 68
Lamp Shield with Butterfly
c. 1900
Leaded glass
Unmarked
6½ x 11 x 1½ in.
Courtesy of Lillian Nassau
Ltd., New York

Hanging from a lamp, as a shield from the glare of the bulb, this decorative glass moth or butterfly would appear to be hovering in the air, attracted to its brightness. Slender metal cames delineate the veins of the wings and the segmentation of the body.

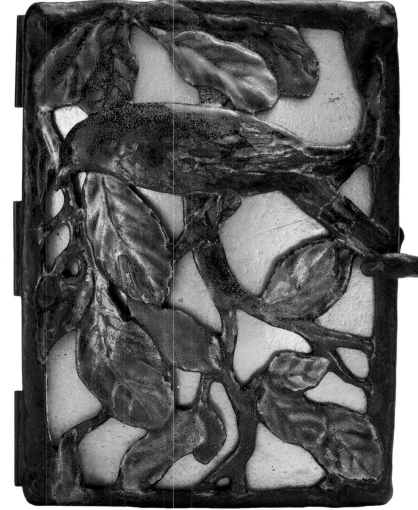

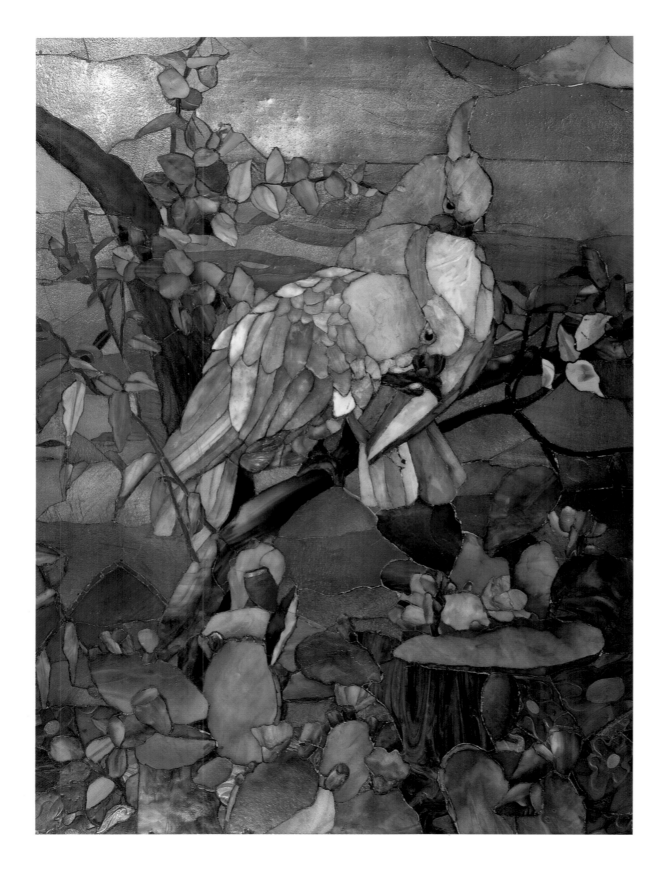

Cat. 70
*Mosaic Panel with Sulphur-
Crested Cockatoos*
c. 1908
Glass tessarae
31 x 23 in.
Haworth Art Gallery,
Accrington, England
(Hyndburn Borough
Council), 1999.33.59

This is one of Tiffany's finest
works in glass mosaic. Two
Greater Sulphur-Crested
Cockatoos, native to
Australia, New Guinea, and
the Aru Islands, perched on
a leafy branch, are
silhouetted against an
iridescent golden sky. Their
soft, luminous feathers are
evocatively suggested with
the texture of pearly white
glass. The composition,
similar to that of the Parrot
and Magnolia window (see
cat. 67), no doubt depends
upon Japanese sources.

In 1890, when he was just
seventeen years old,
Joseph Briggs (1873–1936)
left Accrington, England for
New York. There Briggs
became an associate of
Louis Comfort Tiffany and
worked closely with him in
various capacities for forty
years. He was particularly
involved in the production of
mosaic work. After the
artist's death, he supervised
the disposal of Tiffany's
work at a time when it was
out of favor. In 1933, Briggs
returned to England where
he gave his personal
collection to his hometown.
The Haworth Art Gallery in
Accrington has the finest
Tiffany collection in Europe.

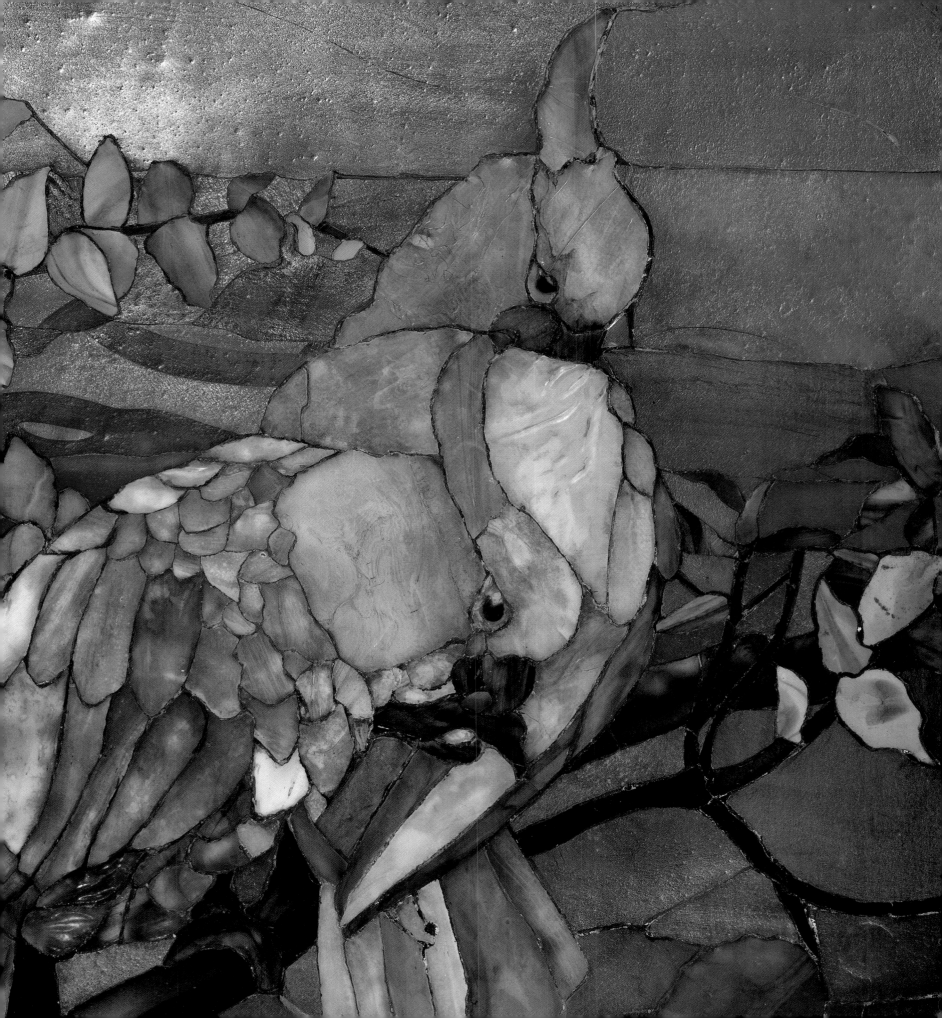

Light Comes from the East

"Light comes from the East," a phrase that connotes the dawning of day, but also the dawning of truth and wisdom, would have had special meaning for Louis Comfort Tiffany. During much of his lifetime Tiffany turned to the East for inspiration, traveling to the exotic Orient of North Africa and the Levant as well as to Moorish Spain, collecting, through Lockwood de Forest, jewelry, furniture, and woodwork from India, and drawing upon the arts of China and particularly Japan for new design visions.

Tiffany considered himself primarily a colorist; he would undoubtedly have expanded the phrase to "Light and color come from the East." He constantly reiterated the profound importance of his 1870 trip to North Africa with R. Swain Gifford for awakening him to the power of color in art.

He found that color not only in the Islamic world, in desert scenery and the clothing of the Arabs as well as in mosques with their brilliantly stained glass lanterns and polychrome tiles, but also in the Christian basilicas of the Byzantine empire, which had stretched from Constantinople as far west as Sicily. There the Roman mosaic tradition persisted in magnificent murals and panels composed of thousands of minute glass tessarae in pure, intense colors. Tiffany employed similar techniques in some private homes and in countless American churches and public buildings.

Even before traveling to the Near East Tiffany would have known of the arts of the East through the books and periodicals that proliferated in the latter half of the nineteenth century. With Owen Jones's 1856 publication of *The Grammar of Ornament* a wide world of formerly unknown decorative motifs opened to designers. Both Edward C. Moore and Louis Comfort Tiffany owned Jones's *Grammar*. Undoubtedly emulating Moore and the libraries he assembled for himself and for Tiffany & Co., which included works on Persian and Arabic as well as Japanese art, Tiffany created his own extensive design library.

For many late-nineteenth-century American artists the art of the East was a passing fancy. For Louis Comfort Tiffany it was a lasting passion. Perhaps his greatest work, Laurelton Hall was replete with Orientalism. Throughout Tiffany's personal and professional lives the light of the East continued to shine.

Detail cat. 77

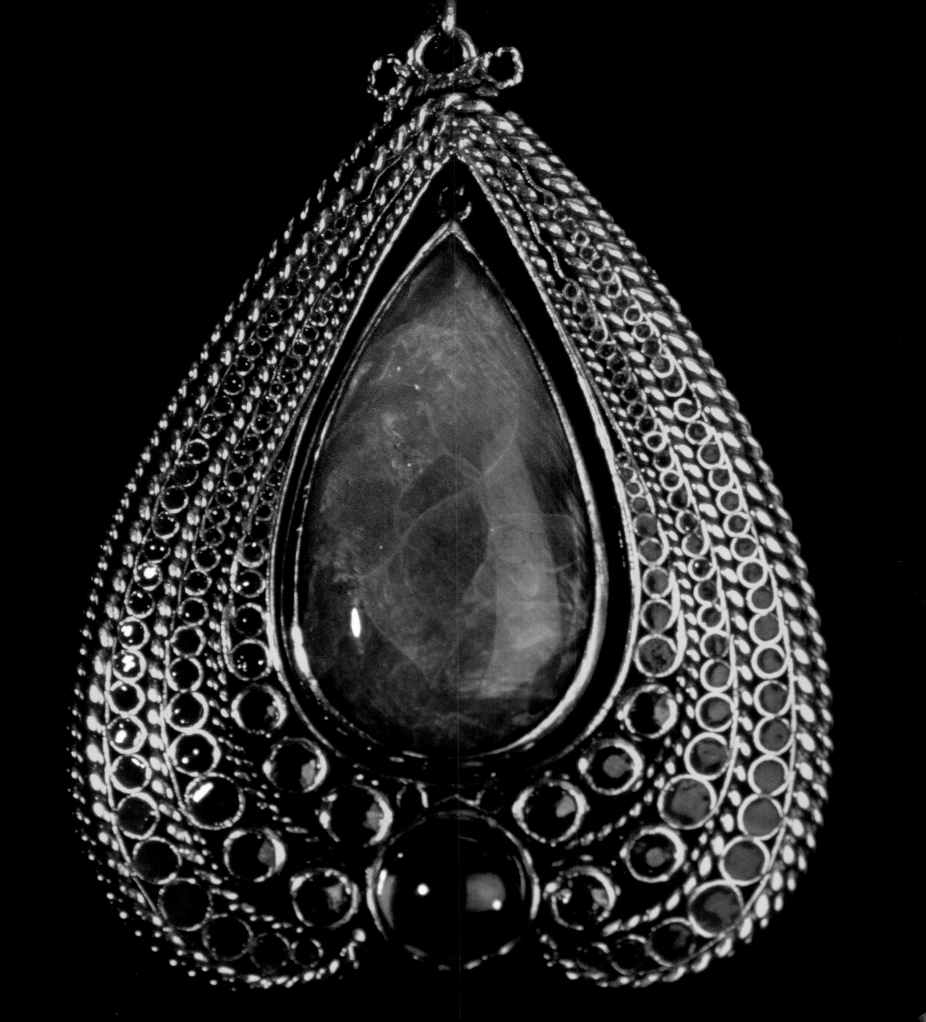

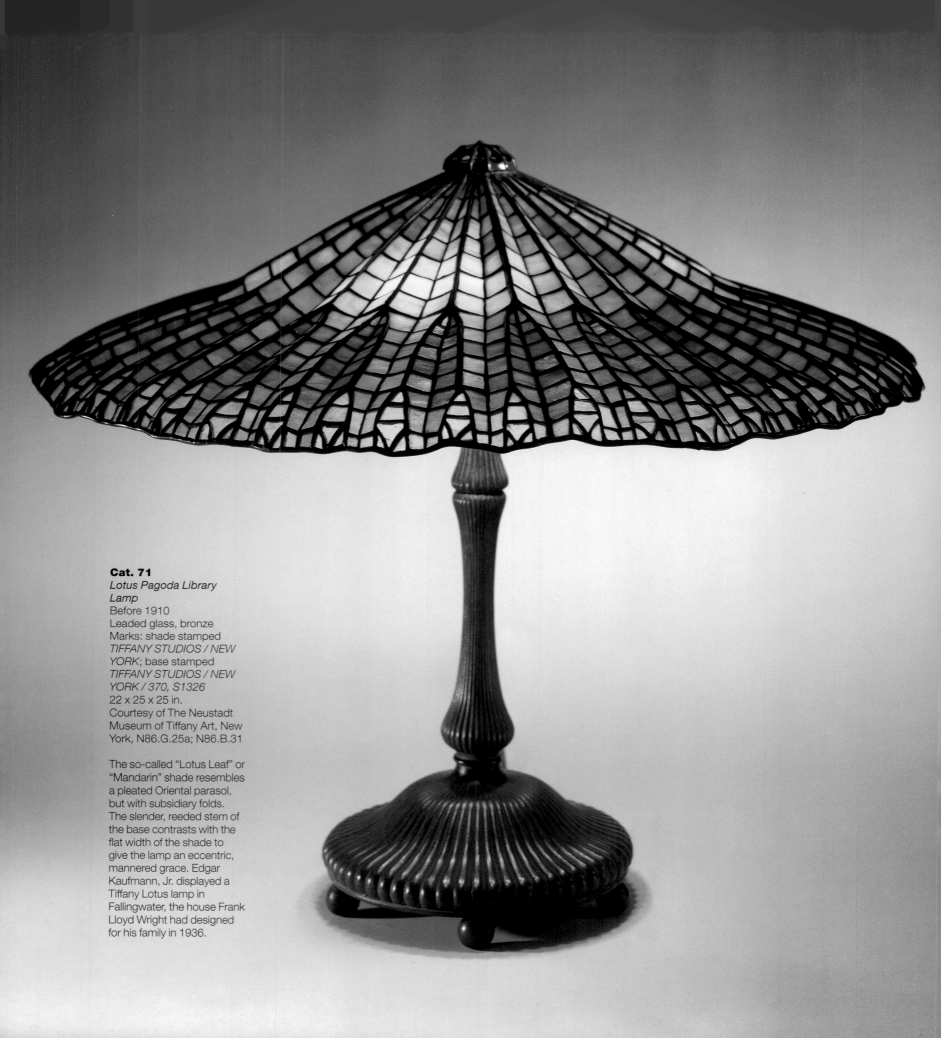

Cat. 71
Lotus Pagoda Library Lamp
Before 1910
Leaded glass, bronze
Marks: shade stamped
TIFFANY STUDIOS / NEW YORK; base stamped
TIFFANY STUDIOS / NEW YORK / 370, S1326
22 x 25 x 25 in.
Courtesy of The Neustadt Museum of Tiffany Art, New York, N86.G.25a; N86.B.31

The so-called "Lotus Leaf" or "Mandarin" shade resembles a pleated Oriental parasol, but with subsidiary folds. The slender, reeded stem of the base contrasts with the flat width of the shade to give the lamp an eccentric, mannered grace. Edgar Kaufmann, Jr. displayed a Tiffany Lotus lamp in Fallingwater, the house Frank Lloyd Wright had designed for his family in 1936.

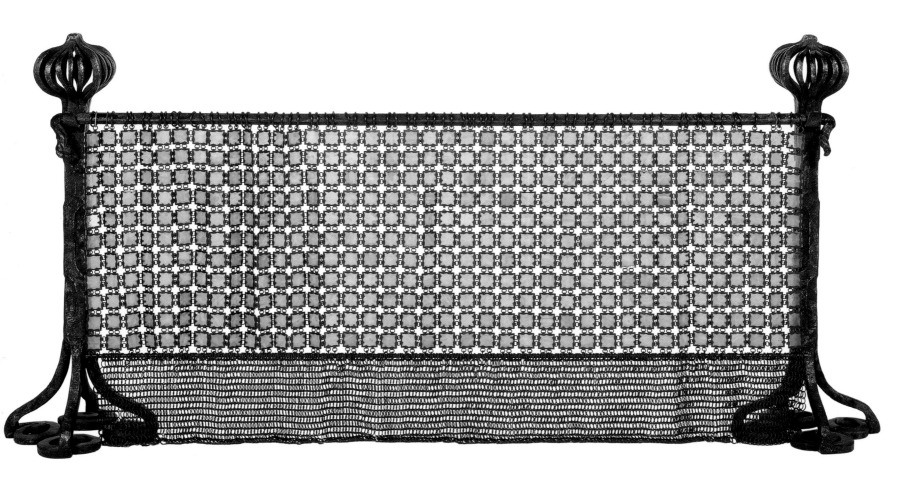

Cat. 72

Fire Screen

From the Claude Fayette
Bragdon House
c. 1903
Wrought iron, glass
31¾ x 57¾ x 9 in.
Courtesy Strong Museum,
Rochester, NY, 78.2619

Claude Fayette Bragdon (1866–1946), a disciple of Louis Sullivan, was an architect, stage designer, theosophist, and author who moved to Rochester in 1884 and worked there as an architect until 1923. He wrote several important books on aesthetic theory. Bragdon designed Cro

Nest, a gray-shingled house, for himself and his first wife, Charlotte Wilkinson, whom he married in 1903.

This fire screen from Cro Nest is a curtain composed of many square, hinged glass plaques suspended from a rod supported by two mace-shaped iron

stanchions. Tiffany used this "chain mail" construction for some of his lamp shades. It is reminiscent of traditional Chinese armor, made of squares of leather (or, in at least one case, stone). The iron posts resemble a pair of bronze and glass andirons Tiffany designed for the Robert W. de Forest house

at 7 Washington Square North, now in The Metropolitan Museum of Art (Joppien 1999, cat. 9, p. 68). These are sturdy fireplace accessories that conform to the Arts and Crafts aesthetic of function and simplicity.

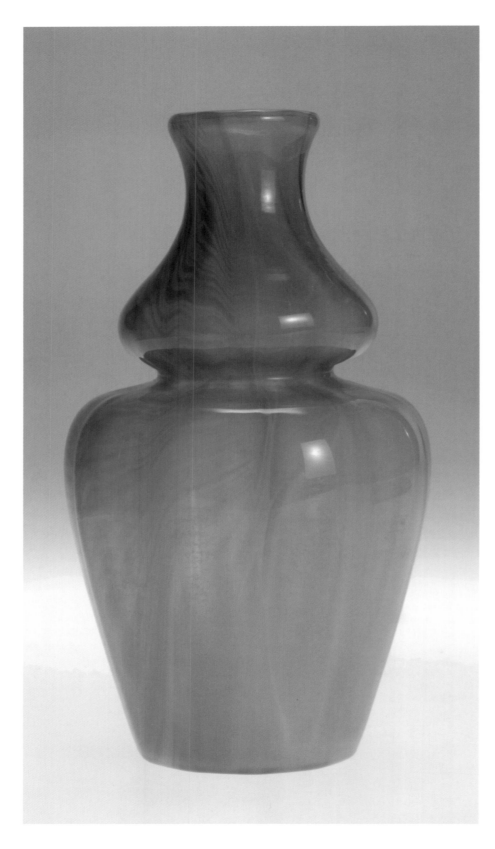

Cat. 73
*Varicolored Tourmaline
Reactive Vase*
Twentieth century
Glass
Marks: inscription, #22 in
Nash inventory, incised *7-
1394 p Louis C. Tiffany
Favrile "Special Exhibit"*
7 x 3½ x 3½ in.
Herbert F. Johnson
Museum of Art, Cornell
University, gift of Louis

Comfort Tiffany through the
courtesy of A. Douglas
Nash, 57.079

This reactive glass vase
adopts a symmetrical
double-gourd shape familiar
from Chinese ceramics.
In the Far East, the gourd
enclosing many seeds
symbolized long life and
numerous progeny.

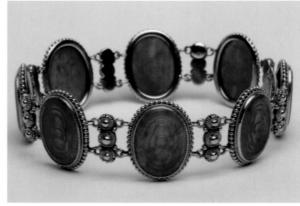

Cat. 74
*Bracelet with Chinese
Jadeites*
c. 1915
Gold and jade
8 x ⅞ in.
Marks: signed on clasp
Tiffany & Co.
Neil Lane Collection

After his father's death at
the age of ninety in 1902,
Louis Comfort Tiffany
became a vice-president of
Tiffany & Co. He soon
began producing jewelry at
Tiffany Furnaces to be
displayed at the Louisiana
Purchase Exposition in
Saint Louis in 1904, where it
was received with great
enthusiasm. Tiffany & Co.
moved to a new Stanford
White building, based on
Palazzo Grimani in Venice,

on Fifth Avenue at Thirty-
seventh Street in 1905. In
1907, Tiffany's jewelry and
enamel design staff moved
into the Thirty-seventh
Street building (the firm
would move again in 1940,
after Louis's death, to its
present location at the
corner of Fifth Avenue and
Fifty-seventh Street). The
Thirty-seventh Street
building has recently been
handsomely restored.
 This bracelet incorporates
Chinese carved jadeite
medallions that are linked
with gold starbursts. The
latter were used in other
jewels—for example a
peridot brooch dated c.
1910 and an opal brooch
dated 1913–14 (Loring
2002, pp. 49, 50).

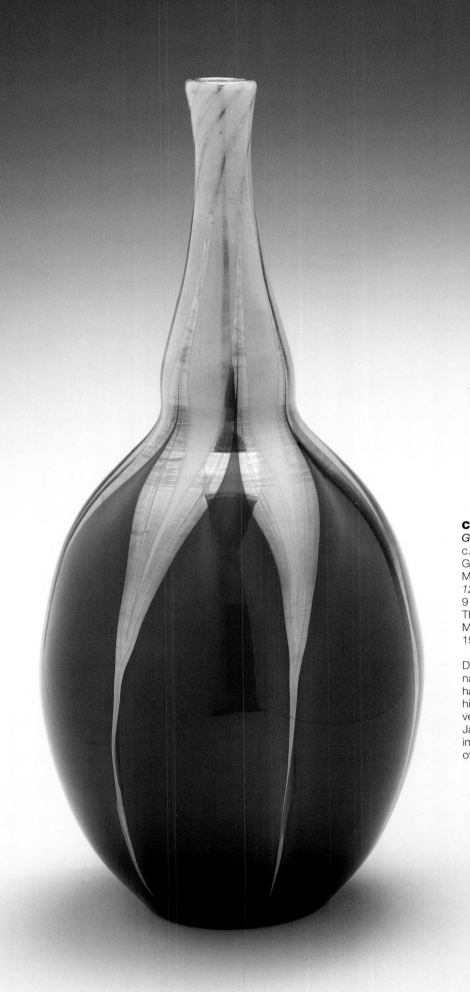

Cat. 75
Gourd-Shaped Vase
c. 1906
Glass
Marks: paper label *LCT 1264A*
9 in. high
The Mark Twain House & Museum, Hartford, CT, 1978.8

Dried, hollow gourds are natural receptacles that have been used throughout history as bottles or drinking vessels. Chinese and Japanese ceramics often imitate the distinctive shape of the bottle gourd.

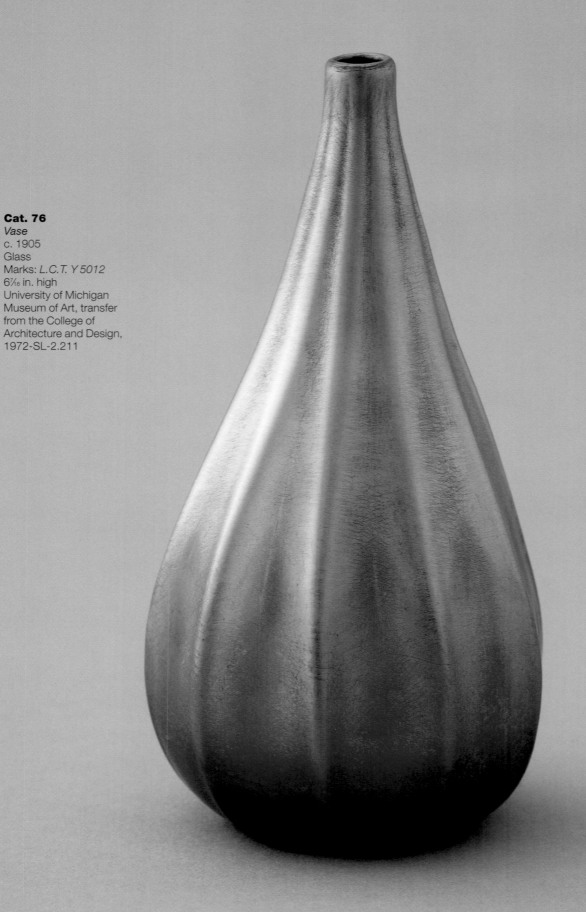

Cat. 76
Vase
c. 1905
Glass
Marks: *L.C.T. Y 5012*
6⅞ in. high
University of Michigan
Museum of Art, transfer
from the College of
Architecture and Design,
1972-SL-2.211

Cat. 77
*Orientalist Pendant
Necklace*
c. 1909
Platinum, opal, sapphire,
enamel
Marks: signed *Tiffany & Co.*
Chain: 16 in.;
pendant: 2⅛ x 1⅛ in.
Neil Lane Collection

Opals had been returned to
fashion at the turn of the
century by René Lalique
and the French Art Nouveau
jewelers who followed his
example. They were a
preferred stone for Tiffany
who has framed the opal
with sapphires and green
and blue enamel in a setting
of twisted gold wire in the
shape of a peacock feather.
The rich colors are
reminiscent of the Mogul
jewelry of India. An archival
photograph of this piece is
labeled "J1070."

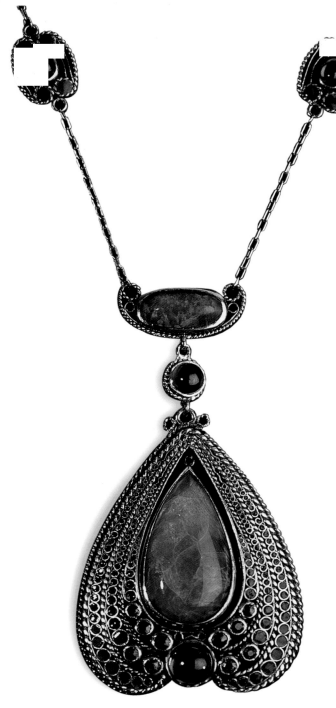

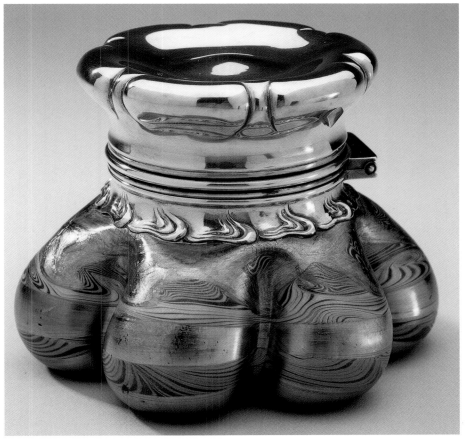

Cat. 78

Inkwell
c. 1902–03
Glass, silver
Marks: engraved Favrile
glass mark and °8468 on
base; silver mounts marked
Tiffany & Co.
4 x 5½ x 5½ in.
Collection of The Newark
Museum, gift of Mr. and
Mrs. Ethan D. Alyea, 1967,
67.120

This inkwell was one of a
series of Favrile vases,
bottles, and inkwells
mounted in silver at Tiffany
& Co.'s silver shop in Forest
Hills, New Jersey, in 1902,
shortly after Louis Comfort
Tiffany became more active
in the firm following his
father's death. Eighty-one
drawings for these pieces
are in the Tiffany & Co.

Archives today (Loring
2002, p. 226). The influence
of Edward C. Moore is felt in
these pieces. This blue
glass "elephant-foot" inkwell
has a wavy border,
reminiscent of Edouard
Colonna's style, and a
hinged cap.

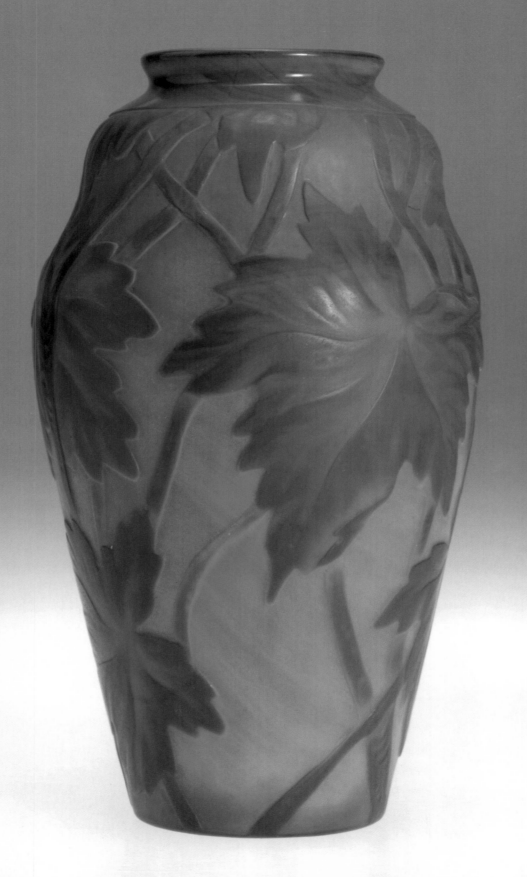

Cat. 79
*Vase with Cameo
Decoration*
1921 or earlier
Glass
Marks: inscription, #23 in
Nash inventory, incised *8-
1395 p L.C.T. Favrile
Exhibition Piece E N
hibilion/Wililion piece*
6¾ x 3½ x 3½ in.
Herbert F. Johnson
Museum of Art, Cornell
University, gift of Louis
Comfort Tiffany through the
courtesy of A. Douglas
Nash, 57.105

Cameo glass, as the name
implies, exploits
superimposed layers of
colored glass to create
carved designs in a
technique similar to that
used to make cameos from
layered stones or natural
seashells. It revives a
technique invented by
Roman glassmakers that
was also used in China
beginning in the eighteenth
century. An inner core of
glass of one color is cased
in a layer of another color.
When the glass is cold, an
artisan carves through the
outer layer of color to
execute his design. In
modern times, acid was
often used in this process.
Here green leaves seem to
screen a sunny yellow
background.

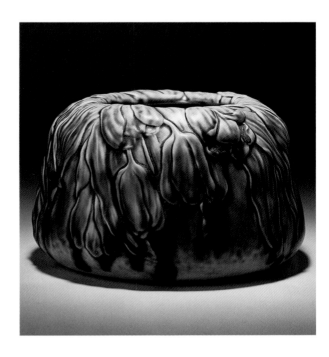

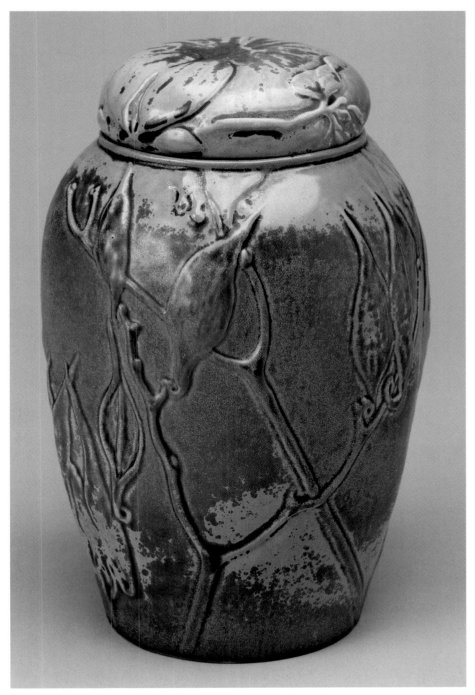

Cat. 80
Brush Pot with Tulips
Tiffany Studios
c. 1905
Glazed stoneware
Marks: *LCT* in a vertically entwined monogram
5⅛ x 8 x 8 in.
New Orleans Museum of Art, museum purchase, George S. Frierson, Jr. Fund, 1991.28

The traditional Japanese brush pot has suggested the form of this squat vessel with a relief of wilted tulips drooping over the sides.

Cat. 81
Covered Jar with Milkweed Pods
c. 1901
Glazed stoneware
Marks: incised on bottom *LCTiffany Furnaces, P5111*
8¾ x 3⅞ x 3⅞ in.
Everson Museum of Art, gift of Bronson A. Quackenbush, 78.40.6 a–b

The ginger jar is a characteristic Chinese ceramic vessel. Tiffany first produced covered jars of this shape in enameled copper, decorated with plant motifs in naturalistic colors. Ceramic versions are treated with solid or mottled glazes. In this case, the motif is milkweed seedpods.

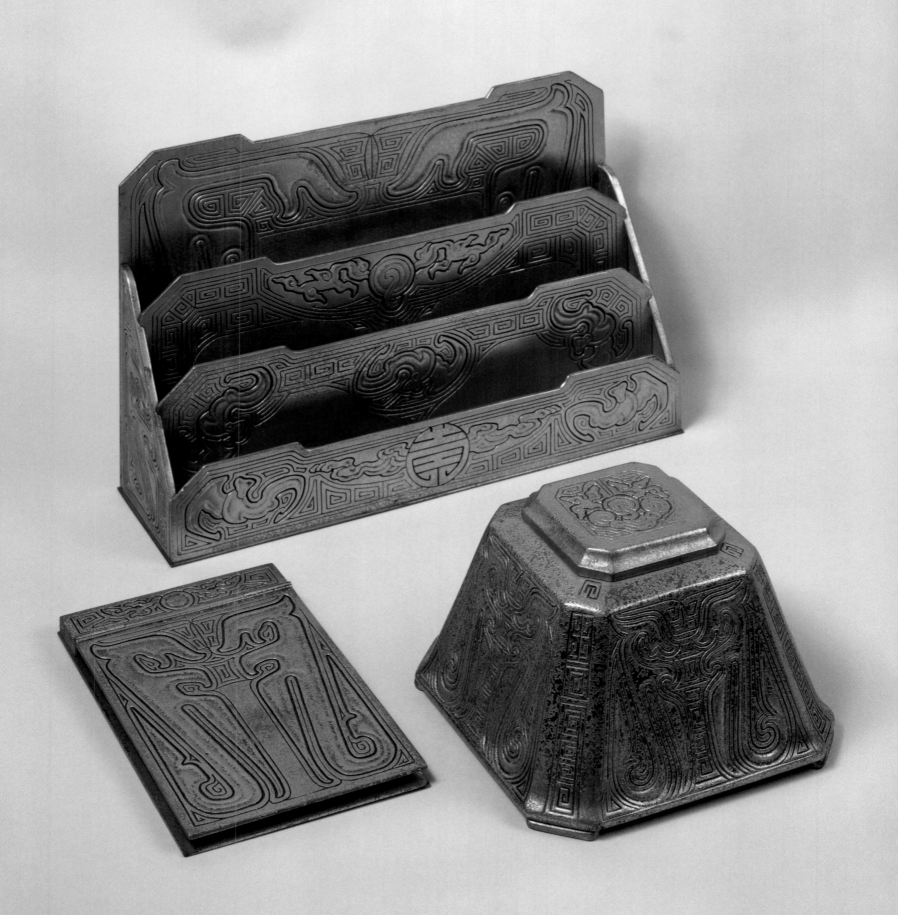

Cat. 82

Desk Set with Chinese Motifs
Letter rack, inkstand, and desk pad
1909–20
Gilded bronze
Marks: each piece *TIFFANY STUDIOS/NEW YORK/1758.*
Letter rack: 8 x 11¼ x 3⅜ in.
Museum of the City of New York, gift of The Carnegie Corporation of New York, Collection of Mrs. Andrew Carnegie

In 1906, Tiffany Studios offered desk sets in four different patterns; by 1910, eight patterns were available. These accessories, to be purchased individually or as a set, were based on historically derived styles: Louis XVI, Venetian, Spanish, and American Indian, among others. The "Chinese" desk set was described in the price list published in 1920 as "adapting the motifs found in the bronzes of the Chou dynasty." The set in the Museum of the City of New York belonged to Mrs. Andrew Carnegie. Photographs of the Carnegie mansion, taken in 1938, show several Tiffany lamps in the very eclectically decorated interior.

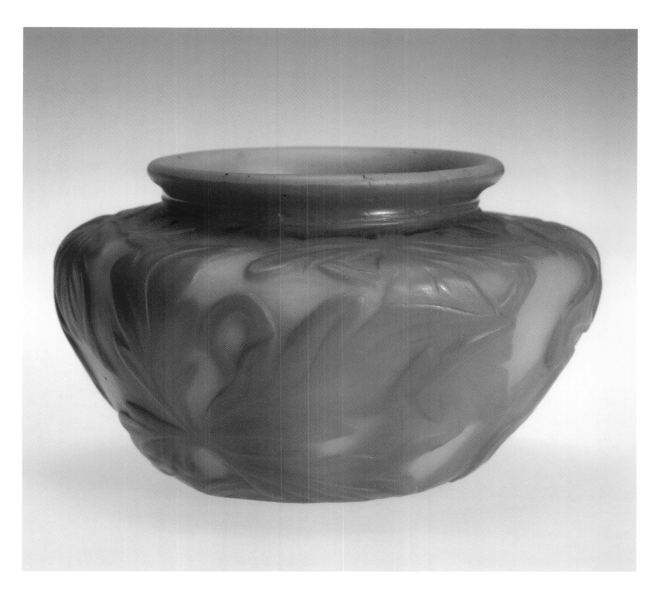

Cat. 83

Vase with Cameo Decoration
c. 1906
Glass
Marks: inscription *L.C.T. 9874A L.C. Tiffany Favrile* on outer rim
2¼ in. high
Herbert F. Johnson Museum of Art, Cornell University, Edythe de Lorenzi Collection, bequest of Otto de Lorenzi, 64.0869

The red leaves that overlay the yellow core of this cameo glass vase are reminiscent in color and design of Chinese motifs such as are found on glass snuff bottles, for example.

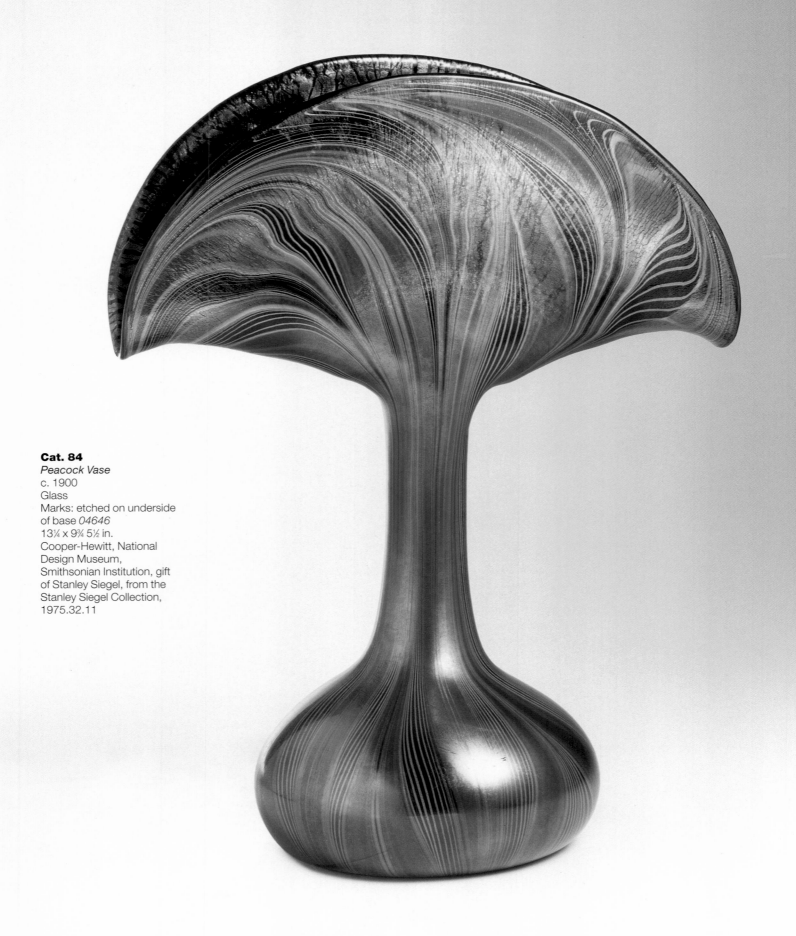

Cat. 84
Peacock Vase
c. 1900
Glass
Marks: etched on underside
of base *04646*
13¼ x 9¾ 5½ in.
Cooper-Hewitt, National
Design Museum,
Smithsonian Institution, gift
of Stanley Siegel, from the
Stanley Siegel Collection,
1975.32.11

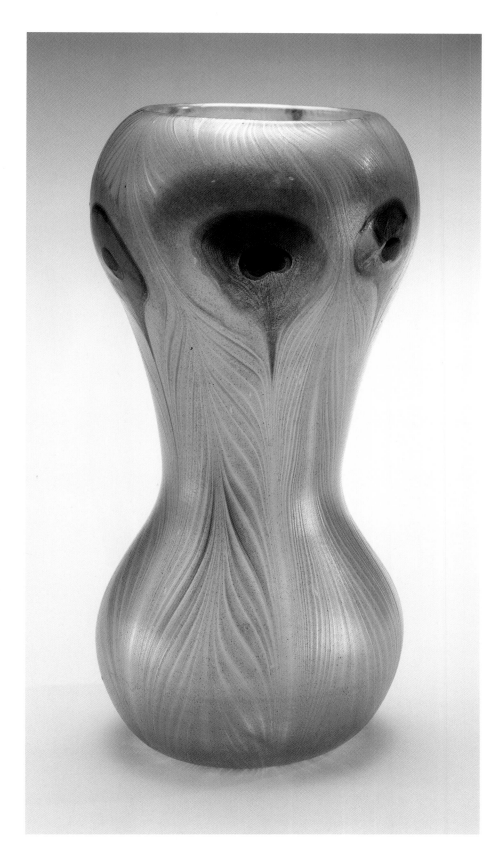

Cat. 85
Vase with Peacock-Feather Motif
c.1898
Glass
Marks: etched °*8040*; paper label *Tiffany Favrile Glass Registered Trademark*; monogram *TGDCO*
8¼ x 4½ x 4½ in.
The Johns Hopkins University, Evergreen House, 1940.1.3

Siegfried Bing described with great eloquence the virtuosity of Tiffany's peacock feather vases in his introduction to the catalogue for an exhibition of the artist's work at the Grafton Galleries in London in 1899 (reprinted from an article he had published the previous year in *Kunst und Kunsthandwerk*, vol. 1):

Having, at the instance of an amateur friend, sought to produce in coloured glass the peacock in all the glory of his plumage, he saw in this motif a theme admirably adapted to enable him to display his skill in glass-blowing—the peacock's feather. For a whole year he pursued his studies with feverish activity, and when at last a large group of vases has been completed embodying this ideal adornment, no two of which were alike, the result was a dazzling revelation.

Just as in the natural feather itself, we find here a suggestion of the impalpable, the tenuity of the fronds and their pliability—all this intimately incorporated with the textures of the substance which serves as background for the ornament. Never, perhaps, has any man carried to greater perfection the art of faithfully rendering Nature in her most seductive aspects, while subjecting her with so much sagacity to the wholesome canons of decoration. And, on the other hand, this power which the artist possesses of assigning in advance to each morsel of glass, whatever its colour or chemical composition, the exact place which it is to occupy when the article leaves the glassblower's hand—this truly unique art is combined in these peacocks' feathers with the charm of iridescence which bathes the subtle velvety ornamentation with an almost supernatural light.

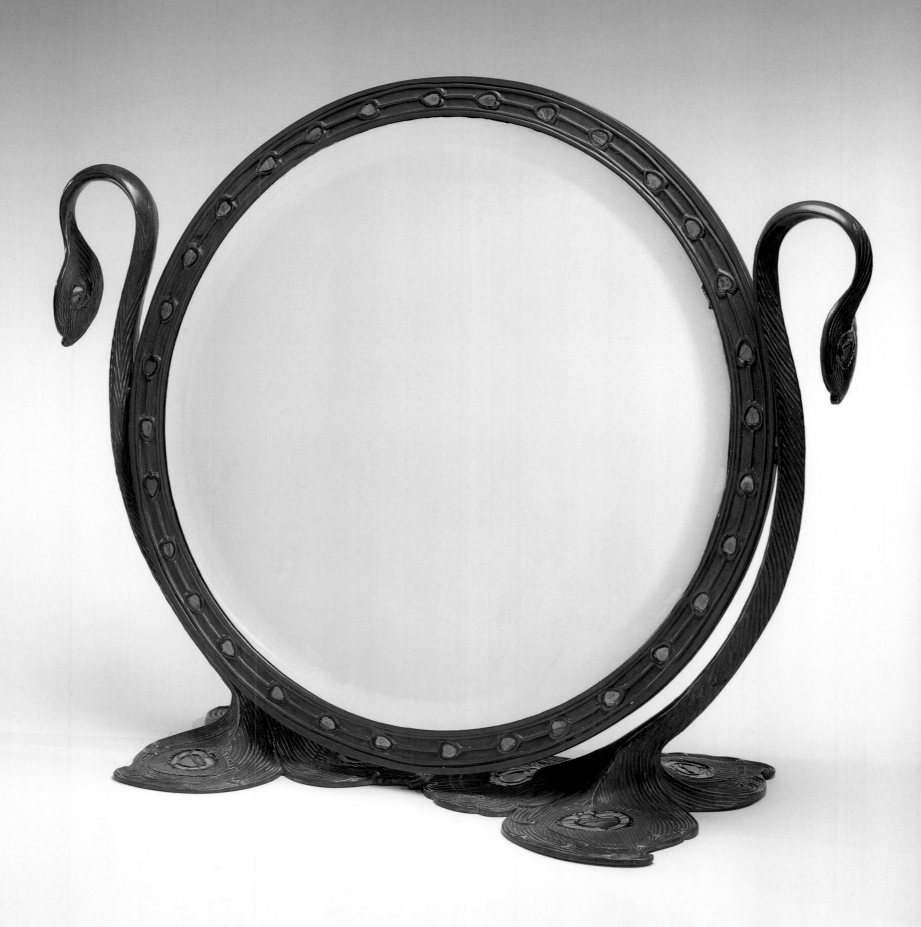

Cat. 86

*Mirror with Peacock-
Feather Motif*
Tiffany Studios
After 1902
Bronze, mirror glass,
enamel
Marks: impressed *TIFFANY
STUDIOS/NEW YORK
29231*
14¾ x 18¾ in.
Courtesy of Lillian Nassau
Ltd., New York

Tiffany showed a variant of
this dressing table mirror in
Turin at the Exposizione
Internazionale d'Arte
Decorativa Moderna in
1902. The frame and stand
develop the motif of
peacock tail feathers with
jewel-like "eyes." A symbol
of vanity, the peacock is a
fitting motif for a mirror frame.
 Peacocks, the showiest
of the pheasants, although

native to India, were
imported in antiquity both to
the West and to the Far
East. They are often
featured in Japanese art,
and it was from that source
that the later nineteenth
century took the image as
an allusion to the quest for
beauty. Whistler famously
painted golden peafowl on
the "peacock blue" walls of
the Leyland dining room

(1876–77), and the motif
was used extensively in
French Art Nouveau jewelry
and metalwork. Tiffany had
adapted the peacock motif
from Byzantine art for the
mosaics in the foyer of the
Havemeyer House and in
his chapel displayed in
Chicago in 1893.

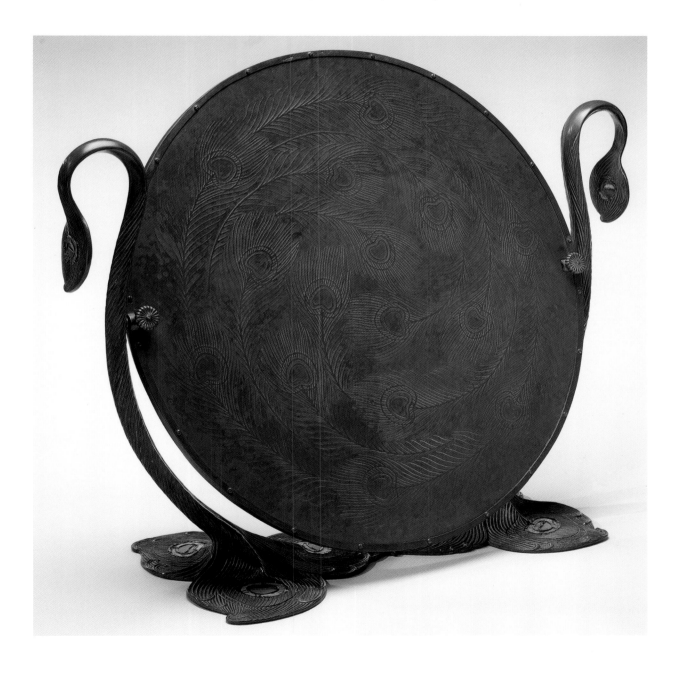

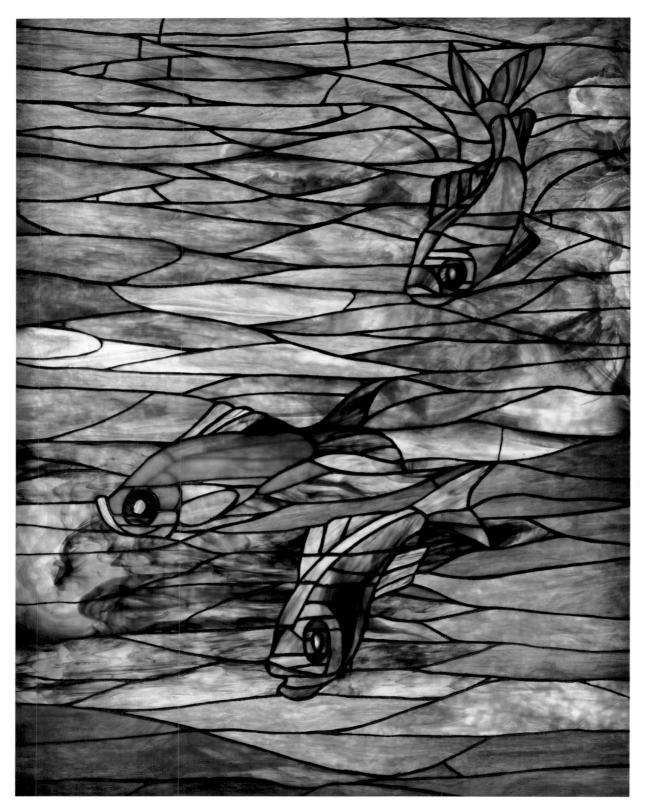

Cat. 87
Window Panel with Swimming Fish
c. 1890
Leaded glass, oak frame
48½ x 36½ x 2½ in.
The Mark Twain House & Museum, Hartford, CT, 1975.50.1

The motif of carp glimpsed through rippling water was borrowed from Japanese sources. Ornamental koi were a much beloved feature of garden ponds in Japan. Here, green and blue striations in the glass itself mimic the currents of the water. Tiffany was always fond of the teasing interplay of glass and water.

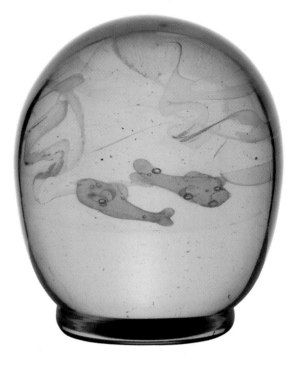

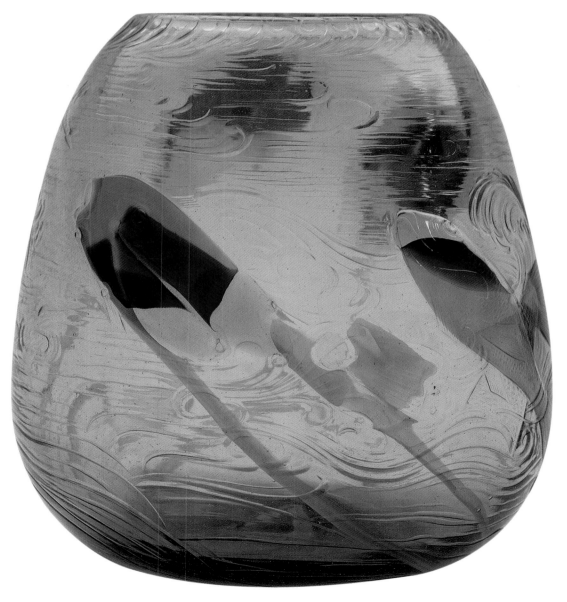

Cat. 88

Doorstop
c. 1913
Glass
Marks: incised on base
1984H L.C. Tiffany. Favrile
6 x 4¾ in.
The New-York Historical
Society, Henry Luce III
Center for the Study of
American Culture, 1965.296

Tiffany often used the so-called "paperweight technique" to make vases. This aquamarine glass sphere, intended for use as a doorstop, is made to resemble a fishbowl in which a pair of goldfish swims. They are similar to the fish in a fishbowl vase in the Haworth Art Gallery; another doorstop is in the Eric Streiner collection (Joppien, 1999, # 179 and #180, p. 173). Paul Hollister discussed work by Tiffany using this technique in his book, *Glass Paperweights of the New-York Historical Society,* in 1974.

Cat. 89

Vase with Fish Intaglio
1893–96
Glass
Marks: oval label *#5161*; oval sticker *20.* °°; round label *Tiffany Favrile Glass/ Registered Trademark T/G/D/C/O*; rectangular sticker with faded handscript *Smithsonian* the rest illegible
7⅛ x 6¾ x 6¾ in.
National Museum of American History, Smithsonian Institution, 30951 (catalogue #96419), gift from Mr. Charles Tiffany

This early vase, made of greenish bottle glass, incorporates irregularly spaced inclusions of colored glass. The surface has been wheel engraved to represent fish swimming amid riling currents of water. The motif betrays the influence of Japanese art, while the technique owes much to the example of English art-glassmakers, as well as of Émile Gallé. The vase was one of the series acquired in 1896 by the United States National Museum (now National Museum of American History, Smithsonian Institution) when Louis Comfort and his father, Charles Lewis Tiffany, arranged to place important examples of Favrile glass in major museums.

Cat. 90

Inkstand
1900–20
Gilt copper, glass
Marks: *L.C.T.* on lower rim
of glass liner
1⅞ x 2 in.
Currier Museum of Art,
Manchester, NH, gift of the
Estate of John F.
Scharffenberger,
1991.1.4a,b

This highly unusual inkwell
has a domed lid with a
whorl of concentric ribs.
Perforations around the
base reveal the blue glass
liner. Rounded, organic
forms give this small object
a strong sculptural
presence.

Cat. 91

Vase
Before 1897
Glass
Marks: printed sticker
*Tiffany Favrile Glass/
Registered Trademark*;
printed label *5163*
8¾ x 6⅞ in.
Cincinnati Art Museum, gift
of A. T. Goshorn, 1897.129

A similar japonesque blue
and silver vase is in the
Tiffany collection of the
Smithsonian Institution (see
cat. 122); another was part
of the Havemeyer gift to the
Metropolitan Museum of Art
(*Metropolitan Museum of
Art Bulletin*, Summer 1998,
fig. 70, p. 58).

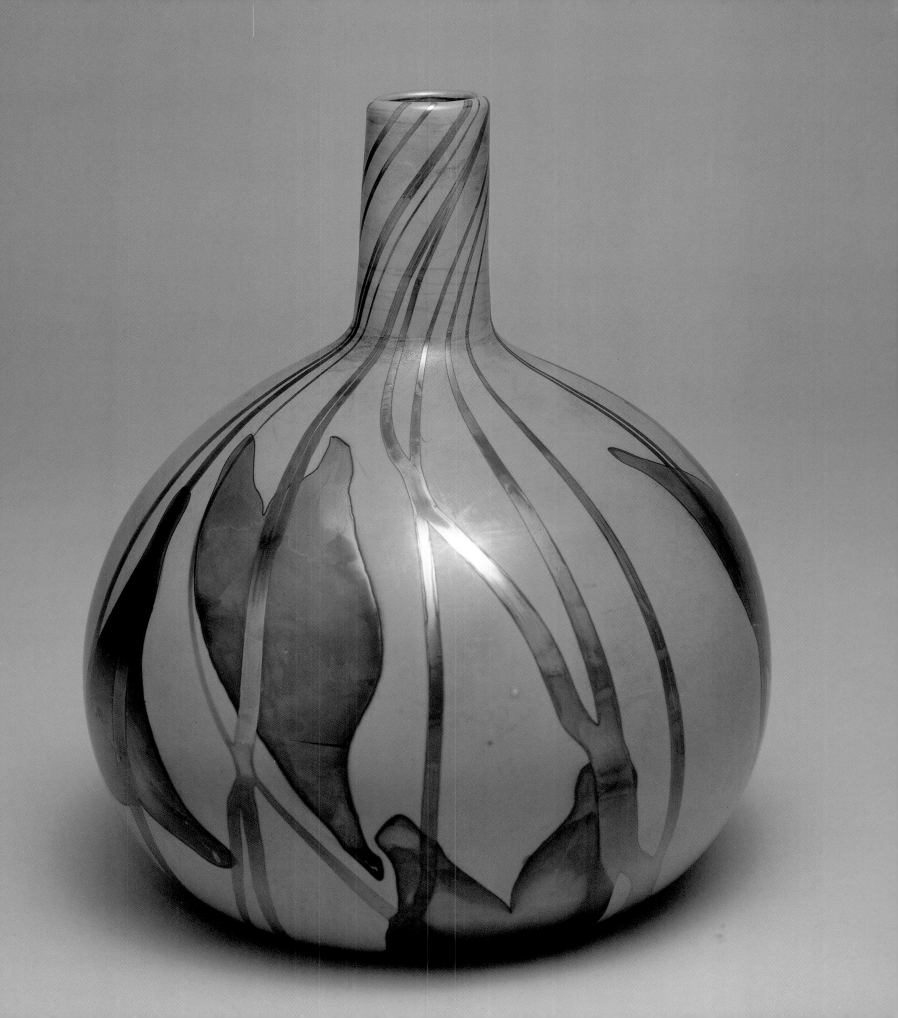

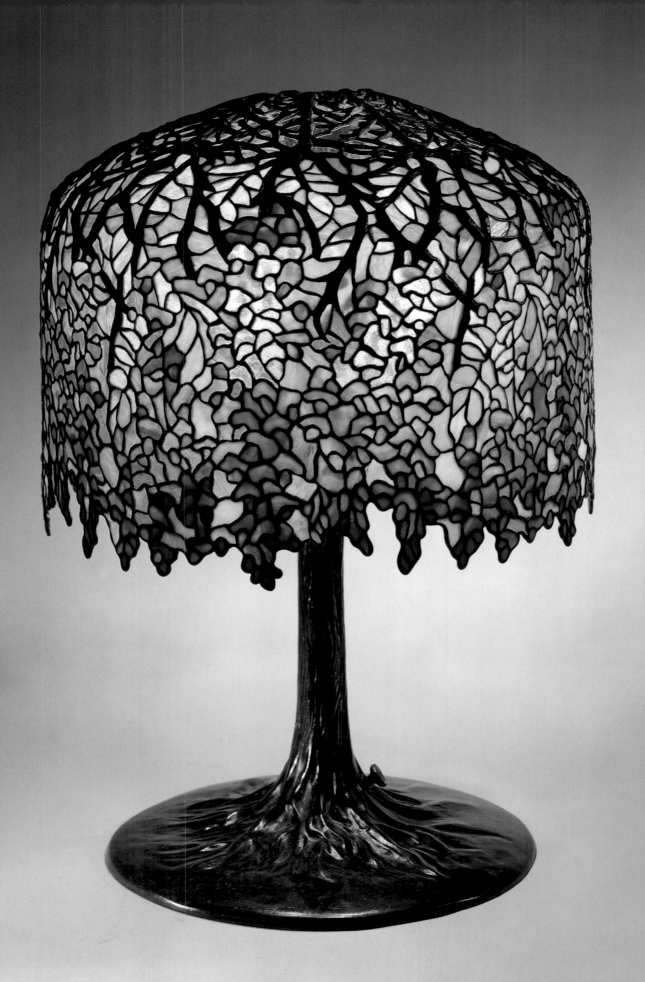

Cat. 92
Wisteria Library Lamp
After 1902
Leaded glass, bronze
Marks: shade stamped
27770, 4, 4; base stamped
*TIFFANY STUDIOS / NEW
YORK, TIFFANY STUDIOS /
NEW YORK / 3158*
27 x 18 x 18 in.
Courtesy of The Neustadt
Museum of Tiffany Art, New
York, N.86.14.8a, b.

Brought from China in the
early nineteenth century, the
flowering vine was named
for the American anatomist
Caspar Wister (1761–1818).
Another variety was
cultivated in Japan. Wisteria
with its pendant purple-blue
or white blossoms was
soon popular in American
and European gardens. It
grew on a canopy above the
Japanese bridge in Monet's
water garden at Giverny and
in Louis Comfort Tiffany's
own gardens.

Mrs. Curtis Freshel who
designed the popular
Wisteria lamp in 1901,
agreed to allow Tiffany
Studios to produce and
market it. The wisteria lamp
shade is composed of
dense clusters of these
flowers. In this example, a
rosy sunset sky provides a
rich, contrasting
background. Pioneer
collector, Dr. Egon
Neustadt, called this a
"glorious battle of the colors
… never violent, never
flagging, and never to be
resolved" (Neustadt 1970,
p. 220). The bronze base
imitates the roots and stem
of the plant.

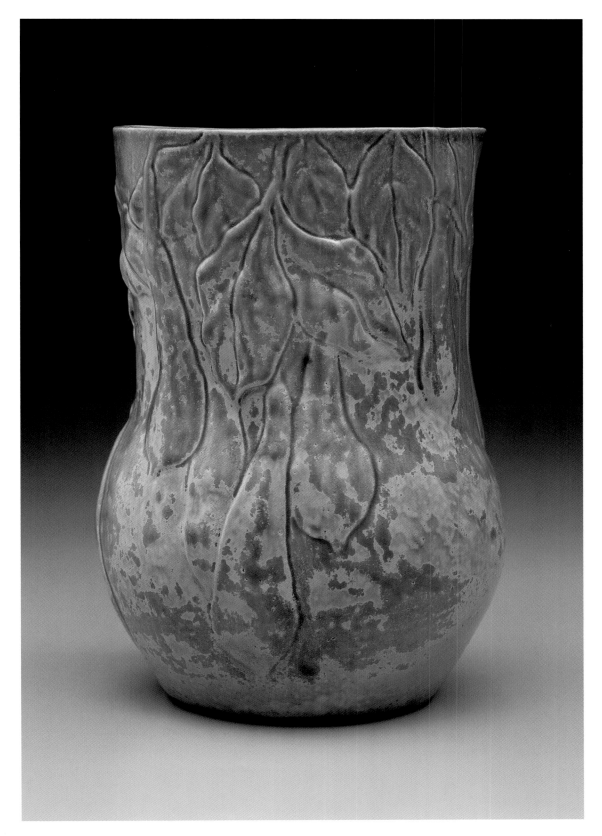

Fig. 54
Watercolor, design for enamel vase with wisteria seedpods, Nash Collection, vol. 3, p. 86, Tiffany & Co. Archives, 2004.

Cat. 93
Vase with Wisteria Seedpods
1904–14
Semi-porcelain
Marks: monogram on base *LCT*
6½ x 4½ x 4½ in.
Courtesy Strong Museum, Rochester, NY, 76.1016

The relief pattern on this vase represents the long, bean-like seedpods of the wisteria (a less familiar motif than the flowering racemes). Here, the glaze is a mottled, celadon green, the natural color of these seedpods. As was generally the case, an enameled copper vessel served as a mold for the ceramic version. Julia Munson's watercolor study for the enamel vase is preserved (see fig. 54).

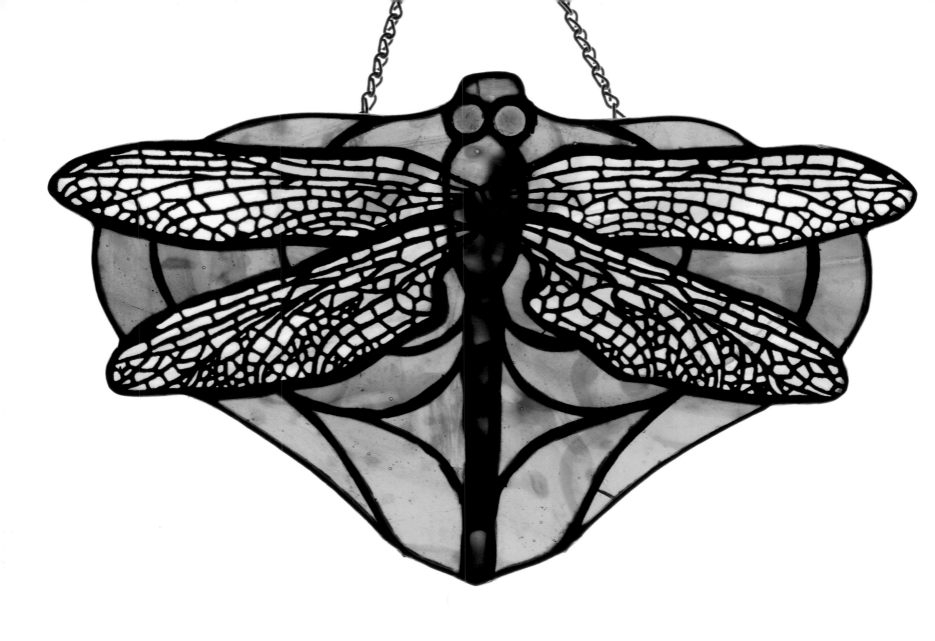

Cat. 94
Lamp Shield with Dragonfly
c. 1912
Leaded glass, brass
6³⁄₁₆ x 10 in.
The Baltimore Museum of Art, gift of Rhoda Oakley, BMA 1990.70

A single dragonfly is centered on this small leaded-glass plaque, made to be suspended from a Tiffany Studios Dragonfly Lamp (see cat. 66). The wings are filled with a delicate network of veins.

Cat. 95
Wallpaper Design: "Spiderweb"
From *What Shall We Do With Our Walls?* by Clarence Cook, Warren, Fuller & Co., New York, 1880

Inexpensive, machine-produced wallpaper transformed home decoration. Christopher Dresser, on the jury for wallpaper at the Exposition Universelle in Paris in 1878, designed for many firms, including Wilson & Fenimores of Philadelphia. By 1880, Louis Comfort Tiffany had made several designs for this medium. In a brochure printed by the firm of Warren, Fuller & Lange, two patterns are reproduced. This one combines clover and spiderwebs on a cream ground.

Cat. 96

Wallpaper Design: "Snowflakes"
From *What Shall We Do With Our Walls?* by Clarence Cook, Warren, Fuller & Co., New York, 1880

This wallpaper design for a ceiling is an Arab-inspired pattern of snowflakes on a gold ground. A rather similar star pattern was used on the ceiling of the Red Room in the White House (see fig. 23). A design for a wallpaper dado is reproduced in *Carpentry & Building* (see fig. 5). These are flat surface patterns in the Japanese manner, which avoids shading or perspective.

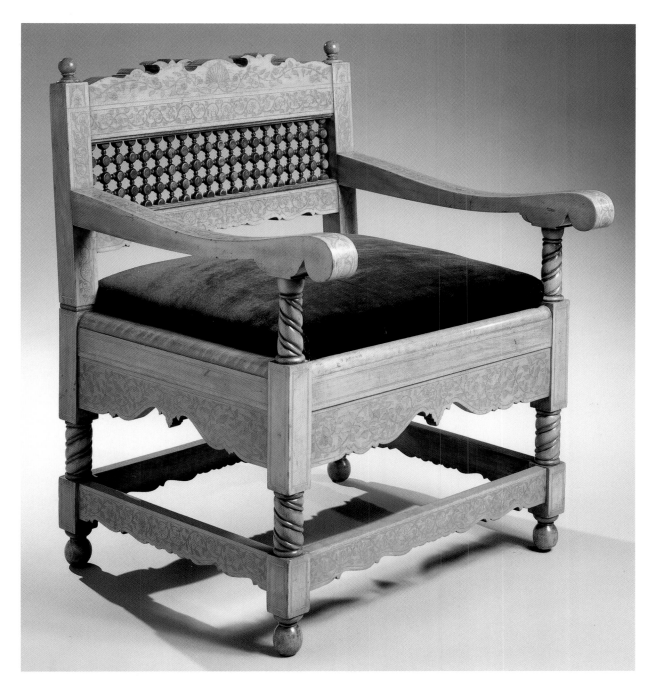

Cat. 97

Armchair
From the George Kemp House
1879
Holly wood and inlay, upholstery
28¾ x 21¾ x 21¾ in.
Collection of The Newark Museum, purchased 1996, bequest of Susan Dwight Bliss by exchange, Sophronia Anderson Bequest Fund, Felix Fuld Bequest Fund, and Membership Endowment Funds, 96.87

In 1879, Louis Comfort Tiffany was engaged to decorate the home of George Kemp on Fifth Avenue in New York, his first major commission. The salon was an Orientalist fantasy (see fig. 6). In fact, the furniture, manufactured by his own company, L. C. Tiffany & Co., in New York, seems to have been inspired by seventeenth-century Indo-Portuguese examples made for export to the West. The inlaid holly wood frame would have originally been ivory white. The florid motifs are based on Mughal Indian forms. The original upholstery was described as olive-green plush embroidered in cream and gold. This hybrid exoticism was characteristic of the Aesthetic period. A very similar, armless version of a seventeenth-century Indo-Portuguese carved chair can be glimpsed in a photograph of Tiffany's own drawing room in the Bella Apartments, also illustrated in *Artistic Houses*.

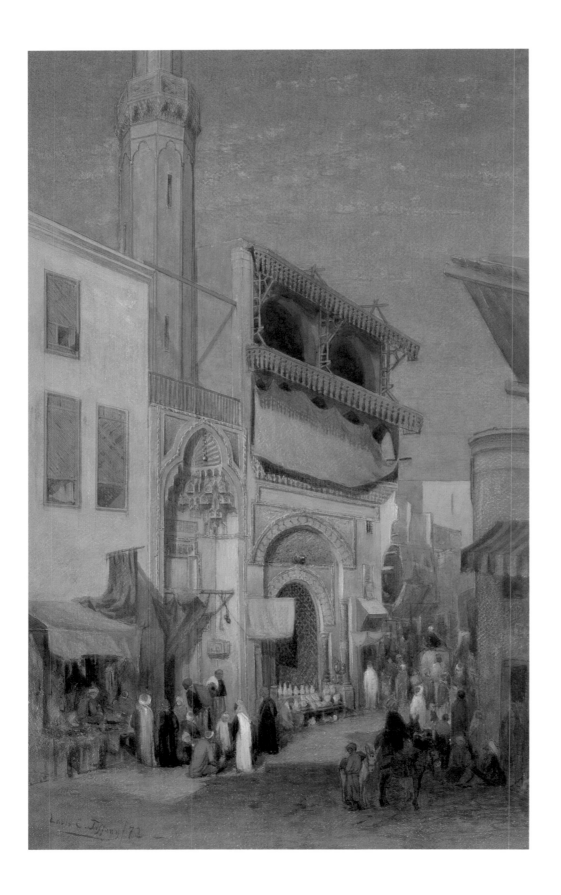

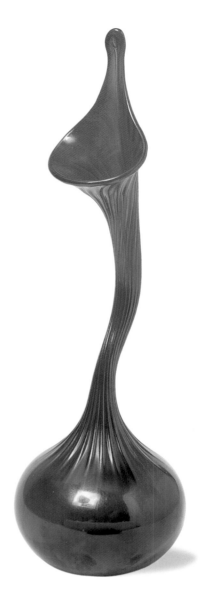

Cat. 98
Near Eastern Street Scene
1872
Watercolor on paper (in
Arab-style frame)
Marks: signed *Louis C.
Tiffany 72*
38½ x 16¾ in. (framed)
Private Collection

His North African travels
would provide Louis Comfort
Tiffany with an enduring font
of subject matter. His
interest was drawn to the
picturesque street life,
particularly merchants and
markets in the Arab
countries he visited. The
picture is displayed in an
Arab-style frame.

Cat. 99

*Persian Rosewater
Sprinkler*
c. 1895–1900
Glass
Marks: *C 38*; sticker on
base *FAVRILE T G D CO*
16¹⁵⁄₁₆ in. high
University of Michigan
Museum of Art, transfer
from the College of
Architecture and Design,
1972/2.223

This swan-necked vessel
with an elongated, calyx-like
lip closely imitates a Persian
rosewater sprinkler, a
traditional luxury product of
the Middle East. A very
similar example from Iran is
in the Corning Museum of
Glass. Tiffany, who had
traveled widely in the Islamic
world, would have been
familiar with these graceful
objects, and he made
numerous variations on the
form. Edward C. Moore also
collected such objects. A
similar example was acquired
by the National Museum,
Stockholm, in 1897; another,
in the Österreichisches
Museum für angewandte
Kunst in Vienna, was
purchased from Siegfried
Bing in 1898 (Joppien 1999,
#88–89, p. 114).

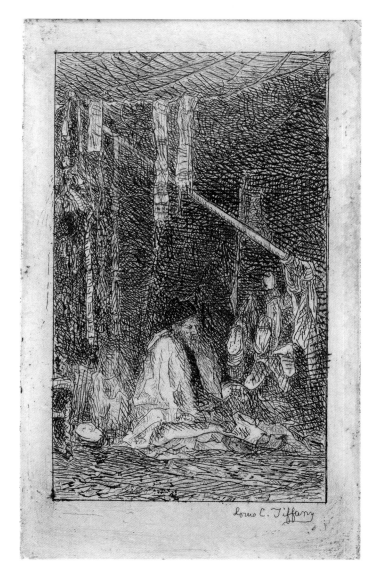

Cat. 100

*Print from Engraving Plate,
Near-Eastern Scene*
Modern
Ink on paper
21½ x 16½ in. (unframed)
Dorothy Schmiderer Baker

Tiffany experimented with
many media, including
printmaking. Only two small
engraving plates are known,
both still in a Tiffany family
collection. A modern print
has been pulled from one of
them. The small image of a
Near-Eastern merchant
seated on the ground amid
his wares is related to
Tiffany's many paintings of
similar subjects (see cat. 4).
An oil sketch of a man in a
turban has been painted on
the reverse. There was a
vogue for etching among
New York artists in the
1870s. In 1877, James D.
Smillie and R. Swain Gifford
were founders of the New
York Etching Club, the first
society of its kind in the
United States. Samuel
Colman was also a member.
It is therefore not surprising
that Tiffany should have
tried his hand at this
medium, but as his primary
interest was color, he may
have found it uncongenial.

Etching is a technique in
which the artist draws with a
needle on a wax-coated
metal plate that is then
dipped in acid, which eats
away only the lines he has
drawn. The etched plate is
then inked, wiped, and the
image printed on paper. It
was considered a
gentleman's art, as it is easy
to learn using the skills of a
draftsman.

Cat. 101

Engraving Plate
Undated — probably
late 1870s
Etched copper plate
Marks: signed in plate *Louis
C. Tiffany*
4⁵⁄₁₆ x 2¾ in.
Dorothy Schmiderer Baker

Cat. 102

Mosaic Clock Face
1895–1900
Foil-backed glass tesserae,
wood frame
32½ x 48½ in.
Carl Heck, Aspen, Colorado

Tiffany Studios produced a small number of clocks with mosaic decoration. This rectangular clock face is composed of brilliant yellow, foil-backed tesserae. The symmetrical design is purely geometric and resembles Early Christian floor mosaics. As there is no indication of hands or clockwork, this may have been a prototype. An "Egyptian"-style mosaic clock is in the Ira Simon collection (Loring 2002, p.192); there is a mosaic clock in the Tiffany-designed reading room in the Town Hall of Irvington, New York. Similar mosaic designs by Tiffany were recently uncovered at the Hudson Theater in New York City, work completed in 1903.

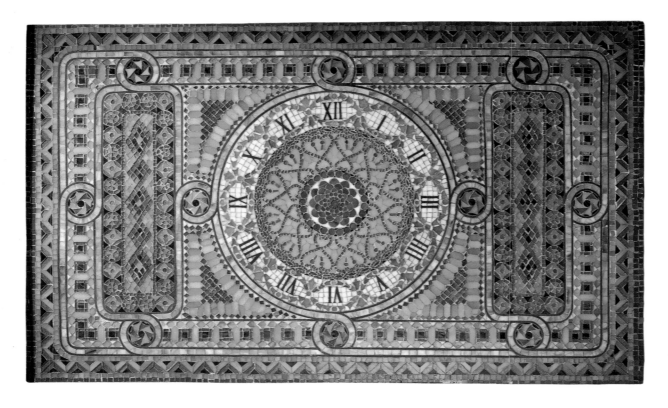

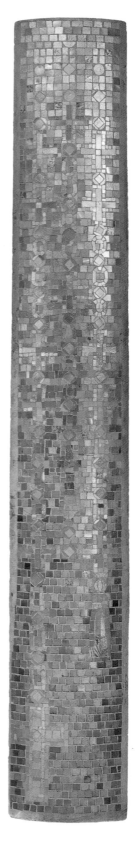

Cat. 103

*Prototype Fragment
of a Column*
c. 1893–1905
Glass tesserae embedded
in plaster
63½ x 8½ in.
Courtesy of Lillian Nassau
Ltd., New York

Gold and peacock-blue glass mosaic tiles encrust this segment of a column with a pattern of pendant crosses. A series of similar engaged columns were featured behind the altar in Tiffany's Byzantine-style chapel shown in Chicago in 1893. This column is also comparable in color and technique to a set of six full-sized columns with a mosaic pattern of long gold cords and tassels that were displayed in the Tiffany Studios showroom where they were placed against similarly patterned silk hangings. Later they were moved to Laurelton Hall. This small column may have been a prototype in the mosaic department where it would have suggested decoration for an ecclesiastical or funerary structure. That such objects were a feature of the Mosaic Department can be seen in a photograph from 1913, in which samples of floor or wall designs as well as columns can be glimpsed behind the work benches (*Metropolitan Museum of Art Bulletin*, Summer 1998, fig. 53, p. 47).

Cat. 104

Pair of Candlesticks
Twentieth century
Bronze, glass
Unmarked
11 in. high (each)
Herbert F. Johnson
Museum of Art, Cornell
University, gift of Isabel and
William Berley, Classes of
1947 and 1945,
99.078.118a–b

Tiffany made numerous
designs for candlesticks
and candelabra, often
combining bronze with
glass. He preferred tall,
attenuated forms that
resemble the stalks of
plants. These candlesticks
incorporate large iridescent
glass beads—"pearls"
trapped in the stem and
ringing the base that seem
to belong to an aqueous
realm, as does the peculiar
claw-like foot. These forms
recall the strange geometry
revealed in the pages of
Ernst Haeckel's study of
marine life, *Kunstformen der
Natur*, first published in 1904.

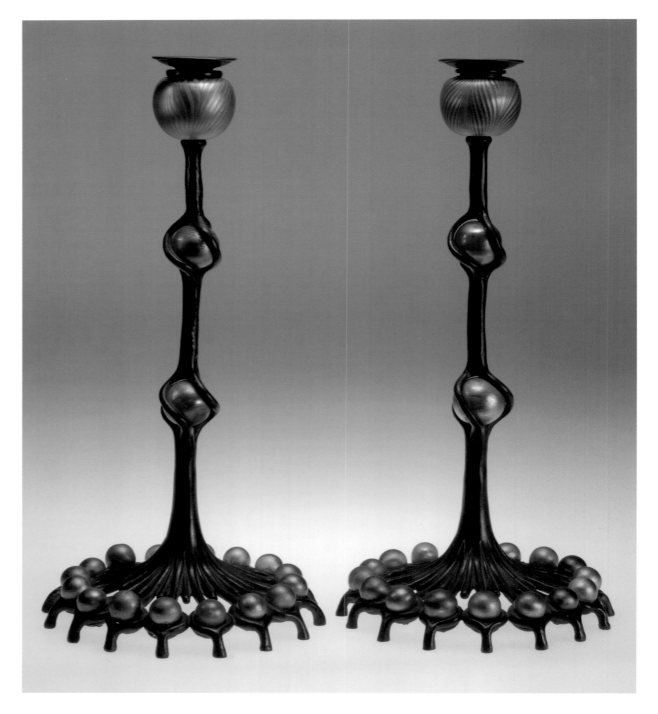

Cat. 105
Chandelier
From Evergreen, the
Garrett House
c. 1885–95
Metal, glass
66 x 29 x 29 in.
The Johns Hopkins
University, Evergreen
House, 1942.1.1087

This six-light electric
chandelier hangs in the
second-floor hallway at
Evergreen, the sumptuous
home of the Garrett family
outside of Baltimore that
was remodeled in the
1880s. Tulip-shaped glass
shades sit on rosettes of
small leaves above the
perimeter of a perforated,
"Moorish"-style metal shade
that shields the central light.

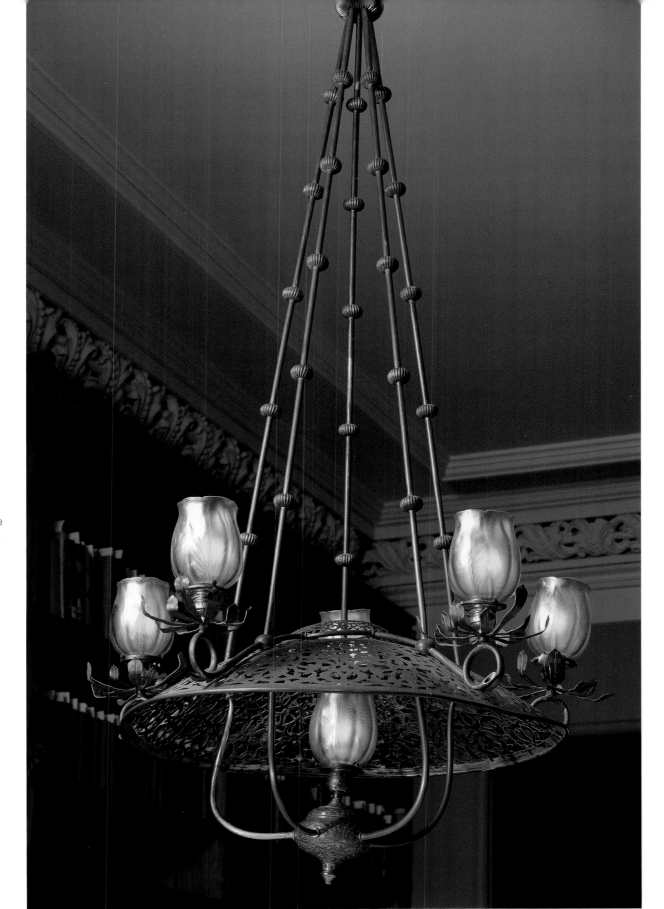

Cat. 106
Fire Screen
From the entrance hall of
the H. O. Havemeyer House
Louis Comfort Tiffany and
Samuel Colman
1890–91
Gilt metal, glass
40 x 44 in.
University of Michigan
School of Art and College of
Architecture and Urban
Planning, on loan to the
University of Michigan
Museum of Art,
1986.146.10

Louis Comfort Tiffany and
his colleague, Samuel
Colman, designed the lavish
interiors of the Havemeyer
House. The entrance hall
was entirely encrusted with
glass mosaic. The fire
screen is artfully constructed
of twisted gilt wire, glass
rods, and glass "jewels."

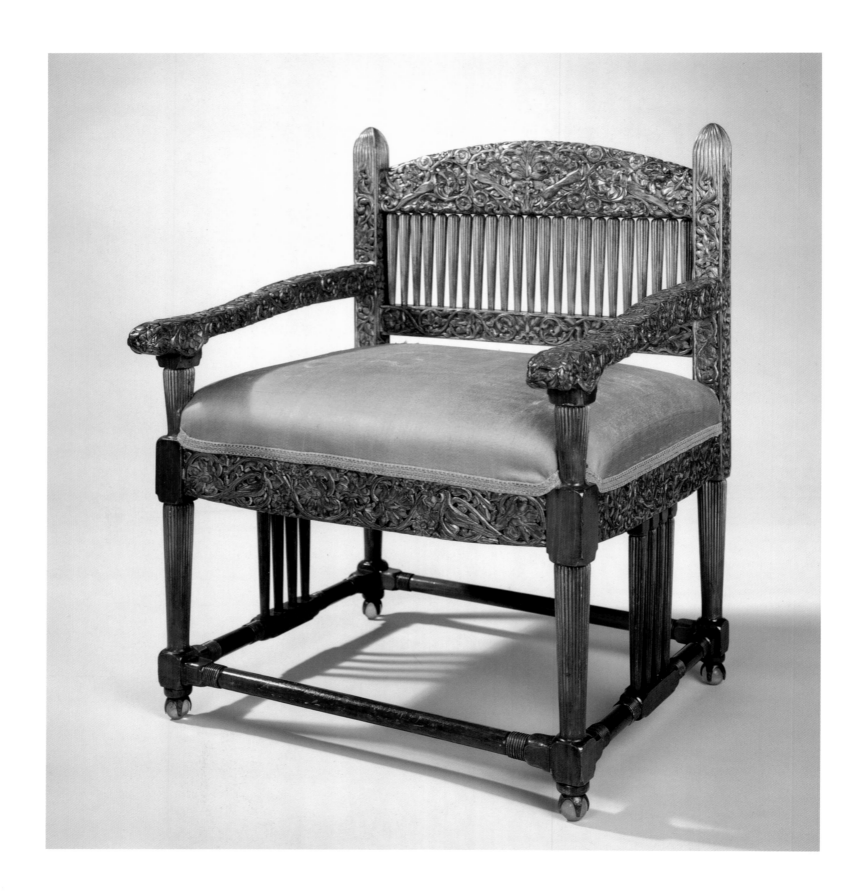

Cat. 107

Armchair
From the music room of the
H. O. Havemeyer House
Louis Comfort Tiffany and
Samuel Colman
1890–92
Ash, mahogany, satinwood,
upholstery, glass
33¾ x 25¼ x 23⅛ in.
Shelburne Museum,
Shelburne, VT, gift of
George G. Frelinghuysen,
1974, 3.3-328A

The Havemeyers often held
private concerts at home.
Their music room was a
precious repository of
Oriental works of art. The
suite of furniture, also
designed by Tiffany, though
quite similar in form to that
made for the Kemp house
ten years earlier, is more
refined in detail (see fig. 12).

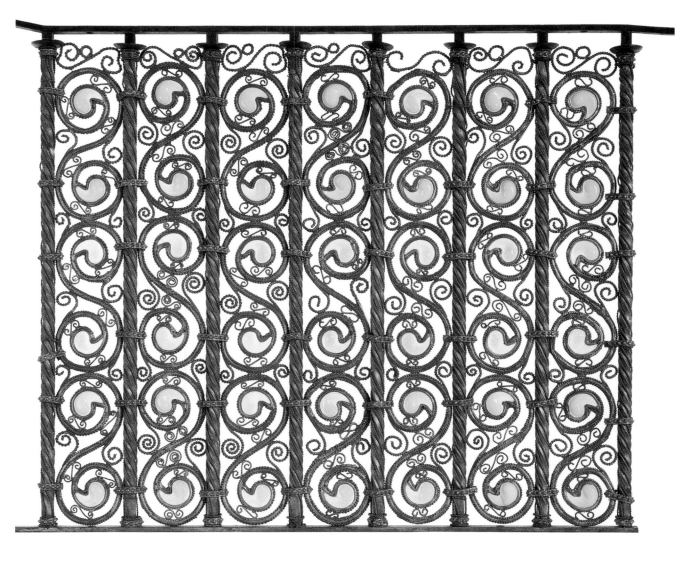

Cat. 108

Balustrade Section
From the third-floor stairwell
of the H. O. Havemeyer
House
Louis Comfort Tiffany and
Samuel Colman
1890–91
Gilt bronze, glass
32 x 42 in.
University of Michigan
School of Art and College of
Architecture and Urban
Planning, on loan to the
University of Michigan
Museum of Art, 1986.146.6

The Havemeyer family's art
collection was displayed in a
gallery for which Tiffany
produced his most daring
and novel invention: a flying
staircase (see fig. 11). The
balustrade of the stairs and
balcony was composed of
metal scrolls set with
glistening, comma-shaped
opalescent glass. This was
a light and glittering
architectural jewelry.

Time is the Measure of all Things
From the Past

Often in the eighteenth century the province of amateur collectors and of dealers, archeology came of age during the years of Tiffany's lifetime. In 1870, R. Swain Gifford and Tiffany visited Herculaneum and Pompeii, where excavations had begun well over a century earlier, but were still largely incomplete. Gifford in letters commented upon the richly colored frescoes and complex mosaic floors at Pompeii.

At the same time that Tiffany was making his first trips abroad, Civil War hero General Luigi Palma di Cesnola was amassing the largest and richest collection of Cypriote antiquities in the world. In 1872, The Metropolitan Museum of Art acquired much of this collection, which Tiffany would honor years later with his Cypriote glass, resembling in its iridescence and pitted surface the long-buried glass of antiquity.

The romance of archaeology captivated the public in the 1870s when a little-known scholar, Heinrich Schliemann, armed with a self-made fortune, knowledge of thirteen languages, and the study of archaeology, set out to unearth Homer's Troy. His discoveries were trumpeted in publications, among them *Troy and its Remains* (1875) and "Dr. Schliemann at Mycenae" in *Scribner's Monthly* (1878).

By 1880 New Yorkers followed in their newspapers the slow progress of "Cleopatra's Needle," a c.1500 BC obelisk given by the Egyptian government, from lower Manhattan to Central Park. The excavations of Sir Flinders Petrie at Tel El Amarna in 1891–92 also made news. Site of the capital city of monotheist Pharoah Ahkenaten, Tel El Amarna would lend its name to Tiffany glass.

Like Edward C. Moore, whose collections went to the Metropolitan Museum in 1891, Louis Comfort Tiffany built an impressive collection of ancient artifacts. Like Moore also, Tiffany, sometimes copying historic details faithfully, adapted the totality freely and eclectically. Glass scarabs, symbolizing resurrection and immortality, embellished not only jewelry, but also metal boxes and art pottery. Tel El Amarna detailing might appear on a Chinese shape. An inkwell in the form of an Egyptian tomb could have polychrome rectangular mosaic pieces, emulating not Egypt, but the courses of colored brick found in Assyrian architecture.

In 1922, Howard Carter's opening of the tomb of young King Tutankhamen held the civilized world spellbound. In this same year Louis Comfort Tiffany and Leslie Nash designed an elaborate enamel and bronze Egyptian dresser set for the wife of Chicago millionaire Cyrus McCormick. By this time methods of archaeology had changed vastly. Tiffany's design sources had not.

Detail cat. 119

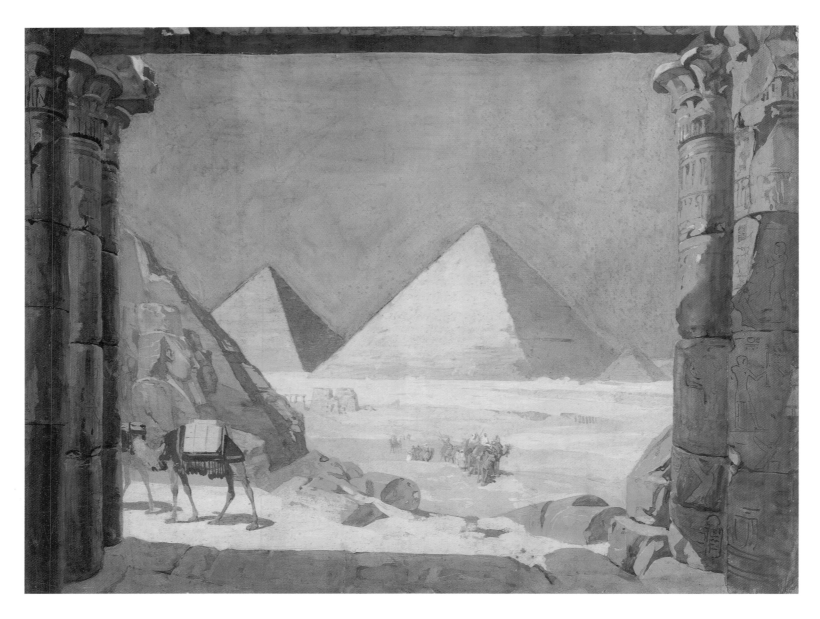

Cat. 109
Egyptian Pyramids Framed by Temple Columns
1908
Watercolor on paper
15¼ x 19¾ in. (unframed)
25 x 29¾ in. (framed)
Private Collection

Tiffany, who had traveled in Egypt in the 1870s, returned in 1908 when he took a boat trip with his family on the Nile. By now, his interest had shifted from scenes of Arab life to the monuments and remnants of the ancient pharaohs. Both Tiffany and his traveling companions documented their travels with photographs, so the paintings of Egyptian views were not necessarily made on site. However, it is said that he annoyed his twenty-year old twins by holding up the progress of the boat when he went ashore to sketch and paint. Here, the pyramids at Giza are framed by temple columns, as if by a proscenium.

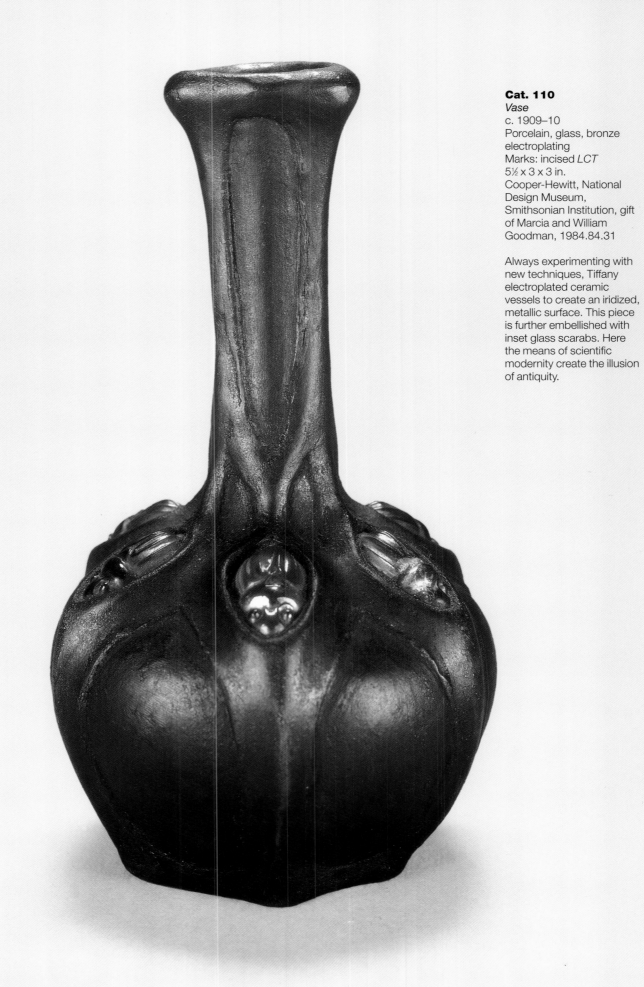

Cat. 110
Vase
c. 1909–10
Porcelain, glass, bronze
electroplating
Marks: incised *LCT*
5½ x 3 x 3 in.
Cooper-Hewitt, National
Design Museum,
Smithsonian Institution, gift
of Marcia and William
Goodman, 1984.84.31

Always experimenting with
new techniques, Tiffany
electroplated ceramic
vessels to create an iridized,
metallic surface. This piece
is further embellished with
inset glass scarabs. Here
the means of scientific
modernity create the illusion
of antiquity.

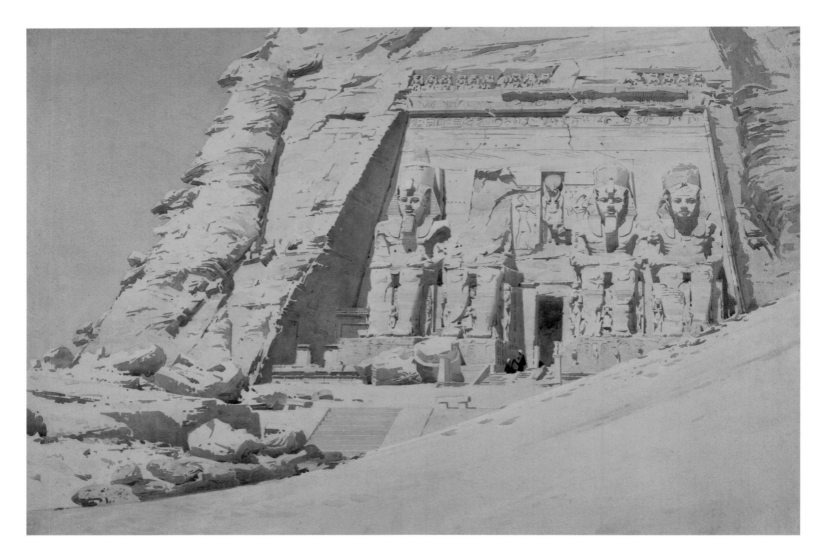

Fig 55
Louis Comfort Tiffany,
The Temple of Ramses,
Abu Simbel, 1908,
watercolor on paper,
15¼ x 19¾ in. (unframed),
Private Collection

Cat. 111
Stamp Box
c. 1905
Gilt bronze, glass mosaic, mold-pressed glass
Marks: *Tiffany Studios/New York*
4½ in. wide
Collection of Gail Evra

Molded Favrile glass scarabs, flanking a golden ball, adorn the hinged lid of this small rectangular box with sloping sides. This is a miniature mastaba, an Old Kingdom tomb form, here composed of blue-green mosaic "bricks." There is a charming whimsy in the choice of the massive Egyptian style for a tiny stamp box.

Cat. 112
Inkstand with Scarabs
c. 1906–10
Bronze, brass, glass
Marks: *1424 / TIFFANY STUDIOS / NEW YORK*, *Louis C. Tiffany*
5½ x 9¼ x 9¼ in.
Brooklyn Museum of Art, Museum Collection Fund, 59.83

Seeing the dung beetle roll its large ball, the Egyptians considered it an emblem of the sun crossing the sky. Here several press-molded scarabs surround the spherical lid of an inkwell. The lower base of this miniature monument can be pulled out to form a pen tray. Tiffany has imagined a desktop Valley of the Kings.

Cat. 113
Vase
c. 1917
Glass
Marks: *Favrile*
Tiffany Studios
5 x 2⅞ x 2⅞ in.
New Orleans Museum of
Art, gift of Karen Harriman
Harris in memory of her
husband, Louis Solomon
Harris (1918–2003),
2003.249.141

The red body of this vase is
an example of Tiffany's
Samian glass. The name
was taken from a variety of
red-clay pottery, first made
at Arezzo in the time of
Augustus, that is found
throughout the Roman
world.

Cat. 114
Ewer
c. 1910
Glass
Marks: etched °4134; paper
label
4½ x 3 x 3 in.
The Johns Hopkins
University, Evergreen
House, 1940.1.42

This little vessel is very
similar in shape to ancient
vessels that may have been
used to contain perfumes or
precious oils. Tiffany has
emulated the iridescence
left on long-buried glass by
contact with mineral
deposits. The swirling
patterns contrived here
using metal oxides are,
however, unlike the random,
blotchy effects on
archaeological specimens.

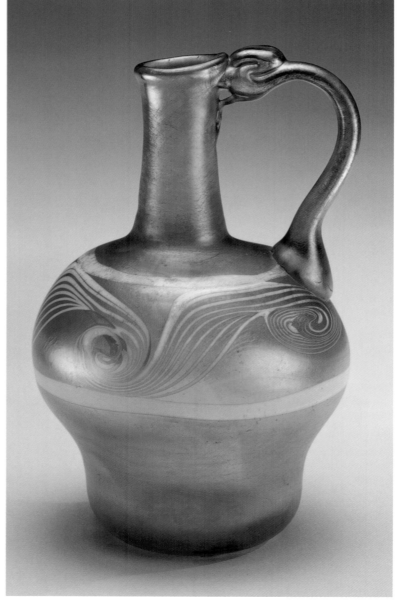

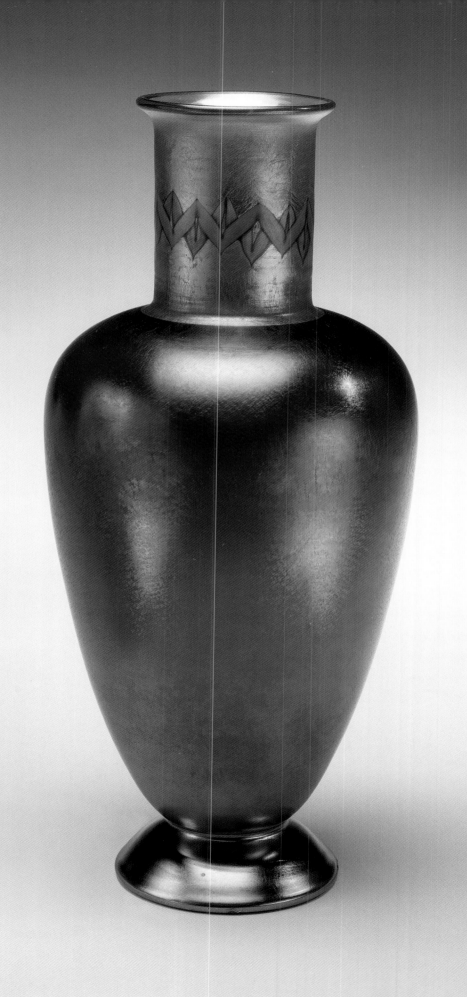

Cat. 115
Tel El Amarna Vase
c. 1913
Glass
Marks: etched *1853H L C*
Tiffany Favrile
10¼ x 4½ x 4½ in.
The Johns Hopkins
University, Evergreen House,
40.1.50

Tel el Amarna is the modern
Arabic name of the site, on
the east bank of the Nile
between Cairo and Luxor
(ancient Memphis and
Thebes), where the heretic
pharaoh Akhenaten built his
new royal city. In c.1350 BC,
this ruler promoted a cult of
the sun that briefly replaced
the traditional worship of the
old Egyptian gods. Flinders
Petrie began the first
archaeological excavations
of the ruins at Tel el Amarna
in 1892. An early glass
workshop was found near
the royal palace.
 The classically proportioned
glass vessels to which Tiffany
gave the name "Tel El
Amarna" are symmetrical and
simple in outline. The body of
the vessel is often of a single
color, here iridescent gold,
with ornament limited to a
geometric band on the neck.
The zig-zag pattern imitates
the designs on early Egyptian
glass made of applied
threads of colored canes.

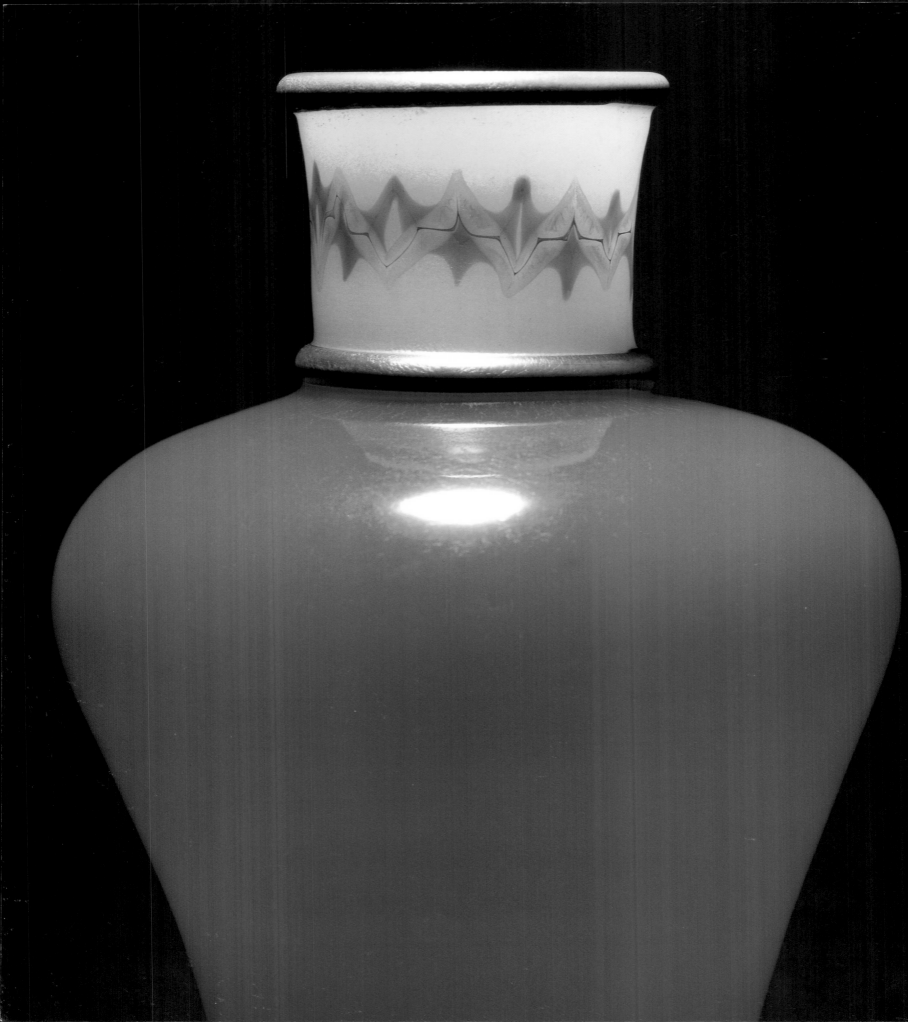

Cat. 116

Tel El Amarna Vase
c. 1912
Glass
Marks: etched *8005 G*
L.C. Tiffany Favrile
7¼ in. high
Toledo Museum of Art, gift
of the W. W. Knight heirs,
1969.266

Red glass is the most
difficult and costly to make.
Legend has it that ruby
glass, made with gold, was
discovered in Prague in the
sixteenth century as an
offshoot of alchemical
experiments, although the
Romans already knew the
secret. After 1900, Tiffany
developed three kinds of
red glass that he named
Ruby, Venetian, and
Samian. In fact, the body of
this vase is amber glass with
a deep red surface finish.
A green and yellow zigzag
band encircles the narrow
neck. The uniform, glossy
surface and perfect
symmetry of this jar are a
great contrast with the
deliberate irregularities of
contemporary Cypriote
and Lava vases, showing
the wide range of Tiffany's
aesthetic.

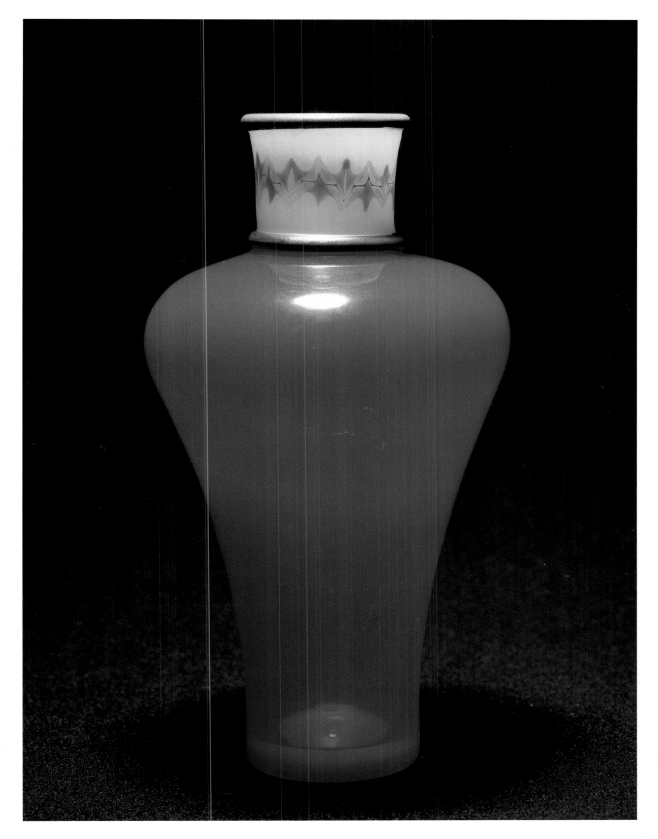

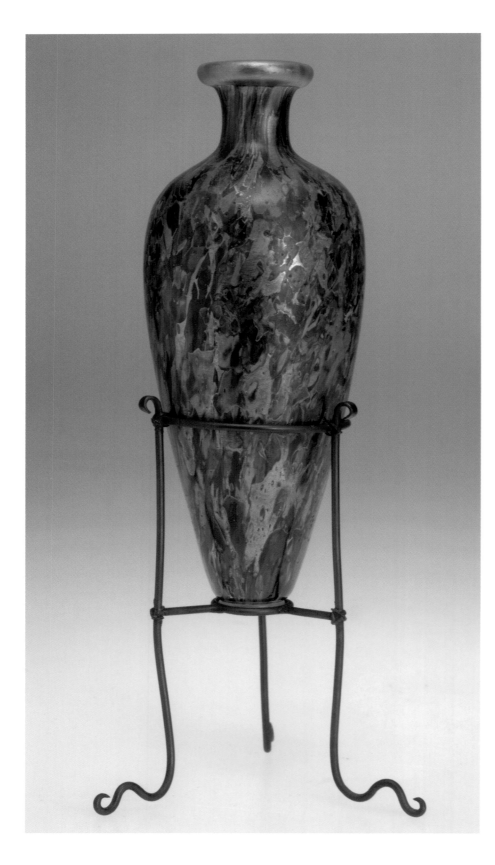

Cat. 117
Cypriote Vase
Twentieth century
Glass; metal stand
Marks: inscription, #4 in Nash inventory, incised *15-1401 p L.C.T. Favrile*
7½ x 2½ x 2½ in.
Gift of Louis Comfort Tiffany through the courtesy of A. Douglas Nash, 57.082
Courtesy of the Herbert F. Johnson Museum of Art, Cornell University

This vase, displayed in a metal tripod stand, closely imitates a precious antique. Tiffany's Cypriote glass had an irregularly pitted surface produced by rolling the hot gather of glass over a marver covered in crumbs of the same glass. It was named for excavations on Cyrus carried out by Luigi Palma di Cesnola while he was United States' consul there, beginning in 1865. Cesnola brought many of these objects to the new Metropolitan Museum of Art in New York when he became the first director in 1879. Ancient glass recovered from those digs revealed the remarkable effects various minerals in the soil had produced on once nearly clear glass. Tiffany sought to artificially elicit similar surface effects.

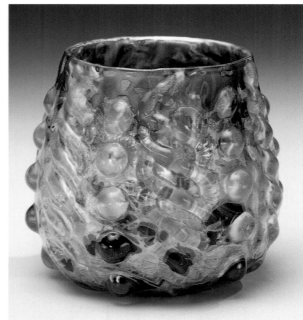

Cat. 118
Cypriote Vase
c. 1904
Glass
Marks: *V617 L. C. Tiffany Favrile*
3¼ in. high
Private Collection, courtesy of Raphael B. Sinai

The exterior surfaces of this unusual gold glass bowl are corrugated with alternating vertical relief patterns of braids and bosses. The interior is an intense, cobalt blue. A very similar vessel, marked "V620," was sold at Christie's New York (June 21, 1979). Tiffany may be emulating the late Roman technique of sandwiching gold leaf inside clear glass.

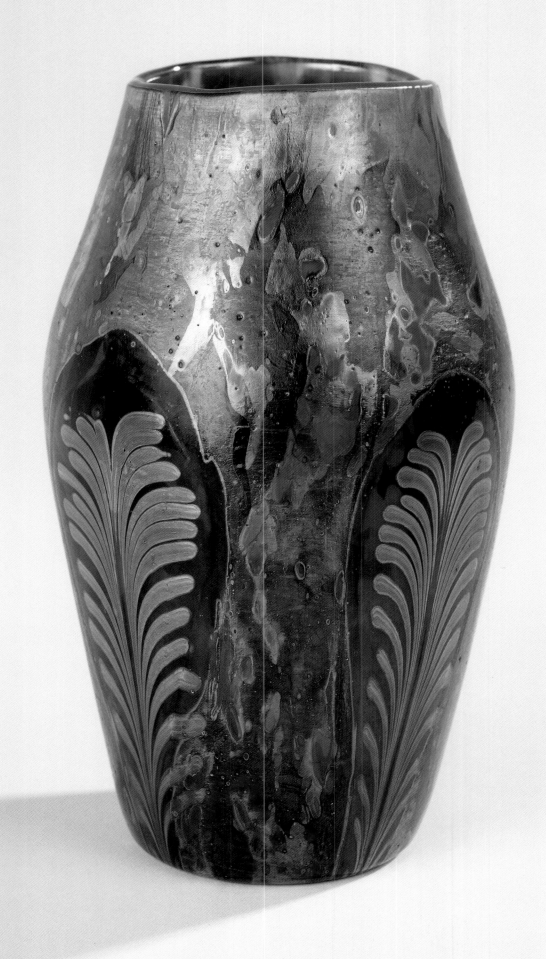

Cat. 119
Cypriote Vase
c. 1916
Glass
Marks: etched on underside of base *1549K + L. C. Tiffany Favrile* in script
6³⁄₁₆ x 3⅛ in.
Cooper Hewitt, National Design Museum, Smithsonian Institution, gift of Thomas Carnase, 1981.50.1

Leaf or feather-like motifs cup the body of this vessel. Vases with this surface treatment include one in The Chrysler Museum of Art and one that was formerly in the Joseph H. Heil collection (Doros 1978, #58, p. 51; illus. p. 67; Christie's New York, 12 June 2003, Lot 106).

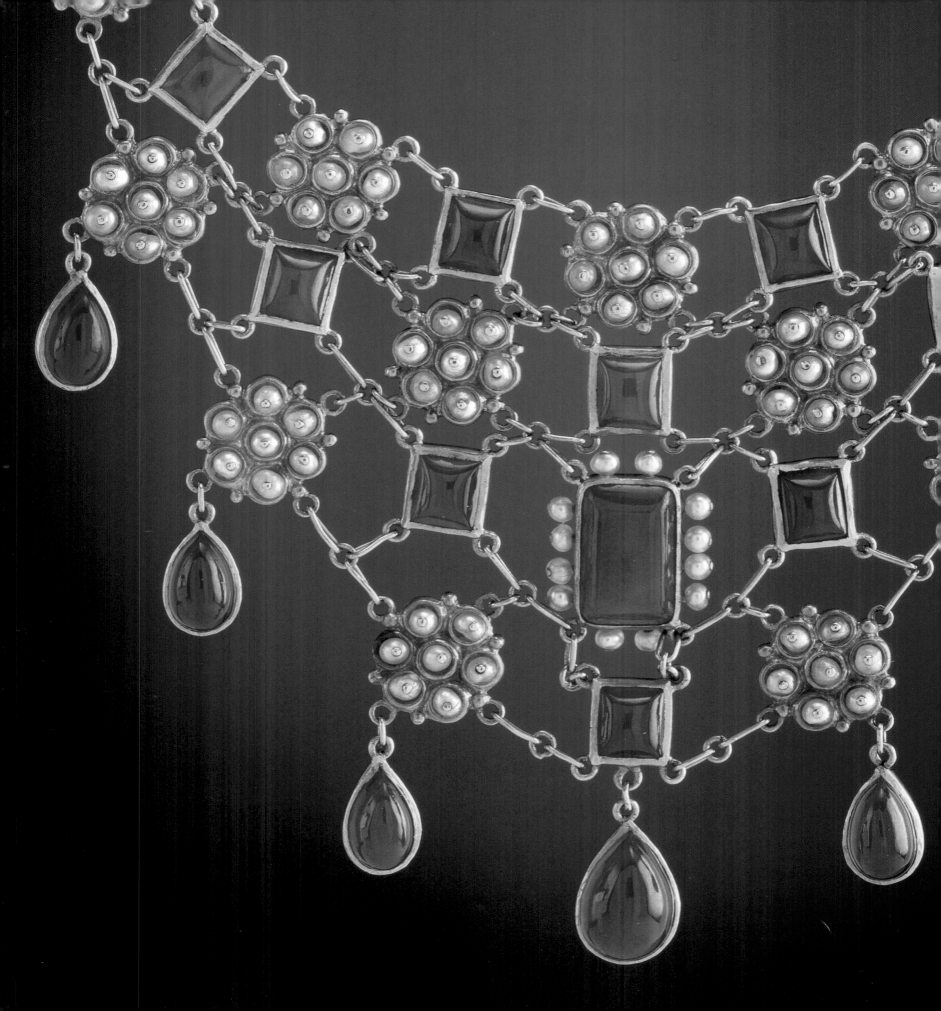

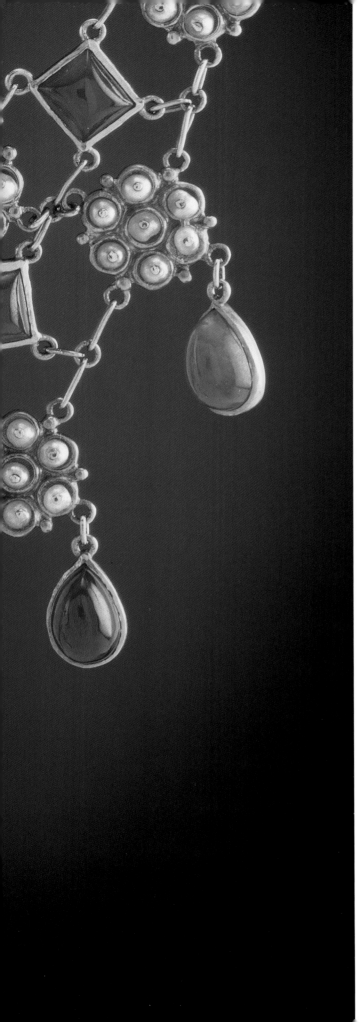

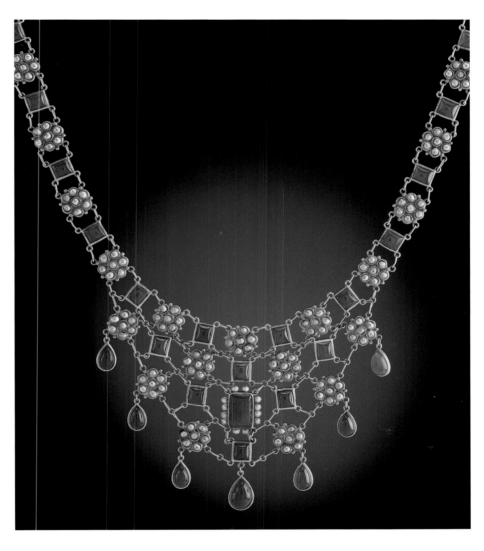

Cat. 120
"Bib" Necklace in the Etruscan Style
c. 1909
Nephrite jade, seed pearl, gold
Marks: signed on clasp
Tiffany & Co.
15 x 2¼ in.
Neil Lane Collection

Tiffany's "Etruscan"-style necklace is composed of seed-pearl rosettes that alternate with square and drop-shaped jadeite cabochons. Excavations of Etruscan tombs had produced evidence of the great skill of ancient goldsmiths. Fringe necklaces with pendants were among the forms they adopted, but the materials used were quite different, either all gold or gold set with carnelian or onyx.

Modern adaptations of these archeological jewels were made in Rome by the firm of Castellani beginning in the mid-nineteenth century. A selection had been shown to great acclaim at the Philadelphia Centennial Exposition in 1876. An archival photograph (Tiffany & Co. Archives) of the gold setting for this necklace is labeled "J973," indicating that it was designed by Julia Munson in about 1909.

Time is the Measure of all Things
Toward the Future

The early stages of the Tiffany revival peaked in the 1950s, coinciding with the revival of Art Nouveau and the height of the paintings movement known as abstract expressionism. Small wonder that a group of modernists, at this same time looking for the roots of the modern movement, felt they had found some in the works of Louis Comfort Tiffany.

There is unquestionably abstraction in Tiffany's glass. One stained-glass window, created for Tiffany's Bella apartment, 1879/80, remains, as Robert Koch stated, "the first and one of the most important abstractions of his career." In a 1974 article Koch quoted Tiffany's contemporary, painter John Leon Moran, who noticed during his visit to the studio the design prototype from which the stained-glass panel would evolve, "a window on which Mr. Tiffany has from time to time daubed the scrapings of his palette with a view to the achievement of accidental effects."

Although Tiffany never proceeded further with the experiment implicit in this window, now at The Metropolitan Museum of Art, he did experiment with the design of furniture forms outside the mainstream of high-style late-nineteenth-century decorating. Clearly of the Arts and Crafts Movement in their simplicity and functionalism, but not derived from exact prototypes, these tables and chairs created for Tiffany's own residence might well bear the title given by Herwin Schaefer to similar objects of vernacular expression, "nineteenth century modern."

The majority of Tiffany's "modernism" and abstraction, however, occurs in his glass vessels, particularly those of the first decade of production. Here in vessels that sometimes undulate like the Clutha glass of Christopher Dresser, or appear pinched like the creations of the "mad potter of Biloxi," George Ohr, are decorations that are part of the glass itself: recognizable stylized nature, but more often vibrant stripes, random dots, or vivid splashes of pure color. Undoubtedly these effects were part of Tiffany's effort to explore the full potential of his medium. In 1955, Edgar Kaufmann, Jr. saw "this love of controlled accident" as "one of Tiffany's strong links to the modern design of our age."

Detail cat. 126

Cat. 121
Table Screen
c. 1905–15
Glass, patinated bronze
Marks: center panel etched on reverse side of bronze frame (lower right) possibly letters *G ONN J*
7⅝ x 12³⁄₁₆ x 3¹⁄₁₆ in.
Cooper-Hewitt, National Design Museum, Smithsonian Institution, gift of an anonymous donor, 1967.48.104d

This small three-panel screen, made by Tiffany Studios, was intended for the tea table, where it would have been placed in front of the spirit flame under the tea urn. The panels are sheets of marbleized glass with vertical streaks of color that would have flickered with the light. This precocious appreciation of aleatory effects was an aspect of Tiffany's work that has been considered premonitory of one direction of modernism. His paintings of sunsets reveal attention to similar effects in nature (see fig. 56). In his Bella apartment, Tiffany had installed a window that imitated in leaded glass random brushstrokes of color. This ambiguous gesture anticipated Roy Lichtenstein.

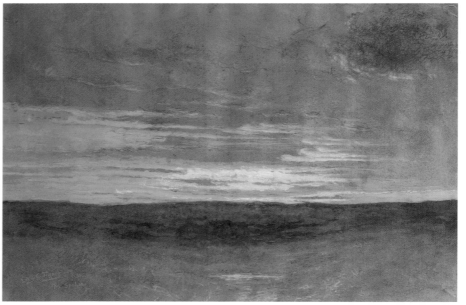

Cat. 122

Blue and Silver Vase
1893–96
Glass
Marks; square label with superscript *3* followed by *4133*; oval label with *75. °°*; round label *Tiffany Favrile Glass/ Registered Trademark/ T/G/D/C/O*; octagonal label in handscript *96.419 acc 30451 Favrile Glass Cut; Mr. Chas Tiffany; New York*
9½ x 6¼ x 6¼ in.
National Museum of American History, Smithsonian Institution, 30453 (Catalogue #96427), collected by Mr. Charles Tiffany, purchased by S.I.

This long-necked ovoid vase is made of opaque grayish-green glass overlaid with iridescent splashings.

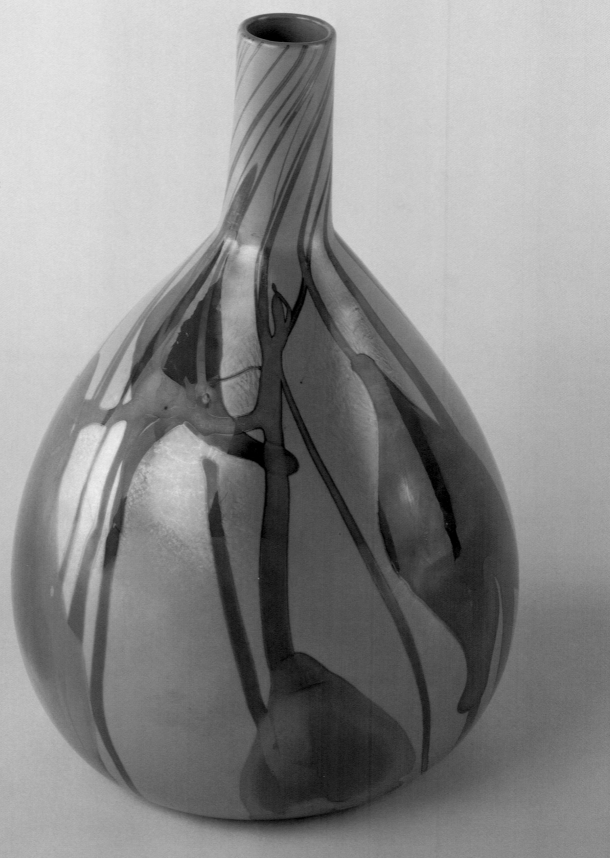

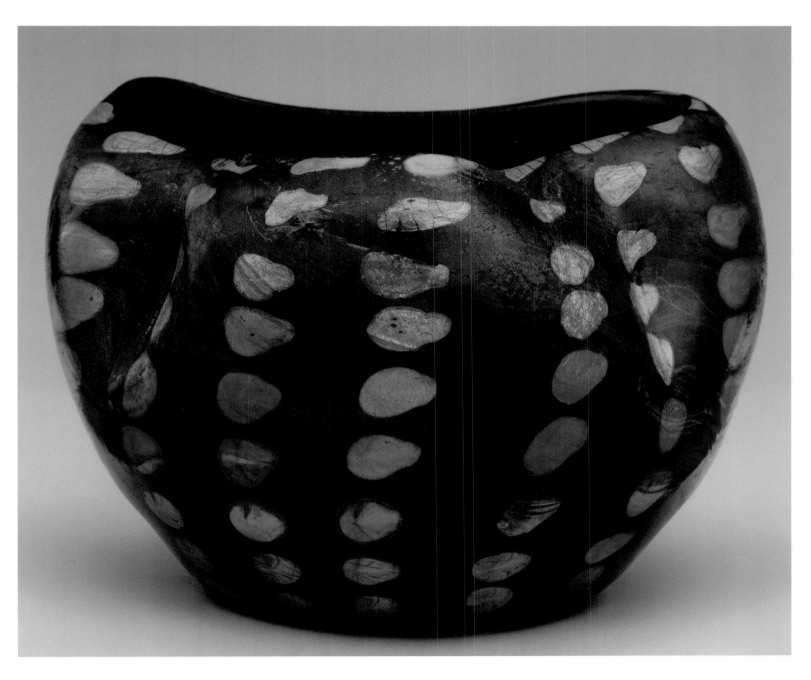

Cat. 123
Vase
1893–96
Glass
Marks: paper label *T G D Co*
[conjoined]
3⅝ in. high
The Metropolitan Museum
of Art, gift of H. O.
Havemeyer, 1896. 96.17.28

Silvery disks float on the
dark iridescent surface of
this bowl that was part of
the Havemeyer gift to The
Metropolitan Museum of Art
in 1896. The pinched-sided
shape resembles that of
some of the Native
American baskets that
Tiffany collected and

displayed at Laurelton Hall.
 Martin Eidelberg has
pointed out that Tiffany's
"early vases show a
remarkable audacity … their
shapes are in every way the
antithesis of the symmetry
traditionally associated with
glass blowing" (Eidelberg
1990, p. 510).

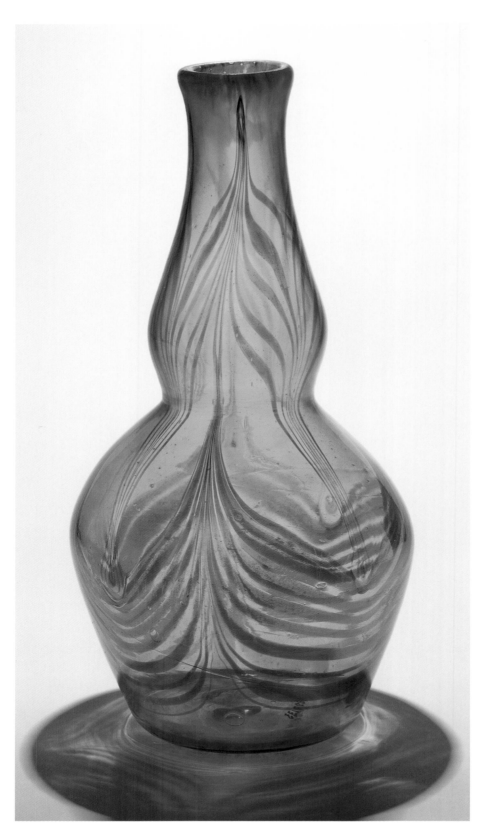

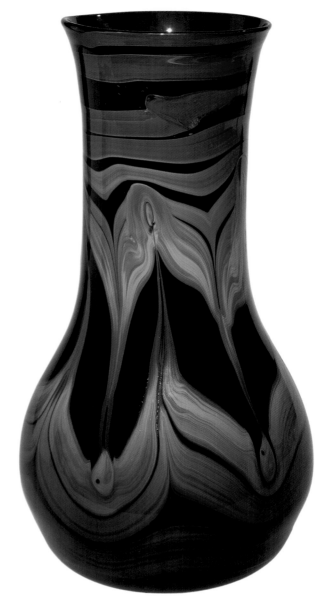

Cat. 124
Vase
1897
Glass
Marks: printed sticker
Tiffany Favrile Glass/
Registered Trademark;
etched on bottom *X2996*
19¼ x 9½ in.
Cincinnati Art Museum, gift
of A. T. Goshorn, 1897.133

Cat. 125
Vase
1897
Glass
Marks: printed sticker
Tiffany Favrile Glass/
Registered Trademark;
etched on bottom *X1058*
14¼ x 9 in.
Cincinnati Art Museum, gift
of A. T. Goshorn, 1897.122

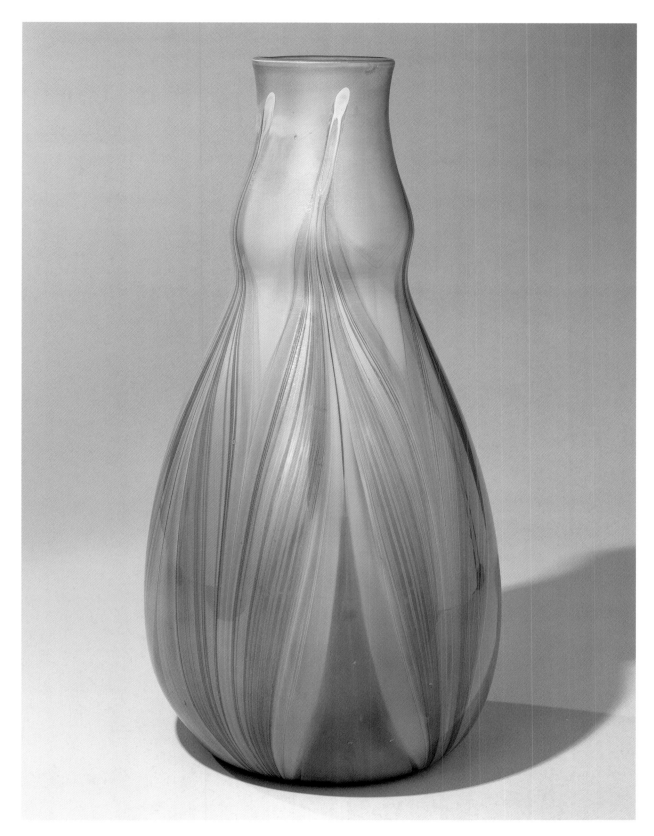

Cat. 126
Vase
1897
Glass
Marks: printed sticker
Tiffany Favrile Glass/
Registered Trademark;
etched on bottom *X1208*
18½ x 9 in.
Cincinnati Art Museum, gift
of A. T. Goshorn, 1897.111

The Cincinnati Art Museum
is the repository of a
collection of Favrile glass
vases acquired from Tiffany
by General Alfred Trabor
Goshorn, the first director of
that institution. Goshorn,
the president of a local paint
manufacturing business,
had served as the director-
general of the International
Centennial Exposition held
in Philadelphia in 1876. The
glass was acquired in 1897,
a *terminus ante quem* that
allows us to see a securely
dated cross section of
Tiffany's early work in glass.

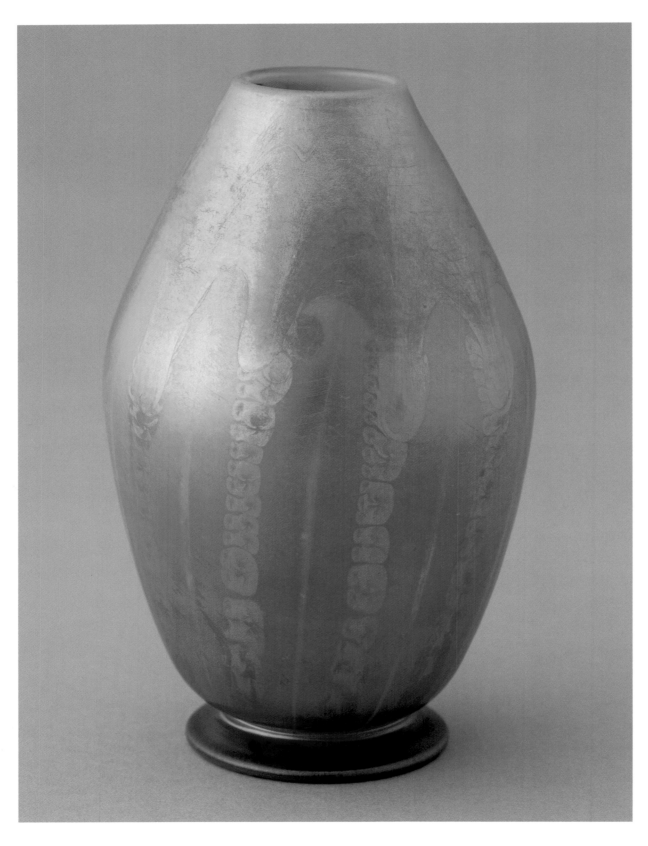

Cat. 127
Vase
c. 1897
Glass
Marks: *L.C.T. G 2964;*
sticker on base *FAVRILE
T G D CO*
5¹³⁄₁₆ in. high
University of Michigan
Museum of Art, transfer
from the College of
Architecture and Design,
1972-SL-2.214

In 1890, Louisine and Henry
Osborne Havemeyer called
upon Louis Comfort Tiffany
and Henry Colman to
design the interiors of the
sumptuous house they built
in New York at 1 East
Sixty-sixth Street on the
corner of Fifth Avenue. The
Havemeyers were
discerning art collectors
who filled the house with
contemporary and Old
Master paintings and
Oriental objets d'art. They
also owned glass by Tiffany.
Predictably, the
Havemeyers chose the
most precious and rarefied
examples of iridescent
Favrile glass for their
personal collection. Nash
called the chain-like motif
we see here "Persian"
decoration.

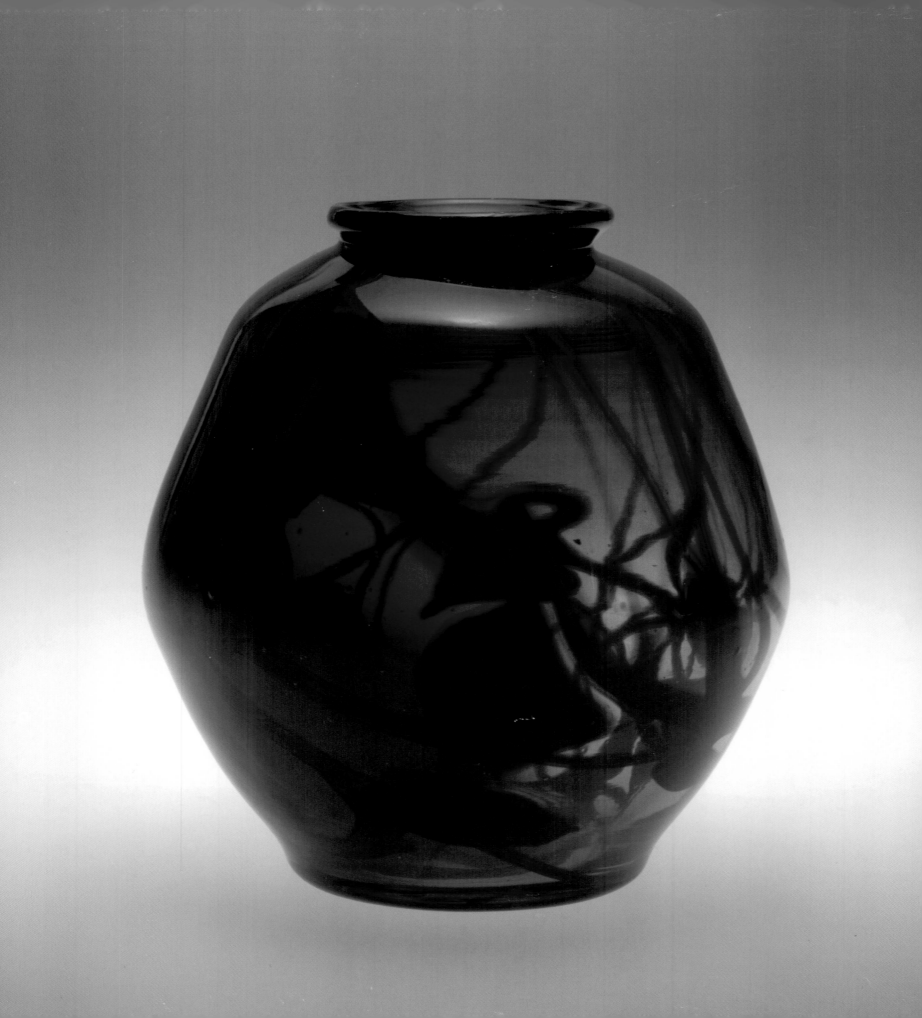

Cat. 128
Reactive Vase
1921 or earlier
Glass
Marks: inscription, #21 in
Nash inventory, incised
6-1393 p L.C.T. Favrile
5½ x 4½ x 4½ in.
Herbert F. Johnson
Museum of Art, Cornell
University, gift of Louis
Comfort Tiffany through the
courtesy of A. Douglas
Nash, 57.102

Reactive, or dichromatic,
glass has the uncanny
property of changing color
depending on whether it is
exposed to direct or
reflected light. In this
example, a shadowy pattern
of leaves meanders across
the body of the vessel.

Cat. 129
Vase
c. 1892–96
Glass
5⅞ in. high
University of Michigan
Museum of Art, transfer
from the College of
Architecture and Design,
1972-SL-2.225

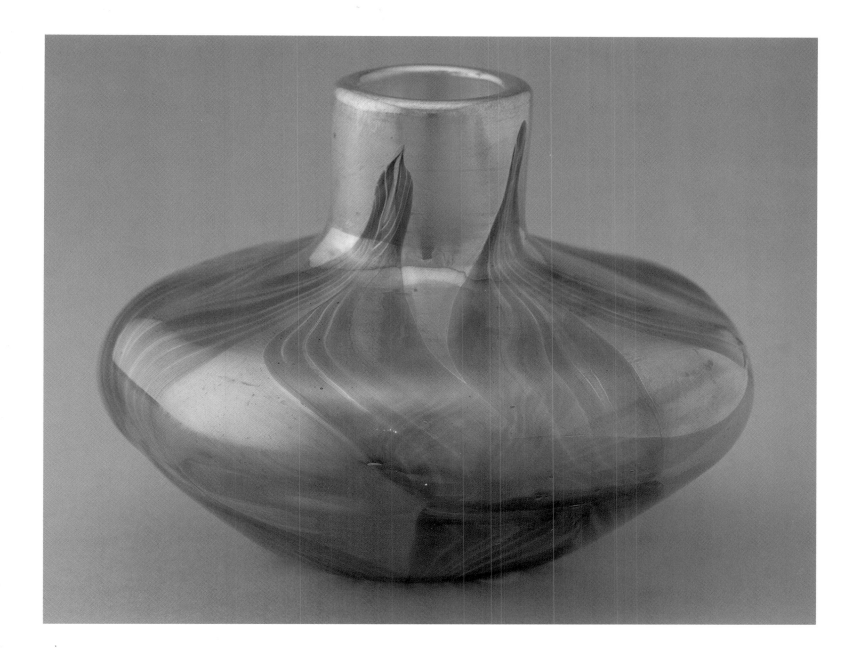

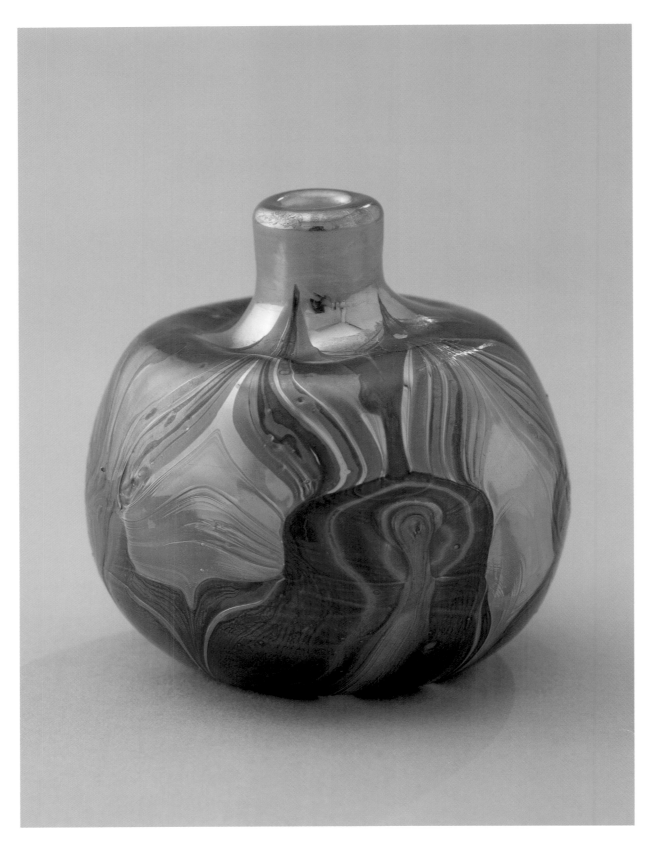

Cat. 130
Vase
c. 1892–96
Glass
3⅜₆ in. high
University of Michigan
Museum of Art, transfer
from the College of
Architecture and Design,
1972-SL-2.215

Cat. 131
Bottle
c. 1892–96
Glass
Marks: sticker on base has
been removed *FAVRILE*?
6¹³⁄₁₆ in. high
University of Michigan
Museum of Art, transfer
from the College of
Architecture and Design,
1972-SL-2.204

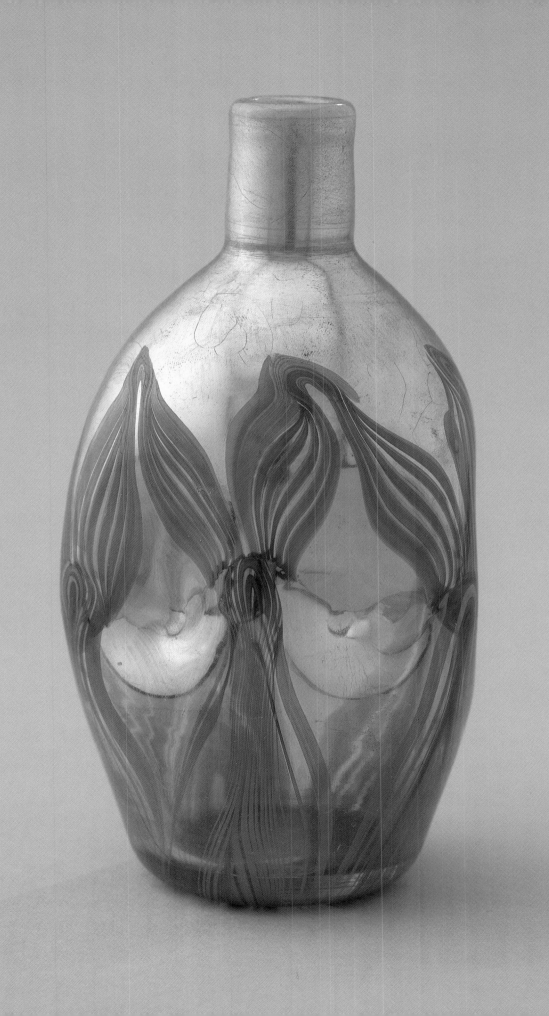

Cat. 132
Trestle-Base Table
From the breakfast room of
The Briars
Designed 1882
Pine, enamel paint
28 x 48 x 30 in.
The Mark Twain House &
Museum, Hartford, CT,
1976.17.5

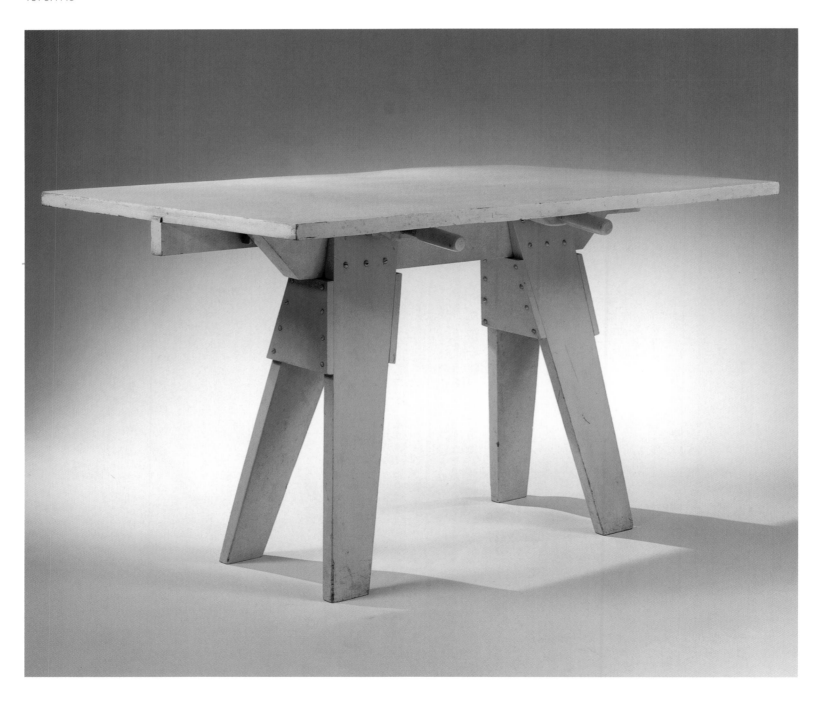

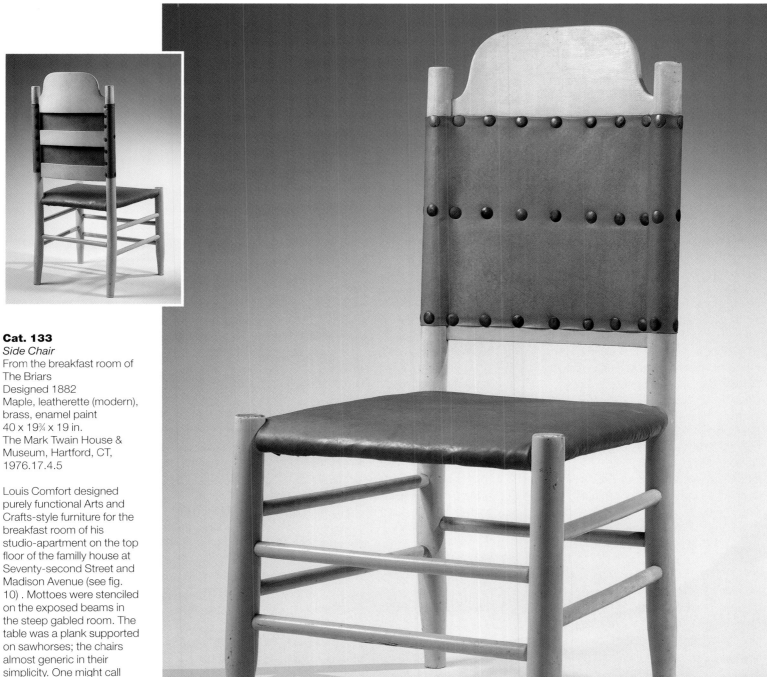

Cat. 133
Side Chair
From the breakfast room of
The Briars
Designed 1882
Maple, leatherette (modern),
brass, enamel paint
40 x 19¾ x 19 in.
The Mark Twain House &
Museum, Hartford, CT,
1976.17.4.5

Louis Comfort designed
purely functional Arts and
Crafts-style furniture for the
breakfast room of his
studio-apartment on the top
floor of the family house at
Seventy-second Street and
Madison Avenue (see fig.
10) . Mottoes were stenciled
on the exposed beams in
the steep gabled room. The
table was a plank supported
on sawhorses; the chairs
almost generic in their
simplicity. One might call
this sophisticated rusticity
"domestic pastoral." Tiffany
used the same white
painted furniture for the
breakfast room of his
country house, The Briars,
near Oyster Bay on Long
Island. Construction on that
house began in 1889, and
the family moved in in 1890.

Selected Bibliography

by Michele Kahn

SURVEYS AND CONTEXTUAL READING

BURKE, Doreen Bolger et al. *In Pursuit of Beauty: Americans and the Aesthetic Movement*. Exh. cat. New York: Metropolitan Museum of Art, 1986.

BURLINGHAM, Michael John. *The Last Tiffany*. New York: Atheneum, 1989.

CLARK, Robert Judson, ed. "Aspects of the Arts and Crafts Movement in America," by Edgar Kaufmann, Martin Eidelberg, Marilynn Johnson, Robert Koch, Robert W. Winter, and Carl El Schorske. *Record of The Art Museum Princeton University* 34 (February 1975).

DE KAY, Charles. *The Art Work of Louis Comfort Tiffany*. New York: Doubleday, Page & Co., 1914; reprint, Poughkeepsie, N.Y.: Apollo, 1987.

DOROS, Paul E. *The Tiffany Collection of the Chrysler Museum at Norfolk*. Exh. cat. Norfolk, Va.: Chrysler Museum at Norfolk, 1978.

DUNCAN, Alastair. *Louis C. Tiffany: The Garden Museum Collection*. Suffolk, Eng.: Antique Collectors' Club, Ltd., 2004.

_____. *Louis Comfort Tiffany*. New York: Harry N. Abrams, 1992.

_____. *Tiffany at Auction*. New York: Rizzoli, 1981.

DUNCAN, Alastair, Martin Eidelberg, and Neil Harris. *Masterworks of Louis Comfort Tiffany*. Exh. cat. London: Thames & Hudson; New York: Harry N. Abrams, 1989.

EIDELBERG, Martin et al. E. Colonna. Exh. cat. Dayton, Ohio: Dayton Art Institute, 1983.

EIDELBERG, Martin, and Nancy A. McClelland, eds. *Behind the Scenes of Tiffany Glassmaking: The Nash Notebooks*, including "Tiffany Favrile Glass" by Leslie Hayden Nash. New York: St. Martin's Press in association with Christie's Fine Arts Auctioneers, 2001.

FAUDE, Wilson H. *The Renaissance of Mark Twain's House*. Larchmont, N.Y.: Queens House, 1978.

FILLER, Martin. "Queen of the Lamps." *House Beautiful* 40 (September 1996): 72, 76.

FRELINGHUYSEN, Alice Cooney. *Louis Comfort Tiffany at The Metropolitan Museum of Art*. Exh. cat. New York: Metropolitan Museum of Art, 1998.

_____ et al. *Splendid Legacy: The Havemeyer Collection*. Exh. cat. New York: Metropolitan Museum of Art, 1993.

_____. "Tiffany and the H. O. Havemeyers." *The Magazine Antiques* 163 (April 1993): 596–607.

GARRETT, Wendell. *Victorian America: Classical Romanticism to Gilded Opulence*. Ed. David Larkin. New York: Rizzoli, 1993.

GREENHALGH, Paul, ed. *Art Nouveau 1890–1914*. Exh. cat. London: Victoria and Albert Museum, 2000.

HUNTING, MaryAnne. "The Seventh Regiment Armory in New York City." *The Magazine Antiques* 155 (January 1999): 158–67.

JOPPIEN, Rüdiger and Susanne Langle. *Louis C. Tiffany: Meisterwerke des Americankanischen Jugendstils*. Exh. cat. Hamburg: Museum für Kunst und Gewerbe, 1999.

KOCH, Robert. *Louis C. Tiffany: The Collected Works of Robert Koch*. Atglen, Pa.: Schiffer Publishing, 2001.

"L. C. Tiffany Dead." *The Art Digest* 7 (Feb. 1, 1933): 9.

LEWIS, Arnold, James Turner, and Steven McQuillin. *The Opulent Interiors of the Gilded Age: All 203 Photographs from "Artistic Houses."* New York: Dover Publications, 1987.

LORING, John. *Louis Comfort Tiffany at Tiffany & Co*. New York: Harry N. Abrams, 2002.

LYNES, Russell. *The Tastemakers: The Shaping of American Popular Taste*. New York: Harper, 1954; reprint, New York: Dover Publications, 1991.

MAYER, Roberta and Caroline K. Lane. "Disassociating the 'Associated Artists': The Early Business Ventures of Louis C. Tiffany, Candace T. Wheeler, and Lockwood de Forest." *Studies in the Decorative Arts* 8 (Spring/Summer 2001): 2–36.

MCKEAN, Hugh. *The "Lost" Treasures of Louis Comfort Tiffany*. Garden City, N.Y.: Doubleday & Company, 1980.

METROPOLITAN MUSEUM OF ART. *19th Century America: Furniture and Other Decorative Arts: An Exhibition in Celebration of the Hundredth Anniversary of The Metropolitan Museum of Art*. Introduction by Tracy B. Berry. Texts by Marilynn Johnson, Marvin D. Schwartz, and Suzanne Boorsch. Exh. cat. New York: Metropolitan Museum of Art, 1970.

The Objects of Art of the Louis Comfort Tiffany Foundation. Exh. cat. New York: Parke-Bernet Galleries, 1946.

PURTELL, Joseph. *The Tiffany Touch*. New York: Random House, 1971.

TRIPP, Susan Gerwe. "Evergreen House, Baltimore, Maryland." *The Magazine Antiques*, 139 (February 1991): 388–97.

TWAIN, Mark (Samuel L. Clemens) and Charles Dudley Warner. *The Gilded Age: A Tale of To-Day*. Hartford, Conn.: American Publishing Co., 1873.

L. C. TIFFANY (BY MEDIUM)

CERAMICS

AUDSLEY, George A. and James L. Bowes. *Keramic Art of Japan*. London: Henry Sotheran & Co., 1875; reprint, Boston: Adament Media Corp., Elibron Classics Series, 2003.

EIDELBERG, Martin, ed. *From Our Native Clay: Art Pottery from the Collections of the American Ceramic Arts Society*. Exh. cat. Essay by Robert A. Ellison, Jr.; catalogue by Betty G. Hut. New York: Christies, 1987.

_____. "Myths of Style and Nationalism: American Art Pottery at the Turn of the Century." *The Journal of Decorative and Propaganda Arts* 20 (1994): 84–111.

FRELINGHUYSEN, Alice Cooney. "Aesthetic Forms in Ceramics and Glass." In Doreen Bolger Burke et al., *In Pursuit of Beauty: Americans and the Aesthetic Movement*, 198–251. Exh. cat. New York: Metropolitan Museum of Art, 1986.

_____. *American Art Pottery: Selections from The Charles Hosmer Morse Museum of American Art*. Exh. cat. Orlando Museum of Art, 1995.

LEVIN, Elaine. *The History of American Ceramics, 1607 to the Present*. New York: Harry N. Abrams, 1988.

PERRY, Barbara A., ed. *American Art Pottery from the Collection of Everson Museum of Art*. Exh. cat. New York: Harry N. Abrams, 1997.

FAVRILE GLASS/STAINED-GLASS WINDOWS/LAMPS

BRUHN, Jutta-Annette. *Designs in Miniature: The Story of Mosaic Glass*. Corning, N.Y.:The Corning Museum of Glass, 1995.

DUNCAN, Alastair. *Tiffany Windows*. New York: Simon & Schuster, 1980.

EIDLEBERG, Martin. "Tiffany's Early Glass Vessels." *The Magazine Antiques* 11 (February 1990): 502–15.

FELD, Stuart P. "Nature in Her Most Seductive Aspects: Louis Comfort Tiffany's Favrile Glass." *Metropolitan Museum of Art Bulletin* 21 (November 1962): 101–12.

FRELINGHUYSEN, Alice Cooney. "A New Renaissance: Stained Glass in the Aesthetic Period," In Doreen Bolger Burke et al., *In Pursuit of Beauty: Americans and the Aesthetic Movement*, 176–97. Exh. cat. New York: Metropolitan Museum of Art, 1986.

GRAY, Nina. "The Work of Tiffany Studios." *The Magazine Antiques* 166 (January 2005): 194–201.

JOHNSON, Marilynn. "America's Dream Garden: The Stained Glass Season." *Apollo Magazine* 3 (May 1980): 394–98.

_____. "Louis Comfort Tiffany and His Glass." *Art & Antiques* 6 (January/February 1980): 102–09.

_____. "Stained Glass of Tiffany and La Farge in the Met's New Wing." *Nineteenth Century* 6 (Autumn 1980): 36–38.

NEUSTADT, Egon. *The Lamps of Tiffany*. New York: Neustadt Museum of Art, 1970.

RIORDIN, Roger. "American Stained Glass," pt. 1–3. *The American Art Review* 2, second division (April 1881): 229–34; (May 1881): 229–34; (June 1881): 59–64.

WILSON, Kenneth M. *The Toledo Museum of Art: American Glass, 1760–1930*. 2 vols. New York: Hudson Hills Press in association with the Toledo Museum of Art, 1994.

FURNITURE AND INTERIORS

FAUDE, Wilson H. "Associated Artists and the American Renaissance in the Decorative Arts." *Winterthur Portfolio* 10 (1975): 101–30.

HARRIS, Neil. "Louis Comfort Tiffany: The Search for Influence." In Alastair Duncan, Martin Eidelberg, and Neil Harris, *Masterworks of Louis Comfort Tiffany*, 13–48. Exh. cat. London: Thames & Hudson, and New York: Harry N. Abrams, 1989.

JOHNSON, Marilynn. "Art Furniture: Wedding the Beautiful and the Useful." In Doreen Bolger Burke et al., *In Pursuit of Beauty: Americans and the Aesthetic Movement*, 142–75. Exh. cat. New York: Metropolitan Museum of Art, 1986.

_____. "The Artful Interior." In Doreen Bolger Burke et al., *In Pursuit of Beauty: Americans and the Aesthetic Movement*, 110–41. Exh. cat. New York: Metropolitan Museum of Art, 1986.

MAYER, Roberta Ann. "Understanding the Mistri: The Arts and Crafts of Lockwood de Forest (1850–1932)." PhD diss., University of Delaware, Newark, 2000.

NAEVE, Milo M. "Louis Comfort Tiffany and the Reform Movement in Furniture Design: The J. Matthew and Ernest Hagen Commission of 1882–1885." In Luke Beckerdite, ed., *American Furniture* 1996, 3–16. Milwaukee, Wis.: Chipstone Foundation, and Hanover, N.H.: University Press of New England, 1996.

JEWELRY/ENAMELS

DEITZ, Paula. "Jewelry Made by a Tiffany Who Chose a Life of Art." *New York Times*, August 9, 1998, sec. 2, p. 35.

FRELINGHUYSEN, Alice Cooney. "The Early Artistic Jewelry of Louis C. Tiffany." *The Magazine Antiques* 162 (July 2002): 90–95.

HARLOW, Katherina. "A Pioneer Master of Art Nouveau: The Hand-wrought Jewellery of Louis C. Tiffany." *Apollo* 116 (July 1982): 46–50.

HOWE, Samuel. "Enamel as a Decorative Agent." *The Craftsman* 2 (May 1902): 61–68.

REIF, Rita. "For Louis Tiffany, Lamps Weren't the Half of It." *New York Times*, October 10, 1993, sec. 2, p. 1.

ZAPATA, Janet. *The Jewelry and Enamels of Louis Comfort Tiffany*. Harry N. Abrams: New York, 1996.

METALWORK

HANKS, David A. with Jennifer Toher. "Metalwork: An Eclectic Aesthetic." In Doreen Bolger Burke et al., *In Pursuit of Beauty: Americans and the Aesthetic Movement*, 252–93. Exh. cat. New York: Metropolitan Museum of Art, 1986.

KENEMY, George A. and Donald Miller. *Tiffany Desk Treasures: A Collector's Guide, including a Catalogue Raisonné of Tiffany Studios & Tiffany Furnaces Desk Accessories*. New York: Hudson Hills Press, 2002.

KOCH, Robert. "A Tiffany–Byzantine Inkwell." *Brooklyn Museum Bulletin* 30 (Spring 1960): 5.

REIF, Rita. "The Tiffany Touch in Metal." *New York Times*, March 6, 1983, sec. 2, p. 26.

MOSAICS

DEUTSCH, Davida Tenenbaum. "The Osborne, New York City." *The Magazine Antiques* 130 (July 1986): 152–58.

LONG, Nancy, ed. *The Tiffany Chapel at the Morse Museum*. Exh. cat. With contributions by Alice Cooney Frelinghuysen, Wendy Kaplan, Laurence J. Ruggiero, et al. Winter Park, Fla.: Charles Hosmer Morse Foundation, 2002.

THOMAS, W. H. "Glass-Mosaic—An Old Art with a New Distinction." *International Studio* 28 (March–June 1906): lxxiii–lxxviii.

PAINTINGS/WATERCOLORS/ DRAWINGS

BURKE, Doreen Bolger. "Louis Comfort Tiffany and His Early Training at Eagleswood, 1862–1865." *The American Art Journal* 19 (Fall 1987): 29–38.

PRICE, Joan Elliott. *Louis Comfort Tiffany: The Painting Career of a Colorist*. New York: P. Lang, 1996.

REYNOLDS, Gary. *Louis Comfort Tiffany: The Paintings*. Exh. cat. New York: Grey Art Gallery and Study Center, New York University, 1979.

WEISBERG, Gabriel et al. *Japonisme: Japanese Influence on French Art 1854–1910*. Exh. cat. Cleveland: Cleveland Museum of Art, 1975.

WALLPAPER/TEXTILES

AYRES, Dianne. *American Arts and Crafts Textiles*. New York: Harry N. Abrams, 2002.

COOK, Clarence. "What Shall We Do With Our Walls?" New York: Warren, Fuller & Company, 1880.

"Decoration & Ornament: The Colman and Tiffany Wall-Papers." *The Art Amateur* 3 (June 1880): 12.

LYNN, Catherine. "Decorating Surfaces: Aesthetic Delight, Theoretical Dilemma." In Doreen Bolger Burke, *In Pursuit of Beauty: Americans and the Aesthetic Movement*, 52–63. Exh. cat. New York: Metropolitan Museum of Art, 1986.

————. "Surface Ornament: Wallpapers, Carpets, Textiles, and Embroidery." In Doreen Bolger Burke, *In Pursuit of Beauty: Americans and the Aesthetic Movement*, 64–109. Exh. cat. New York: Metropolitan Museum of Art, 1986.

————. *Wallpaper in America: From the Seventeenth Century to World War I*. New York: Barra Foundation/Cooper-Hewitt in association with W.W. Norton, 1980.

PECK, Amelia and Carol Irish. *Candace Wheeler: The Art and Enterprise of American Design, 1875–1900*. Exh. cat. New York: Metropolitan Museum of Art, 2001.

THEMATIC CURRENTS in L. C. TIFFANY'S OEUVRE

ANCIENT WORLD THROUGH THE MIDDLE AGES

ACHILLES, Rolf. "Art from the Past and 'Art from the Past': Tiffany and the Middle Ages." *Stained Glass* 79 (Spring 1984): 22–26.

BULLEN, J. B. *Byzantium Rediscovered*. London: Phaidon Press, 2003.

COLEMAN, Caryl. "A Sea of Glass." *The Architectural Record*, 2 (January–March 1893): 265–85.

"Dr. Schliemann at Mycenae." *Scribner's Monthly* 15 (January 1878): 307–20.

JEWITT, Llewellynn, F. S. A. "Ancient Irish Art." *The Art Journal*, 3 (June and October 1877): 174–76, 297–300.

RAGUIN, Virginia Chieffo. *Stained Glass from Its Origins to the Present*. With a contribution by Mary Clerkin Higgins.

New York: Harry N. Abrams, 2003.

TAIT, Hugh, ed. *Five Thousand Years of Glass*. Rev. edition. London: British Museum Press, 2004.

WEIR, Hugh. "Through the Rooking Glass—An Interview with Louis C. Tiffany." *Collier's, the National Weekly* 75 (May 23, 1925): 10–12, 50–52.

EXOTICISM & ORIENTALISM/NEAR EAST, FAR EAST, & INDIA

ALCOCK, Sir Rutherford. *Art and Art Industries in Japan*. London: Virtue and Co., 1878; reprint, Bristol: Ganesha Publishing, 1999.

BING, S., ed. *Le Japon artistique*. 6 vols. Eng. trans., London: Sampson Low, Marston, Searle & Rivington, 1889–90; reprint, Boston: Adamant Media Corporation, Elibron Classics series, 2004.

CUTLER, Thomas W. *A Grammar of Japanese Ornament and Design*. London: B. T. Batsford, 1889; reprint, Mineola, N.Y.: Dover Publications, 2003.

EWARDS, Holly, ed. *Noble Dreams—Wicked Pleasures: Orientalism in America, 1870–1930*. Exh. cat. Williamstown, Mass.: Sterling and Francine Clark Art Institute, 2000.

HEAD, Raymond. *The Indian Style*. Chicago: University of Chicago Press, 1986.

HOSLEY, William. *The Japan Idea: Art and Life in Victorian America*. Exh. cat. Hartford, Conn.: Wadsworth Atheneum, 1990.

JONES, Owen. *The Grammar of Ornament*. One hundred folio plates, drawn on stone by F. Bedford. London: Day and Son, 1856; reprint, New York: DK Publishing, 2001.

MAYER, Roberta A. "The Aesthetics of Lockwood de Forest: India, Craft, and Preservation." *Winterthur Portfolio* 31 (Spring 1996): 1–22

NAGATA, Seiji. *Hokusai: Genius of the Japanese Ukiyo-e*. Translated by John Bester. Tokoyo: Kodansha International, 1995; reprint in paperback, 1999.

PERRY, Barbara, ed. *Fragile Blossoms, Enduring Earth: The Japanese Influence on American Ceramics*. Exh. cat. Syracuse, N.Y.: Everson Museum of Art, 1989.

RAWSON, Jessica, ed. *The British Museum Book of Chinese Art*. New York: Thames & Hudson, 1993

SAID, Edward W. *Orientalism*. New York: Pantheon Books, 1978; reprint, New York: Penguin, 1995.

SHELTON, William Henry. "The Most Indian House in America." *House Beautiful* 8 (June 1900): 419–23.

WICHMANN, Siegfried. *Japonisme: The Japanese Influence on Western Art since 1858*. London: Thames & Hudson, 1981.

LOOKING TO THE FUTURE/ CHANGING TASTES

AMAYA, Mario. "The Taste for Tiffany." *Apollo Magazine* 81 (February 1965): 102–09.

BING, S. *La Culture artistique en Amérique*. Paris: privately printed, 1896. Translated as *Artistic America, Tiffany Glass, and Art Nouveau*. Introduction by Robert Koch (Cambridge, Mass.: M.I.T. Press, 1970).

JOHNSON, Philip. "Decorative Art a Generation Ago." *Creative Art* 12 (April 1933): 297–99.

KAPLAN, Wendy et al. *The Arts & Crafts Movement in Europe & America: Design for the Modern World*. Exh. cat. Los Angeles: Los Angeles County Museum of Art, 2004.

_____. "Tiffany and Design Reform." In *The Tiffany Chapel at the Morse Museum*, 7–19. Exh. cat. Winter Park, Fla.: Charles Hosmer Morse Foundation, 2002.

KAUFMANN, Edgar Jr. "Tiffany Glass Then and Now." *Interiors* 119 (February 1955): 82–85.

SAARINEN, Aline B. "Famous, Derided and Revived." *New York Times*, March 13, 1955, sec. 2, p. 9.

SCHAEFFER, Herwin. "Tiffany's Fame in Europe." *Art Bulletin* 44 (December 1962): 308–28.

WEISBERG, Gabriel P. *Art Nouveau Bing: Paris Style 1900*. Exh. cat. Washington, D.C.: Smithsonian Institution Traveling Exhibition Service, 1986.

WHITEWAY, Michael, ed. *Shock of the Old: Christopher Dresser's Design Revolution*. Exh. cat. London: Smithsonian, Cooper-Hewitt National Design Museum in association with V&A Publications, 2004.

NATURE

EIDELBERG, Martin. "Nature Is Always Beautiful." *American Ceramics* 14 (April–June 2003): 44–47.

_____. "Tiffany and the Cult of Nature." In Alastair Duncan, Martin Eidelberg, and Neil Harris, *Masterworks of Louis Comfort Tiffany*, 65–120. Exh. cat. London: Thames & Hudson, and New York: Harry N. Abrams, 1989.

HAECKEL, Ernst. *Art Forms in Nature: The Prints of Ernst Haeckel*. With contributions by Olaf Breidbach and Irenaus Eibl-Eibesfeldt. Preface by Richard Hartman. Munich: Prestel Verlag, 1998; reprint, 2004.

MCNALLY, Sean M. "The Deep Sea." *Stained Glass* 79 (Fall 1984): 244–45.

Index

© Scala Publishers Ltd. 2005

First published in 2005 by
Scala Publishers Limited
Northburgh House
10 Northburgh Street
London EC1V 0AT
United Kingdom

Distributed outside the participating venues
in the book trade by
Antique Collectors' Club Limited
Eastworks
116 Pleasant Street, Suite 60B
Easthampton, MA 01027
United States of America

ISBN 1 85759 384 7 (cloth)
ISBN 1 85759 414 2 (paperback)

Project managed by Joan T. Rosasco (Exhibitions
International) and Esme West (Scala)
Edited by Kate Clark, Stephen Frankel (Exhibitions
International), and Esme West (Scala)
Designed by Nigel Soper
Produced by Scala Publishers
Printed and bound by CS Graphics, Singapore

10 9 8 7 6 5 4 3 2 1

PHOTOGRAPHY CREDITS

Allen Memorial Art Museum, Oberlin College, Oberlin, OH:
cat. 43; Avery Architectural and Fine Arts Library, Columbia
University: figs. 10, 11, 12, 26; The Baltimore Museum of Art:
cats. 58, 59, 94, fig. 4; Brooklyn Museum of Art/Central
Photo Archive: cats. 2, 112; Pat Cagney: cat. 57; Christie's
Images: fig. 50; The Chrysler Museum of Art, Norfolk, VA:
cats. 30, 32, 60; Cincinnati Art Museum: cats. 45, 47, 48, 91,
124, 125, 126; The Cleveland Museum: cats. 21, 54, 64;
Cooper-Hewitt, National Design Museum, Smithsonian
Institution: cats. 29, 110, figs. 6, 8; The Corning Museum of
Glass: cats. 14, 27, 25; Brad Flowers: cat. 35; Matt Flynn:
cats. 119, 121; Brian Franczyk Photography, courtesy
Wright, Chicago, IL: fig. 46; T. M. Gonzalez for the Toledo
Museum of Art: cat. 116; Richard Goodbody: cats. 6, 7, 8, 9,
13, 14, 18, 22, 25, 37, 50, 53, 61, 68, 69, 71, 75, 85, 86, 87,
92, 100, 101, 103, 105, 111, 114, 115, 118, 132, 133, figs.
7, 55, 56; Haworth Art Gallery: cat. 70; Helga Studio: cats. 1,
3, 4, 15, 16, 82, 98, 109, fig. 13; Laurent-Sully Jaulmes: fig.
33; Herbert F. Johnson Museum of Art, Cornell University:
cats. 36, 51, 73, 79, 83, 104, 117, 128; Dave King: cat. 84;
Pernille Klemp: fig. 38; Kunstgewerbemuseum Staatliche
Museen zu Berlin: fig. 30; Neil Lane Collection: cats. 17, 74,
77, 120; Library of Congress Prints and Photographs
Division, Washington, DC: figs. 23, 24; Mark Twain House &
Museum: fig. 9; Jason McCoy, Inc., New York, courtesy
Stephen M. Cadwalader: cats. 39, 46, 49; Photograph ©
2005 The Metropolitan Museum of Art: cat. 44; Photograph
© 1991 The Metropolitan Museum of Art: cat. 67;
Photograph © 2004 The Metropolitan Museum of Art: cat.
123; Watson Library, The Metropolitan Museum of Art: fig. 21;
Sanders Milens, © Shelburne Museum Shelburne, Vermont:
cat. 107; Digital Image © The Museum of Modern
Art/Licensed by SCALA/Art Resource, New York: cats. 31,
41, 67; Rodney McCay Morgan, photographer, 1940,
Frederick Vanderbilt National Park Site, Hyde Park, New York,
National Park Service: fig. 25; The Charles Hosmer Morse
Museum of American Art, Winter Park, FL © The Charles
Hosmer Morse Foundation, Inc.: fig. 48; Lillian Nassau, Ltd.,
New York: fig.49; National Academy of Design, New York: fig.
3; The Newark Museum: cats. 38, 78, 97; New Orleans
Museum of Art: cats. 40, 42, 80, 113; The New-York
Historical Society: cats. 26, 66, 88, figs. 15, 16, 20, 22;
General Research Division, The New York Public Library,
Astor, Lenox and Tilden Foundations: cats. 95, 96, figs. 27,
28, 32; Art & Architecture Collection, Miriam and Ira D.
Wallach Division of Art, Prints and Photographs, The New
York Public Library, Astor, Lenox and Tilden Foundations:
figs. 5, 19; Jeffrey Nintzel © 2005: cats. 56, 90; William
O'Connor: cats. 19, 20, 102; John Parnell: cat. 56;
Philadelphia Museum of Art: fig. 34; E. Pourchet, Paris: fig.
36; Réunion des Musées Nationaux / Art Resource, New
York: fig. 35; Dave Revette: cats. 52, 81; Photographic
Services, Smithsonian Institution: cats. 28, 89, 122; fig. 51;
Tim Thayer: cat. 62; Tiffany & Co. Archives: cats. 10, 11, 34;
figs. 4, 17, 52, 53, 54; Michael Tropea: cat. 63; James Via:
cats. 5, 72, 93; Western Pennsylvania Conservancy: fig. 45;
John White: cat. 24; Winterthur Library: Printed Book and
Periodical Collection: back cover; Wisconsin Historical
Society: fig. 18; Scott Wolff: cat. 33; Patrick Young: cats. 76,
99, 106, 108, 127, 129, 130, 131

Front cover: detail cat. 84
Back cover: Tiffany Glass and
Decorating Company, from
King's Photographic Views of
New York, Boston, 1895.
Frontispiece: detail cat. 17